AMERICAN EPICS

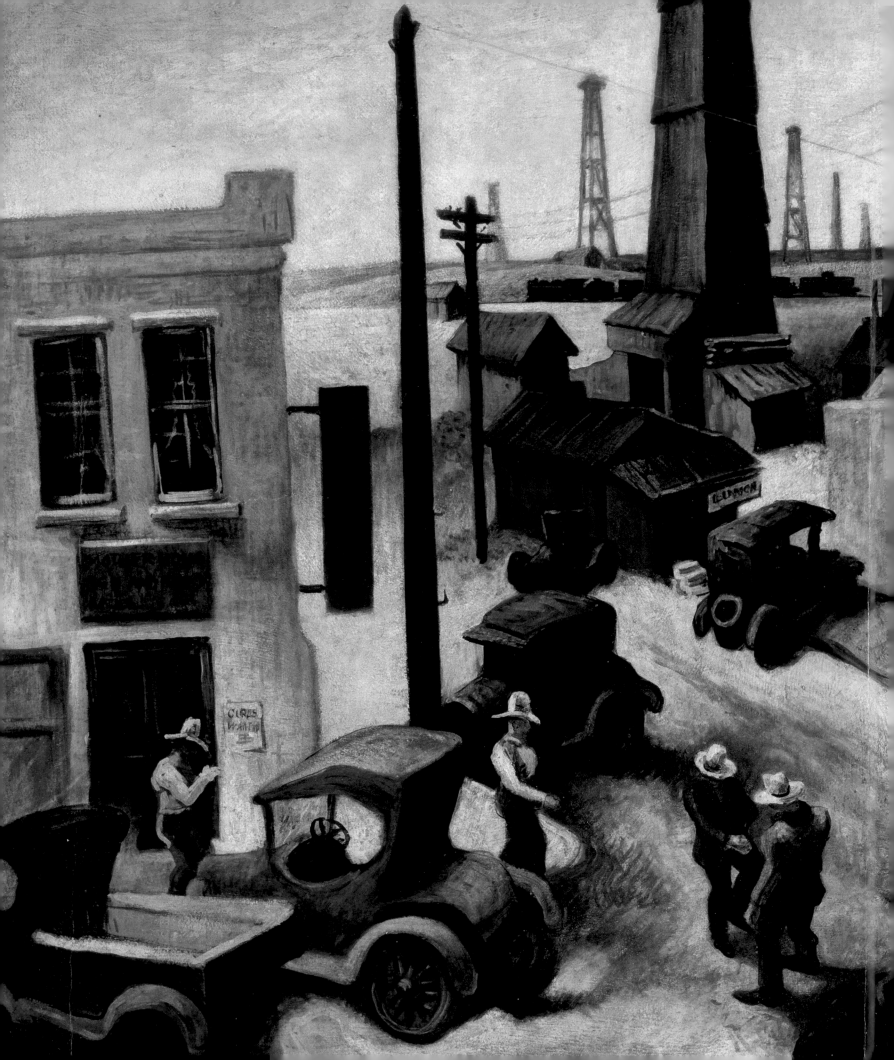

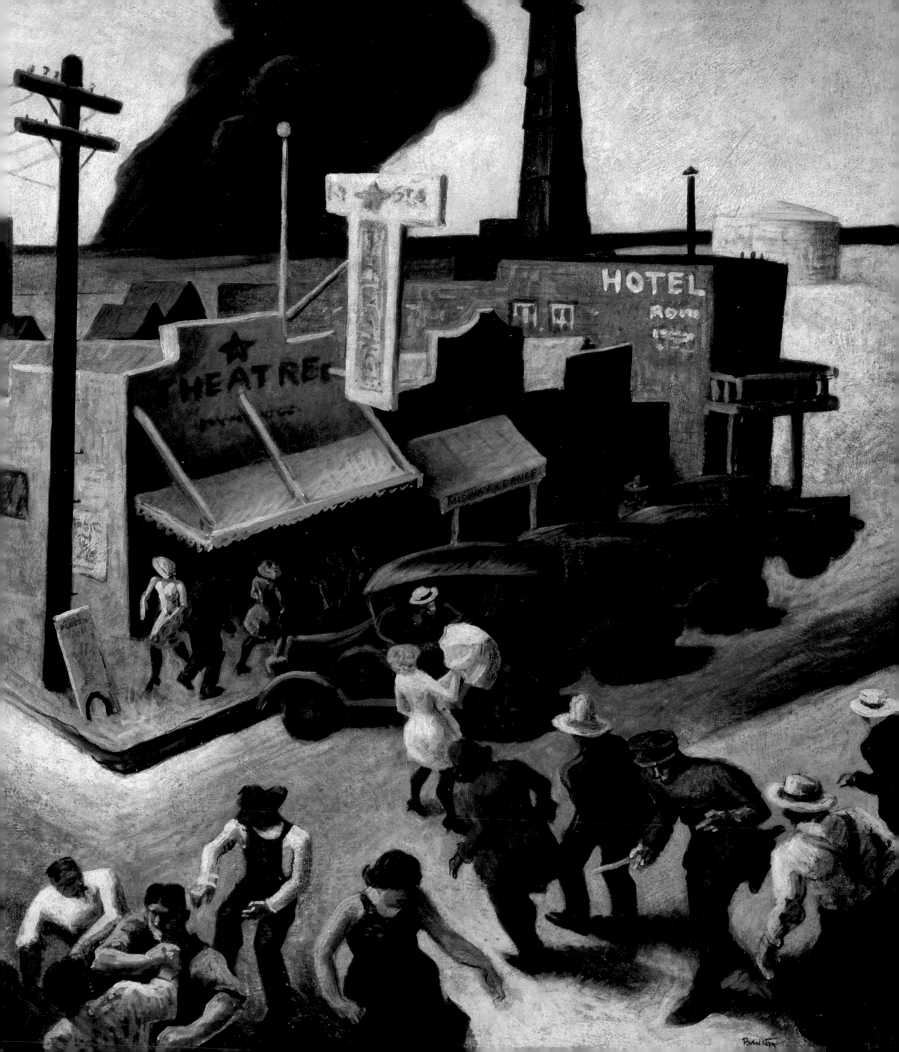

THOMAS HART BENTON

AMERIC

EDITED BY
Austen Barron Bailly

AN EPICS

and HOLLYWOOD

WITH CONTRIBUTIONS BY

Austen Barron Bailly, Matthew Bernstein, Janet C. Blyberg, Sarah N. Chasse, Margaret C. Conrads, Erika Doss, John Herron, Rob LaZebnik, Greil Marcus, Leo G. Mazow, Pellom McDaniels III, Richard J. Powell, and Jake Milgram Wien

PEABODY ESSEX MUSEUM
SALEM, MASSACHUSETTS

DELMONICO BOOKS · PRESTEL
MUNICH LONDON NEW YORK

CONTENTS

FOREWORD

It's in our nature to want to watch our human frailties played out on an epic canvas. Ancient societies had anthropomorphic gods, a huge pantheon expanding into centuries of dynastic drama.... It's the everyday stuff of everyman's life, but it's writ large, and we love it.
—Tom Hiddleston, film actor

A list of the Western world's literary epics logically begins in ancient Greece, with Homer's *The Iliad* and *The Odyssey*, and includes later classics such as Dante's *Divine Comedy*, John Milton's *Paradise Lost* and *Paradise Regained*, Lord Byron's *Childe Harold's Pilgrimage*, and Henry Wadsworth Longfellow's *Evangeline* and the *Song of Hiawatha*. By the mid-nineteenth century, the list takes surprising twists and turns, embracing new literary forms, including Walt Whitman's *Song of Myself* and such nonliterary epics as Richard Wagner's opera *The Ring of the Nibelung*. That trend continues into the twentieth and twenty-first centuries, with James Joyce's *Ulysses*, Ezra Pound's *Cantos*, J. R. R. Tolkien's *Lord of the Rings*, and J. K. Rowling's Harry Potter series weighing in for the literary, and the likes of *Gone with the Wind*, *Ben-Hur*, and the Star Wars series propelling motion pictures into the genre.

Our project's title—*American Epics: Thomas Hart Benton and Hollywood*—indicates that we think of the painter as a member of this time-honored and multifaceted tradition of storytelling. Determined to use the art of his time as a means of mass communication, Benton also clearly understood the power of visual effects to attract attention to cultural and social issues. His achievement—a captivating and widely circulated art made for and embraced by the public—is well established. And this project's goal is straightforward: to provide a fresh perspective on that achievement by focusing on how he mined American filmmaking as a key resource for his style, process, and imagery.

Aligning Benton with the concept of the epic suggests that we should expect to meet a hero in his body of work—a figure engaged in an extended series of superhuman deeds and fabulous adventures, influenced by divine intervention and including detours into the underworld. While these key characteristics are evident in many literary epics and a host of science-fiction and fantasy cinematic epics today, they are less pronounced in Benton's paintings. Instead, he gravitated toward the intent of an epic: to capture, express, and even question the origins, spirit, and values of a particular time or nation in language and imagery accessible and relevant to many people across successive generations. Benton obviously thought that themes such as cultural identity, westward expansion, prejudice and tolerance, and the larger-than-life American Dream were worthy of epic treatment played out by not one central hero but a cast of many heroes and heroines, from the mythic Yankee to African American farmers and soldiers.

Benton's highly stylized approach embraced the value of the vignette in breaking down a story into smaller pieces of narrative, a technique familiar to writers, artists, and filmmakers alike. He also manipulated the genre, reenvisioning the epic through the lens of modern art, not just in terms of the visual artist's redefinition of color and form but especially through his attention to the technologies and techniques of his era's new medium, film. The immersive and often panoramic theatrical sensibility in many of Benton's paintings owes much to this attention.

Mingling elements from the high and the popular arts, Benton takes us on a journey through America's humanity, its strengths and weaknesses. The affecting presence of emotion and narrative also invites us to consider why cultures, nations, and artists create epics and how, even whether, the concept

of the epic as a fount of philosophy is still relevant for today's audiences.

Although this project has not required the cast of thousands typical of Hollywood's heyday of epic films, it has been the product of a large national team with wide-ranging expertise and points of view. The Peabody Essex Museum (PEM) is honored to have been the lead organizer, captained by the considerable talents, scholarship, dedication, and professional camaraderie of Austen Barron Bailly, our George Putnam Curator of American Art. To our collaborating partners — the leaders and staff of the Amon Carter Museum of American Art and The Nelson-Atkins Museum of Art — we extend our deepest appreciation for the excellence and collaborative spirit that they have consistently provided. We are also pleased that the Milwaukee Art Museum has joined our project as the exhibition's fourth venue. The evolution of the exhibition and its many contributors, including PEM's exceptional staff, are eloquently detailed elsewhere in this volume.

Ambitious endeavors require not only talent, time, and commitment but also enlightened philanthropy. The Peabody Essex Museum, the Amon Carter Museum of American Art, and The Nelson-Atkins Museum of Art are most grateful to the National Endowment for the Humanities (NEH) for a generous grant through its highly competitive America's Historical and Cultural Organizations program, awarded on the occasion of the NEH's "Celebrating 50 Years of Excellence." We also deeply appreciate the important grant given by the National Endowment for the Arts. Thanks go as well to Furthermore: a program of the J. M. Kaplan Fund for helping to fund the publication of this volume. At the Peabody Essex Museum, Carolyn and Peter S. Lynch and the Lynch Foundation have provided significant support, and we would also like to thank our East India Marine Associates for their annual support of PEM's exhibition program.

Canvas, paint, stories! — this trajectory was Thomas Hart Benton's version of Hollywood's lights, camera, action! Whether during Benton's time or our own, as countries and religions contend with unsettling, often violent, circumstances, humankind benefits from remembering that storytelling is common to all civilizations. In the form of literature, art, or film, the story is our most enduring method of making sense of the human experience — past, present, and future.

Dan L. Monroe
The Rose-Marie and Eijk van Otterloo Director and CEO,
Peabody Essex Museum

Lynda Roscoe Hartigan
The James B. and Mary Lou Hawkes Chief Curator,
Peabody Essex Museum

PARTNERS' STATEMENT

American Epics: Thomas Hart Benton and Hollywood is the result of the first collaboration between the Peabody Essex Museum (PEM), the Amon Carter Museum of American Art, and The Nelson-Atkins Museum of Art. Rather than adopting the typical co-organizational model for traveling exhibitions, each of our institutions brought to the table invaluable resources that, when combined, proved to be formidable.

With the arrival of Austen Barron Bailly at PEM from the Los Angeles County Museum of Art, which supported the project's initial curatorial travel and research, PEM took the helm of this complex and ambitious project. Building on the foundations laid by Bailly and cocurators Jake Milgram Wien and Margaret C. Conrads, PEM oversaw the National Endowment for the Humanities implementation grant, the National Endowment for the Arts grant, a grant from Furthermore: a program of the J. M. Kaplan Fund, as well as the planning, development, and management of the exhibition and publication. The Nelson-Atkins is home to the largest collection of Benton's art in the world, including ten panels from his *American Historical Epic* mural series, and it proudly serves as the largest lender to this exhibition. The Nelson-Atkins contributed extensively to the exhibition in other crucial ways, namely providing the conservation expertise and guidance for the entire project – including examination, analysis, and treatment of Benton's works. Conrads served for more than two decades as the senior curator of American art at the Nelson-Atkins before becoming deputy director of art and research at the Amon Carter. Her involvement in the exhibition led to the Amon Carter's key role on the project, and the museum lent scholarly and strategic expertise every step of the way.

The Nelson-Atkins mounted *Thomas Hart Benton: An American Original*, the last major Benton exhibition, in 1989, coinciding with the centennial of the artist's birth. More than twenty-five years have passed since that influential survey. *American Epics: Thomas Hart Benton and Hollywood* marks a thematic centennial – that of Benton's involvement with motion pictures. Via our collective efforts, audiences throughout America will discover overlooked relationships among Benton's art, the movies, and visual storytelling in twentieth-century America. We are delighted that the Milwaukee Art Museum has joined our national tour: now museumgoers in New England and Texas, as well as Wisconsin, will see the first major Benton exhibition ever presented in their respective regions while those in Missouri can look at their native son's art and career from fresh perspectives. We are privileged to make these opportunities possible and to represent this successful collaborative model, one that responded to curatorial initiatives and moved beyond traditional biographical retrospectives.

Dan L. Monroe
The Rose-Marie and Eijk van Otterloo Director and CEO, Peabody Essex Museum

Andrew J. Walker
Director, Amon Carter Museum of American Art

Julián Zugazagoitia
Menefee D. and Mary Louise Blackwell Director and CEO, The Nelson-Atkins Museum of Art

ACKNOWLEDGMENTS

Thomas Hart Benton's *The Kentuckian* (1954; pl. 19), which depicts Burt Lancaster as a manly American frontiersman clad in fringed buckskin, inspired writers of the long-running animated television program *The Simpsons* to spoof the painting in the show's second season. The scrawny and unappealing character Mr. Burns is running for governor and in need of a makeover, so his campaign team suggests the classic Daniel Boone look pictured in Benton's composition. The reference is a revealing testament to the power of Benton's image and his relevance to Hollywood, American art, and popular culture; it also alludes to the origins and evolution of this exhibition.

A promotional painting for the movie *The Kentuckian* (1955), Benton's canvas entered the collection of the Los Angeles County Museum of Art (LACMA) in 1977, a gift from Lancaster, the director and star. When LACMA invited conceptual artist Michael Asher to create a work for its 1981 exhibition *The Museum as Site: Sixteen Projects*, Asher chose *The Kentuckian* as the basis for his witty installation *Sign in the Park*. Asher linked Benton's Hollywood canvas depicting pioneer Lancaster—and his faithful dog—to LACMA's physical location near Hollywood and within dog-friendly Hancock Park: he moved a "dogs must be kept on a leash" sign from the park into the galleries and replaced the park sign with a stanchion containing a faux movie poster directing visitors to Benton's painting inside the museum. Then there was the painting's 1990 cameo on *The Simpsons*. In 2006, the painting's Hollywood connections inspired independent curator and historian Jake Milgram Wien to come to LACMA, where I was an American art curator, to pitch his idea for an exhibition exploring Benton's relationships to the US motion-picture industry. At the time, I was researching my doctoral dissertation on Benton's *American Historical Epic* mural series. Our mutual interest in Benton as modern history painter and muralist—and as a visual storyteller of and for America—was the impetus for the project. In 2012, the *Los Angeles Times* announced LACMA's receipt of a planning grant from the National Endowment for the Humanities (NEH) to further develop the exhibition, prompting a writer and producer for *The Simpsons*, Rob LaZebnik, to call and invite me to see the Benton drawing he owns, *Young Executive* (pl. 64). LaZebnik's drawing is included in the exhibition, and he wrote a delightful piece about it for this catalogue.

Wien's ideas and research led to his role on this nearly decade-long collaborative enterprise that began at LACMA. My sincerest thanks go to Wien and to all my LACMA colleagues who helped launch this project, especially Bruce Robertson, former chief curator of American art; Ilene Susan Fort, senior curator and Gail and John Liebes Curator of American Art; curatorial assistant Devi Noor; research interns Meagan Blake and Samuel Crosby; development officers Stephanie Dyas, Chi-Young Kim, and Ondy Sweetman; film curators Elvis Mitchell and Bernardo Rondeau; conservators Joe Fronek and Janice Schopfer; and registrar Amy Wright. The support of LACMA's American Art Council was instrumental, as was that of Nancy Thomas, deputy director for art administration and collections; Zoe Kahr, deputy director for exhibitions and planning; and Michael Govan, director and CEO of the museum.

It has been a privilege to lead the cocuratorial team of Margaret C. Conrads, deputy director of art and research

at the Amon Carter Museum of American Art, Wien, and consulting film curator Matthew Bernstein, professor of Film and Media Studies, Emory University, who guided the selection of films included in the exhibition. Their conceptual, logistical, and scholarly contributions to this project have been essential and inspired. The essays written by each of us for this volume represent new directions in Benton scholarship, but we are indebted to art historians Henry Adams, Matthew Baigell, and Karal Ann Marling—as well as catalogue contributors Erika Doss, who authored the first examination of Benton in Hollywood, and Leo Mazow. Their publications on Benton provide the foundation for any reevaluation of this seminal American artist.

The NEH planning grant brought together an exceptional interdisciplinary team of scholars—Doss, Charles C. Eldredge, John Herron, Richard B. Jewell, Pellom McDaniels III, and Richard J. Powell—whose perspectives are reflected throughout the exhibition and book, made possible in part by a grant from Furthermore: a program of the J. M. Kaplan Fund. I appreciate the scholars' advisory efforts, the NEH's continuing support in the form of an implementation grant to fully realize *American Epics*, as well as the support of the National Endowment for the Arts. Doss, Herron, McDaniels, and Powell all contributed texts to this catalogue. I thank them for their groundbreaking essays, and I am also grateful for the insights presented in essays by Janet C. Blyberg, Mazow, and the inimitable Greil Marcus.

I deeply appreciate the excellent work and model collegiality of our partner institutions. At the Amon Carter, Conrads led the museum's talented staff, including Maggie Adler, assistant curator; Alessandra Guzman, exhibitions manager; Claudia Sanchez, art and research administrative assistant; Will Gillham, director of publications and his team; Marci Driggers, director of registration and collections and her team; Judy A. Ivey, associate director of development and her team; Stacy Fuller, director of public engagement and her team, especially Peggy Sell, interpretation manager; Randy Ray, chief financial officer; Janice Craddock, director of information technology and her team; Tracy Greene, public information officer and her team; Tim Smith, exhibition designer and installation director and his team; and Andrew J. Walker, director.

At the Nelson-Atkins, Antonia Boström, director of curatorial affairs; Cindy Cart, manager of exhibition planning; and Stephanie Fox Knappe, the Samuel Sosland Curator of American Art, spearheaded the institution's involvement. I thank them for their commitment and vision. I greatly appreciate the tremendous efforts of the museum's experienced conservation staff, which provided its critical expertise for the exhibition and tour, an undertaking led by Mary Schafer, paintings conservator, with Elisabeth Batchelor, director of conservation and collections management, and Scott Heffley, senior paintings conservator. And we appreciate the help of the many conservators nationwide who assisted in the preparation of works for the exhibition. Thanks also go to Katelyn D. Crawford, assistant curator of American art; Kirsten Milliard, American art department assistant; Sarah Beeks Higdon, director of advancement and her team; Toni Wood, director of marketing and communications and her team; Jill Kohler, head of registration and her team, especially Kara Kelly, associate registrar; along with Adam Johnson, acting head, education and interpretive planning; Adrienne Lalli-Hills and Melissa Mair, interpretive planners; Matthew D. Smith, senior exhibition designer; Michele Boeckholt, Beth Byers, and Susan Patterson, graphic designers; the information technology team of Tim Graves, James Schwartz, and Brandon Wilcox; and Mark Milani, head of collections handling and exhibitions installation, and his team.

At PEM, the leadership of director Dan L. Monroe and deputy director Josh Basseches helped to make this project possible. Chief curator Lynda Roscoe Hartigan provided insightful and creative guidance throughout the entire process. Priscilla Danforth, head of exhibition planning, deftly and diplomatically guided this complex venture, with details managed by Jaime DeSimone and Caitlin Lowrie. The expert skills of registrars Claudine Scoville, Brittany Minton, and Monique Le Blanc served the project exceedingly well. The exhibition's presentation benefitted significantly from Emily Black Fry, lead interpretation planner, and the input of Gavin Andrews, assistant director of family, student, and youth programs; and Juliette Fritsch, chief of education and interpretation. Their ideas informed not only Kurt Weidman's exhibition design, conceived with the assistance of Karen Moreau-Ceballos and director of design Dave Seibert, but also the presentation of media components of the exhibition overseen by Jim Olson, director of integrated media, and his skilled team. And special thanks go to production designer Charles McCrary, who offered meaningful feedback on the exhibition's early design strategies. Jay Finney, chief marketing officer, and his public relations staff, especially Dinah Cardin and Whitney Van Dyke, promoted this exhibition, which is supported by funding secured with the help of Anne Butterfield, director of institutional giving; Janet Mallet Natti, grant writer; and Amanda Clark MacMullan, chief philanthropy officer. Sid Berger, PEM's Phillips Library director emeritus, and Barbara Kampas, head of library collections, not only expanded the library's holdings to support our research but also acquired the first Benton objects to enter PEM's collection—rare, limited-edition volumes illustrated by the artist, which are included in the exhibition. Senior photographer Walter Silver skillfully photographed these books and other works by Benton for the exhibition and publication.

Associate curator Sarah N. Chasse provided vital research support and developed this book's engaging timeline. American art intern Francisca Moraga provided extraordinary research support and all manner of inspired contributions. Intern Kasey Walko was also a great help. The art historical acumen of seasoned assistant curator Janet C. Blyberg helped guide the work of the entire project and led to her writing an essay for this volume. Editor Gail Spilsbury offered skilled support along the way, and Claire Blechman, digital assets manager, adeptly managed all the images.

I am particularly thankful to Kathy Fredrickson, director of exhibition research and publishing, for her experience and guidance overseeing the publication and to Mary DelMonico and the copublishing team at DelMonico Books • Prestel for their collaboration. The opportunity to work with such accomplished publishing professionals, including outstanding editor Nola Butler and talented designer Roy Brooks of Fold Four, has been a great pleasure.

In the course of researching and preparing this exhibition and book, many friends and colleagues helped advance the project, and their efforts on our behalf are much appreciated. Special thanks go to Judith Barter and Sarah Kelly Oehler, the Art Institute of Chicago, Chicago, Illinois; Iris Cohen; Steven Cole; Joseph Goddu; Randall Griffey, The Metropolitan Museum of Art, New York; Kate Haw and her team, Archives of American Art, Smithsonian Institution, Washington, DC; Elizabeth Hughes and Annette Sain, Ralph Foster Museum, College of the Ozarks, Point Lookout, Missouri; Lois Katz; Sandy and Erlene Krigel; Jan B. Leonard, UMB Investment and Wealth Management; Steve Siddon, Thomas Hart Benton Home and Studio State Historic Site, Kansas City, Missouri; and Allison Smith, VAGA, New York. I am delighted that the Milwaukee Art Museum, Milwaukee, Wisconsin, is presenting the exhibition's grand finale and want to thank Jim DeYoung, Dawn Gorman Frank, Daniel T. Keegan, Jane O'Meara, Melissa Hartley Omholt, Brady Roberts, and Brandon K. Ruud for their contributions and enthusiasm.

The generosity of private and institutional lenders is an exhibition's lifeblood, and I express my profound gratitude to the numerous individuals as well as directors and staff members at the following institutions who lent works to this exhibition: Cici and J. Hyatt Brown and their curator David Swoyer; Barbara Guggenheim, Guggenheim Asher Associates; Sheila and Milton B. Hyman; Vivian Kiechel, Kiechel Fine Art, Lincoln, Nebraska; Susie and Robert Knapp, Jr.; Rob and Claire LaZebnik; Eleanor Kay MacDonald; Megan Benitz and Terry Oldham, Albrecht-Kemper Museum of Art, Saint Joseph, Missouri; Rochelle L. R. Oakley and Ann H. Sievers, Art Gallery, University of Saint Joseph, West Hartford, Connecticut; Veronica Roberts, Meredith D. Sutton, and Simone J. Wicha, Blanton Museum of Art, the University of Texas at Austin; Elizabeth Tufts Brown, Louise Lippincott, Sarah Minnaert, and Lynn Zelevansky, Carnegie Museum of Art, Pittsburgh, Pennsylvania; Christa Barleben and James A. Nottage, the Eiteljorg Museum of American Indians and Western Art, Indianapolis, Indiana; Annie Farrar, Evelyn Hankins, and Melissa Ho, Hirshhorn Museum and Sculpture Garden, Smithsonian Institution, Washington, DC; Michele Ahern, Steve Koblik, Kevin Salatino, and Jessica Smith, the Huntington Library, Art Collections, and Botanical Gardens, San Marino, California; colleagues acknowledged above at the Los Angeles County Museum of Art; Martha Kjeseth Johnson and Debbie Mallett Spanich, the Maier Museum of Art at Randolph College, Lynchburg, Virginia; Grant Holcomb, Colleen Piccione, and Monica Simpson, Memorial Art Gallery of University of Rochester, Rochester, New York; Alex Barker

and Jeffery Wilcox, Museum of Art and Archaeology, University of Missouri, Columbia; Elliot Bostwick Davis, Erica E. Hirshler, Janet Moore, and Malcolm Rogers, Museum of Fine Arts, Boston; Nancy Anderson, Judy Cline, and Earl A. Powell III, National Gallery of Art, Washington, DC; Margaret Grandine, John Gray, and Wendy Shay, National Museum of American History, Washington, DC; Brandon Fortune, Molly Grimsley, Dorothy Moss, and Kim Sajet, National Portrait Gallery, Washington, DC; Captain Henry J. Hendrix II, Karin Hill, Gail Munro, and Pam Overmann, Navy Art Collection, Naval History and Heritage Command, Washington, DC; colleagues acknowledged above at The Nelson-Atkins Museum of Art; Stacy Cerullo and Douglas Hyland, New Britain Museum of American Art, New Britain, Connecticut; John Coffey, Margaret Gregory, Tiara Paris, and Lawrence J. Wheeler, North Carolina Museum of Art, Raleigh; David R. Brigham, Robert Cozzolino, Jennifer Johns, and Anna Marley, Pennsylvania Academy of the Fine Arts, Philadelphia; Rebecca Eddins and Allison Perkins, Reynolda House Museum of American Art, Winston-Salem, North Carolina; Gary Kremer and Joan Stack, the State Historical Society of Missouri, Columbia; Peter John Brownlee, Elizabeth Glassman, and Cathy Ricciardelli, Terra Foundation for American Art, Chicago, Illinois; Jan B. Leonard, Thomas Hart Benton and Rita P. Benton Testamentary Trusts and Vice President and Managing Director, UMB Bank; Carter Foster, Barbara Haskell, Barbi Spieler, and Adam Weinberg, Whitney Museum of American Art, New York. To anyone who aided our efforts but was inadvertently omitted here, I thank you.

It is an honor to acknowledge the vision of George Putnam, who endowed my position and helped inaugurate a new direction for American art at PEM, which this exhibition represents. Benton's only daughter, Jessie, has been a continual source of vitality for this project. Her warmth, openness, and firsthand familiarity with her father's art informed this exhibition, as does her delight in introducing Benton to new audiences. I am especially pleased that a new generation of Benton admirers includes my young children, Leonce and Jane, who have become lively and engaged viewing companions of Benton's art. I want to thank my parents, Karen and Errol Barron, and my brother, Eliot, for their enthusiasm and input on my Benton work, and so many other fronts. Finally, my most heartfelt thanks go to my husband, Jonathan Bailly, for his steadfast support and patience, and for his appreciation of my seemingly epic focus on the art of Thomas Hart Benton.

Austen Barron Bailly
The George Putnam Curator of American Art,
Peabody Essex Museum

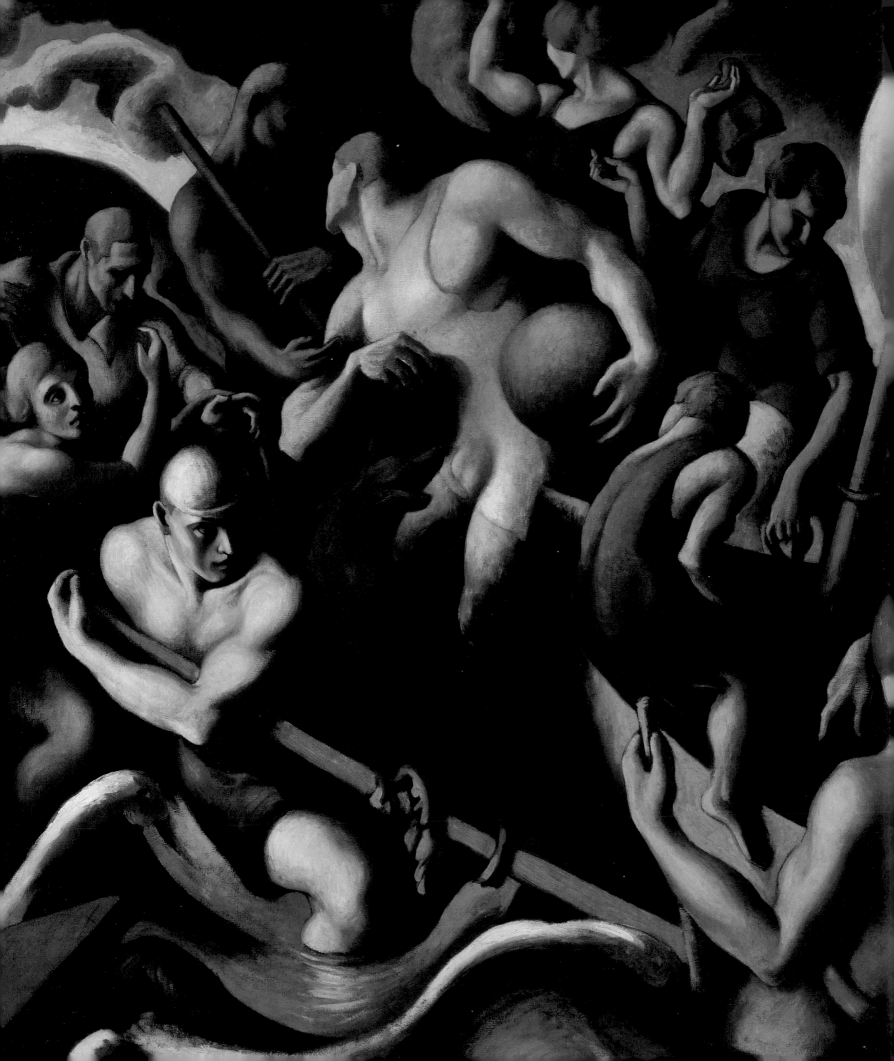

INTRODUCTION

Austen Barron Bailly

I am not a Hollywood news column fan, and I have not read any books about the place. I know it only through the direct experiences of an artist interested in making pictures of America and American things.
–Thomas Hart Benton, "Hollywood Journey"

A century ago, Thomas Hart Benton (1889–1975) wanted to be known as the major American artist of his day. Although trained in Chicago and Paris and a member of the vanguard modern art community in New York around 1915, Benton had yet to make the kind of defining contribution to the art history of the United States that his forebearers had made to American political history.[1] Casting about for work and opportunities, the ambitious painter looked to Fort Lee, New Jersey – the "first Hollywood." He started working there on silent era motion-picture productions in various artistic capacities, such as painting sets for director Rex Ingram. He quickly understood the rising influence of the emerging film industry and its force in contemporary storytelling. Recognizing that "a gulf had opened between painted and film representation," Benton remained attentive throughout his career to Hollywood's dominant role.[2] *American Epics: Thomas Hart Benton and Hollywood* explores, for the first time, how Benton's exposure to moviemaking affected his art and career.

In 1920, Benton painted *People of Chilmark (Figure Composition)* (pl. 70), the life-size canvas that boldly signaled a totally new direction in his life as an American modernist. The canvas reveals Benton's interest in American people and their stories, as well as the emergence of his highly recognizable cinematic style. Here was a canvas that had the unmistakable look of canonical paintings from European art history, complete with complex Renaissance and mannerist compositional structures and chiaroscuro. But the painting was also startlingly American. Benton replaced history painting's nude, biblical, historical, or mythological figures with a montage of contemporary Americans, including an African American man.

These youthful, athletic bodies, most dressed in 1920s bathing costumes, were Benton's people – identifiable friends and neighbors from Chilmark, Massachusetts, a village on the island of Martha's Vineyard, where, beginning that year, he spent every summer. He gave them classical, dramatic guises with solemn expressions and placed them in a stylized day-at-the-beach setting, mimicking the exaggerated acting styles of *tableaux vivants* and silent films. And he illuminated this popular history painting with stark unnatural light and a range of colors then unimaginable in film: teal, burnt orange, yellow, sienna brown, ocher, salmon pink, lavender. The backdrop of the painting features azure, cobalt blue, and forest green, with key compositional elements accented by carmine red – colors recognizable today as the basic palette for the three-color Technicolor process.

To create *People of Chilmark*, Benton revived outmoded working methods of fifteenth- and sixteenth-century old masters that paralleled the storyboard-to-final-take production techniques developed by the motion-picture industry. He started by sculpting clay models of his intended painting compositions and lighting them to highlight the three-dimensional forms. He created numerous studies of these dioramas in the production of his large-scale paintings, which he populated with highly sculptural, brightly lit characters meticulously arranged in energetic, rhythmic, and often symbolic compositions.

Next to the ebony black background at the top of *People of Chilmark*, against which the red bathing cap, yellow swimsuit, and skin tone of the central figure stand out, we discern the profile and brown skin of the muscular African

American man; light strikes the crown of his head, highlighting his distinctive close-cropped hair. He is not rendered in exaggerated or caricatured proportions but appears physically similar to all the other figures in the painting. He is one of the people of Martha's Vineyard. He reaches out and touches the bicep of a white man, who is twisting to look directly at him and whose right shoulder bears down deeply. The white man's contorted pose partially reveals his profile; his neck and head strain up toward the black man, who looks down but does not appear to meet the white man's gaze. The extreme darkness of the small chasm between these two figures, into which the body of the black man dissolves, underscores the profound indeterminacy of this visual moment. The formal, conceptual, and, in fact, racial experiments in this painting indicate that beyond reinventing classical traditions and developing a new style, Benton was fundamentally concerned with race and modern American identity. These were key issues for the emerging film industry too. Through his rendering of these muscular and fleshy modern men and women, white and black, Benton at once embraced and challenged the ideal figure and its traditions. Benton continued this modernist maneuver throughout his career, appropriating and reinterpreting classic American characters, historical events, and themes in his narrative paintings, just as Hollywood did in its movies.

People of Chilmark is emblematic of the formal as well as the thematic connections between Benton's art and the movies, which are the subjects of this exhibition and catalogue. *American Epics: Thomas Hart Benton and Hollywood* explores Benton's narrative painting and his approach to the figure and race, Hollywood's corresponding approach to visual storytelling and character representation, and the broad theme of American identity. It is a collective effort on the part of veteran Benton scholars and specialists from other disciplines writing about the artist for the first time to recover and reexamine the artistic and cultural complexities that motivated and informed the way Benton painted his American pictures.

In 1924, Benton started traveling regularly around the country "by foot, bus, and train, searching out American subject matter." He recounted in his autobiography, "I started going places . . . and plowed around in the back countries where old manners persisted and old prejudices were sustained . . . I took them as they came."[3] These experiences deepened Benton's interest in blending American history with the vernacular, in collapsing distinctions between modern America and mythic America. By going on location, Benton infused his painterly stagecraft with the authenticity Hollywood sought in its movies. Benton proved a keen observer and recorder of American places and people, even their dialects, in image and in prose. Readers relish these traits in Benton's 1937 autobiography *An Artist in America*, which is still in print, and in his ability to capture regional characteristics, settings, and dialogue. The stories and descriptions collected on these journeys work like a screenplay, vividly conjuring scenes of 1920s and 1930s America that made their way into his drawings, paintings, and murals. To most Americans, Benton's imagery was captivating because it was similar to their own

experience and, frequently, to what they saw in the movies. This was the so-called Golden Age of Hollywood, when Benton achieved his greatest recognition as an artist.

Benton went to Hollywood for the first time in the summer of 1937; he was on assignment to portray the motion-picture industry for *Life* magazine. By this time, he was one of the most famous artists in America. He had appeared on the December 24, 1934, cover of *Time* magazine, and people knew him primarily as a public muralist, the nationally acclaimed artist of four monumental mural commissions completed between 1930 and 1936. His celebrity and talent led to important Hollywood commissions. Between 1939 and 1954, the great directors and producers of the day—including John Ford, Walter Wanger, and Darryl F. Zanuck—commissioned him to create artwork promoting their movies. Today, most people know little of Benton's engagement with Hollywood; *American Epics* aims to change that.

Hollywood writer and humorist Rob LaZebnik admits that he knew little of Benton's Hollywood experiences when he fell for Benton's drawing *Young Executive* (1937; pl. 64), a satirical glimpse of the industry and its power players. To set the stage for this book, LaZebnik relates how he came to own the drawing and how it serves as a measure of Benton's visual acumen and knack for dialogue, an enthusiastic endorsement for the staying power of Benton's art and the quality of his storytelling. Around the same time that he drew *Young Executive*, Benton started, but never finished, an essay about his first trip to Hollywood. The manuscript, Benton's "Hollywood Journey," unpublished until now, reveals his love-hate relationship with Tinseltown. The artist's clever, perceptive, even diagnostic, response to what he observed on the 20th Century Fox lot feels utterly relevant today.

Benton's multilayered relationship to Hollywood and popular culture, and to American history and art history, gave the artist latitude to blur fact and fiction, mythic and modern. As the cultural historian Constance Rourke discusses in her 1931 book *American Humor: A Study of the National Character*, many American artists were "using native sources as a point of radical departure."[4] Benton's attentiveness to America's vernacular, regional cultures, and to images of African Americans (more so than those of Native Americans), related to what Rourke calls America's "comic trio": the Negro minstrel, the Yankee, and the backwoodsman. Rourke argues that "these mythical figures . . . represented contentious elements in the American scene."[5] Benton was continually drawn to America's contentious, even violent, elements and to their satirical and ironic underpinnings. And he had a penchant for exaggeration, caricature, and the grotesque. He frequently depicted what he called "undisciplined, uncritical" arts, or "popular arts," as a way of dramatically extracting authentic meanings expressive of American character—what Rourke believes "had always been the great American subject."[6]

In *True West: Thomas Hart Benton and American Epics*, I look at Benton's lifelong engagement with the dominant national epic—westward expansion. Beginning with his mural series *American Historical Epic* (1920–28; pls. 1–14),

Benton began challenging and reflecting the myths and realities of the West in his art. His revisionist approach to the past brought him into critical, playful, or sympathetic exchange with historical and cinematic traditions of telling and retelling national sagas. Director John Ford encapsulated the emotional and narrative thrust of iconic American themes, stories, and characters in his films, as Benton did in his paintings and murals. John Herron illuminates how Ford constructed the twentieth century's most influential visions of the American frontier through films that appear as artful and composed as paintings and advance the mythologies of the West as the ultimate expressions of American identity. Margaret C. Conrads's case study of Benton's commissions to illustrate and promote John Ford's film adaptation of John Steinbeck's *The Grapes of Wrath* demonstrates the influence and appeal of Benton's style, draftsmanship, and compositional stagecraft on moviemakers and audiences alike. Richard J. Powell deconstructs these themes in a meditation on the sophisticated visual and conceptual strategies underlying Benton's seemingly down-home painting *Romance* (1931–32; pl. 45). Writing about Benton for the first time, Powell presents a landmark assessment of Benton's responses to African American culture and the South. Matthew Bernstein's description of African American movie culture emphatically reminds us that when the likes of Benton and Ford were making their art, segregated theaters divided the millions who saw the movies that were shaping American culture and constructing racial identities through typing and stereotyping.

Erika Doss was the first to write extensively on the relationships between Benton, Hollywood, and American art and culture. In her latest essay on these subjects, she tracks the rise of the movie industry and considers the range of artistic responses to Hollywood's dominance, situating Benton's Hollywood endeavors in context with those of other American artists who "mined the dream factory." Janet C. Blyberg's overview of Benton's 1937 Hollywood drawings reconsiders this substantial and revelatory body of work in relation to its original commission and reception. Her assessment reveals the knotty connections between American art, Hollywood, and critics that Benton's work calls attention to. Leo G. Mazow examines Benton's fascination with the actual equipment and mechanics of making movies. Mazow shows how the artist's fastidiousness and acute observational skills, showcased in his Hollywood drawings, can illuminate our understanding of Benton's interest in cultural production and his meticulous approach to all his subjects. Jake Milgram Wien explores how Benton combined the qualities and production techniques of motion pictures with a rigorous working method emulating old master painters to develop a luminous and three-dimensional narrative style. In looking at how Benton actually produced such memorable paintings, Wien identifies what makes them cinematic.

As the essays in this book show, Benton developed an expert ability to combine high art and popular culture in his work. But Wien's essay on Benton's World War II paintings from 1942 demonstrates that the artist's attempt to unite comics, pulp magazines, and racial stereotypes in propagandistic mural paintings compromised the success of those works. Pellom McDaniels III's new interpretation of Benton's related wartime painting, *Negro Soldier* (1942; pl. 79), probes the tensions inherent in Benton's most problematic images of African Americans and exposes their stereotypical treatment in relation to the historic achievements of the very men Benton set out to represent. By way of conclusion, Greil Marcus explores the tensions that characterized Benton's life and career. Marcus demonstrates that despite, or because of, Benton's often contradictory positions on American culture and race, the artist is a great American subject in his own right. Marcus shows how Benton's restlessness and drive to know and paint America shaped not just the man and his art but also the people and places he painted.

"Benton, Hollywood, and History: A Timeline" by Sarah N. Chasse, gives readers a framework for evaluating the connections between Benton's life and art and the cultural milestones, historic events, and cinematic highlights of twentieth-century America. It reveals the predominant aspects of Benton's era—the legacy of westward expansion and efforts to conserve the western wilderness, race relations, war, the Depression—along with the trajectory of Hollywood and its major achievements. As Benton reported about his experience in Hollywood, "I made it my business while on 'the lots' to ask questions. I was not interested in particular Stars but in what went on all the time no matter what young ladies or young men were being blazzoned [*sic*] on the billboard headlines of the country. The first thing that I asked was 'How do you get the stories for the movies?' I wanted to begin at the beginning." *American Epics: Thomas Hart Benton and Hollywood* also wants to begin at the beginning. Going back to the artist's early involvement with moviemaking inspired this volume's new takes on Benton and his efforts to make pictures about America.

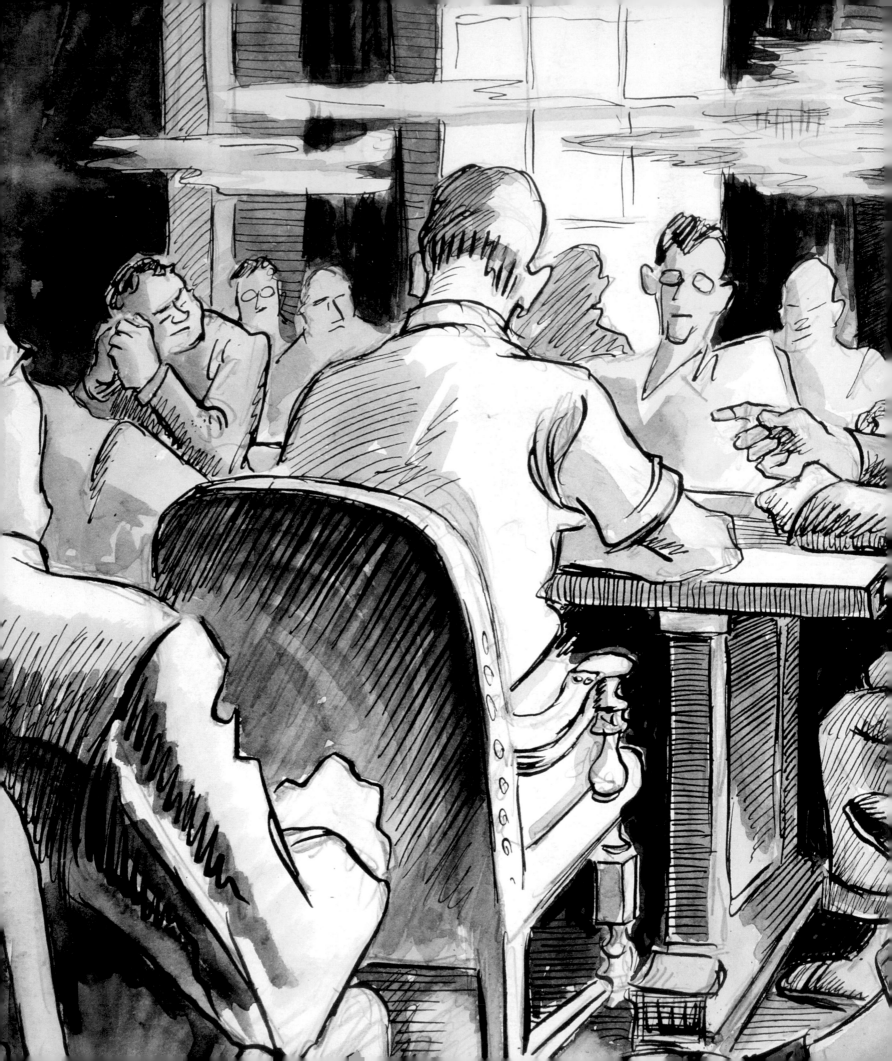

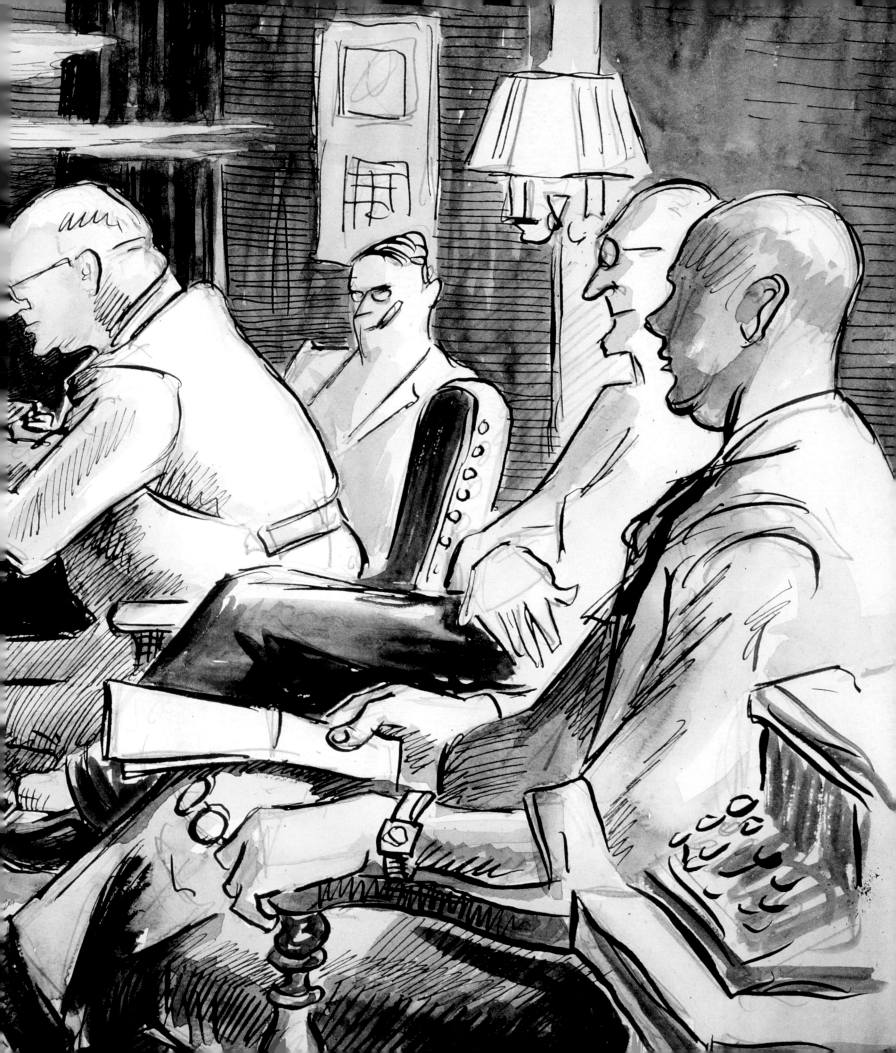

THE YOUNG EXECUTIVE AND ME

Rob LaZebnik

I think that it's necessary to have one work of art in your house that sums up who you are—a visual expression of your history and beliefs. With any luck, it's a piece that leaps out at a judgmental visitor, sending him the message that you're deeper and more complicated than you know you actually are.

The piece that delivers the goods for me is a drawing by Thomas Hart Benton (fig. 1), and my path to owning it began in the 1970s, at home in Columbia, Missouri. When my parents took me to see Benton's murals at the State Capitol in nearby Jefferson City, I came fully prepared for the intellectual outing by bringing along my Coleco Electronic Quarterback game. But I was surprised to find myself riveted by the art. There's a lot for a ten-year-old to gape at in those paintings: the betrayed lover Frankie shooting her man Johnnie, scantily clad lady dancers, Jesse James's gang robbing both a railroad *and* a bank. He even painted a boy eating a sandwich. This Benton guy *got* me.

I left Missouri for college and lived briefly in Manhattan, where I pledged to myself that I'd never let the big city eat away at my midwestern-ness. And, indeed, I remember walking to work down a crowded Broadway, being jostled at every step and saying, "Excuse me . . . sorry . . . my fault!"

I was relieved to move to sprawling Los Angeles, where I embarked on a career writing television comedy. But I also struggled to hold onto my Missouri roots in Hollywood, a city where Starline Tours buses roam my neighborhood and native-plant landscaping makes my front yard look like a set from *The Good, the Bad and the Ugly*.

Around the time I was getting used to pulling the morning paper out of an agave plant, I visited an art fair and a Benton drawing leapt out at me from a gallery's booth. It was a picture of an older heavyset man, chomping on a cigar, glancing at some notes, and talking on the weirdest telephone you've

Pages 18–19: *Conference Table,* or *Directors' Meeting, 20th Century-Fox Studio* (detail of pl. 65), 1937

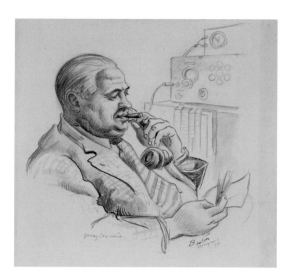

Fig. 1 (pl. 64). Thomas Hart Benton, *Young Executive*, 1937

ever seen. He looks faintly amused, weary, and self-satisfied all at once. Benton called him "Young Executive," which made me laugh. Put this guy in a modern suit, give him an iPhone, and I've met him: I've pitched shows to him, and he chuckles at straight lines and frowns at the jokes. He's an amiable narcissist who tells stories about the 1980s detective shows that made him a fortune. He is a timeless denizen of Hollywood, and I decided I had to have him.

I'd never known that Benton visited Hollywood. The idea of owning an ironically named Thomas Hart Benton piece that wedded Missouri and Los Angeles was too good to be true. Unfortunately, it was, of course, expensive, so – still a practical midwesterner at heart (others have used the word *cheap*) – I decided it was an indulgence and walked away. But I couldn't get that drawing out of my head, so I went back the next day and left with the *Young Executive* under my arm.

Since owning the piece, I keep discovering things about Benton that make me feel more connected to him. When he came to LA in 1937 to make Hollywood sketches for *Life* magazine, he had been stationed on the 20th Century Fox lot. I've worked on the Fox lot myself for many years. He worked out of the office of a producer named Raymond Griffith, who, I found out, was in the old Executive Building, which still stands. Now, whenever I walk by this building, I picture Benton working away inside, and I fantasize about running into Griffith's office, finding Tom with his sketch pad in hand, and telling him to stop making so many drawings because I want mine to be worth more.

I had known of Benton's reputation as a pugnacious man of the people, but the more I read about him, the more I was surprised to find that he was also a deep thinker who delved into philosophy and politics and art theory. At first glance, he was nothing like me – a guy who's mostly just trying to make people laugh.

And yet humor also punches through in Benton's art and how he spoke about it. For instance, he told his editor at *Life* that in his Hollywood pictures he "wanted to give the idea that the machinery of the industry, cameras, big generators, high voltage wires, etc., is directed mainly toward what young ladies have under their clothes."[1]

He was also a terrific writer, whose autobiography *An Artist in America* is filled with anecdotes that reveal a man who, traveling far and wide, discovered the little comic moments that life offers. Sketching one morning in a field in the South, he recounts:

> With a new shiny nickel I induced a little boy to pose. Though I had barely enough elbowroom to move, I finished him off. . . . Dime, so named I learned because he was a tenth child, ran off in confusion. Later he came back and wanted to see his picture. . . .
> "Is 'at me?" he queried skeptically.
> "Sure, that's you," I answered.
> "How you know is me?" he said seriously.
> "Weren't you here when I made it?" I asked.
> "Yeah 'en Ah's still heah now too," he asserted.[2]

Now when I look at the Benton drawing hanging by my front door, I think of how Benton and I came to Hollywood in different eras, but both of us looked at it with a Missourian's eye and found it strange, inspiring, a little bit depressing, and certainly funny. *Young Executive* always reminds me that we share this, and I'm excited now to share it with you.

HOLLYWOOD JOURNEY

Thomas Hart Benton

A great deal of newsprint is turned out on Hollywood every day of the year. There must be a dozen or so reporters of inside stuff constantly on the job. No doubt also a considerable number of books have been turned out about what goes on there. I am not a Hollywood news column fan, and I have not read any books about the place. I know it only through the direct experiences of an artist interested in making pictures of America and American things.

I was sent out to Hollywood by one of our top magazines to gather material for a painting of the movies which they wished to use in a color spread. I went with full credentials and because no doubt of the potential publicity value lying in these was well received both on the movie lots and in the houses of Hollywood people of position and parts. I also had friends to help me. Years ago when many of the big companies were located in Fort Lee, New Jersey, I had worked for one or another of them in various artistic capacities. Some of the people I knew then were now living in Hollywood. These old acquaintances were well disposed toward me and were of considerable help in unearthing interesting material. It was mainly, however, my magazine connection which opened doors and answered questions and set the stage for the drawings in this book.

Let me say in launching my account that it is a personal account. It is a record of one individual's experiences. It covers only what happened to one person in a short month's time. It is not by any means an authoritative study of the movie industry and environment, but simply a story of an artist's contacts with these. It does not pretend to cover everything or even to thoroughly cover what it touches. It is just the kind of thing, with the addition of pictures, which every Hollywood visitor engages in when he returns home and his friends say, "Tell us about."

Time and again we hear it said that Hollywood is not America and that its life, its behavior and aspirations have nothing to do with America. Its extravagances pictured as utterly its own are supposed to result strictly from the peculiarities of an Art with its special demands and effects on character and ways of doing things. This I found was only partially true. Hollywood is different. But it is not qualitatively different from a great deal that is very much American. The first picture in this book, the Story Conference [*Director's Conference*, p. 109, this volume] on the opposite page, is certainly an American picture. Apart from its detail it might be duplicated in the skyscrapers of any city. The room where the conference takes place is truly a creation of an extraordinary sort but it is inspired by idealisms which are shared by a very large percentage of American businessmen. The furnishings are decided and evident proclamations of status. They indicate in an inescapable way that the office's chief occupant engages himself in all the top social diversions. Because of their symbolic importance they provide a background where a part of importance may be naturally and unconsciously acted. The difference between this room and the office of your banker or stockbroker friend in New York, Chicago or Kansas City is only one of degree. Every American magnate who doesn't go in for the collection of Rembrandts (which is a very special kind of status performance) has an enlarged office photograph of himself standing on the deck of an expensive yacht with a big fish in his hand—frequently there is a president or two in the background. If the magnate ever shot a deer, he has its stuffed head up on the wall. If there are any hounds around either he or one of his family wears a pink coat and rides to them, and has photographs of himself taken while doing so. These are always conspicuously placed.

The Hollywood office pictured is simply the American business magnate's office in its idealized form. Instead of one stuffed head, here is a room full. Instead of one varmint skin, here are a dozen or so. Instead of a paltry photograph or two, here is a gallery. Furthermore, the trophies are of an ultimate sort. They are not merely local trophies. They record travel in strange and romantic places, and carry a suggestion of dangerous adventure successfully accomplished. This is something with a plus. Only Assyrian kings, English lords and Roosevelts go in for such far-flung stuff. Its status value is pretty final. A little observation of Chicago and New York offices should dispel any notions as to the peculiarly exotic character of the business stages set in Hollywood. They are not different kinds of stages but are simply pointed up and dramatized.

The people engaged in this conference are, it is true, not exactly like people usually seen gathered around great carved and shiny desks. But they are doing just about what is always done under such circumstances. They are yessing the guy behind the desk. A story conference in Hollywood is not particularly different from the average business conference. It deals with a lot [of] fictions in which people are forced or agreed to believe. Business conferences are generally held to rationalize actions which have already been taken by whatever big boy is behind the big business desk. They determine ways and means of giving these actions palatable reasons on [illegible] without going to jail. Whenever some local Napoleon of business has made his moves, he calls in his associates and applesauces them into believing they were responsible factors therein, and after involving them and obtaining their flattered and secret surprised yesses, proceeds to shove a lot of hard detailed coordinating work on them. Napoleons have ideas—the yes-guys carry them out and get in most of the trouble about them as well as doing most of the hard work.

The little fellow behind the big desk in the picture is one of the Napoleons of the film business. Everyone in filmland just as in law and business wants to be called a Napoleon. Everyone who lives in an American town of more than 50,000 people knows someone with the Napoleon complex. It's an interesting mental condition wherein the fortunate victim is able actually to put the grandeur delusion to work. Most people who get hipped with delusions suffer an arrest of profitable activity. The Napoleonic complex however has a reverse effect. It heightens and intensifies the most ordinary practical activities by according them enormous significance. Every move then becomes portentous, weighted with momentous eventuality. The Napoleonic fellow thoroughly convinced of his self significance, and the significance of his doings, is dynamically persuasive in getting others to do. He not only jumps around himself but gets others to jump around. He gets things done. In the Hollywood Story Conference picture [*Conference Table*, pl. 65] it's easy enough to see who is boss, who is being yessed, who is the Napoleon of the situation. And whether it's easy to see or not, you should be able to guess that the associate conferees when they leave the big table are due for some kind of headaches that is the lot of ordinary business associates when they leave Napoleons.

American business Napoleons, you may say, don't jump out of their seats and wave sticks, like the guy in the picture. They are dignified and contained. In this there is a point. But it is not a fundamental point. Ordinary business is supposed to be unemotional and coldly matter of fact, and in ordinary business conferences expressive techniques are conditioned by this tradition. The expression of business ideas is unemotional and coldly matter of fact for logical and artistic reasons—they must harmonize with the traditional concepts of business and the business man. If however you should inject into any business conference following correct traditional lines, a sudden approval, say of the Wagner Act, I think the matter of business expression would suffer a rapid change of technique. Now in a filmland story conference, such emotionally charged injections are frequent. For, in a story conference as distinguished from a business conference, there are not only the fictions by and in which men live their daily lives which must be considered and adhered to, but there are the particular fictions which are created for actors to act in. These fictions are designedly emotional, and artistic logic calls for a display of feeling about them. Emotion in an emotional setting is convincing. In the proper setting, business magnates are just like Hollywood Napoleons. They jump up and down, beat on tables, and slam doors.

A moving picture story conference while it deals with emotional charged fictions is not by any means a conference of artists free for a moment from economic pressures and engaged in the simple business of finding a vehicle for the expression of their life experiences. The moving picture Art is predominantly an economically conditioned Art. Its forms are like gambling in the stock market. They are plays for a cash return. A story conference is therefore a genuine business conference as well. Although the fact may not be openly admitted because of certain illusions which have to be maintained, and which shall be dealt with later, there is behind every movie story the immediate and pressing question of profit. It is because of this fact that the movie Art of Hollywood, the environment it creates and the behaviors it induces, may be regarded as genuinely a part of American business institutionalism. They are not something apart, something exotic, but are of the very warp and woof of our predominant social force. The movie Art is not only a

business but a business expression. It speaks in, by and through the patterns of the American business mind. It is go-getter, optimistic, sentimental, politically conservative. It sings and clowns in Rotary Club fashion, and romances with a high regard for the *status quo* in everything. This is not said critically but merely as a statement of fact. Without its recognition Hollywood, and the Art of Hollywood, may never be understood.

I made it my business while on "the lots" to ask questions. I was not interested in particular Stars but in what went on all the time no matter what young ladies or young men were being blazoned on the billboard headlines of the country. The first thing that I asked was "How do you get the stories for the movies?" I wanted to begin at the beginning. This seemed to me a simple question, open to direct answer. I soon found that it was not. Everyone I questioned had a different story. The replies I got always seemed a little evasive as if the person questioned were risking his creative credit. I picked out a particular drama then being run on one of "the lots" and set out like a detective to find some clues to its story origin. I talked to directors, assistant directors, producers, assistant producers and all kind of assistants without getting anywhere. I got the feeling that all these people secretly claimed the story but were too magnanimous to do so openly. Each of them left with me the impression that his was the finally responsible genius in the matter. Although I recognized the movie Art as a sort of communal Art, I suspected as in the case of all communal activities someone was bossing the work. I figured that someone was supplying the "ideology" and saw to it that story meanings and techniques were directed thereto. Having no luck in the technical field proper, I applied myself to the "business offices." There in the advertising end I found credit where credit was due. There I found the little Napoleon in the picture – the boss idea man, handsomely and properly enthroned. The pure business man of "the lots" advertising end let me in on the story origin, and also on the nature of movie genius from the business point of view. I there got the connection from the box office and the dramatic vehicle. It came indirectly and through the unguarded and unjealous admiration of men whose concern was not with any pretense of Art but with profits. A story I soon learned was something to wrap about personalities who were either in the movie lots pay or available for its pay and that the genius of a story lay not in what it told about life, but in what it offered as opportunity for dragging in all the variety of currently advertised acting talent within reach. The first trick was to get a story that would fit names popular in the box office of the country. The second trick, suggested but not openly admitted, was to see that the story cut across none of the accepted fictions of business thought and idealism. The third trick was to set the action of the story in as many gorgeous settings as possible. This last I was told was a costly evil but was made necessary by the competition of rival firms; a company could not risk failure to show itself magnificently and expensively, especially in its feature films.

My story conference hero, I was soon made to understand, had an absolutely unapproachable genius for fulfilling all the requirements of movie story selection. His assistants worked within the patterns he set. The evidence of box office returns was absolute proof of the value of these patterns, and nobody questioned them. The function of all associates was to further them. I got an ear full about this man and naturally wanted to see him. I gathered right away that I was touching a Napoleonic complex and was prepared for difficulties – still I represented a very popular magazine and could afford to take a chance in boldness. Although I was only a painter I had my credentials

from something important, something institutionally respectable and of great publicity value. I discovered that it did not take much persuasion to meet my man. I went to his offices and was properly introduced. He posed for me. I made a portrait drawing of him. I listened to stories of him which his assistants were itching to give me. I was shown dozens and dozens of photographs of him in action. I was even assigned a young man who guided me around in his footsteps so I could get secret glimpses of genius on the move. Everything was done to impress me with the leader's importance. Although I knew it was advertising office stuff, I was impressed. In spite of [the] fact that I remember some of the pictures for which this Napoleon was responsible as being about the most stupid and absurd concoctions I had ever come across, I was convinced of the fact that here was an affected person, and that within the mores and traditions of the business art in which he was engaged, he was genuinely of top order. Patently he was acting every moment but it was the unconscious acting of a person whose part is being played within the conventions of a life rather than of an Art. It was the acting of a politician or a banker, of a man following patterns expected of him in a field with clear traditions. Objectively regarded as a little ridiculous, but so are parts of those who fervently defend the constitution or the destiny of the proletariat. The true value of a part can only be determined by its settings. I accepted the settings, the Napoleonic delusion, and there with the greatness of the movie lot hero.

"How does he decide on a story? Where does he get his stories?" I asked. "Granted he does know a good movie story, where does he find it?"

I was told that he might find a story idea anywhere. So fertile was his mind that even a simple newspaper line might suggest one and set his inspiration going.

"Does he write the stories?" I asked.

"No, no." I was told. "His time is too valuable. We have writers for that."

"I suppose he tells the story to the writers."

"Well, it's something like that only the story is worked out in conference with his assistant producers and directors, and the writers are there too occasionally."

"I should think they'd have to be there all the time," I said.

"No, that isn't essential. The writers only write, they don't decide on the stories."

"Well how can they write if they don't know what the story is about," I stuck in.

"You don't understand. They are told that. The idea is that the writers are not allowed to interfere with the development of a picture story. A picture story is not a written story but a pictured one. Writers put the plot in script form and supply dialogue for the actors but they are not really responsible for a story, especially a feature story. Sometimes a written story is taken, sometimes as you know we even buy the rights on a book, but we never shoot stories as written. Stories as written don't make good pictures."

"Well, what's the use of writing them," I asked.

"The assistant producers and directors must have something to go by. Of course after a story is written it has to be changed all the time. The writers are kept pretty busy keeping up with the story. Moving picture writing is a hard job, it takes a skilled man."

"It must be a tough job," I agreed. "I wonder if the writers like it?"

"We get the best there are. If they're up to the work they stay with us. A good man always likes his work."

"Where do the writers stay?" I asked.

"They have their individual offices."

I was taken around to see a writer. He was a young man. He knew that he was on exhibit and was a little embarrassed. So was I. I was afraid the fellow guiding me was going to ask him to write so I could see how it was done.

And so on.

Benton's typing ended with "how it was done"; he wrote "and so on" in longhand. Apart from the correction of a few obvious typographical errors, the author's idiosyncrasies of spelling, capitalization, punctuation, and syntax have been preserved.

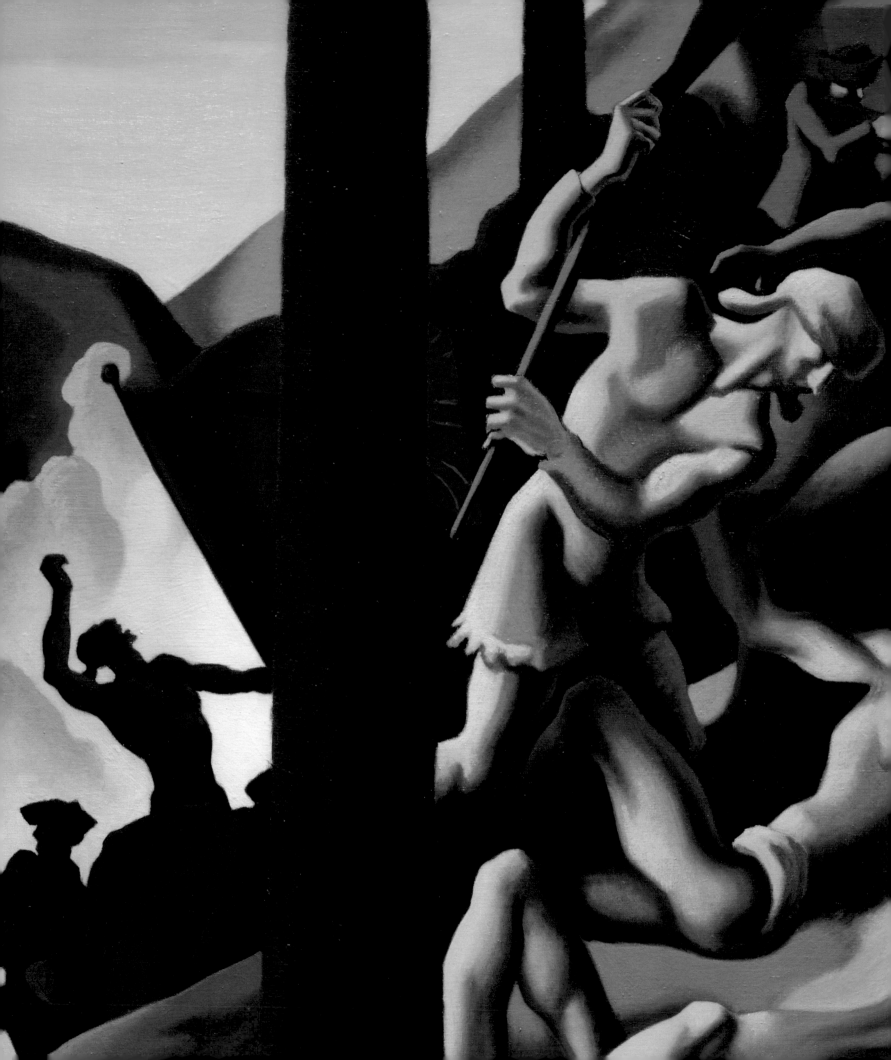

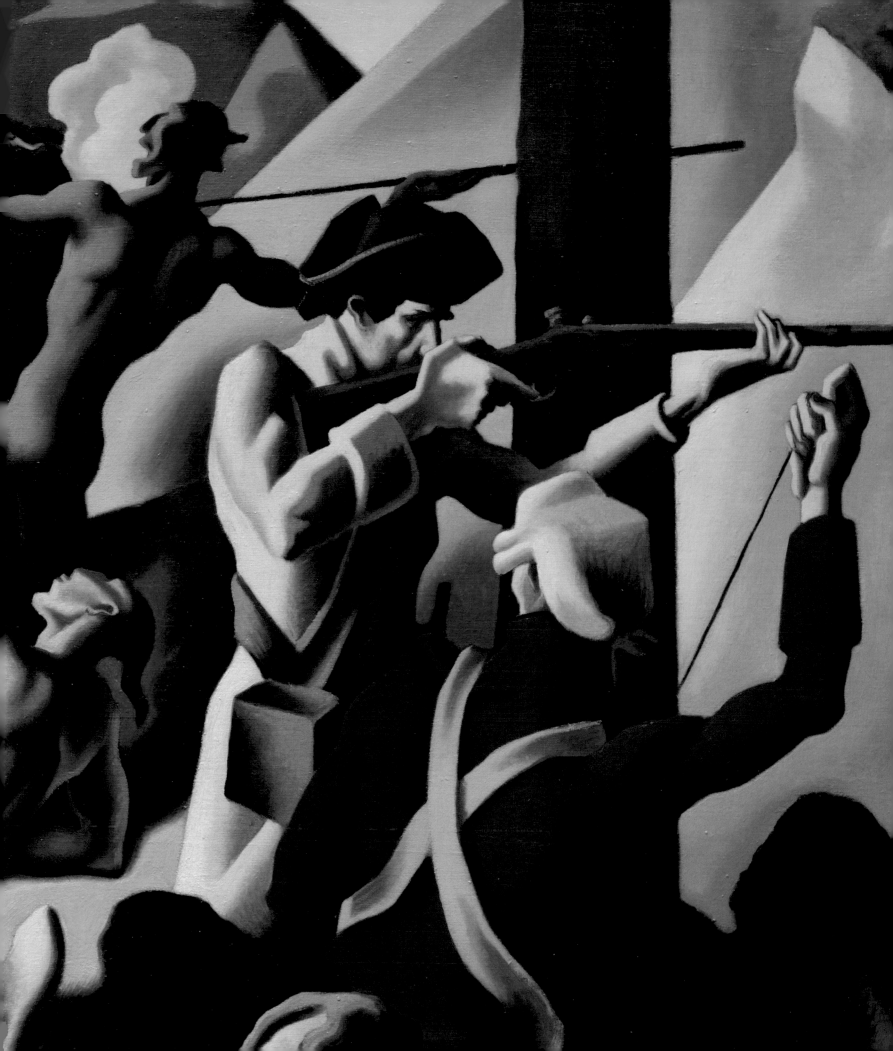

TRUE WEST
THOMAS HART BENTON AND AMERICAN EPICS

Austen Barron Bailly

By 1932, Thomas Hart Benton was a well-known muralist, considered by critics to be one of the "big shots" of American painting.[1] That year, curator Holger Cahill selected *Aggression* (1923; pl. 3), a panel from Benton's *American Historical Epic* (1920–28), for the Museum of Modern Art's (MoMA) exhibition *American Painting and Sculpture, 1862–1932*. Cahill included Benton's public art in this landmark survey to demonstrate the artist's "characteristically American style in mural painting, in which he shows a healthy absorption in contemporary subject matter."[2]

The MoMA exhibition opened just as Benton completed a mural series commissioned by the Whitney Museum of American Art, *Arts of Life in America* (1932). For Benton, contemporary subject matter had become "the popular arts," a subject he wrote about in his essay for the catalogue the Whitney published in conjunction with the unveiling of its new murals. Benton characterized the popular arts as the "undisciplined, uncritical" aspects of American life that ran into "pure unreflective play . . . [where] people indulge in personal display; they drink, sing, dance, pitch horseshoes."[3] Benton saw these activities as indicative of American culture and character and as pervasive in the twentieth century's most popular and modern medium—the movies. Within the *Arts of Life* series, the panel *Arts of the West* (fig. 1) was by far the most cinematic. Benton excerpted imagery from Hollywood westerns straight onto the eight-by-thirteen-foot (movie-screen scale) canvas on which he created a montage of what he called the region's "real people and actual doings."[4] While discussing these murals in an interview thirty years later, Benton remembered being chastised for painting the West "just like the movies," then added, chuckling, "Well, God . . . it *was the movies*."[5]

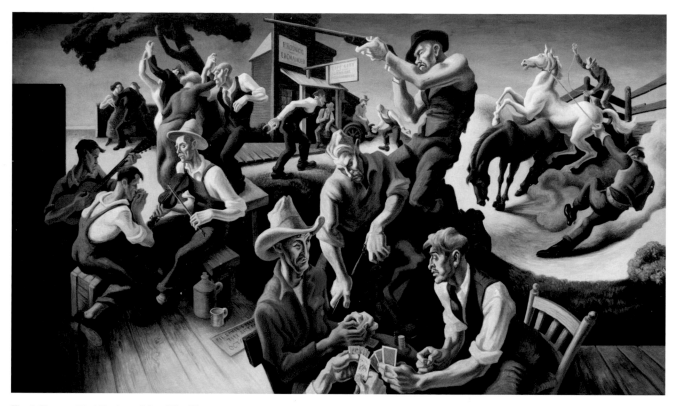

Fig. 1. Thomas Hart Benton, *Arts of the West*, from the mural series *Arts of Life in America*, 1932. Tempera with oil glaze on canvas. New Britain Museum of American Art, New Britain, Connecticut, Harriet Russell Stanley Fund, 1953.21

THE GAMBLE

The titles of the vignettes within *Arts of the West* call to mind many sights and sounds of the old West: a "Swing 'em Round and Come Down the Middle" square dance in "Home Town Orchestra and Dancing"; a clink of iron and a dusty thud against soft earth in "Horseshoe-Pitching"; a cock, crack, and pume of a fired bullet in "Shooting"; and the neighs, snorts, stompin' and yellin' of a rodeo in "Getting the Wild Ones (Bronco Busting)." This boisterous soundscape revolves around the relatively silent game of: "Poker."[6] (Note the symbolic red, white, and blue poker chips set on the table.) At the bottom edge of the canvas, Benton painted a disembodied pair of hands holding cards. The painted hands take the place of the viewer's hands – or Benton's.

Looking at the pairs of hands around the card table leads the eye up to gunmen's hands loading, locking, and aiming rifles. The gunslingers' presence injects the center of the canvas with energy and movement and "men with guns," what cultural historian Robert Warshow declared to be, along with "the gangster," "the most successful creation of American movies."[7] He observed that "guns as physical objects, and the postures associated with their use, form the visual and emotional center" of the western, making Benton's *Arts of the West* utterly cinematic in its combination of archetypal westerners and settings – and allusions to violence.

The *Arts of Life* series' first panel is *Indian Arts* (fig. 2), which Benton also wrote about in the Whitney exhibition catalogue: "I have seen in the flesh everything represented except the Indian sticking the buffalo. That instance of romantic indulgence is a hangover from [James Fenimore] Cooper, Buffalo Bill and the dime novels, as in truth is the spirit of the whole panel on Indian

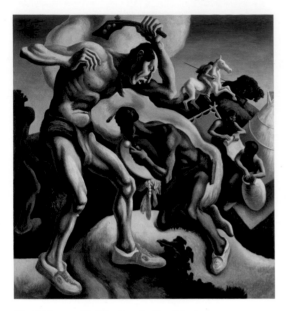

Fig. 2. Thomas Hart Benton, *Indian Arts*, from the mural series, *Arts of Life in America*, 1932. Tempera with oil glaze on canvas. New Britain Museum of American Art, New Britain, Connecticut, Harriet Russell Stanley Fund, 1953.22

Arts. One does not have to be a boy scout to understand and forgive this—through romance we Americans provide compensation for what we actually have done to the Indian."[8] In both *Arts of the West* and *Indian Arts*, Benton deliberately pictured mythic and stereotypical visions of the West—the ones "we Americans" went to see in Hollywood movies. As the novelist and essayist Toni Morrison has suggested, "American means white."[9] Benton understood that this "white" America was his audience, even as he acknowledged the injustices of romancing that majority perspective.

In *Arts of the West* Benton foregrounded America's fantasies about the West over "what we have actually done"—namely, the actual democratic, ecological, and racial risks Americans took to colonize and settle the West. But earlier in his career, in his first attempt at public art, Benton tried to combine the West's myths with its realities. Seeking to participate in public debates about who and what was authentically American, Benton created his *American Historical Epic*, a critical history of the United States (pls. 1–14).[10] Without a commission to pay for it or a building to house it, Benton independently produced a cinematic series of fourteen mural panels—each five to six feet high by four to six feet wide. Installed side by side, the panels—*Discovery*, *The Palisades*, *Aggression*, *Prayer*, *Retribution* (chapter one); *Clearing the Land*, *Planting*, *The Slaves*, *The Witch* (chapter two); and *The Pathfinder*, *Over the Mountain*, *The Jesuits*, *Struggle for the Wilderness*, *The Lost Hunting Ground* (chapter three)—amount to more than sixty feet in length.[11] The titles and imagery unflinchingly revised traditional and idealized versions of American history to emphasize scenes of violence and exploitation.

In hindsight, the poker game in *Arts of the West* may well have symbolized the fundamental creative gamble Benton knew he had lost in his *Epic*. His racially charged reinterpretations of the myths of westward expansion had failed to resonate; after nearly a decade of work, Benton had received no official public mural commissions, and in 1928 he abandoned the project. The *Epic* panels were unsold and in Benton's possession until his death. Today, ten of the fourteen panels hang in the public auditorium of the Nelson-Atkins Museum of Art in Kansas City, Missouri, including the last chapter of the series, which focuses on the West, a prominent theme in the artist's work from the 1920s through the 1960s. In the late 1920s, Benton's original desire to challenge the myths of the West recorded in books or dramatized in silent era westerns gave way to playing with these myths and then reinterpreting them in visually cinematic ways. By the end of his career, Benton was responding to the use of Technicolor and CinemaScope in Hollywood westerns as well as to what Julia Leyda has characterized as the region's positive values: "freedom, individualism, mobility, masculinity, and a patriotism rooted in a love of the land itself."[12]

MODERN MYTHMAKING

Benton was well aware of the power of triumphal views of American history that embraced the concept of Manifest Destiny and its role in ordaining westward expansion as the national narrative; he was named after his great-great-uncle, Thomas Hart Benton, Missouri's first senator from 1821 to 1851, who famously championed the ideology.[13] The senator's son-in-law, John Charles Frémont, was the leading explorer and mapper of the West between 1838 and 1854 (fig. 3). He was called "the Pathfinder." The sobriquet came directly

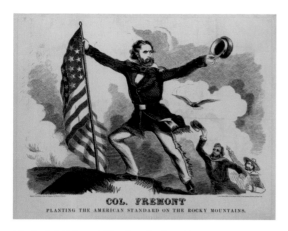

Fig. 3. *Col. Frémont Planting the American Standard on the Rocky Mountains*, published by Baker & Godwin, New York, 1856. Library of Congress Prints and Photographs Division, Washington, DC

from James Fenimore Cooper's 1840 novel, *The Pathfinder*, one of Cooper's celebrated *Leatherstocking Tales*, and Benton used it as the title for the tenth panel of his *Epic* (pl. 10).[14]

Cooper's *Leatherstocking Tales* also included *The Last of the Mohicans* (1826) – which Mary Lea Bandy and Kevin Stoehr deem the original source and framework for the mythology of the American West.[15] Director Maurice Tourneur's *The Last of the Mohicans* (1920) was the first adaptation of the canonical novel as a feature-length film, and white actors in "brownface" were cast as the Indians. Benton's monumental and elongated Indian bodies in the *Epic* – as well as his wholly imaginary portrait *King Philip* (1922; pl. 15), depicting the Wampanoag chief who led the deadly Native American rebellion against the Puritans known as King Philip's War (1675–78) – were as exaggerated and artificially constructed as their counterparts in the movies.[16]

In sheer scale and historical scope, Benton's first mural project was epic indeed. His painterly ambitions reverberated with the cinematic aims of silent film directors who sought to push the modern medium to new lengths in technical, narrative, and artistic terms. But Benton rightly noted that "Cooper, Buffalo Bill and the dime novels" set the standards for popular American storytelling about the "national celebration of the taming of the wilderness."[17] This was a mythology that paradoxically celebrated the agricultural and military conquest of Indians forcibly removed from their land or ignored their existence on the frontier in favor of glorifying the pioneers' ability to settle it.[18] This same mythology also consistently disregarded the role of African Americans in the American epic, but Benton pictured blacks in *Over the Mountain* (pl. 11).

In his *Epic*, Benton also visualized the perpetrations of American conquerors and pioneers, whom historian Richard Slotkin called America's true "founding fathers . . . the rogues, adventurers, and land-boomers; the Indian fighters, traders, missionaries, explorers, and hunters who killed and were killed until they had mastered the wilderness; the settlers who came after."[19] Benton represented the ruthless motivations of early colonists, to whom America provided "an opportunity to regenerate their fortunes, their spirits, and the power of their church and nation; but the means to that regeneration became the means of violence."[20] In picturing these experiences in his revisionist version of the national epic, Benton represented what Slotkin called the "myth of regeneration through violence . . . the structuring metaphor of the American experience."[21]

Toni Morrison similarly identifies the glorification of colonization and westward expansion in official American history as a "master" American identity, one that is typically "backgrounded by savagery" in the form of the African American enslaved or the American Indian conquered.[22] She observes that "deep within the word 'American' is its association with race," and that "living in a nation of people who *decided* that their world view would combine agendas for individual freedom *and* mechanisms for devastating racial oppression presents a singular landscape for a writer" – or, in Benton's case, for a painter.[23] Benton's imagery in the *Epic* conformed to this trope of the American wilderness as a "staging ground" for colonization but called attention to national myths that overlooked democratic hypocrisies.

The *Epic* reveals Benton's creative urge to commingle the national sagas of slavery and the frontier, particularly in *Over the Mountain*. It is the Herculean, but also the "beast of burden" black bodies that make possible the pioneer's journey toward the establishment of civilization in the West. The scene

demonstrates the utility of African American figures to a white artist. Black bodies provided mechanisms for exploring classic themes of American identity, such as freedom and equality. Yet their imagined forms can be seen as degrading or animalistic, mimicking racist characterizations in mainstream Hollywood westerns of the day.[24] Nevertheless, these laborers also represented Benton's attempt to signal that African Americans and their strength, sacrifice, and contributions were integral, even essential, to the nation's development.

"History was not a scholarly study for me but a drama," Benton wrote in 1933 about his dream to create an American epic.[25] He saw the story of the West, how Americans "changed the face of a continent," as representative of the country's "tremendous facts of common existence."[26] At the same time, he knew that the best stories took these historical experiences as creative points of departure. Historian Patricia Nelson Limerick emphasizes that America's past was "not a story but raw material," available to anyone. But she underscores that the strategic selection of characters and "facts" was essential for the "imaginative coherence" of successful American mythmaking.[27] Benton freely selected symbols from the national past but, unconventionally, gravitated toward those that called to mind its unheroic, shameful episodes. This tendency made his *Epic* incoherent, even impotent, for most contemporary audiences, who frowned on the debunking of beloved national myths.[28] Early filmmakers, meanwhile, embraced the celebratory plot lines of such familiar American stories.

In his debut feature film, *The Homesteader* (1919), Oscar Micheaux, the first prominent African American film director, chose the symbolic West as the place where, according to film historian Gerald Butters, Jr., he could "demonstrate uncompromised African American manhood."[29] James Cruze's 1923 blockbuster, *The Covered Wagon*, the silent era's first epic western, also successfully orchestrated a selection of historical "facts." Shooting on location from Kansas to Oregon lent what art historian James A. Nottage aptly calls a "veneer of authenticity" to the ninety-eight-minute movie about two wagon trains journeying along the Oregon Trail in 1848.[30] *Variety* pitched *The Covered Wagon* as a "mighty screen epic," winning over audiences.[31] It was "big and sweeping, true to the soil," according to the *Los Angeles Times*, giving audiences "a deeper appreciation of the land in which you live," while the *New York Tribune* declared it "the first real American epic of the screen."[32] Cruze's success possibly inspired Benton to keep at his *Epic* and to explicitly emphasize westward expansion in each panel of the series' last chapter.

The structure of Benton's *Epic* was at odds with Hollywood's linear narrative style, evident in *The Covered Wagon*. Benton created a visual pairing of *The Pathfinder* (pl. 10) and *The Lost Hunting Ground* (pl. 14) by connecting the panels compositionally, and the rhetorical parity established Benton's take on westward expansion. American history could be told from the perspective of the white Pathfinder or the Native American, but in Benton's version of the story, the final look goes to the Indian. Cruze told the same competing versions of westward expansion, now as a dramatic plot device for the unfolding story of the pioneers. In one scene, members of the Native American cast surround an abandoned plow and the intertitle bears a quote from an elder chief warning his tribe of the westward-bound pioneer: "The Pale Face . . . brings this monster that will bury the buffalo—uproot the forest—and level the mountain." The next intertitle reads: "The Pale Face who comes with this evil must be slain or the red man perishes," and the Indians on screen close their circle around the plow (fig. 4).

Fig. 4. Film still from *The Covered Wagon*, 1923, directed by James Cruze. Paramount Pictures

Fig. 5. Film still from *The Covered Wagon*, 1923, directed by James Cruze. Paramount Pictures

As if these scenes are happening simultaneously, Cruze immediately fades in on a close-up of another plow at Westport Landing, then pans out to picture the farm equipment and the pioneers who will bring the tools with them on the covered wagons seen in the background (fig. 5). This sequence of shots transforms the plow into a symbol of opportunity and predicts the pioneers' ability to survive the foreshadowed Indian attacks as well as succeed out West.[33] Benton underestimated Americans' appetite for such celebratory storylines about progress and triumph over adversity. He overlooked this preference by incorporating a radical narrative flexibility into the sequencing of his murals. Without the restriction of an actual architectural setting for his self-commissioned series, Benton had the freedom to create episodic variations on his themes of violence and exploitation in American history. Through his sophisticated compositional designs, coordinating figural forms, and repeating landscape and background elements across the panels, Benton could have paired nonsequential scenes or moved panels to different locations to create new narratives. But none of the configurations would have produced a traditional, heroic version of the national saga.

This flexibility recalls "intercutting," the silent era editing technique of repeating different versions of the same scene to "stutter" a storyline for emphasis or dramatic effect.[34] Benton stuttered the national epic and ended up presenting westward migration as an unresolved modern odyssey that led to nowhere after the "final" scene, *The Lost Hunting Ground*, and thus had no plot. Inevitably, the *American Historical Epic* was a flop, especially as audiences expected to experience reassuring stories in public art, "the living dream of a glorious past," as in *The Covered Wagon*, still showing twice daily eleven weeks into its New York run.[35] The successful mythmaking that Hollywood generated put pressure on Benton to make his own art more coherent or, at least, more like what millions of Americans saw every week on the big screen.

The next (and last) time Benton addressed the racially violent histories of the American West – *Custer's Last Stand* (1945; pl. 18) – he chose one of the most familiar western myths of all. The subject reflects what film scholar Thomas Schatz identifies as the "cross-fertilization of the Western and war film."[36] John Ford's *Fort Apache* (1948), loosely based on General George Armstrong Custer's actions at the Battle of Little Bighorn, epitomized these new "cavalry movies." On the back of his painting, Benton wrote: "barroom picture in the St. Louis mode." This was a reference to the brewer Anheuser-Busch's use of painter Cassilly Adams's "bloody panorama" from 1892 of Custer's Last Stand on their advertising calendars. Benton claimed he had seen this image "as far back as I can remember . . . in every saloon and pool hall in the Southwest."[37]

Benton's remake of this ubiquitous imagery includes US Cavalry and Indian figures in a bizarre combination of poses lifted from old masters' canvases, westerns, and Benton's own *Epic*. Custer's symbolic assassin, Sitting Bull, rides a galloping horse and appears to levitate from a cloud-like mass of white dust. He is poised to launch the spear that will pierce the heart of the demonic general, who stands amid a heap of fallen bodies, guns blazing. Sitting Bull surmounts the classically composed pyramidal arrangement of the figures, which forms an apex for the triumphant Lakota chief. These fine art and popular art appropriations, and the ascension of the saintly Sitting Bull over the devilish-looking Custer, toys with the same essential ingredients of calendar art and highly fictitious movies about the Custer legend, including

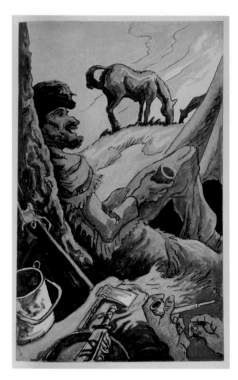

Fig. 6. Thomas Hart Benton, illustration for Francis Parkman's *The Oregon Trail*, published by Limited Editions Club, New York, 1945. Phillips Library, Peabody Essex Museum, Salem

gratuitous violence, scalpings, tomahawks, pistols, bows and arrows, horseback riding, and half-naked bodies of dead and dying Indians strewn across the plains. Benton mirrored, if not mocked, the use of such imagery in Raoul Walsh's *They Died with Their Boots On* (1941), which glorified Custer. Original trailers promoted Walsh's period piece as "the boldest!" and "the biggest!" motion picture ever to portray "the imperishable story of history's most colorful hero . . . charging to glory." Paradoxically, and decades ahead of Arthur Penn's revisionist western about Custer, *Little Big Man* (1970), Benton appeared to be satirizing the stereotypical imagery associated with the Custer legend and transforming it into farcical critique.

The same year that Benton created his Custer painting, he also created illustrations for a 1945 limited edition of Francis Parkman's *The Oregon Trail: Sketches of Prairie and Rocky-Mountain Life*, originally published in 1849 (fig. 6). The novelist Herman Melville enjoyed the influential historian's memoir and reviewed the book upon its release. Melville's appraisal demonstrates the persistent allure of journeying physically or imaginatively through a storied West:

> He who desires to throw himself unreservedly into all the perilous charms of prairie life; to camp out by night in the wilderness, standing guard against prowling Indians and wolves, to ford rivers and creeks; to hunt buffalo . . . to hear of wars and rumors of wars among the hostile tribes of savages; to listen to the wildest and most romantic little tales of border and wilderness life; in short, he who desires to quit Broadway and the Bowery — though only in fancy — for the region of wampum and calumet, the land of beavers and buffaloes, birch canoes and "smoked buckskin shirts" will do well to read Mr. Parkman's book.[38]

Melville's summary also inimitably conveys the magnetism of Western image-making inspired by being in the West — or on location.

ON LOCATION

Beginning with his first trip west in 1926, Benton traveled around the region regularly. He synthesized nearly a decade of experiences in "The West," the penultimate chapter of his 1937 autobiography *An Artist in America*. These trips were the impetus for a shift away from confronting the mythic West through the lens of racial violence to celebrating its wilderness, which he described as having a "releasing effect" on him, as an artist and a man.[39] Benton began to embrace the West as a place of harsh, breathtaking beauty and personal regeneration, as well as a place defined and shaped, and still threatened, by environmental violence, such as oil and natural gas exploration and extraction. He explored these themes in *Boomtown* (1927; pl. 16), his first major painting of a Western landscape that he had "actually rubbed shoulders" with.[40]

Conceived on location in Borger, Texas, *Boomtown* reveals Benton's awareness of how easily myths celebrating expansionism or industrial progress in the West suppressed national ambivalence about what cultural historian Peter C. Rollins calls "despoiling a Virgin Land," as described, for example, in Cooper's *Leatherstocking Tales* or Henry David Thoreau's *Walden*.[41]

Benton's painting suggests the western films' "oil-field" subgenre, later epitomized by *Boom Town* (1940) and *Tulsa* (1949), which celebrated the success stories that resulted from the exploitation of America's natural resources. Benton's written description of Borger, however, has more in common with director and screenwriter Pare Lorentz's documentaries for the US government. In *The Plow That Broke the Plains* (1936) and *The River* (1938), Lorentz dramatically pictured root causes of Depression-era environmental crises, which Benton had witnessed a decade earlier:

> I was in the Texas Panhandle when Borger was on the boom.
> It was a town then of rough shacks, oil rigs, pungent stings from gas pockets. . . . Out on the open plain beyond the town a great thick column of black smoke rose as in a volcanic eruption from the earth to the middle of the sky. There was a carbon mill out there that burnt thousands of cubic feet of gas every minute, a great, wasteful, extravagant burning of resources for monetary profit. All the mighty anarchic carelessness of our country was revealed in Borger. But it was revealed with a breadth, with an expansive grandeur, that was as effective emotionally as are the tremendous spatial reaches of the plains country where the town was set.[42]

The elevated perspective of the painting captures the rough-and-ready action unfolding on the street and the enormous billowing of black smoke in the not-so-distant background. A woman in a white dress opens her umbrella in a futile effort to prevent the mill's ashes from covering her. Benton's mise-en-scène draws the eye diagonally back to the spewing cloud and establishes a dramatic symbol for a new West in the process of changing socially, culturally, and environmentally. He reprised this theme in his first official mural commission, *America Today* (1930–31), in the panel *Changing West* (fig. 7).

On assignment for *Life* magazine in the summer of 1937, Benton traveled for the first time to the ultimate emblem of the modern West – Hollywood. He returned to Tinseltown on several occasions between 1937 and 1941 to create artwork promoting two movies, *The Grapes of Wrath* (1940) and *The Long Voyage Home* (1940), both directed by John Ford. By the time Benton met Ford, the director's first sound western, *Stagecoach* (1939), shot in Monument Valley, Utah, had been nominated for seven Academy Awards and was credited with fueling what Schatz defines as a "widespread resurgence of the Hollywood A-Western."[43] Benton's pre–World War II Hollywood journeys and associations with Ford, along with his experience of illustrating *The Oregon Trail* around 1945, undoubtedly kindled his fascination with the West and the western.

BENTON'S WESTERNS

In the 1950s and 1960s, Benton regularly undertook extended trips to the West, concentrating on its definitive landscapes – the Grand Tetons, the Rocky Mountains, the Great Plains. This was around the time when influential cultural critic Robert Warshow and renowned French film theorist André Bazin were penning the first serious studies of the western film genre. In 1955, Bazin devised useful and evocative categories for mid-twentieth-century westerns in his seminal article, "The Evolution of the Western."[44] He

Fig. 7. Thomas Hart Benton, *Changing West*,
from the mural series *America Today*,
1930–31. Egg tempera with oil glazing over
Permalba on a gessoed ground on linen.
The Metropolitan Museum of Art, New York,
Gift of AXA Equitable, 2012.478a–f

used "classic westerns" produced from around 1939 to 1941 as the basis for his analysis. According to Bazin, films such as Ford's *Stagecoach* possessed an "ideal balance between social myth, historical reconstruction, psychological truth, and the traditional themes of the Western mise-en-scène." He considered post–World War II "superwesterns" and "modern westerns" of the 1950s evidence of the genre's ongoing evolution. The characteristics Bazin ascribed to these later modes correlate with Benton's 1950s and 1960s paintings about the West.

Bazin saw superwesterns, such as George Stevens's *Shane* (1953), as movies that "set out to justify the Western – by the Western." These weren't just movies *about* the mythic West; they *were* mythic and represented an "expression of [the western's] decadence." Benton's *The Kentuckian* (1954; pl. 19), his last official Hollywood commission; *Trading at Westport Landing (Old Kansas City)* (1956; p. 214), a mural for a private collection in Kansas City; and *Independence and the Opening of the West* (1958–61), his monumental mural for the entry-way of the Harry S. Truman Presidential Library, fall into this category.

Burt Lancaster directed and starred in *The Kentuckian* (1955). Benton's large canvas of the same name shows Lancaster as the film's protagonist "Big Eli" leading "Little Eli" (Donald MacDonald) and their faithful hound on a quest to make a new life, far from the constraints of civilized society. This meant going West or, symbolically within Benton's composition, to the left. A distant undulating landscape beckons the frontiersman to this mythic realm, where blue skies, freedom, and new beginnings await. Lancaster invited Benton on set to observe filming and make studies of the two actors. Benton had Lancaster sit for him, and he used the elaborate series of preparatory studies, drawings, and oil sketches (pls. 20–28) to complete a full-length portrait. It was intended to promote the movie, but Benton rejected Lancaster's wide-screen format and used a vertical orientation for his painting instead (fig. 8).

Lancaster shot *The Kentuckian* in CinemaScope, a wide-screen technique introduced in 1953 that used anamorphic lenses to stretch the filmic image to almost twice the width of the standard 1.37:1 ratio. This was seen as a glorious technological development (not to mention the special effect that might save the movies, distinguishing them from the small-screen televisions then found more and more in American households). Bazin explained that the motion-picture industry believed CinemaScope would "renew the Westerns whose wide-open spaces and hard riding called out for wide horizons." However, he considered this "deduction too pat and likely sounding to be true" and was skeptical that CinemaScope would add anything "decisive to the field." Bazin mentioned Lancaster's *The Kentuckian* as an example of "the problem of Cinemascope," adding that the movie "bored the Venice Festival to tears."[45] Benton, too, seemed to recognize that Lancaster's choice of CinemaScope for the *The Kentuckian* poorly matched the story and its themes, which were about the trials, tribulations, and hopes of "the Kentuckian" and not the grandeur of western scenery.[46] Benton's choice of a vertical format not only conveyed the towering significance of the frontiersman in the American imagination but also served more practical purposes as a reproduction would easily adapt to the movie poster format (pl. 29).

Benton did succumb, however, to the allure of the "super-wide screen" and the "super-production" western in his *Trading at Westport Landing* and the Truman Library mural, *Independence and the Opening of the West* (fig. 9). *Trading at Westport Landing* is filled with conventional western imagery and

Fig. 8. Thomas Hart Benton sketching Burt Lancaster for the painting *The Kentuckian*, 1954. Private collection

Fig. 9. Thomas Hart Benton, *Independence and the Opening of the West*, 1958–61, mural for the Harry S. Truman Presidential Library and Museum, Independence, Missouri

has the CinemaScope typographic effect of swelling upward at the edges. The Truman Library mural also included innumerable western types and realistic details. Benton based these features on extensive firsthand research and drawings made in "Cheyenne country," in Colorado's southern Rockies, and in "various museums devoted to the history of the West . . . all so necessary for the verisimilitude of the mural" (fig. 10).[47] Benton also labored to achieve "for the first time in any of my murals a single perspective scheme," a technical development he called "infinite projection" that "could be fully encompassed from one point of view."[48] Metaphorically, that point of view belonged to the white male gunman, the head of the pioneer family at the apex of the composition. This complex, analytical composition, perpetuating infinite frontier myths, had all the trappings of the superwestern.

What Bazin called the "modern western" evaded this iconographically excessive and illusionary realm of mythmaking. In modern westerns, "the understanding and awareness of the means matches perfectly the sincerity of the story . . . they are 'novelistic.'" Responding to a "touching frankness of attitude toward the western" in the early 1950s, Bazin described "an effortless sincerity" on the part of directors "to get inside its themes." He cited director Anthony Mann's films *The Naked Spur* (1953) and *The Far Country* (1954) as required viewing for "anyone who wants to know what a real western is." They inspired Bazin to describe modern westerns using words like *feeling*, *sensibility*, and *lyricism*—words that also apply to Benton's meditative "cowboy picture" *Open Country* (1952; pl. 17) and are especially apt for his last major western landscapes: *The Sheepherder* (1957), *Trail Riders* (1964–65), and *Lewis and Clark at Eagle Creek* (1967). These paintings are emblematic of Benton's return to the West; their mountainous imagery calls to mind scenes from films like Mann's *The Far Country* or Jacques Tourneur's *Canyon Passage* (1946), in which horseback riders pass through magnificent mountain scenery (fig. 11). Benton liberated these landscape compositions from the layers of props and details, narrative threads, or CinemaScope effects that had defined his historical murals. Using a non-widescreen format for his own modern westerns, Benton produced Technicolor-tinged landscapes that feel utterly cinematic.

Benton based *The Sheepherder* (fig. 12) on a view of the Grand Tetons in western Wyoming, which he called "my first effort with 'grand' scenery."[49] He framed a long shot of the distant peaks with a depth of field as sharp as the foreground elements, including a characteristic cow skull. Surrounded by yellow aspen foliage set off by dark evergreens in the middle ground, a lone man on horseback guides ambling wooly sheep. This was the kind of scene Benton witnessed in the 1950s during autumn sojourns in Wyoming, and he conveyed a palpable sense of open air and an unfolding narrative, touching on something he wrote twenty years earlier: "Still in secret vision, sentimental if you will, the boys of the open country represent full manhood. They have the kind of wonderful physical readiness which goes with the Western tradition of manhood."[50]

Trail Riders (pl. 30), painted when Benton was about seventy-five years old, revived these traditions. Benton studied the painting's Canadian Rockies scenery during a rigorous trek that took "nearly ten hours on horseback. . . . I still possessed a pretty good measure of endurance—especially since I had been in the saddle very little since my boyhood."[51] Benton transformed his journey into the Assiniboine area south of Banff into a composition of undeniably lyrical sensibilities with all the vibrancy of Technicolor, the most famous

Fig. 10. Thomas Hart Benton sketching a buffalo skull for the Truman Library mural, 1959. Louise Bruner Papers, Archives of American Art, Smithsonian Institution, Washington, DC

Fig. 11. Film still from *The Far Country*, 1954, directed by Anthony Mann. Universal Pictures

Fig. 12. Thomas Hart Benton, *The Sheepherder*, 1957. Oil and egg tempera on canvas. American Museum of Western Art–The Anschutz Collection, Denver, Colorado

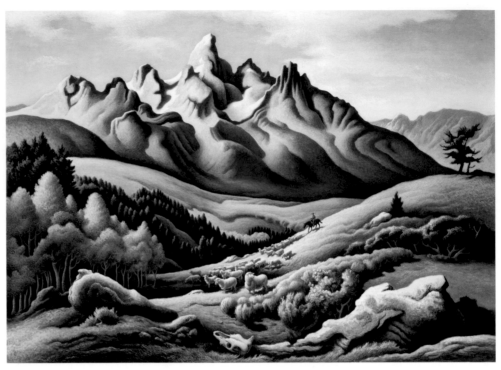

brand of color-process filmmaking. Undulating mauve and ocher rock formations dwarf the horsemen and flank the pyramidal peak rendered in lavender and white with turquoise reflections from the sky and glacier, all set off by emerald green pines, russet and yellow scrub trees and bushes, and bright red wildflowers. Technicolor, which reached its "peak usage" in the 1950s, possessed an "exact reality" color quality that film historian Paul Varner notes seemed, ironically, "so realistic that it was thought unrealistic," much like the palette and compositions of Benton's westerns.[52] Benton's rhythmic arrangements of clouds, lakes, snow, trees, and mountain passes in *Trail Riders* coalesce within a mise-en-scène so intensely colored and selectively composed that it matched, even outdid, Hollywood's best efforts.

Benton's final western was the luminous *Lewis and Clark at Eagle Creek* (pl. 31). Benton wrote in a 1968 memoir added to the revised editions of his 1937 autobiography that he had become "fascinated" with the journals of the Lewis and Clark expedition while conducting preparatory research for the Truman mural.[53] So desirous of painting a historical picture about the explorers, Benton turned to the federal government in the summer of 1965 in order to follow in their footsteps: "I made a three week reconnaissance of the upper Missouri River, from Omaha to its headwaters at Three Forks, Montana, searching out Lewis and Clark camp grounds and other sites of historical and archaeological interest. This trip was organized for me by the Corps of Army Engineers and the National Park Service." The 185 miles of what Benton called "Wilderness" country was

> taken in a five-day float down stream [that] passed through the last extensive stretch of the Missouri that remains in its primitive condition. It is the area of the gigantic white cliffs and eroded rock sculptures so graphically described in the Lewis and Clark journals. It is also today a center of controversy between nature conservationists who

wish to keep its primitive character and the Corps of Army Engineers who wish to turn it into another reservoir. Although I am indebted to the engineers for the opportunity to explore the region, I went along, and still go along, with the conservationists.[54]

Benton's "Wilderness" (capitalized and in quotation marks) is undoubtedly a reference to the 1964 Wilderness Act, which defined *wilderness*, in part, as "retaining its primeval character and influence, without permanent improvements or human habitation."[55] In *Lewis and Clark*, Benton minimized the arriving expedition party to the tiny scale seen from a distant vista point, where buffalo roam free, to emphasize the pristine and ancient landscape that Meriwether Lewis so influentially described in his journal on May 31, 1805. *Lewis and Clark at Eagle Creek* is the single work of Benton's career that directly connects his contemporary artistic and personal journeys in the West to a specific, identifiable moment from the national past, one defined by Lewis — and by romance: "The hills and river cliffs we passed today exhibit a most romantic appearance. . . . As we passed on it seemed as if those seens [*sic*] of visionary inchantment [*sic*] would never have an end."[56]

Eagle Creek represented the "beauty of the untamed wilderness no white man saw before" — a historically accurate detail announced in the trailer for Rudolph Maté's *The Far Horizons* (1955). This dramatization of the Lewis and Clark expedition billed the story as "the greatest of all American sagas . . . in the annals of the West they were the first." In retracing the historic explorers' path, Benton found an answer to the question that he had initially used to open "The West" chapter in the original edition of his autobiography: "Where does the West begin?"

This Edenic landscape was symbolic of America's paradise before its biblical fall: it marked the advent of the West's colonization and the telling of those histories from white America's perspective. *Lewis and Clark at Eagle Creek* was Benton's origin story for the western, which film historian Janet Walker stresses must be understood as a "profoundly historical genre."[57] This place and moment in American history represented the beginning of the West as a true national epic, one ultimately told through the nation's historical race relations and its search for national identity and character — what Benton, some thirty years earlier, had described as the "something different, the final involved and contradictory complex of American life."[58] In journeying to Eagle Creek, Benton revised his *American Historical Epic*, his first creation myth for the United States, by sublimating the violence and racial oppression that had made all previous mythic Wests possible. This momentous expedition, which Benton found "immensely interesting," allowed the artist to pay homage to Lewis and Clark's adventures and enchanting visions and to the fact that the romantic West possessed a power in American culture that would "never have an end."

AMERICAN HISTORICAL EPIC

Chapter 1

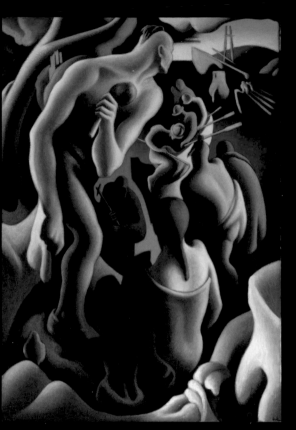

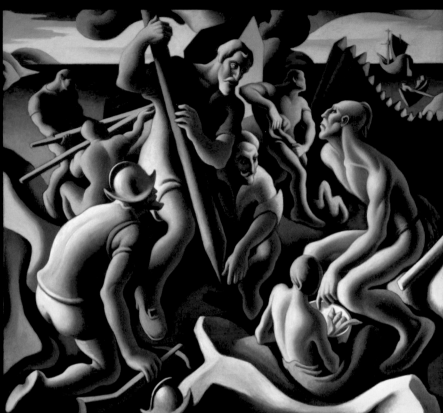

Plate 1
Discovery, 1920
Oil on canvas
60 1/16 × 42 1/8 in. (152.6 × 107 cm)
The Nelson-Atkins Museum of Art, Kansas
City, Missouri, Bequest of the Artist, F75-21/1

Plate 2
The Palisades, 1921–22
Oil on canvas
66 1/8 × 72 in. (168 × 182.9 cm)
The Nelson-Atkins Museum of Art, Kansas
City, Missouri, Bequest of the Artist, F75-21/2

Plate 3
Aggression, 1923
Oil on canvas
65 7/8 × 27 1/8 in. (167.3 × 70.8 cm)
The Nelson-Atkins Museum of Art, Kansas
City, Missouri, Bequest of the Artist, F75-21/3

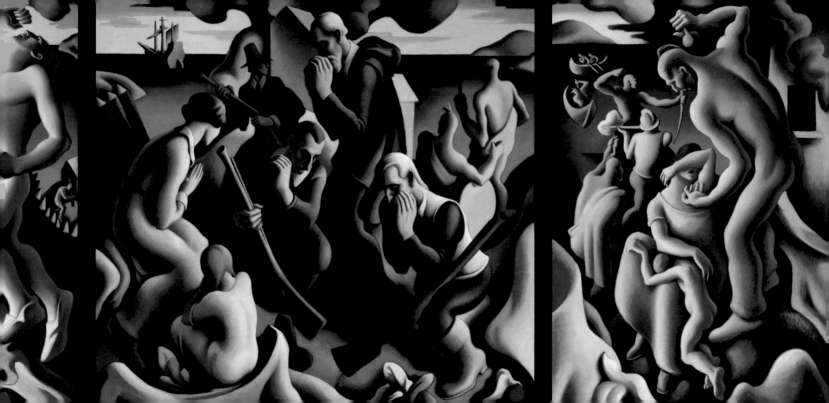

AMERICAN HISTORICAL EPIC

Chapter 2

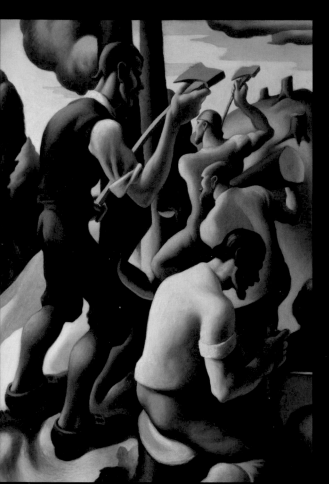
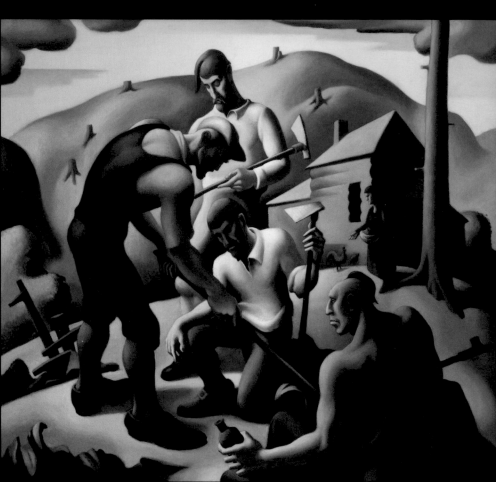

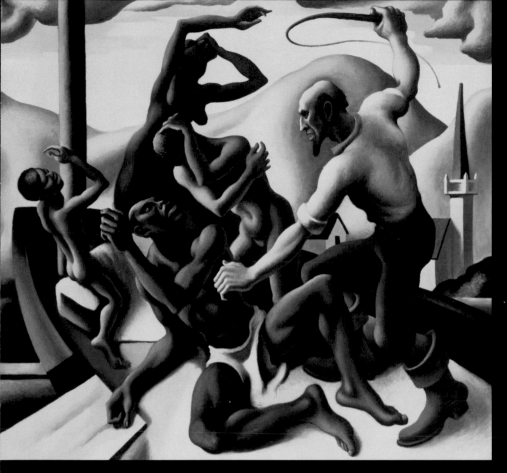

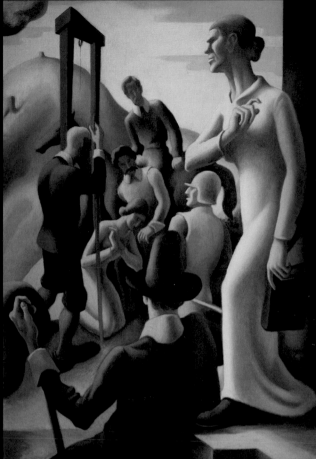

Plate 8
The Slaves, 1925
Oil on canvas
66 ½ × 72 ⅜ in. (168.8 × 183.8 cm)
Terra Foundation for American Art, Chicago,
Daniel J. Terra Art Acquisition Endowment
Fund, 2003.4

Plate 9
The Witch, 1925–26
Oil on canvas
59 ¼ × 41 ¼ in. (150.5 × 104.8 cm)
Private collection, New York

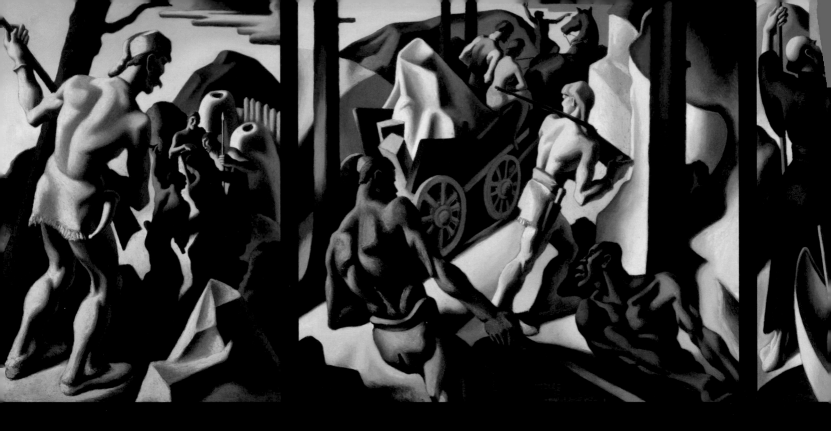

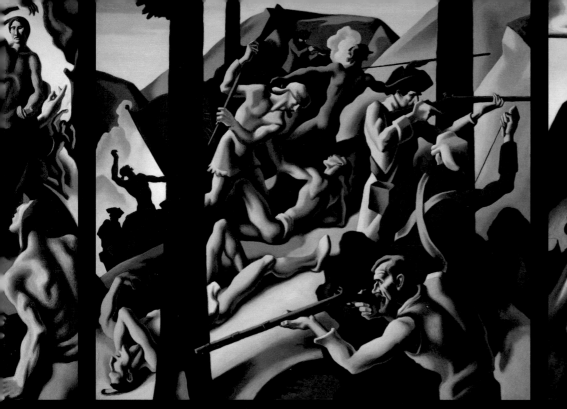

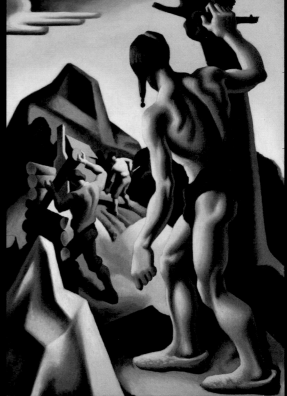

Plate 13
Struggle for the Wilderness, 1927–28
Oil on canvas
66 ¼ × 72 ¼ in. (168.3 × 183.5 cm)
The Nelson-Atkins Museum of Art, Kansas
City, Missouri, Bequest of the Artist, F75-21/9

Plate 14
The Lost Hunting Ground, 1927–28
Oil on canvas
60 ¼ × 42 ⅛ in. (153 × 107 cm)
The Nelson-Atkins Museum of Art, Kansas
City, Missouri, Bequest of the Artist, F75-21/10

JOHN FORD, THOMAS HART BENTON, AND THE AMERICAN FRONTIER

John Herron

In 1940, on the set of *The Long Voyage Home*—a film adapted from the plays of Eugene O'Neill and starring John Wayne—director John Ford posed for an unusual publicity photograph (fig. 1). In the photo, Ford sits at the end of a crowded bar, hoisting a pint of ale in a toast. To his right is a frequent collaborator, the Academy Award–winning actor Thomas Mitchell. To his left are a handful of artists, including Thomas Hart Benton. Benton was on set as part of an elaborate marketing plan arranged by the film's producer. With no instructions other than to paint whatever he wanted, Benton had unlimited access to the studio lot. He often attended the daily screenings of uncut footage, or "rushes," and was granted time with the film's busy stars for portrait sittings. Ford did not like artists loose on set, but Benton and the others—"a grand bunch of guys," the director later remembered—soon won him over. This casual photograph was more than a promotional tool, however. For Ford, it was a public statement about film, art, and the American narrative. Sitting at the bar, surrounded by the most prominent painters of the age, the director made it known that he was a peer, capable of producing cinematic work on par with the best American art.[1]

This was not the only encounter between Ford and Benton. Later in 1940, with the support of Darryl Zanuck,

Fig. 1. John Ford (in sunglasses), with Benton and other artists and actors on the set of *The Long Voyage Home*, 1940. Private collection

then-head of 20th Century Fox, Ford commissioned Benton to produce a series of lithographs for the film version of John Steinbeck's *Grapes of Wrath*. Eschewing traditional photographic publicity stills, the studio would eventually use these popular prints to advertise the picture. Even more significantly, Ford relied on Benton's paintings of these famous Dust Bowl refugees to give his film a particular, if not distinctive, tone.[2]

It is not surprising that Ford and Benton would find a common cause. They shared similar politics, an understanding of art as social commentary, and a passion for history, especially the founding narrative of America. And Ford approached cinema much like Benton approached painting. Ford saw his films, which often portrayed the arrival of civilized communities to an unsettled frontier, as ninety-minute civics lessons. His movies were as much about citizenship and morality as they were about adventure and romance. Ford's films and Benton's paintings often reflected the progressive themes of the period, and with a similar devotion to the republican tradition, each produced historical epics that explored what it meant to be American.[3]

The artistic and political interests of both men found a congenial home in the American West, the land of promise and potential. Benton's family history and political activism, supported by a rural boyhood dipped in "pioneer flavor," familiarized him with the conventional Whiggish trajectory of western settlement. His work in film solidified his grasp of the iconography and typology of the regional narrative and resulted in a commitment, both personal and professional, to understand the place of the West within the national imagination. Ford came to the West from a less personal direction, but with a deeper understanding of the populist significance of the region. Ford used the West as a stand-in for America, and his films used western settings and motifs to investigate the rational foundation of civic life. His westerns are filled with movement: pioneers cross the plains, ranchers drive cattle to market, a stagecoach travels the Overland Trail. Such action did not just give his plots motion and direction, it represented the desire to build bonds of political unity. Ford's films explored the problems of law and authority, progress and order, justice and retribution—issues central to America's founding mythology—and in elevating the

Fig. 2. *Stagecoach*, 1939, directed by John Ford. 20th Century Fox

western to national epic, his movies, explained philoso-
pher Robert Pippin, became America's *Odyssey*.[4]

Critics of the mythic West of art and film are ubiqui-
tous. At best, the argument goes, these representations
are products of quaint nostalgia and, at worst, relics of a
falsified memory designed to cover up the many sins of
Manifest Destiny. Such commentary misses the point,
however. Benton and Ford were neither apologists nor
antimodernists. And their work was never as simple as
their detractors insist. Behind Ford's stunning visual fram-
ing was an exploration of American progress. His main
characters are thrown together in difficult environments,
and as individuals without shared traditions, they must
create a workable community. It is never easy; heroes like
the aging gunfighter and the pioneering rancher struggle
to adapt to change. As part of this larger effort to narrate
national development, his films illustrate the difficulty of
building, and then defending, American society. But such

transitions, however painful, are as necessary as they are
valuable. The genius of Ford's westerns is their ability to
celebrate the binding forces of the frontier with a keen
awareness of the costs of American modernization. His
films reveal the fragile nature of familial bonds and the
limitations of legal authority, but at base, they also cele-
brate the virtues of Jeffersonian agrarianism.[5]

In its stereotypical form, the American West is
marked by vast open spaces and solitude. In Ford's favor-
ite setting, Monument Valley, for example, the environment
dominates the frame (fig. 2). Western nature is beautiful
but unsettled, wild, even chaotic. These sweeping land-
scapes were never intended to overwhelm the individual,
however, but to suggest possibility. The western setting
provided an opportunity to be present at the founding of
the American political story. Ford's films and Benton's
paintings were an artistic tribute to the original virtues re-
quired to build a civil society.

Plate 15
King Philip, 1922
Oil on canvas
30 1/8 × 25 3/16 in. (76.5 × 64.3 cm)
Art Gallery, University of Saint Joseph, West Hartford,
Connecticut, Gift of the Reverend Andrew J. Kelly, 1937

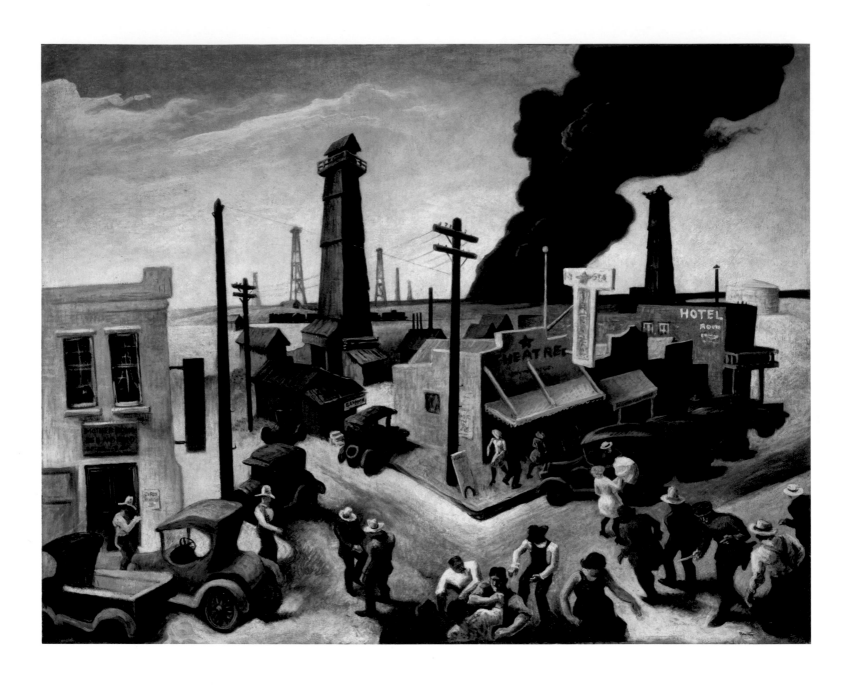

Plate 16
Boomtown, 1927
Oil on canvas
45 × 54 in. (114.3 × 137.2 cm)
Memorial Art Gallery of University of Rochester, Rochester,
New York, Marion Stratton Gould Fund, 51.1

Plate 17
Open Country, 1952
Tempera with oil on canvas, mounted on panel
27 ⅛ × 35 ⅜ in. (69.2 × 89.5 cm)
The Nelson-Atkins Museum of Art, Kansas City, Missouri,
Bequest of David L. and Elise B. Sheffrey, F89-33

Plate 18
Custer's Last Stand, 1945
Oil on canvas
42 × 48 in. (106.7 × 121.9 cm)
Albrecht-Kemper Museum of Art, Saint Joseph, Missouri,
Purchased with funds donated by the Enid and Crosby
Kemper Foundation

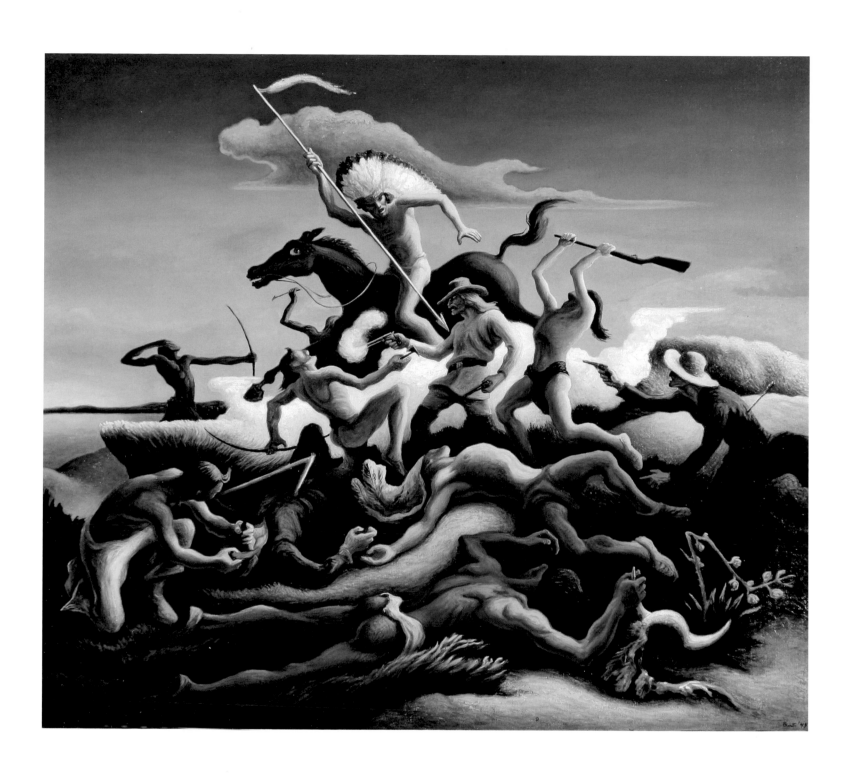

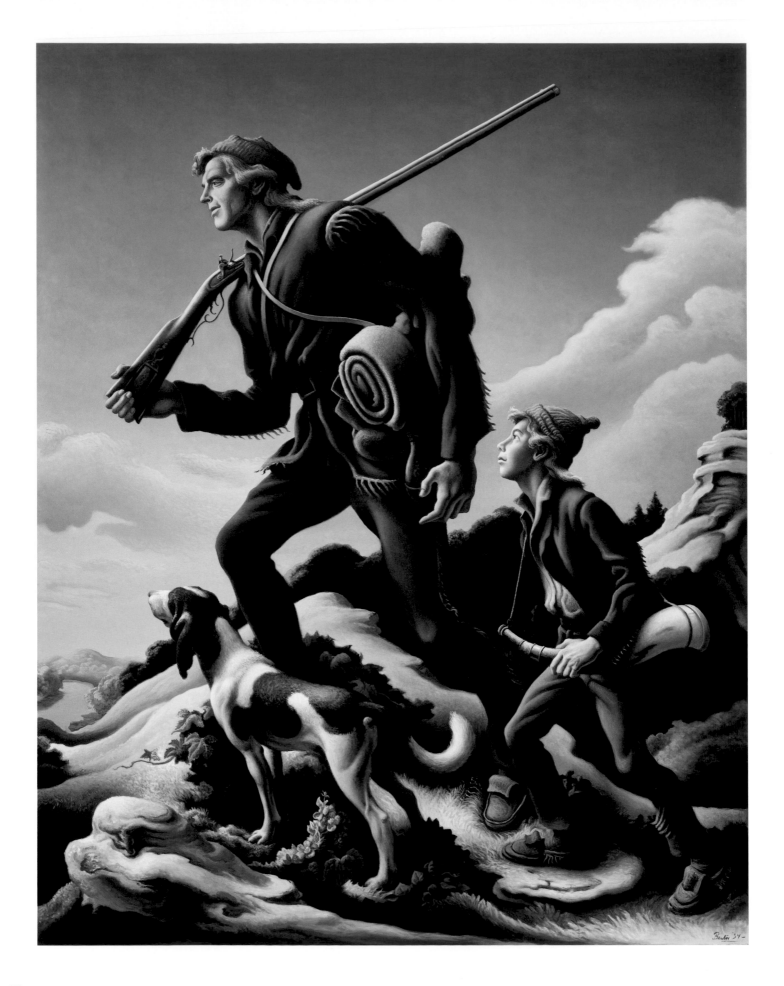

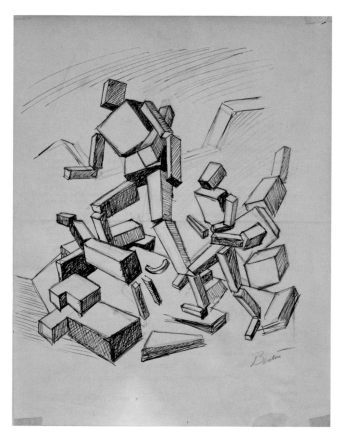

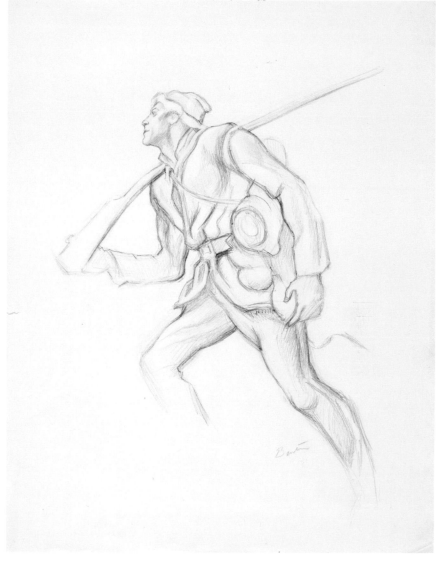

Plate 19
The Kentuckian, 1954
Oil on canvas
76 ⅛ × 60 ⅜ in. (193.3 × 153.4 cm)
Los Angeles County Museum of Art,
Gift of Burt Lancaster, M.77.115

Plate 20
Cubist sketch for *The Kentuckian*, 1954
Ink and graphite on paper
10 ⅞ × 8 ⅜ in. (27.6 × 21.3 cm)
T. H. Benton and R. P. Benton Testamentary
Trusts, UMB Bank Trustee

Plate 21
Sketch for *The Kentuckian* (Burt Lancaster
as "Big Eli" Wakefield), 1954
Graphite on paper
16 ⅞ × 12 ⅞ in. (42.9 × 32.7 cm)
Los Angeles County Museum of Art,
American Art Council, M.2010.95.1

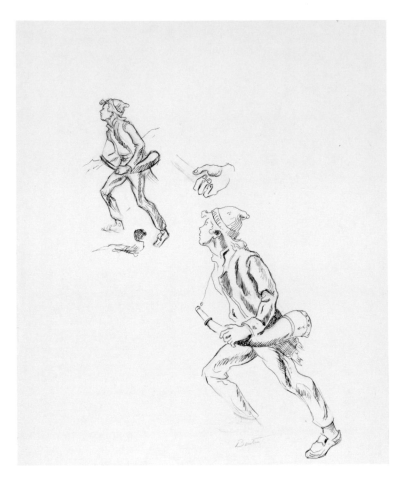

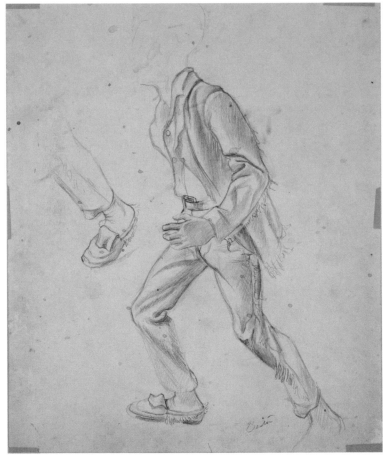

Plate 22
Sketch for *The Kentuckian* (Donald
MacDonald as "Little Eli" Wakefield), 1954
Ink on paper
16 ⅞ × 13 ⅞ in. (42.9 × 35.3 cm)
Los Angeles County Museum of Art,
American Art Council, M.2010.95.2

Plate 23
Sketch for *The Kentuckian* (Donald MacDonald
as "Little Eli" Wakefield), 1954
Graphite on paper
16 ½ × 13 ¾ in. (41.9 × 34.9 cm)
T. H. Benton and R. P. Benton Testamentary Trusts,
UMB Bank Trustee

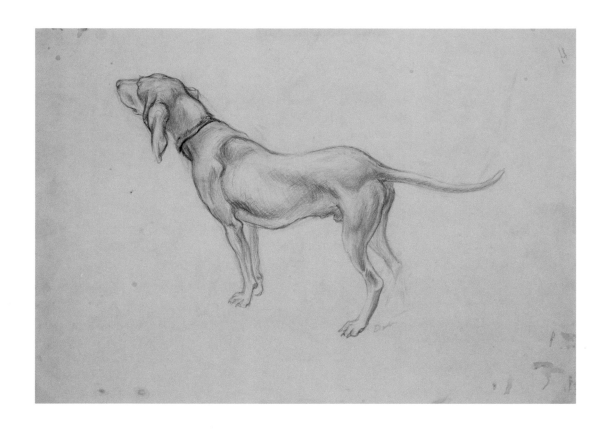

Plate 24
Sketch for *The Kentuckian* (dog), 1954
Graphite on paper
13 ¾ × 16 ½ in. (34.9 × 41.9 cm)
T. H. Benton and R. P. Benton Testamentary Trusts,
UMB Bank Trustee

Plate 25
Sketch for *The Kentuckian* (Donald MacDonald as "Little Eli" Wakefield), 1954
Graphite on paper
17 ¾ × 12 ¾ in. (45 × 32.4 cm)
Private collection, Boulder Creek, California

Plate 26
Sketch for *The Kentuckian* (Donald MacDonald as "Little Eli" Wakefield), 1954
Tempera on paper
21 × 17 ¾ in. (53.3 × 45.1 cm)
Private collection, Boulder Creek, California

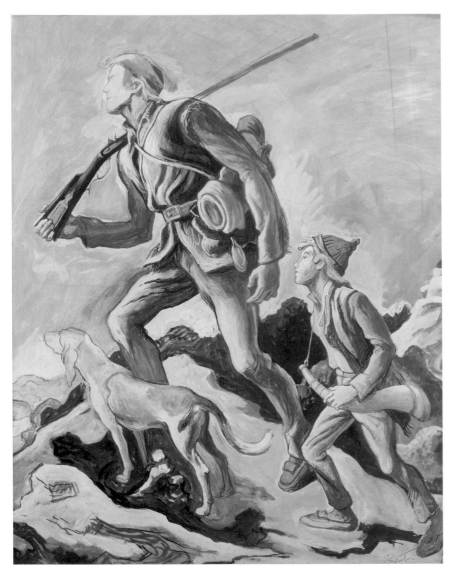

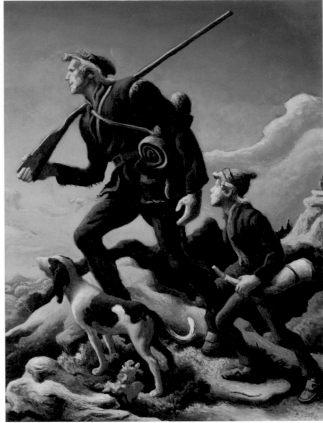

Plate 27
Grisaille sketch for *The Kentuckian*, 1954
Watercolor, gouache, and graphite on paper
25 5/8 × 17 1/4 in. (65 × 43.8 cm)
T. H. Benton and R. P. Benton Testamentary Trusts,
UMB Bank Trustee

Plate 28
Sketch for *The Kentuckian*, 1954
Oil on Masonite panel
15 1/2 × 12 1/4 in. (39.4 × 31.1 cm)
T. H. Benton and R. P. Benton Testamentary Trusts,
UMB Bank Trustee

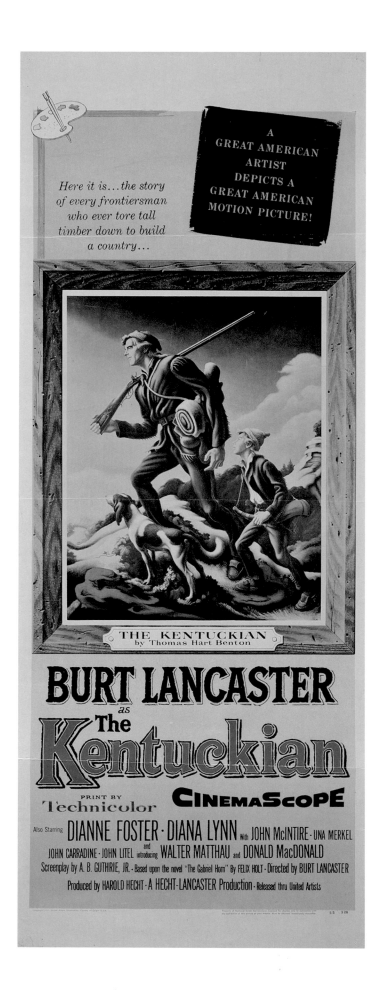

Plate 29
Poster for *The Kentuckian*, 1954
Commissioned by United Artists Corporation
36 × 14 in. (91.4 × 35.6 cm)
Los Angeles County Museum of Art, Balch Art
Research Library, Special Collections

Plate 30
Trail Riders, 1964–65
Oil on canvas
56 ⅛ × 74 in. (142.6 × 188 cm)
National Gallery of Art, Washington,
Gift of the Artist, 1975.42.1

Plate 31
Lewis and Clark at Eagle Creek, 1967
Polymer and tempera on Masonite panel
30 ½ × 38 in. (77.5 × 96.5 cm)
Courtesy of the Eiteljorg Museum of American Indians
and Western Art, Indianapolis, Indiana, 1989.2.10

THE GRAPES OF WRATH IN PICTURES

Margaret C. Conrads

Darryl Zanuck, head of the major motion-picture studio 20th Century Fox, purchased the film rights to John Steinbeck's controversial and bestselling novel *The Grapes of Wrath* within weeks of its publication in April 1939, paying the then-enormous sum of $75,000. Steinbeck's book came out at the height of the California farm labor crisis, prompting some cities to ban the novel and some members of the press to suggest that Zanuck bought the rights to prevent a film adaptation.[1] Nonetheless, Zanuck produced the film, hiring John Ford to direct and Thomas Hart Benton to produce art for the advertising campaign. 20th Century Fox's specialty in adapting novels, Zanuck's comfort with risk, and a promotional plan featuring a well-known artist seemed to ensure the project's success, despite the book's many detractors and a depressed movie market.[2] *The Grapes of Wrath* was indeed a big hit, winning two Academy Awards—for Jane Darwell, best actress in a supporting role, and John Ford, best director.

Benton's commission for *The Grapes of Wrath* (1940) was the first of three film-related assignments between 1939 and 1941 that had been engineered for him by Reeves Lewenthal, who, in this case, had partnered with Harry Brand, chief publicist for the movie.[3] Benton executed the project in a matter of months, matching the speed of moviemaking at the time. The project included six lithographs: five portraits of the novel's main characters and another print interpreting the novel's pivotal scene, the Joad family's departure from their Oklahoma home for California (pls. 32–37). On January 24, 1940, when the movie premiered at the Rivoli Theatre in midtown Manhattan, Benton's images loomed large near the entrance (fig. 1). A billboard with the film credits featured oversize blowups of four of the five black-and-white portraits—Tom Joad, Ma Joad, Rosasharn, and Jim Casy, and a twenty-four-foot enlargement of the print *Departure of the Joads* greeted moviegoers from above the marquee.[4] Benton's art promoted the movie not only at theaters but also in newspapers, magazines, and souvenir programs.[5]

The collaboration between Benton, Zanuck, and Ford was a particularly good fit. They mutually embraced the trend of telling stories in a documentary-like visual style.[6] Benton and Zanuck were particularly attracted to content

that poked at people's consciences, and Benton and Ford frequently relied on stereotypical imagery of the Depression, making their work seem familiar and accessible. To emphasize the effects of the Depression, both Benton and Ford chose to focus their artistry on the family and their story rather than on broader social issues.[7] Benton's art directly inspired Ford as he prepared to start shooting. According to Dan Ford, the director's son, *The Grapes of Wrath*'s art director, Richard Day, presented Ford and the cinematographer, Gregg Toland, with production sketches imitating Benton's style. Dan Ford recounted that these sketches prompted the team to "emphasize the contrasts, to go for a stark, almost documentary effect: murky silhouettes against light skies, and grim figures bent against the wind."[8] While there was no real critical response to Benton's advertising images, his influence on the look of the movie was recognized by the *New Yorker*, which compared the beauty of the film to that found in Benton's art.[9] Zanuck, however, was troubled by Benton's images because "everything's leaning." Even so, he knew they would help sell the picture.[10]

Benton derived his five lithographs of the film's lead actors from drawings that he had made previously of ordinary people in Oklahoma and Arkansas. Benton later noted that he altered the features of his figures to deter

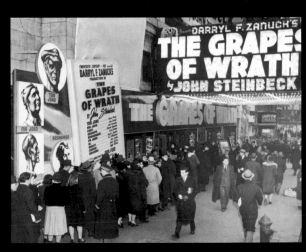

Fig. 1. Moviegoers waiting in line outside the Rivoli Theatre, Times Square, New York, 1940

association with the earlier sitters, yet there was surely another motive for the changes: his adjustments aligned the faces more closely with those of the actors, especially Darwell and Henry Fonda.[11] Delineated in Benton's signature style, the characters' emotional states are rendered as clearly as their physiognomy through the high contrast of light and shade, the expressive outlines, and the gritty texture of crayon on stone. The drawings' black-and-white palette matched the film's austerity. And while Benton's portrayals of the Oklahomans captured a sense of their individual personalities, it denied the bone-chilling distress of the period's migrants overall.

In contrast, *Departure of the Joads*, in all its forms—the lithograph (fig. 2), a rendition in oil (pl. 38), and the front endpapers of a 1940 Limited Editions Club publication of the novel—seems to have been an imaginative amalgamation of Benton's readings of the book and perhaps the script.[12] On one sheet of paper, Benton synthesized the emotions and the action of chapter 10 of the novel and what would become about nine minutes of footage in the film. Art critic Thomas Craven pointed out Benton's special ability to condense narratives, noting that his prints stand out among the performances of contemporary draughtsmen as the most compact and the most effective."[13] In the right half of the image, Benton depicts the male family members loading the truck, and in the middle ground, Ma Joad supports the weak but resistant Granma. This vignette and another that shows Granpa slouching outside the house sum up the pain of the leave-taking. It is a crucial moment in the narrative: the Joads flee their life in Oklahoma with no knowledge of what is to come.

In corresponding scenes from the book, the film, and the art, the landscape is the ever-present, silent main character. In Benton's image, the landscape fills the sheet and the narrative is embedded within it, reinforcing the role of the land as the primary shaper of the Joads' experience. Dramatic, jagged, white clouds pierce the black predawn sky. Their suggested movement creates a sense of anxiety and restlessness, which, perhaps not coincidentally, is similarly evoked through the film's crosscutting.[14] Benton's earthscape adds tension to the scene. The undulating land of the foreground, as well as the truck, tugs the viewer to the right, while the clouds pull left. A diagonal line evenly bisects the composition from lower left toward upper right. The sharply silhouetted, off-kilter poses of the faceless figures add to the composition's instability while mirroring the characters' mix of grief and resolve. But Benton and Ford, more than Steinbeck, subtly relieve the scene's anguish. A sliver of moon, which despite its diminutive size hangs gracefully in the center of the image between the clouds, and the upright figure of a little girl, representing Tom's sister Ruthie, help ground Benton's composition and provide the only promise of hope at this juncture in the narrative. Although upbeat music accompanies the movie moment, Benton's landscape is still softer

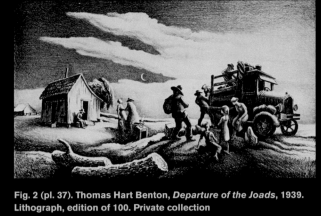

Fig. 2 (pl. 37). Thomas Hart Benton, *Departure of the Joads*, 1939. Lithograph, edition of 100. Private collection

than Ford's bleak, hard-edged, more documentary-like departure scene. *Departure of the Joads* follows the trajectory of Benton's recent paintings and prints, including *Approaching Storm* (1938), *The Wood Pile* (1939), and *Frisky Day* (1939), all of which reflect the artist's romantic notion of the West as the farmer's Promised Land, a notion that he shared with Steinbeck.[15]

The print and its variants capture the essential and poetic humanity of Steinbeck's tale.[16] Benton did not present social causes or the harsh realities of the period as overtly as Steinbeck had. Nor did he imbue his work with the newsreel quality of Ford's film.[17] *Departure of the Joads*'s primary purpose was advertising, and the image gave Benton the perfect platform for presenting his particular mythic America.

Benton's work on *The Grapes of Wrath* project came at a moment of professional quandary. A recent exhibition at Associated American Galleries of thirty-seven paintings from across his career was met with significant critical and monetary success,[18] and the Metropolitan Museum of Art had recently bought their second Benton painting, *Roasting Ears* (1938). Yet, the criticism of *Susannah and the Elders* (1938) and *Persephone* (1938–39; pl. 73) elicited, as art historian Justin Wolff has suggested, uncertainty about the currency his art had at this moment. Benton later admitted that he was "stuck" at the end of the 1930s, writing, "there came over me now and then a sense of uneasiness . . . I was almost completely frustrated . . . [by the] new democratic patterns," as the world began to unravel.[19] Within a year, he would channel his political and artistic frustrations into a new series that displayed his outrage at the horrors of World War II—the *Year of Peril*.

Plate 32
Ma Joad, 1939
From *The Grapes of Wrath* print series, commissioned
by 20th Century Fox Film Corporation
Lithograph, edition of 25
Image: 6 ¾ × 6 ¾ in. (17.1 × 17.1 cm)
State Historical Society of Missouri, Columbia, 1975.35

Plate 33
Pa Joad, 1939
From *The Grapes of Wrath* print series, commissioned
by 20th Century Fox Film Corporation
Lithograph, edition of 25
Image: 9 ½ × 7 in. (24.1 × 17.8 cm)
State Historical Society of Missouri, Columbia, 1975.36

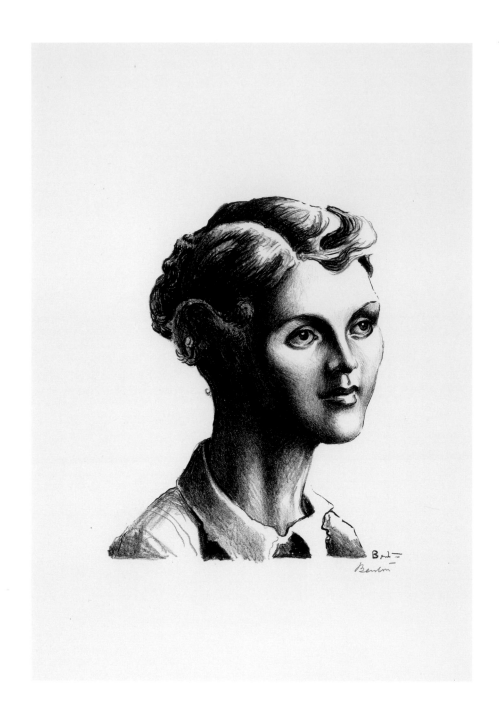

Plate 34
Sharon [Rosasharn] *Joad*, 1939
From *The Grapes of Wrath* print series, commissioned
by 20th Century Fox Film Corporation
Lithograph, edition of 25
Image: 7 ½ × 6 in. (19.1 × 15.2 cm)
State Historical Society of Missouri, Columbia, 1975.37

Plate 35
Tom Joad, 1939
From *The Grapes of Wrath* print series, commissioned
by 20th Century Fox Film Corporation
Lithograph, edition of 25
Image: 9 ½ × 6 ¾ in. (24.1 × 17.1 cm)
State Historical Society of Missouri, Columbia, 1975.38

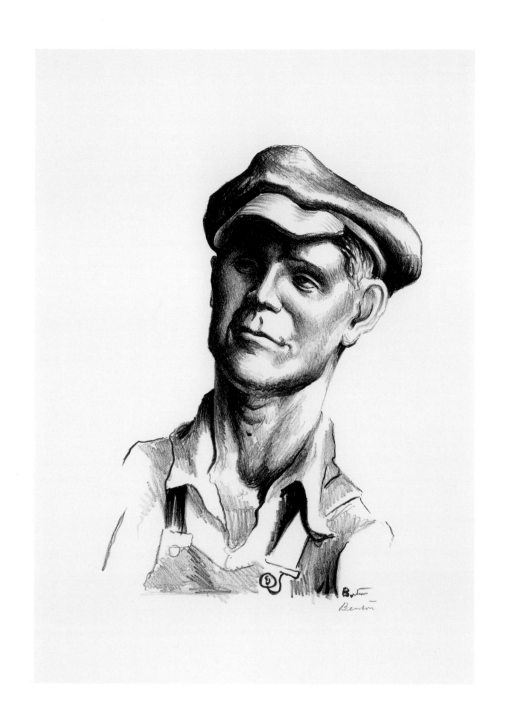

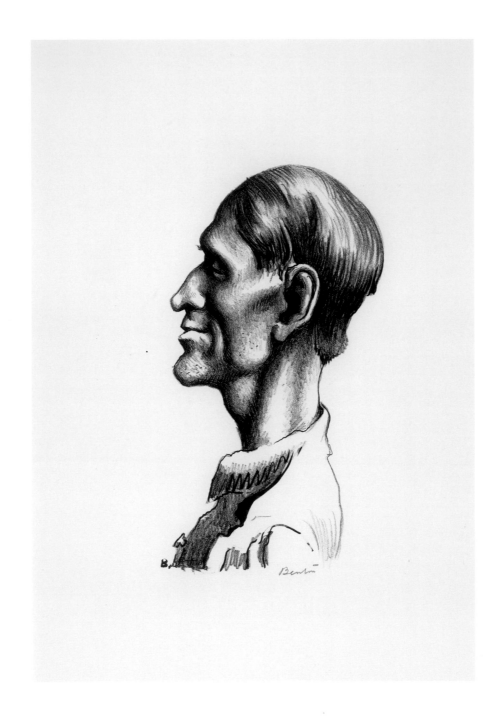

Plate 36
The Reverend Jim Casy, 1939
From *The Grapes of Wrath* print series, commissioned
by 20th Century Fox Film Corporation
Lithograph, edition of 25
Image: 8 ¼ × 4 ½ in. (21 × 11.4 cm)
State Historical Society of Missouri, Columbia, 1975.39

Plate 37
Departure of the Joads, 1939
From *The Grapes of Wrath* print series, commissioned
by 20th Century Fox Film Corporation
Lithograph, edition of 100
Image: 12 ¾ × 18 ¼ in. (32.8 × 47 cm)
Private collection

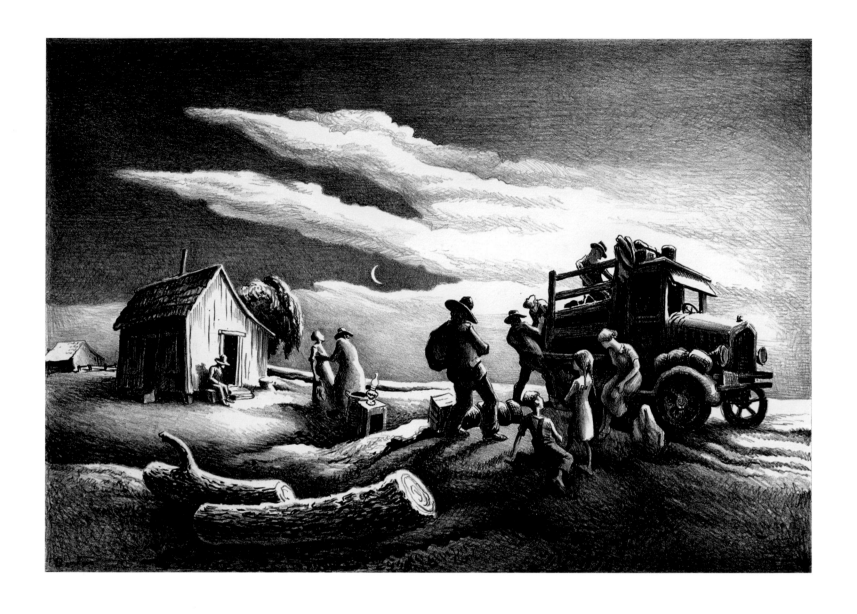

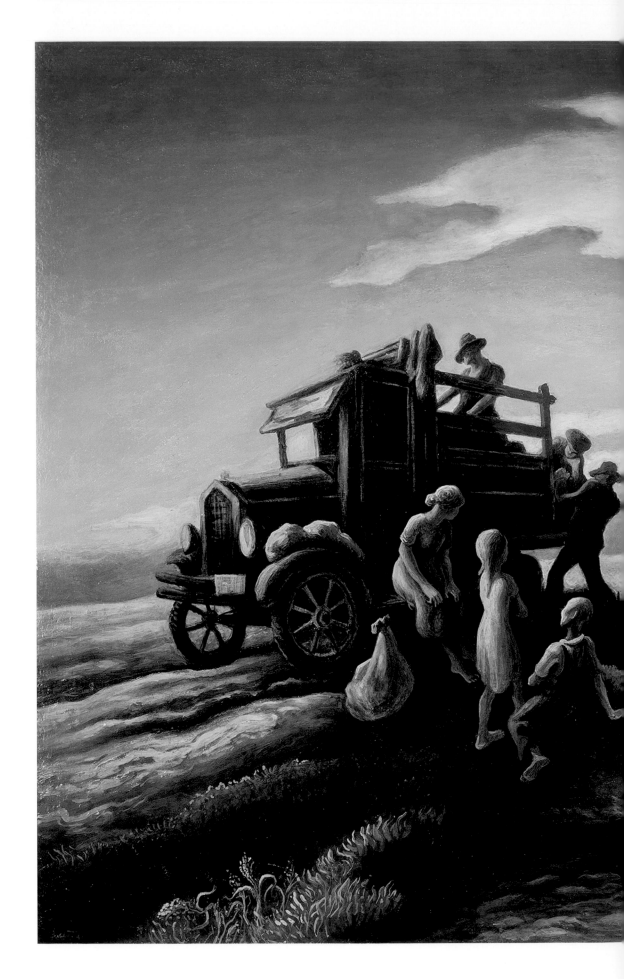

Plate 38
Departure of the Joads, 1939
Oil and tempera on fiberboard
29 ½ × 45 ¾ in. (74.9 × 116.2 cm)
Ralph Foster Museum, College of the Ozarks,
Point Lookout, Missouri

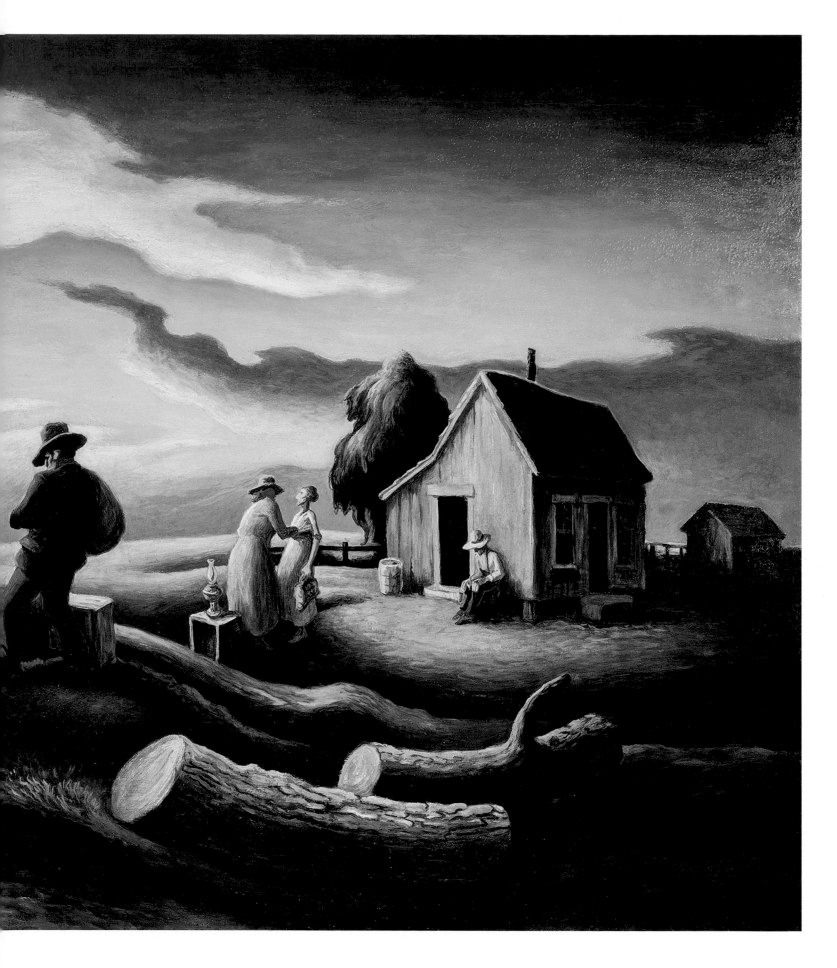

Plate 39
John Steinbeck, *The Grapes of Wrath*, 1939
Two volumes, illustrated by Thomas Hart Benton
Rawhide-and-grass-cloth binding
Limited Editions Club, 1940
Phillips Library, Peabody Essex Museum, Salem

Plate 40
Endpapers, illustrated by Thomas Hart Benton
From John Steinbeck, *The Grapes of Wrath*,
1939, volume 1
Limited Editions Club, 1940
Phillips Library, Peabody Essex Museum, Salem

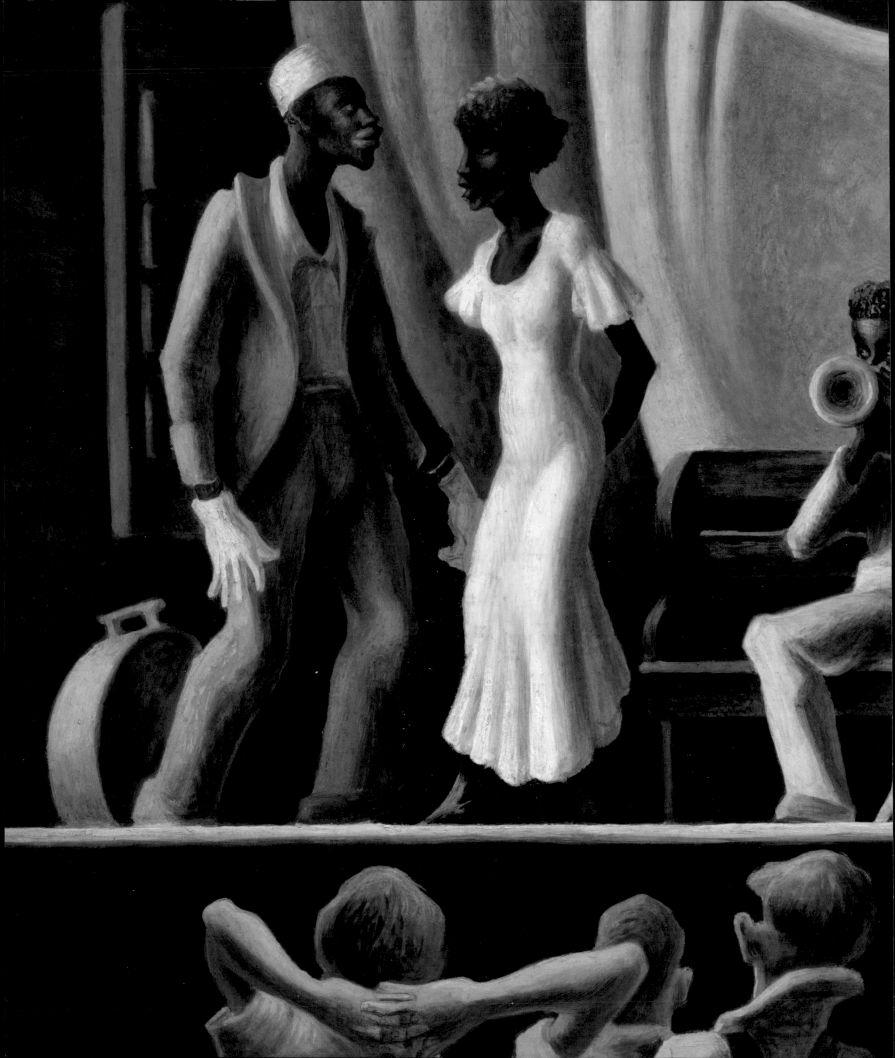

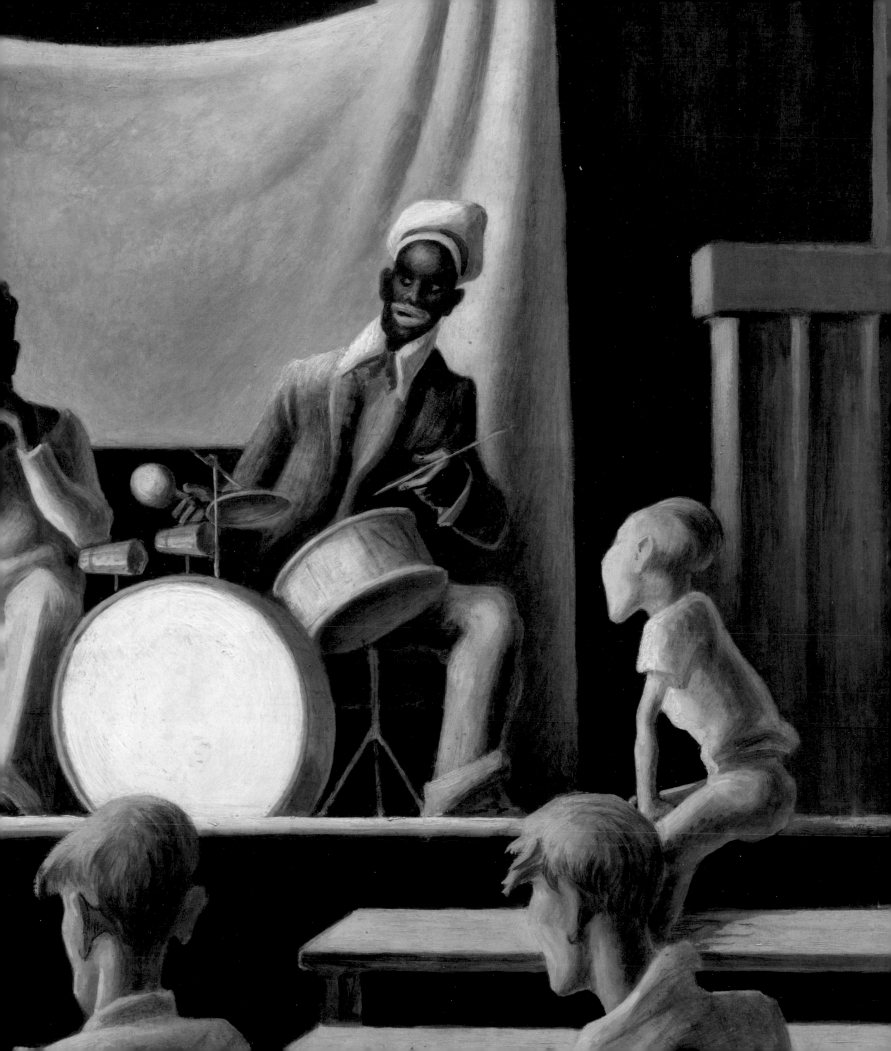

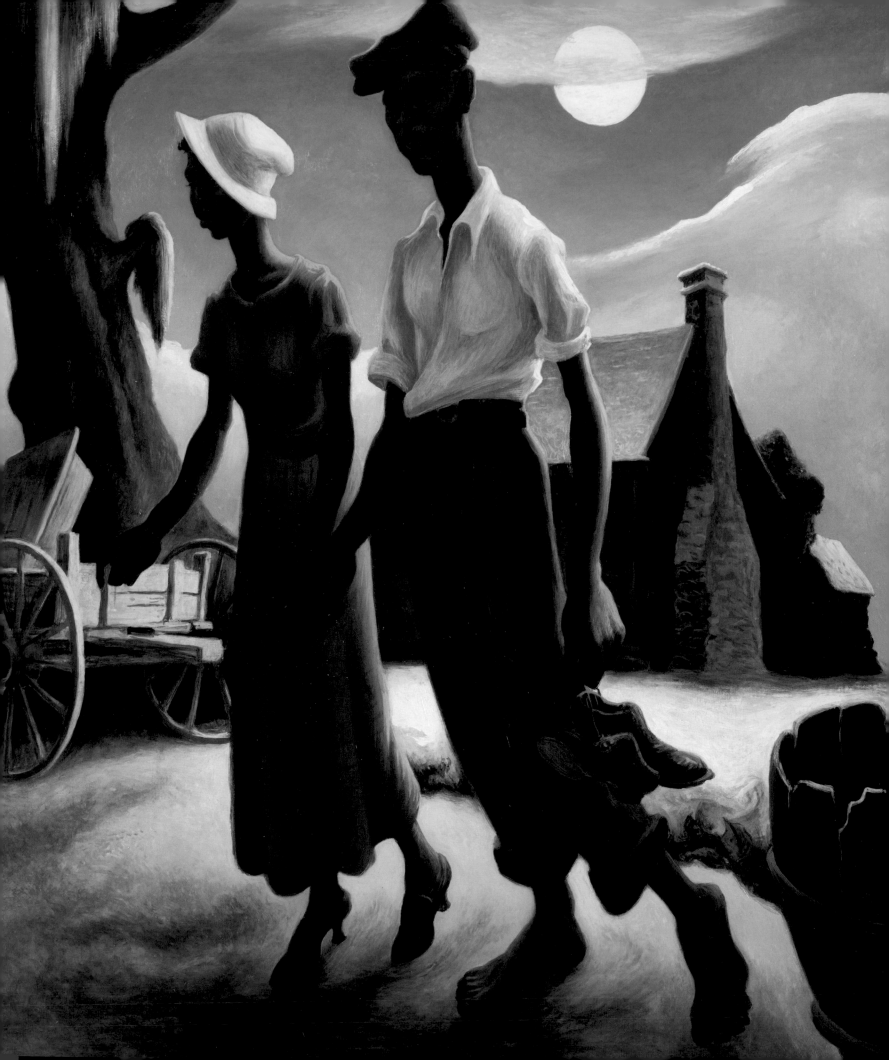

"DEM SHOES"
THOMAS HART BENTON'S *ROMANCE*

Richard J. Powell

I felt strange as I always do in Georgia, particularly at dusk. I felt that things unseen to me were tangibly immediate. It would not have surprised me had I had a vision.
– Jean Toomer, *Cane*[1]

An impossibly elongated couple, walking hand in hand, commands center stage in *Romance* (1931–32; pl. 45), a painting by the renowned American artist Thomas Hart Benton. A woman, wearing a red dress and a cloche, and her partner, a barefoot man with his shirtsleeves and pant legs rolled up, are enveloped by an idealized southern United States landscape – a rickety wagon, a moss-covered tree, a cabin with a stone chimney, a worn-out barrel – and an anthropomorphic sky, with a cloud-shuttered moon resembling the heavy-lidded all-seeing eye of a gigantic deity.

Depicted with downcast heads and austere, serious expressions, the pair appears to be moving with an intended objective in mind, their long, gangly limbs are caught mid-stride, almost as if they are dancing but without the frivolity or theatricality of a pas de deux. Their mirrored movements and near-identical poses underscore their assumed status as a couple and suggest a common purpose within the painting's implicit narrative, in which they are ostensibly walking away from the rustic scene behind them and toward an open, shadowy land ahead, at the lower-left corner of the painting.

A pictorial detail that, while plausible within this mise-en-scène, stands out and demands discussion is the pair of shoes the man holds from their knotted shoestrings. There's nothing strange or incongruous about this vignette: in Benton's day, people in rural and/or impoverished communities frequently went barefoot, and they often carried their shoes, ready to slip into

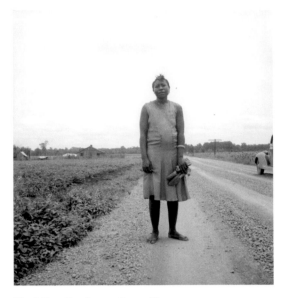

Fig. 1. Dorothea Lange, *Negro Woman Carrying Her Shoes Home from Church, Mississippi Delta*, July 1936. Gelatin silver print. Farm Security Administration, Office of War Information Photograph Collection, Library of Congress, Washington, DC, LC-USF34-009514

them when absolutely necessary or desired (fig. 1). But Benton's inclusion of this particular detail is arguably a narrative device, augmenting the story of this couple and their unspecified trek and, in juxtaposition with the painting's title, complicating its presumed theme of love with ideas and matters more equivocal, allusive, and, as suggested by the omnipresent, ocular full moon in the picture's background, intrinsically poetic.

The brown oxfords dangling from the man's fingers beg the question, Why has this lanky, applejack-wearing man chosen to go barefoot? Maybe the shoes are treasured possessions, not the kind of sartorial goods one knowingly subjects to a dusty, rocky country path. Or perhaps his big feet would be uncomfortably cramped were he to attempt to squeeze them into those relatively minuscule shoes. Or possibly the couple's ultimate destination requires a sure-footedness and heel-to-earth traction that only his bare feet can provide. While any of these reasons are believable, the fact remains that Benton has clearly made the man's shoeless-ness and swinging shoes (as opposed to the woman's pumps, which don't seem at all extraordinary) the scene's pictorial missile (or what the French cultural critic Roland Barthes calls the work's psychological *punctum*), the locus of tension, irony, and flesh-and-leather-bound reality.[2]

Benton's autobiography *An Artist in America* offers clues to what he might have intended with this visual passage. In the chapter titled "The South," Benton inserted the following, somewhat cryptic, anecdote from his travels in the late 1920s below the Mason-Dixon Line:

> Two Negro boys were walking along a dusty north Georgia road. They were barefoot. Their new pants were rolled up in fat cuffs below their knees. Both had shiny patent leather shoes hanging from their shoulders. One carried a bulging black paper suitcase, the straps of which were reinforced with strands of rope. It was a heavy load. They were sad-eyed and their lips drooped.
>
> "Mistah," said one to me, "is it fuh frum hyeah to Noo Yauk?"[3]

As suggested in this story (and possibly in Benton's *Romance*), the triumvirate of bare feet, unworn shoes, and African American travelers collectively conjures not just an image of a leisurely stroll or an obligatory walk by country folk but also visions of escape and migration. Beyond this particular recollection, there are other references in Benton's autobiography to black subjugation and white brutality in the South that function as subliminal spurs for these boys: the psychological cuts and actual blows that prompted them to take up a "heavy load" and seek refuge in "Noo Yauk." Their journey—a symbolic, barefoot pilgrimage to freedom—and their shoes—emblems of prestige and modernity—resonate with Benton's *Romance* through these same components, the couple's sober, ambulatory undertaking and the scene's overarching serious-mindedness and moon-lit singularity. Indeed, the descriptive breakdown and itemized recounting of bare feet, rolled-up cuffs, and hanging shoes operated in both Benton's text and his painting as surrealistic fragments: focal, discernable elements that triggered subconscious figments of corporeality, orderliness, and flight, respectively. And one doesn't want to exclude from a discussion of Benton's fixations on bare feet and isolated shoes his lifelong admiration for fellow Missourian, the author and humorist Mark Twain, and Twain's well-documented deployment of these same emancipatory icons in *The Adventures of Tom Sawyer* and *Adventures of Huckleberry Finn*.[4]

Observing an African American shoeshine boy cleaning a pair of riding boots on the back stoop of a southern hotel, Benton became captivated by the boy's work song, which he repeated over and over again, Benton noted in his autobiography, with "a funereal solemnity":

Dem ole duhty shoes
Dem ole duhty shoes
Who se-e-ehd dem shoes — [5]

Like Vincent van Gogh's paintings of abandoned, seemingly forsaken shoes, the spare refrain of Benton's shoeshine boy paints an evocative still life with words: a sound-painting fraught with privation, melancholy, and the ghostly specter of the feet that once resided in an empty pair of brogans.[6] In another Benton painting, *Butterfly Catcher* (1942; fig. 2), the artist consigned a derelict, shabby shoe to a landscape of forest undergrowth, rotted tree trunks, and debris, relying on the viewer's ability to conceptually link the true butterfly chaser (in the far distance), the butterfly's literary associations with departed souls, and the cadaverous shoe in the immediate foreground. Vacant, unfilled shoes, and other marked absences in Western art and visual culture, often signify death, and, in the context of Benton's *Romance,* the barefoot man's dangling oxfords unavoidably evoke, along with Mark Twain's two defiantly shoeless protagonists, the lynched bodies of black men, suspended from gnarled tree branches and strained ropes.[7]

However, the *Romance* couple's blackness is not crucial to the painting's implied narrative, nor is it the primary reason for imposing a sociological interpretation onto this scene. While this woman and man, in facial features and physical bearing, are unmistakably African American, they rise above that era's more characteristic, garden-variety racism and reject that moment's red-cheeked, tobacco-stained guffaws. No sight gags here. And yet, the couple's African physiognomy and bucolic, southern demeanor are not obscured or downplayed as much as they are made entirely normative, attesting to — as evidenced in Benton's entire oeuvre — their full membership in the artist's expansive American demographic.[8]

One senses that Benton's agenda in *Romance* is not exclusively a racially informed one. The couple and the landscape they inhabit are characteristically Bentonesque, rising, falling, and undulating to a folksy cadence tapped out within his own American regionalist head and then put into operation within each work of art. As the art historian Leo G. Mazow has proposed, Benton considered sound an eloquent, knowledge-producing element within his painted universe, and sound is "meaning forming" through its narrational depictions and visual transmogrifications.[9] Land, sky, and the vestiges of civilization bend and sway to some internal dirge or folk song of Benton's creation. The couple's feet, perfectly arched and promenading in bluesy unison, conform to Benton's sinuous, thoroughly perfected formulae, as do their slender, ballet dancer ankles, emerging from beneath illusionistic cascades of flouncy red cotton and stiff blue denim.

Benton set *Romance* in the same down-home milieu and folkloric atmosphere as that of his fellow Jazz Age "primitivist," the photographer Doris Ulmann (fig. 3). Aesthetically preempting Ulmann's *Roll, Jordan, Roll* — her 1933 *hommage* to rural black life in South Carolina — Benton's *Romance* turned its southern setting and peoples into a virtual sea, visually rising, subsiding, and "rolling" with the same expressivity as the Negro spirituals he

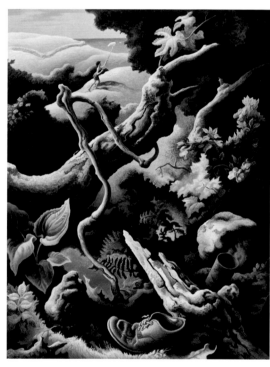

Fig. 2. Thomas Hart Benton, *Butterfly Catcher*, 1942. Oil and tempera on canvas, mounted on panel. Collection of Jessie Benton

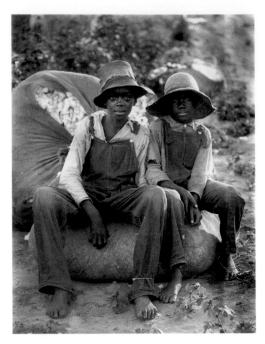

Fig. 3. Doris Ulmann, *South Carolina*, 1929–30. Platinum print. Doris Ulmann Collection, Special Collections & University Archives, University of Oregon Libraries, Eugene

experienced during his travels throughout the South in the late 1920s.[10] Benton vividly remembered one foray into an African American church in those years: "The deep beautiful tones came out . . . cut here and there with the lifting wail of a high soprano, so high that it was truly like an angel's voice." He continued: "If anywhere in the world the Christian faith is still touched with the hand of God, it is among the southern Negroes of the back country who cling to traditional ways."[11]

In the advent of sound motion pictures, Hollywood, too, discovered the affective, acoustic powers of Negro spirituals. Around the same time that Benton was exhibiting his southern-inspired drawings and watercolors in New York City, two films featuring African American actors and musical performances, *Hallelujah!* (1929) and *Hearts in Dixie* (1929), had showy premieres in both Broadway and Harlem movie theaters.[12] *Hallelujah!*, the more artistic and critically successful of these two "all-colored cast" motion pictures, brought cinematic grandeur to many of the themes, characters, and aesthetic sensibilities that Benton was exploring in works like *Romance*. The film's director, King Vidor (who eventually acquired Benton's somewhat stereotypical oil on canvas *Negro and Alligator* [pl. 42]), equitably and carefully apportioned his movie camera's "eye"—and the associated psychological interest—between his actors and the film's striking open-air locations in rural Arkansas and Tennessee (fig. 4). Vidor's comprehensive vision in *Hallelujah!* was not unlike Benton's visual-narrative blend in *Romance*: a version of the South that engaged audiences through different narrative strains and on multiple sensory levels.

And what about *Romance*'s presumed subjects—the love and starry-eyed sentimentality announced in its title and underlined by the painted couple's synchronized movements and clasped hands? Although written a few years before Benton painted *Romance*, the lyrics to Richard Rodgers and Lorenz Hart's popular song "My Romance" (1935), composed for the Broadway musical *Jumbo,* could have easily served as the painting's caption:

> My romance doesn't have to have a moon in the sky,
> My romance doesn't need a blue lagoon standing by,
> No month of May, no twinkling stars, no hide away, no soft guitars.
> My romance doesn't need a castle rising in Spain,
> Nor a dance to a constantly surprising refrain.
> Wide awake, I can make my most fantastic dreams come true.
> My romance doesn't need a thing but you.[13]

And just like Rodgers and Hart's rhetorical refusal of the popular clichés of storybook romance in their Broadway song, Benton eviscerated this work, removing the trappings that viewers expect a romantic painting to contain and replacing those pictorial platitudes (excepting the full moon) with an African American couple, a desolate southern landscape, and a pervasive solemnity.

Again, Benton's autobiography helps unravel the unprecedented, non-romantic nature of *Romance.* At the end of the chapter titled "The South," Benton tells an inquisitive white southerner that black people (or, to precisely quote a purposefully ironic Benton in this instance, "the niggers") are the most important factor in the making of Southern culture.[14] After describing at great length the central roles African Americans played in the language development and early education of southern whites; the "unique and characterful" contributions African Americans have made to the music, humor, and

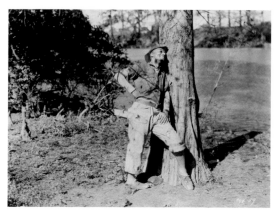

Fig. 4. Daniel Haynes on location in *Hallelujah!*, directed by King Vidor, 1929. Gelatin silver print. Thomas Cripps papers, David M. Rubenstein Rare Book & Manuscript Library. Duke University, Durham, North Carolina, Box ST1, c.1

civilization of the South; and the immeasurable debt white southerners owed to black people in terms of the region's workforce and economy, Benton goes on to say that the South is "a land of beauty and horror, of cultivation and refinement, laid over misery and degradation." He continued, "It is a land of tremendous contradictions, [the] beauty of southern homes has filled both song and story for years, yet the greater part of the houses of the South are dilapidated shacks with no grass in the yards and no flowers within miles."[15]

After this near-description of *Romance* – from the pivotal place African Americans occupy in the painting to the shabby cabin and flowerless, swept-dirt yard – Benton ends the chapter with the following:

> In spite of the above, the South remains our romantic land.
> It remains so because it is. I have seen the red clay of Georgia
> reveal its colors in the dawn, and the bayous of Louisiana glitter
> in magnolia-scented moonlight. There are no *crude facts*
> (emphasis mine) about the South which can ever kill the romantic
> effect of these on my imagination.[16]

Benton's repetition of the adjective *romantic* in this concluding statement and his resounding interpretation of the South as colorful, redolent, and, yet, paradoxical in its overall impression and bearing on his artistic imagination are revealing. His words advocate for expanding and modulating the inferred meaning of the title of his painting, foregrounding *Romance*'s assumed explanation of the work (as solely illuminating the centrally placed, hand-holding couple as "lovers") and, instead, uncapping and unfurling *Romance*'s gist to intelligently and critically encompass the entire scene, especially its deep, subterranean overtures to defeat, savagery, deprivation, and spiritual resolve. Rather than potentially destroying Benton's *Romance*, the realities of the South's racism, violence, abject poverty, and willed ignorance ironically helped fashion Benton's painting, stealthily symbolized in the traveling black bodies, a barefoot pilgrim, and a pair of disembodied, hanging shoes.

In the pocket-size percentage of *Romance* that contains "dem shoes," Benton was knowingly prefacing the idea of the "romantic South" with more than the painting's cryptic title could ever convey. Whether or not one interprets the unshod man's shoe-baggage as ill-fitting personal effects, prestige items, Mark Twainisms, lynch fragments, or odd trophies of respectability, their significations offset and heavily trod over the overt story lines and conceits of an idealized South and its "special" way of life. The moon at dusk (or is it the setting sun?) conspired with Benton, winking and intimating that the romance we assumed was present in the painting could rightly be tapped as such. But the painting's "crude facts" and asylum-seeking lovers betray an even greater devotion and human trajectory, all under the watchful eye of God.

MOVIE CULTURE IN THE SEGREGATED ERA

Matthew Bernstein

From the inception of film history (the early 1890s) well into the mid-1970s, segregated moviegoing persisted in much of the United States, but especially in the South. This miserable practice—whether backed by law or by local custom—segregated audiences according to residential neighborhoods, schedules (usually, midnight shows or special screenings for African Americans only), or seating plans (for example, the infamous "buzzard's roosts" in theater balconies). There are countless stories of African Americans who experienced the humiliation of buying their tickets at a separate entrance and climbing long staircases to balconies where the view was distant and toilet facilities cramped or nonexistent, as well as stories of children in their best clothes being instructed to behave demurely and avoid causing any disturbance (fig. 1).[1]

"Colored theaters"—as the movie houses dedicated to black audiences were called, especially in the South—typically lacked the glamorous trappings of white first-run theaters during Hollywood's Golden Age, from the teens through the early 1960s. They could not show the latest studio films until months, if not a year, after they premiered

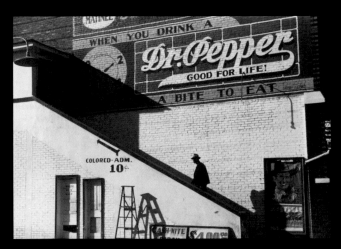

Fig. 1. Marion Post Wolcott, *Negro Going in Colored Entrance of Movie House on Saturday Afternoon, Belzoni, Mississippi Delta, Mississippi*, 1939. Photograph. Prints and Photographs Division, Library of Congress, Washington, DC

in white theaters.[2] The number of black theaters was never documented and estimates varied by decade, from 100 in the teens to 800 in the 1930s, which stands in marked contrast to the tens of thousands of white theaters that existed during the same period. Black audiences were virtually invisible to major studios as they devised their advertising campaigns. The situation began to change most notably with David O. Selznick's plantation epic *Gone with the Wind* (1939) and, during World War II, the all-black musicals *Cabin in the Sky* and *Stormy Weather* (both 1943). The year 1949 saw a cycle of race-relations "problem pictures," including *Pinky*, the story of a light-skinned southern black woman who, having passed for white in the North, confronts ugly racism on her return to the South.

And yet, in spite of this deplorable situation, which drove many to spend their leisure time doing other activities (for example, listening to the radio at home or going to church services and social events, or becoming involved with black fraternal lodges that espoused the values of self-help, community service, and leadership), African American moviegoers enjoyed a rich, though segregated, film culture. Over the decades, black actors achieved greater prominence in Hollywood films, and black audiences and the black press savored and celebrated their performances. This is evident in the intense coverage black actors received in the major black newspapers, such as the *Atlanta Daily World*, the *Afro-American* (Baltimore), the *Chicago Defender*, the *New York Amsterdam News*, and the *Pittsburgh Courier*. When films featuring major black roles—such as *Imitation of Life*, *Gone with the Wind*, *Cabin in the Sky*, *Stormy Weather*, and *Pinky*—appeared, articles and interviews abounded.[4]

On these occasions, the black newspapers published, alongside wire stories, articles bylined by local authors, publicity stories, film reviews, and think pieces (largely about the lack of opportunities in Hollywood for black performers). The papers also reprinted rave reviews from the press books created by the studios to help local exhibitors promote new releases (what today, in a greatly reduced form, are called press kits). Black movie critics often faced the moral dilemma of approving of superlative black performances in films with retrograde racial politics. (Hattie McDaniel's Oscar-winning turn as Mammy in *Gone*

with the Wind was the most famous example.) Such articles balanced their celebrations of great actors with analysis of the flaws in a film's racial politics, which often, in turn, inspired other reviews or letters to the editor. At the same time, local theater managers were creative in reworking the studio-designed ads, which all but ignored black cast members.[5] All of these discourses testified to a lively, rich segregated movie culture.

Movies made expressly for black audiences—from entrepreneur-directors such as Oscar Micheaux and companies like Million Dollar Productions—were few and far between. Yet, the cultural significance of these "race films," and their affirmation of cultural identity, remained much greater than their small numbers, their modest box office receipts, and their short theater runs would suggest. From the teens through the 1930s, Micheaux, in particular, specialized in making powerful films about controversial topics, such as lynching, "passing" for white, and deceptive religious leaders. The latter issue was featured in *Body and Soul* (1925), a film starring Paul Robeson in his screen debut.[6]

Similar affirmations also took place inside the movie theater itself (fig. 2). Many film programs had live stage acts featuring the finest jazz and blues performers (including Cab Calloway, Duke Ellington, Billie Holiday, Ethel Waters, and many others). In Chicago during the 1920s, black filmgoers danced to live jazz bands accompanying melodramatic scenes in white Hollywood films. Here, the musicians improvised instead of following the scores distributed by the major white film companies, in effect undercutting the intended tone of a scene. This created a distinctive live screening experience. As film historian Mary Carbine has written of Chicago's black community, "the picture houses provided a space for consciousness and assertion of social difference as well as the consumption of mass amusements."[7]

Race movies, never a strong box-office presence, went into decline as Hollywood studios began making serious, progressive films about race relations in the late 1940s and continuing through the 1950s (the decade during which Sidney Poitier emerged as a major star). Segregated movie seating was gradually dismantled in the South in the early 1960s through a mix of protests (for example, in Chapel Hill, North Carolina) and quiet, behind-the-scenes negotiations between city officials, business executives, and black community and student leaders (in Atlanta, Georgia). Admittedly, movie theaters were low on the priority list of National Association for the Advancement of Colored People (NAACP) leaders, Congress of Racial Equality (CORE) volunteers, and student groups, especially when compared with lunch counters, department stores, and other high-profile public spaces, but the symbolism of desegregating places of entertainment remained powerful.

The movement began in earnest in the late 1950s and early 1960s. Segregated seating and theaters were

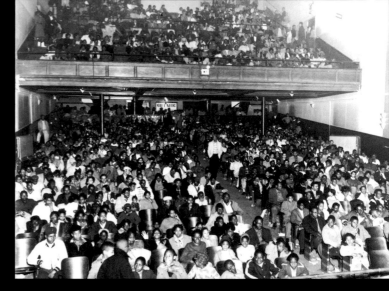

Fig. 2. Lenox Theatre, Augusta, Georgia, 1920s.
Historic Augusta

legally abolished with the Civil Rights Act of 1964, and yet they continued to operate through the first half of the 1970s. This had to do with habits of movie attendance and residential housing patterns that continue today in suburban malls and multiplexes.

Just as desegregation brought an end to many businesses catering to African Americans, so too did it mean the end of a unique film culture. Since the 1980s, the explosion of cable and satellite TV outlets, the rise of hip hop, and the vast miscellany of online content—even as theatrical film distribution continues—has caused the decentralization of popular culture at large, which affords both black and white Americans the freedom of constructing their own new culture, albeit one in which filmmakers and TV and Internet producers of color still have too few opportunities to express themselves.

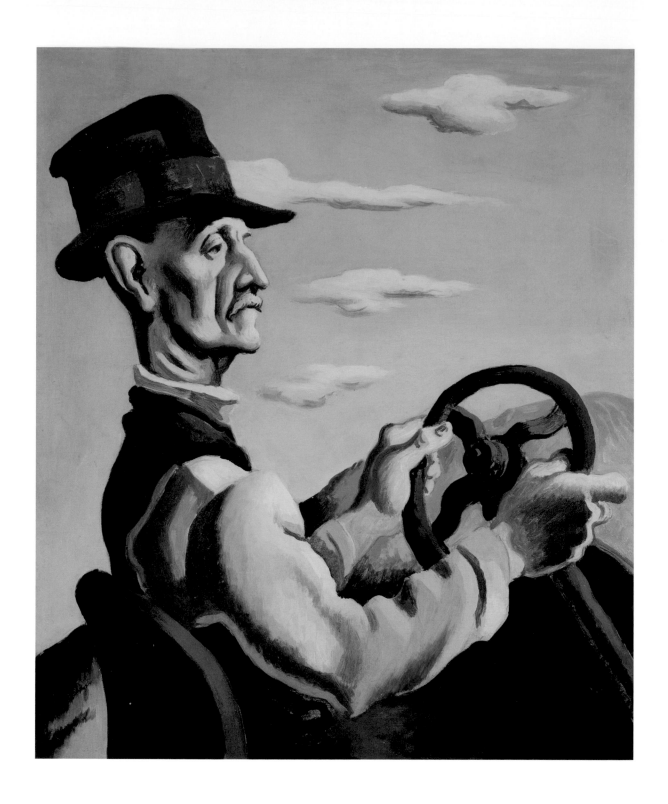

Plate 41
Yankee Driver, 1923
Oil on canvas
26 × 23¼ in. (66 × 59.1 cm)
The Huntington Library, Art Collections, and Botanical
Gardens, San Marino, California, Purchased with funds
from the Art Collectors' Council and the Virginia Steele
Scott Acquisition Fund for American Art, 2009.5

Plate 42
Negro and Alligator, 1927
Oil on canvas
45½ × 33 in. (115.6 × 83.8 cm)
Private collection

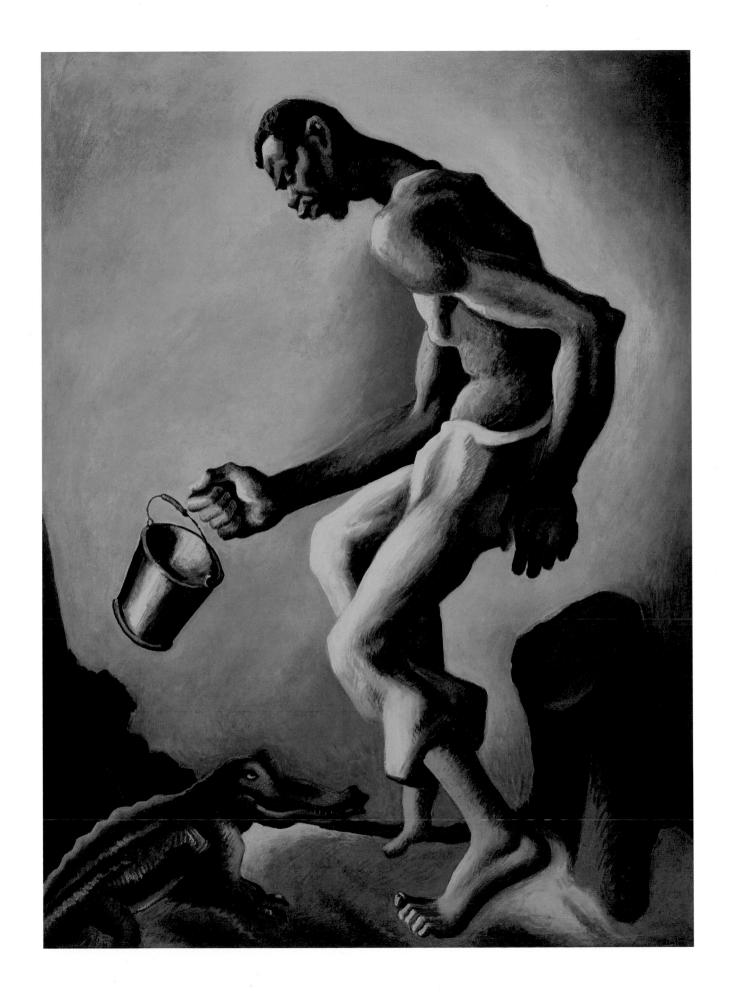

Plate 43
Bootleggers, 1927
Egg tempera and oil on linen, mounted on Masonite panel
68 ¾ × 74 ¾ in. (174.6 × 189.9 cm)
Reynolda House Museum of American Art, Winston-Salem,
North Carolina, Museum purchase with funds provided by
Barbara B. Millhouse, 1971.2.1

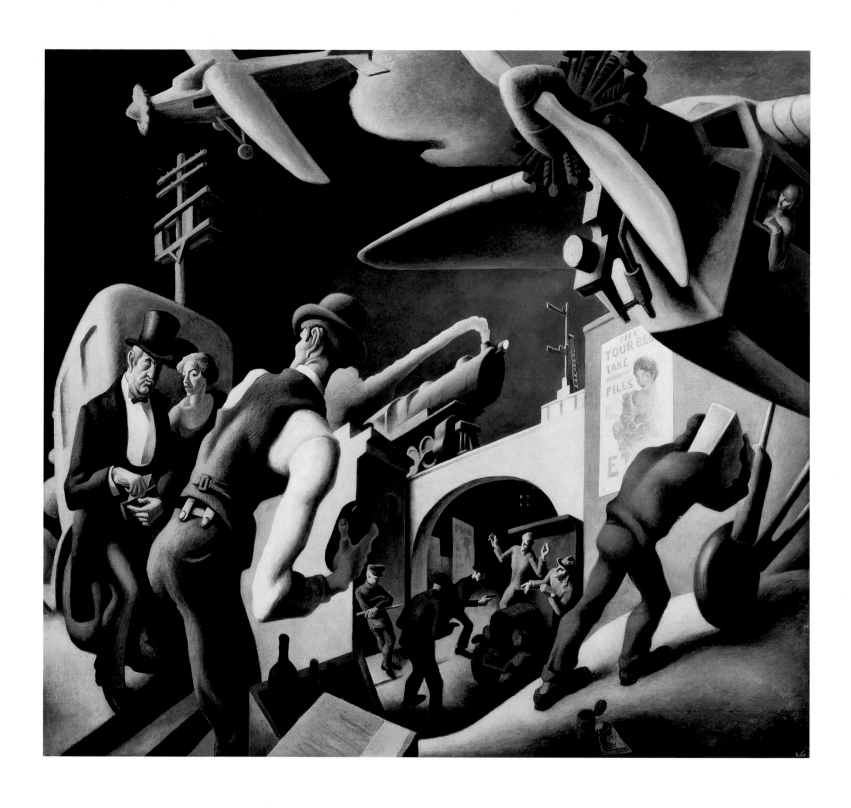

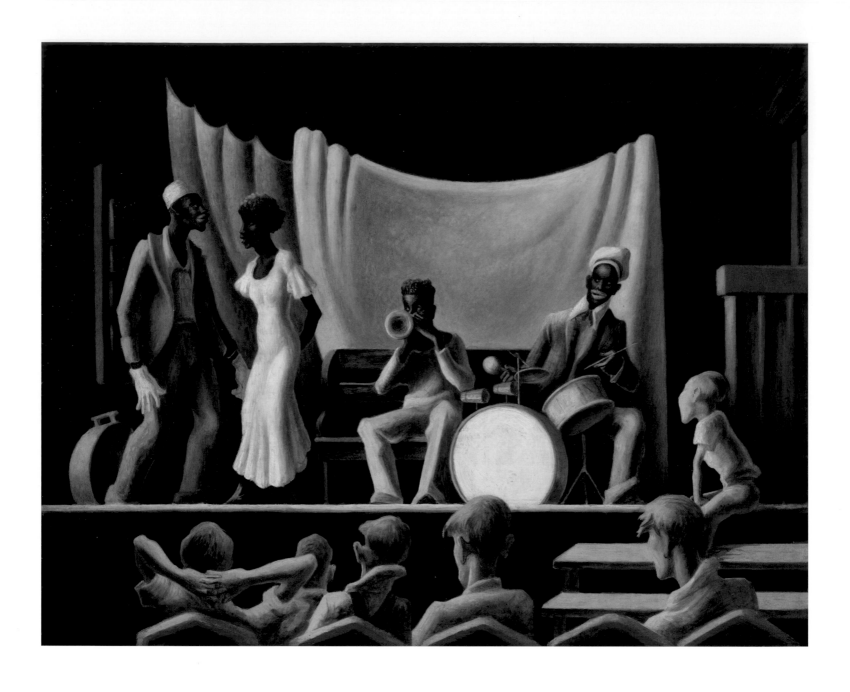

Plate 44
Minstrel Show, 1934
Tempera with oil on Masonite panel
28 ³⁄₈ × 35 ⁷⁄₈ in. (72.1 × 91.1 cm)
The Nelson-Atkins Museum of Art, Kansas City,
Missouri, Bequest of the artist, F75-21/13

Plate 45
Romance, 1931–32
Tempera and oil varnish glazes on gessoed panel
45 ¼ × 33 ¼ in. (115 × 84.5 cm)
Blanton Museum of Art, The University of Texas at Austin,
Gift of Mari and James A. Michener, 1991, 1991.187

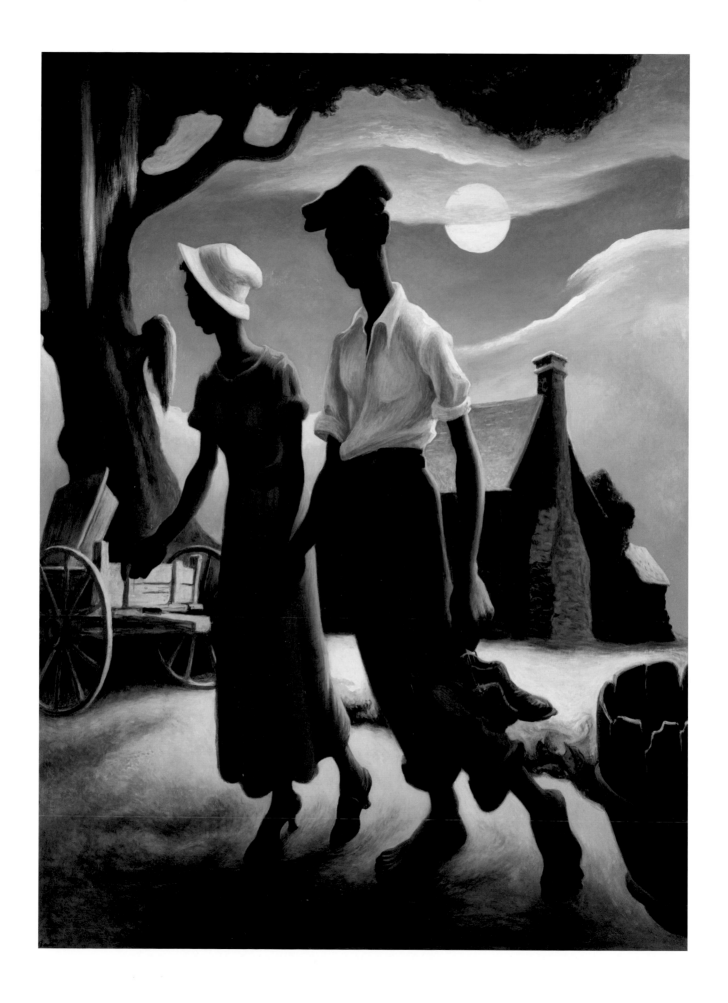

Plate 46
Preparing the Bill, 1934
Oil on canvas
46 $\frac{1}{16}$ × 38 $\frac{7}{16}$ in. (117 × 97.9 cm)
Collection of the Maier Museum of Art at Randolph
College, founded as Randolph-Macon Woman's College,
Lynchburg, Virginia, Tenth purchase made possible by
the Louise Jordan Smith Fund, 1958.2

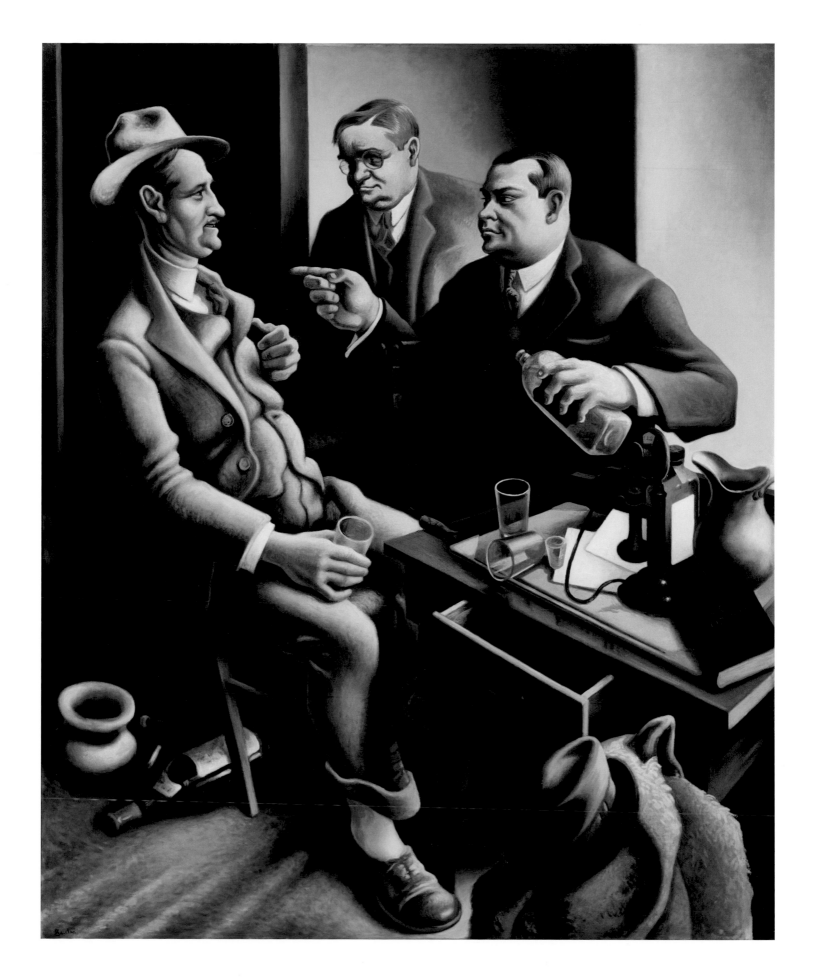

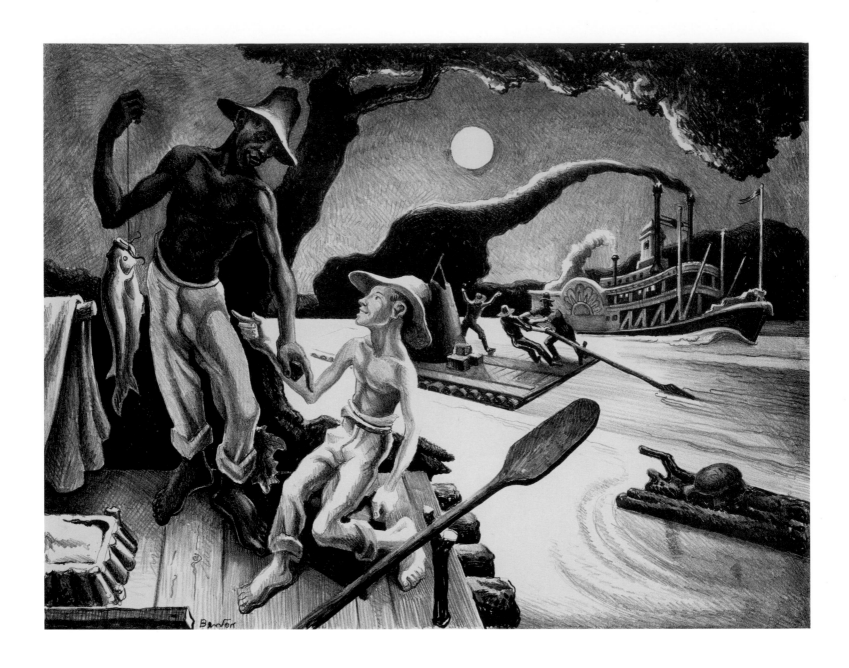

Plate 47
Huck Finn, 1936
Circulated by Associated American Artists
Lithograph, edition of 100
Image: 16 ¼ × 21 ⅝ in. (41.3 × 54.9 cm)
The Nelson-Atkins Museum of Art, Kansas City,
Missouri, Gift of Mrs. Peter T. Bohan, 61-79/1

Plate 48
Jesse James, 1936
Circulated by Associated American Artists
Lithograph, edition of 100
Image: 16 ⅛ × 21 ⅞ in. (40.9 × 55.6 cm)
The Nelson-Atkins Museum of Art, Kansas City,
Missouri, Gift of Mrs. Peter T. Bohan, 61-79/3

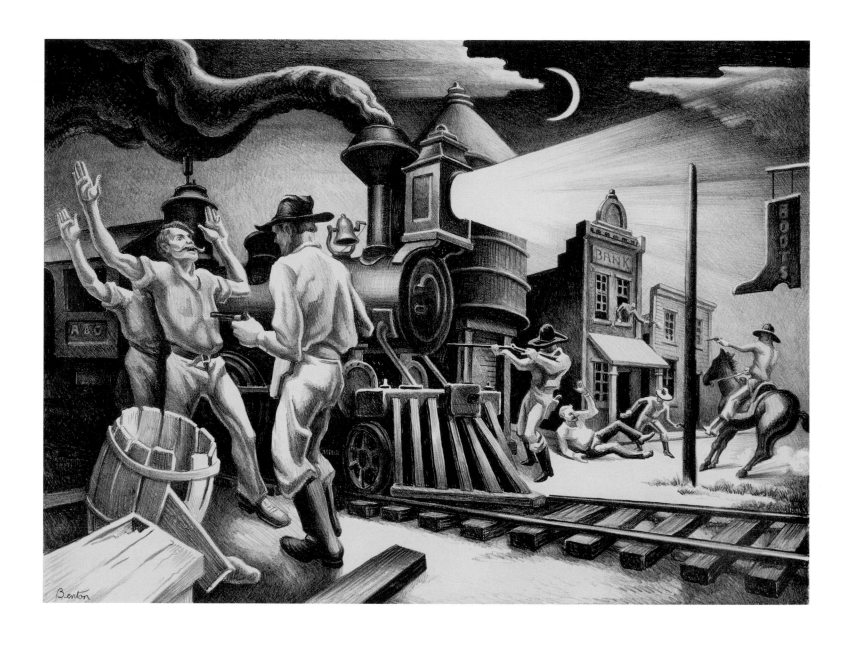

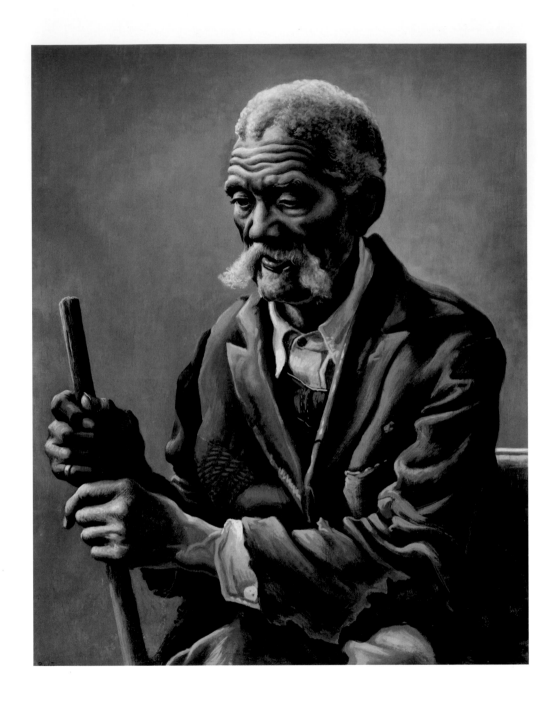

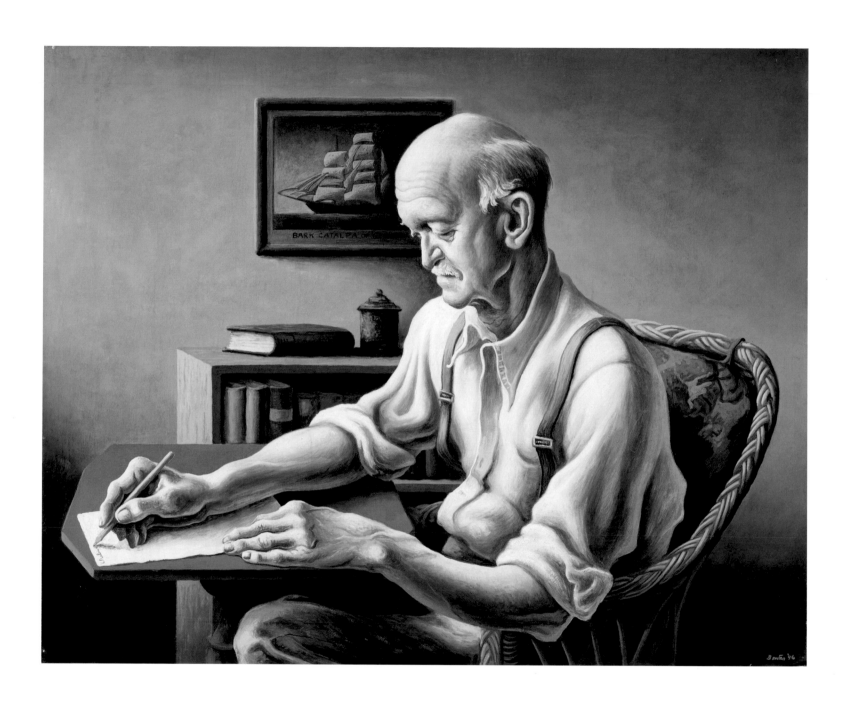

Plate 49
Aaron, 1941
Oil and egg tempera on canvas, mounted on plywood
30 5/16 × 24 5/16 in. (77 × 61.8 cm)
Pennsylvania Academy of the Fine Arts, Philadelphia,
Joseph E. Temple Fund, 1943.3

Plate 50
New England Editor, 1946
Oil and tempera on gessoed panel
30 × 37 in. (76.2 × 94 cm)
Museum of Fine Arts, Boston, The Hayden Collection –
Charles Henry Hayden Fund, 46.1456

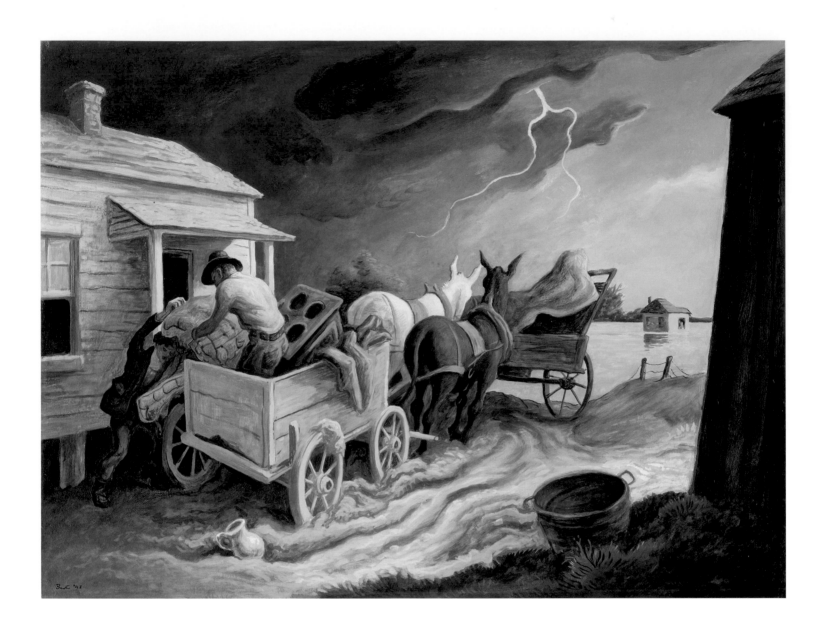

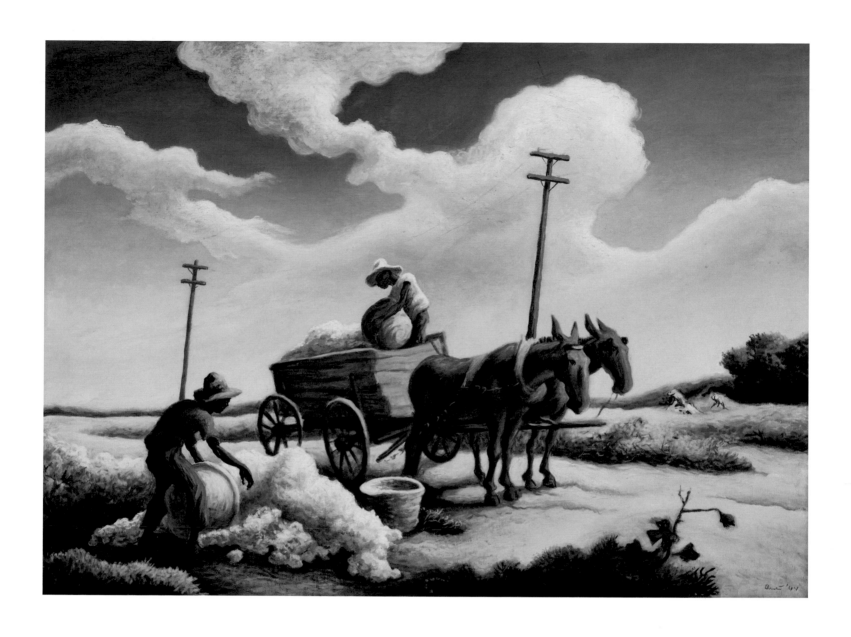

Plate 51
Spring on the Missouri, 1945
Oil and tempera on Masonite panel
30 ¼ × 40 ¼ in. (76.8 × 102.2 cm)
North Carolina Museum of Art, Raleigh,
North Carolina, Purchased with funds from
the State of North Carolina, 77.1.3

Plate 52
Plantation Road, 1944–45
Oil and tempera on canvas, mounted on plywood
28 ½ × 39 ⅜ in. (72.4 × 100 cm)
Carnegie Museum of Art, Pittsburgh,
Patrons Art Fund, 46.22

Plate 53
Portrait of a Musician, 1949
Casein, egg tempera, and oil varnish on canvas,
mounted on wood panel
48 ½ × 32 in. (123.2 × 81.3 cm)
Museum of Art and Archaeology, University of Missouri –
Columbia, Anonymous gift, 67.136

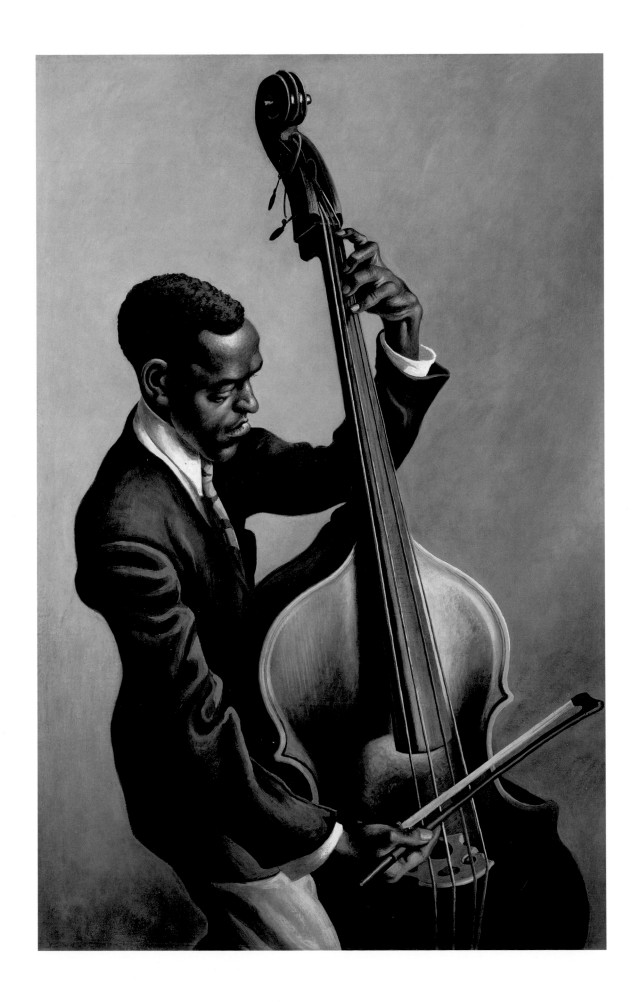

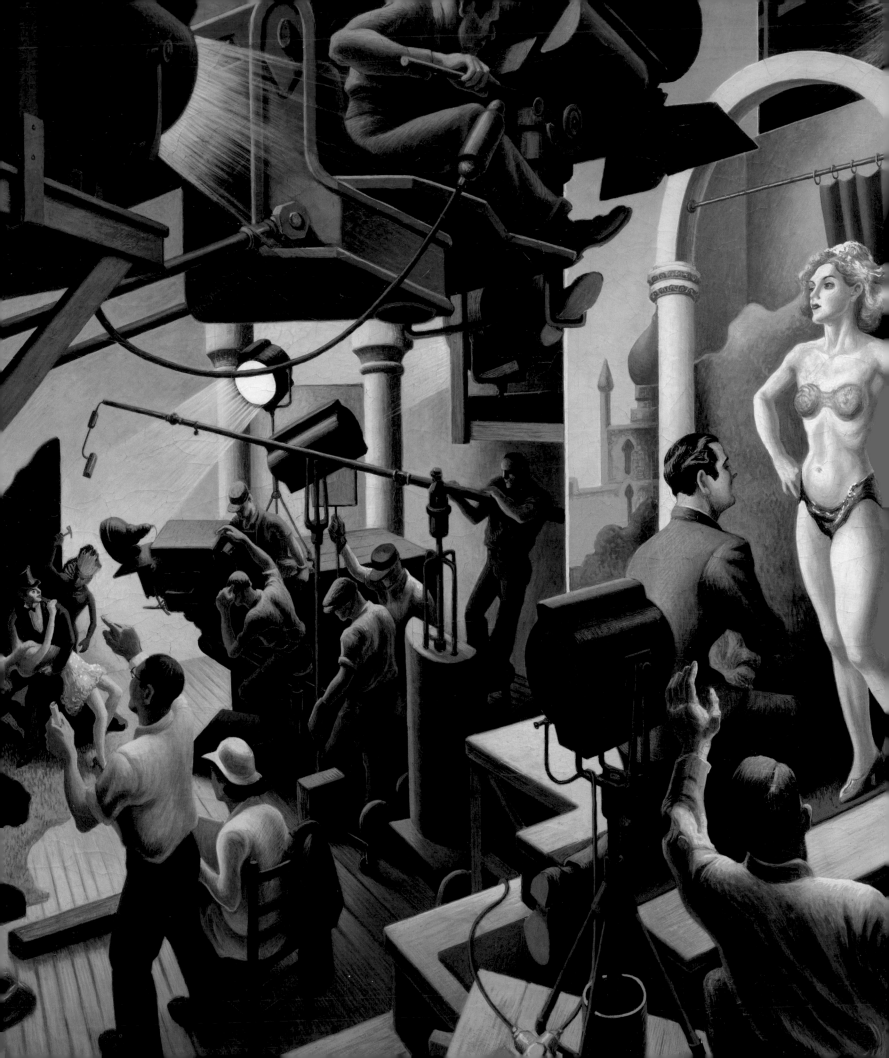

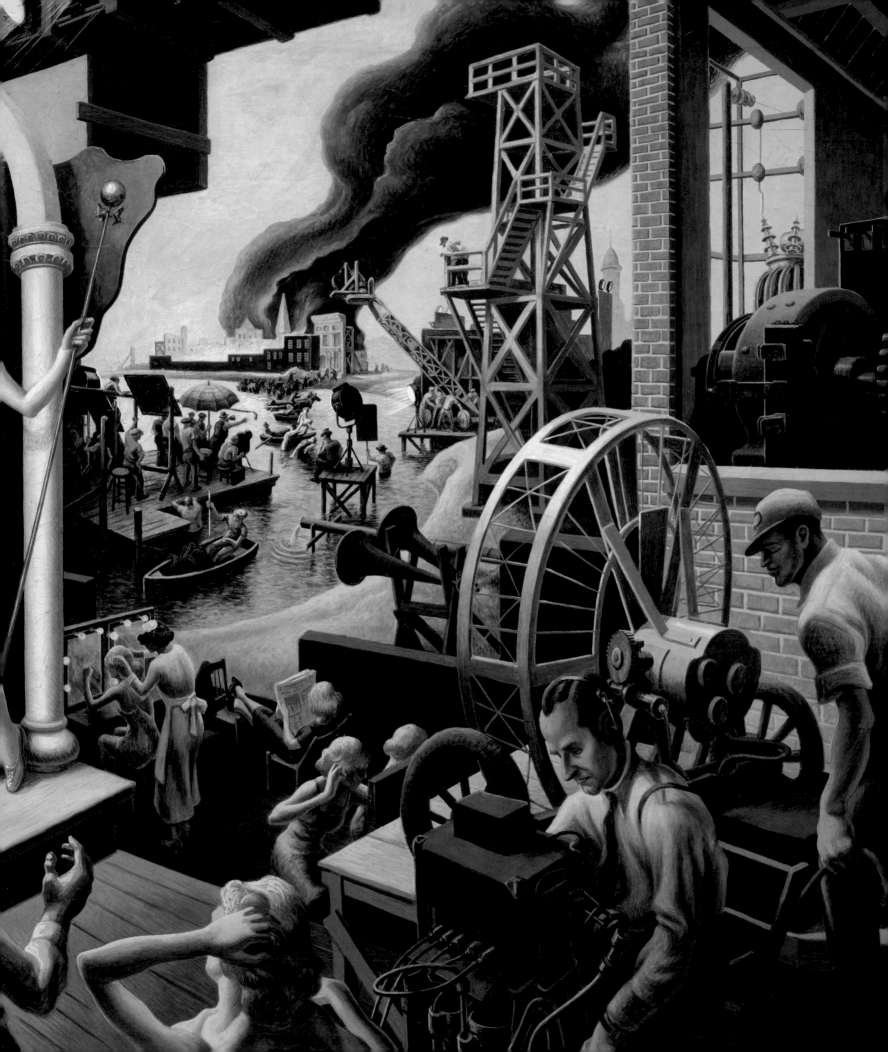

MINING THE DREAM FACTORY

THOMAS HART BENTON, AMERICAN ARTISTS, AND THE RISE OF THE MOVIE INDUSTRY

Erika Doss

In August 1937, Thomas Hart Benton traveled to Hollywood, commissioned by *Life* magazine to paint a "movie mural" illustrating how feature films were made. The artist spent much of his time at 20th Century Fox's studios in Century City, a commercial and residential area of Los Angeles, where the pictures *Ali Baba Goes to Town*, a screwball comedy starring Eddie Cantor and Gypsy Rose Lee; *Life Begins in College*, a farce featuring the Ritz Brothers comedy team; and *In Old Chicago*, a big-budget musical showcasing movie stars Tyrone Power and Alice Faye, were being filmed on various lots. Based on what he described as the "several hundred drawings" that he made during his month-long visit, Benton's dynamic painting *Hollywood* (1937–38; pl. 72) is filled with the stars, supporting actors, directors, skilled technicians, and machines of major studio production of the movie industry's Golden Age of the 1930s.[1]

At the center of the large horizontal canvas, which echoes the proportions of a movie screen and embodies the energized collage aesthetics and frenetic pacing of motion pictures themselves, is a scantily dressed chorus girl auditioning for a scene in *In Old Chicago*. As Benton explained in a letter to Daniel Longwell, the *Life* editor who arranged his Hollywood assignment:

> The young lady who occupies the center of the panel is more a symbolical than an actual movie figure. I wanted to give the idea that the machinery of the industry, cameras, carpenters, big generators, high voltage wires etc. is directed mainly toward what young ladies have under their clothes. So I took the clothes off but added a few little bits for the post office. I hope you like the picture. I do.[2]

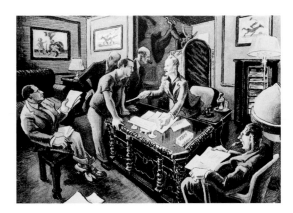

Fig. 1. Thomas Hart Benton, *Director's Conference*, 1937. Ink and ink wash on paper. Location unknown

Fig. 2. Thomas Hart Benton, *Carthay Circle*, 1937. Watercolor, gouache, and graphite on paper. Private collection

Benton also told reporters that he hoped his painting might be displayed in "some large motion picture theater," where moviegoers could scrutinize the "combination of machine and sex that Hollywood is."[3]

Benton put a lot into this project, including sketching a series of sardonic Hollywood "notes" depicting industry activities, such as story conferences and movie premieres (figs. 1, 2) and writing a caustic essay titled "Hollywood Journey," both intended for an exposé on "what goes on" in the movie industry.[4] But the commission with *Life* fell through. Benton's candid take on "the machinery of the industry" did not segue with how the movie industry expected to be seen. Nor was it compatible with how popular magazines like *Life*, which depended on motion-picture advertising income, typically depicted the movies. And it certainly did not fit the glamorous and romantic image of Hollywood that the industry fostered and American audiences expected to see: "the national fairytale," observed Ruth Suckow in a 1936 article, of "overnight rise to fame and material wealth, to social opulence, with Sex and Beauty in headline type."[5]

Almost from its infancy in the early twentieth century, the American film industry has been called a "dream factory": a fabricator of fantastic moving images, an entertainment enterprise promising stardom and riches to those lucky enough to work in "the movies."[6] The "factory" part of that identity, however, was mostly discounted, especially by the movie industry. Downplaying the structural realities of its assembly-line operations, studio-system management policies, and general corporate profit profile, the movies avoided a mass-production reputation in favor of rags-to-riches fables of individual success: an American Dream of the independent upward mobility of movie stars. Success stories, like that of Theodosia Goodman, the daughter of a Cincinnati tailor who morphed into the exotic silent movie icon Theda Bara, or Tom Mix, the son of a Pennsylvania stable master who became the highest paid cowboy actor of the 1920s, helped fuel that dream.

Adopting certain symbolic and economic strategies, the movie industry cultivated and controlled its dream factory image through much of the twentieth century. In the 1910s, for example, when many American movies were produced in studios on the East Coast, the industry institutionalized a star system of celebrity players who were avidly marketed in posters, stills, lobby cards, newspaper ads, and fan magazines, such as the industry organ *Photoplay*, launched in 1911. During the 1920s, the industry, now centered in Southern California, capitalized on its sweeping cultural dominance with self-referential symbols and rituals, including a huge sign with fifty-foot-high by thirty-foot-wide letters that spelled out its name in the Hollywood Hills; red-carpet premieres with swanky celebs and mobs of fans at exotic theaters like Grauman's Chinese; a Walk of Fame featuring movie star footprints; and, beginning in 1929, the Academy of Motion Picture Arts and Sciences annual awards ceremony, where bronze "Oscars" were handed out for movie industry "bests." By the 1930s, the industry's overblown opinion of its own self-importance had become the subject of a number of movies about the movies— about, especially, how stars like Theda Bara and Tom Mix were born.[7]

American artists—from authors such as F. Scott Fitzgerald, Budd Schulberg, and Nathanael West to painters like Benton, Edward Hopper, and Reginald Marsh—responded to this powerful new mode of mass communication in different ways.[8] In the industry's early years, some worked for the studios designing sets, painting backdrops, and making movie posters. Many artists were influenced by the anarchic aesthetic of the movies, whose

Fig. 3. Edward Hopper, *New York Movie*, 1939.
Oil on canvas. The Museum of Modern Art,
New York, Given anonymously, 396.1941

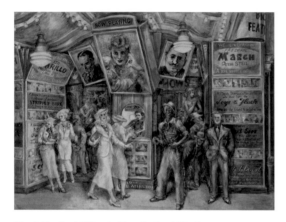

Fig. 4. Reginald Marsh, *Twenty Cent Movie*,
1936. Carbon pencil, ink, and oil on
composition board. Whitney Museum of
American Art, New York, purchase, 37.43a–b

dynamic and illusory visual representations assaulted "natural" or stable understandings of time, space, and storytelling. Others were drawn to the physical settings of moviegoing: Hopper, a movie enthusiast, illustrated plush theater interiors in paintings such as *New York Movie* (1939; fig. 3). Marsh rendered movie theater facades and audiences in *Paramount Picture* (1934) and *Twenty Cent Movie* (1936; fig. 4). Still other artists explicitly critiqued the dream factory: the evidence of its structural operations, celluloid offerings, and incredible fan base, as well as the celebrity lifestyles of its stars, provided rich fodder for these works. Benton, whose experience with the movies was extensive, worked all these angles.

Settling in New York in the early teens, after spending several years in Paris studying modern art, Benton found jobs in the burgeoning movie studios of Brooklyn and Bedford Park, New York, and Fort Lee, New Jersey. Like the high-tech start-ups of the 1990s in California's Silicon Valley, the early movie industry was innovative, collaborative, and informal, backed by risk-taking entrepreneurs who sought to capitalize on cinema's phenomenal growth and expanding market. As film historian Ben Singer notes, nearly 5,200 feature films and some 31,300 one-, two-, and three-reelers (each about ten to twelve minutes long) were produced in the United States alone between 1912 and 1920. Movie theaters multiplied in number and size: in 1900, New York City featured 97 nickelodeons (named for their five-cent admission fee), seating from two hundred to five hundred people; by 1910, there were four hundred such theaters in Manhattan—and more than twenty thousand, according to *Scientific American*, in the nation's "northern cities." During the 1910s, upscale "movie palaces" were built to accommodate one thousand to five thousand patrons for nonstop showings that began around noon and continued until late at night.[9] With their inventive stories, stereotypical characters, dynamic visual effects, and seemingly infinite variety—from westerns and comedies to melodramas, mysteries, biblical spectacles, Civil War sagas, and more—the movies were the most accessible, popular, and influential mass medium of the early twentieth century.

Benton was introduced to the infant industry in 1914 by Rex Ingram (born Reginald Hitchcock in Dublin), who had studied sculpture at Yale University under Lee Lawrie, best known for *Atlas* (1937), the large bronze figure in front of Rockefeller Center. Ingram's movie career included directing Rudolph Valentino in the silent film classic *The Four Horsemen of the Apocalypse* (1921), considered Hollywood's first blockbuster. (With an eleven-reel running time of 156 minutes, it was also one of the longest features made in the silent era.) As Ingram noted:

> When I was a student at the Yale School of Fine Arts . . . I frequently dropped into the motion picture theaters at New Haven. Most of the pictures I saw were crude, but they fascinated me, not so much for what they were as what they could be. As scene after scene was flashed, I would reconstruct it in my imagination. . . . "If they would only do it this way," I would say to myself, picturing groupings that would give artistic semblance of what could be attained.[10]

He and Benton shared studio space at the Lincoln Square Arcade Building at Sixty-Fifth Street and Broadway in New York; a rambling "refuge," Benton later wrote, that harbored "prize fighters, dancers, models, commercial artists, painters, sculptors, bedbugs, and cockroaches."[11] Ingram sculpted, Benton

painted, and both scrambled for odd jobs in the movie industry to make a living. First joining the Edison Company in the Bronx, where he wrote scenarios, dressed scenes, and did some bit acting, Ingram subsequently worked for Vitagraph (located in Brooklyn), then at Fox, Universal, and World studios (in Fort Lee).[12] He began directing his first pictures in 1916 and continued to sculpt and sketch while making twenty-seven movies and building a reputation as an extraordinarily creative and fiercely independent cinema "artiste" who detested the corporate mind-set of the big studios. In the mid-1920s, Ingram left Hollywood in disgust and settled in the French Riviera, where he started his own production company. He retired from the movies in the 1930s and spent the rest of his life sculpting. As a writer for *Theatre Magazine* observed in 1928, "Rex Ingram is one of the few motion picture directors with a distinct cultural background, an artist's conscience, temperament, and an ambition that transcends the narrow limitations imposed by Hollywood's 'Big Business.'" A decade later, Benton would grapple with similar themes in his painting *Hollywood* and in his critical essay "Hollywood Journey," denouncing the movies as "an economically conditioned Art."[13]

As he advanced in the early motion-picture industry, Ingram created opportunities for Benton and other artists. Benton designed sets and painted backdrops for Fox and Pathé studios, making seven dollars a day. He even did a bit of stunt work, later recalling: "One time Rex got it into his head that I might be made into an actor and gave me a part in a barroom scene with Paddy Sullivan and Jimmy Kelly and a lot of other pugs in those days who put on the fights for the movies." The name of Benton's silver-screen debut remains unknown, and the movie itself has no doubt disappeared — fewer than 14 percent of early silent features survive today in their original format — but the film in question might have been *Broken Fetters* (1916), a "white slavery" melodrama that Ingram directed for Universal. The five-reel picture starred Violet Mersereau as a street urchin who is rescued from a Chinatown opium den by a handsome painter "disowned by his wealthy father" for refusing to "give up his profession as an artist." Welterweight boxer Sullivan played the role of "Mike." Ingram's script faintly echoed Benton's life story: his father, M. E. Benton, a prominent Missouri congressman, had never been pleased with his eldest son's pursuit of modern art and, on learning that Benton had played a drunken lout in a silent movie, wrote him a "scathing letter" questioning his "artistic ambitions."[14]

Benton persevered, relying on additional movie industry assignments to finance his painting career. "I had five years' experience with it, off and on," he told an interviewer in 1973, adding,

> It was all very informal in those days and the pictures were just
> sort of made up as they went along. I recall how the workmen,
> the designer, the head scene-painter, and myself would have dinner
> at Lüchow's to plan what we were going to do next day. Then I
> would go to the New York Public Library and look up what I could on
> the background of whatever the story called for. Then I would make
> sketches and go back to the film studio, where I would paint —
> everything was in black and white, of course — the backdrops, which
> were quite illusionary.[15]

Benton also recalled sketching pictures of "the movie-queens of the day, Theda Bara, Clara Kimball Young, Violet Mercereau [*sic*]" for industry

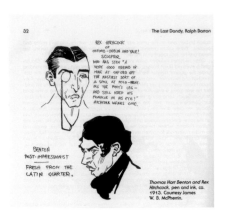

Fig. 5. Ralph Barton, caricatures of Rex Ingram and Thomas Hart Benton, c. 1913. Reproduced in Bruce Kellner, *The Last Dandy: Ralph Barton, American Artist, 1891–1931*, published by University of Missouri Press, Columbia, 1991. Courtesy of James W. B. McPherrin

Fig. 6. Edward Hopper, *Potiphar's Wife*, drawing for "Vamps of All Times," feature in *Photoplay*, December 1921. The Museum of Modern Art Library, New York

publicity.[16] In 1914, Pathé advertised full-color portraits of the stars in their hit serial *The Perils of Pauline*: "magnificent reproductions on canvas from the originals by the celebrated artists [Walter Dean] Goldbeck, [Arthur Watkins] Crisp, and [Z. P.] Nikolaki," which exhibitors and fans could buy for two dollars and fifty cents each.[17] Benton's movie star pictures likely served the same purpose.

Other American artists also found work in the early movies. Ralph Barton, a cartoonist who shared quarters with Ingram and Benton at the Lincoln Square Arcade and cleverly lampooned them in a circa 1913 drawing (fig. 5), drew hundreds of illustrations for *Photoplay*, where he was the art editor from 1920 to 1925.[18] In 1921, Barton arranged a six-part commission in *Photoplay* for Hopper, who drew a series of comic line drawings spoofing "the vamp" throughout history (fig. 6). Earlier, in 1914, Hopper had designed movie posters for Éclair, a French film company that operated a US studio in Fort Lee.[19] Ashcan school artist Everett Shinn and muralist Hugo Ballin were hired by Goldwyn Pictures as the art directors for *Polly of the Circus* and *Sunshine Alley*, both filmed in 1917.[20] And American painter George Overbury "Pop" Hart was employed by the World Film Company to design sets for major releases like *Trilby*, a 1915 picture starring Clara Kimball Young. Hart lived in Fort Lee, where World was based and where Benton moved in the spring of 1917 "to be in easier reach of the movie studios, where Rex Ingram continued to provide bits of work."[21]

By this time, however, the movies had become an increasingly formal industry of skilled laborers and professional associations, and those "bits of work" dried up for freelance artists. Benton later discounted his contributions to early films, writing "While I was working in the movies I never once regarded the material offered there as fit for serious painting."[22] Yet Ingram's example, along with particular moviemaking practices Benton picked up, certainly influenced the shape and scope of Benton's modern art. In 1917, for example, he began to fashion clay models to "study anatomical detail and the play of light and shade" before commencing to paint. Ingram did much the same, working out his production plans with models and copious sketches before shooting scenes.[23] Likewise, Benton appropriated the scale and palette of the movie backdrops he painted: "Observing the scene painters, I became interested in 'distemper,' or glue painting, and began experimenting with that medium. . . . Later it would lead to the egg-tempera techniques which I used for my murals of the thirties."[24] Indeed, with its larger-than-life-size panels, strong light-dark contrasts, and turbulent compositions, Benton's first mural project, *American Historical Epic* (1920–28), mimics the frenzied, flickering look of the early silent pictures. Originally planned as a fifty-panel series of interconnected scenes depicting the evolution of the United States, the (never-completed) mural would have been the paint-on-canvas equivalent of a feature-length silent movie.

Benton began to hone his version of an accessible modern American art — later called regionalism — during his years in the early film industry, and both the form and content of the movies proved influential. The serialized melodramas and silent movies he worked on featured "typed" characters (bad guys, virtuous women, crazed villains) and tried-and-true plot devices (cliff-hangers, sensational stories, and pantomimed theatrics), all of which drew diverse audiences, including many non-English-speaking immigrants, to the theaters week after week. Likewise, audiences enthusiastically embraced the cut-and-paste editing and brisk pacing of the movies, and demanded

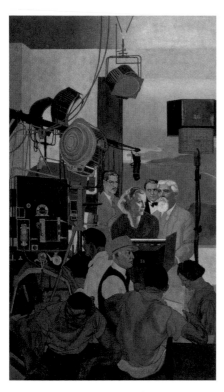

Fig. 7. Stanton Macdonald-Wright, *A Motion Picture Studio*, from the mural series for the Santa Monica Public Library, 1935. Oil on plywood. Santa Monica Public Library, Santa Monica, California

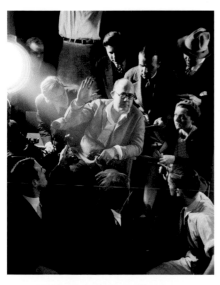

Fig. 8. Will Connell, *Director*, 1937. Gelatin silver print. Courtesy of California Museum of Photography, University of California, Riverside

more thrills, more sensations. Directly participating in the creation of this dynamic new form of visual mass communication, Benton simultaneously developed his own acutely cinematic style of painting.

His work in the early film industry further acquainted him with the business of making movies. By the end of the 1920s, Hollywood was the fifth-largest industry in the United States, grossing $1.5 billion annually and accounting for 90 percent of worldwide film production.[25] The "Big Eight" studios, which included Paramount, 20th Century Fox, and Universal, monopolized film production, distribution, and exhibition, releasing an average of 358 feature-length movies per year in the 1930s, and many more serials and shorts. In 1938, more than 574 feature films were released, and box office receipts totaled $663 million.[26] Motivated by mass production and profit, Hollywood's "dream factory" was no different than any other kind of modern factory, which Benton convincingly conveyed in *Hollywood*.

Other artists similarly considered the industry on critical terms. In 1935, Stanton Macdonald-Wright, who studied modern art with Benton in Paris and founded in 1912 the short-lived abstract art movement synchromism (which Benton also practiced), painted an immense thirty-eight-panel mural for the Santa Monica Public Library, which included a scene called *A Motion Picture Studio* (fig. 7). Gloria Stuart, a Depression-era star, who later played the role of the elderly Rose in the 1997 movie *Titanic*, is shown flanked by director Frank Tuttle and actor Leo Carrillo, and surrounded by studio lights, cameras, and movie equipment. Macdonald-Wright was also a film pioneer, producing the first full-length stop-motion film in full color in 1919 and later inventing a kinetic light process that illuminated film sets with intensely saturated and constantly changing colors.[27] The metal box in front of Stuart in *A Motion Picture Studio* is labeled "Synchrome," the name of Macdonald-Wright's patented "light machine."

Featuring some two hundred images of living, historical, and mythical figures, Macdonald-Wright explained that his mural represented "two streams of human development: one technical, the other imaginative," which "coalesce and fuse" in the "medium of the moving picture." He included a tongue-in-cheek portrait of Benton in the mural's opening scene, depicting his longtime friend as a "primitive man" trying to "harness the blind forces of Nature." While he shared Benton's cynicism about the movie industry's artlessness — complaining in one 1922 article about "the stupidity of the photo-drama" — Macdonald-Wright remained faithful to the medium itself, asserting that film held "the greatest potentialities for art expression." As he argued, "Those who have been in a moving picture stage and laboratory during the filming of a picture know what a great role the inventions along the lines of precision machinery, chemistry, and electricity play in the process."[28]

Other artists were more interested in spoofing the industry's "inventions." In 1937, photographer Will Connell teamed up with well-known screenwriters Nunnally Johnson and Patterson McNutt to create the book *In Pictures: A Hollywood Satire* (fig. 8). Highlighting Connell's snarky black-and-white portraits of tyrannical movie directors, porcine producers, and vapid stars, *In Pictures* is layered with insider humor and visual puns. As Tom Maloney, the editor and publisher of *U.S. Camera* observed, "Connell shows how wide the abilities of the camera are when a thorough technician, a penetrating mind, and the all-important satirical impulse are blended in one talent capable of dissecting a national institution with its own instruments of torture . . . ground glass, shutter and lens."[29] Like Benton, Connell focused especially on

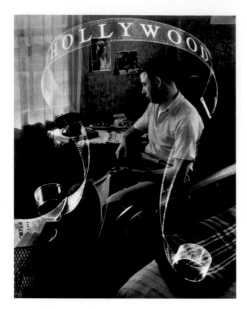

Fig. 9. Will Connell, *Promised Land*, 1937.
Gelatin silver print. Courtesy of California
Museum of Photography, University of
California, Riverside

Fig. 10. Thomas Hart Benton, *The Poet*, 1938.
Lithograph. Smithsonian American Art
Museum, Gift of Frank McClure, 1970.88

Hollywood's "combination of machine and sex," juxtaposing photos of cameras, light, and *juice* (industry lingo for electricity) with those of casting couches and lecherous studio bosses.

In Pictures also featured the short story "Hollywood Conference," which was loosely based on the 1935 Broadway comedy *Boy Meets Girl* (which itself parodied scriptwriting) and had been previously published in the *Saturday Evening Post* in October 1936.[30] The format of Connell's photo book, including its industry-specific images and narrative of "the actual goings-on at a Hollywood story conference," were no doubt the model for Benton's own proposal for a book on the movies a year later. Connell's photograph *Promised Land* (1937), and Benton's sketch *The Poet* (1938), both depict aspirational industry figures—an actor and a screenwriter, respectively—confronting the structural constraints of the dream factory (figs. 9, 10).

Benton challenged norms and conventional behaviors throughout his career, recalling in his 1937 autobiography the "uneasiness" he had felt since he was a teenager about the expectations of conformity, "of a family devoted to such practices as law, politics, and business." Just a few years before he died, Benton remarked: "There has always been a slight resentment in me for any institutionalized forms of art, whether they are radical or conservative." As he developed as an American modernist, Benton's preferred subjects were creative and spontaneous, the "popular outpourings," he wrote, of the "arts of life." These, he explained, were "generally undisciplined. They run into pure, unreflective play . . . [and] have a sort of pulse, a go and come, a rhythm."[31] *Hollywood*'s extreme busyness, with its hectic scenes of animated workers and machines, clearly illustrates the industry's feverish pulse. But Benton's overall view of the movies, like Connell's, was a cynical disillusionment that the formerly slapdash studios had become so thoroughly professionalized, and institutionalized, as an "American business."[32]

The barbed prose of Benton's essay "Hollywood Journey" conveys his frustrations with the industry's corporate mind-set and correspondingly mediocre movies. Each studio, said Benton, was manned by a "boss idea man" surrounded by "yes-guys." His drawing *Director's Conference* (see fig. 1) depicts 20th Century Fox head Darryl Zanuck, whom Benton described as "the little fellow behind the big desk . . . an American business Napoleon," and other studio executives. Such a meeting was not, Benton wrote, "a conference of artists . . . engaged in the simple business of finding a vehicle for the expression of their life experiences." Rather, the movie industry was "like the stock market," focused only on "a cash return" from its banal products. Recalling Zanuck's productions for Fox, for example, Benton remarked: "I remember some of the pictures for which this Napoleon was responsible as being about the most stupid and absurd concoctions I had ever come across."[33]

Robert Witt Ames similarly assessed the movie industry's profit motives in his 1935 mural *Hollywood* (fig. 11). A self-taught artist, raised in the Philippines (where his father was stationed in the military), Ames appropriated the traditional Filipino medium of carved mahogany wood relief for his large-scale appraisal of the movies. His busy, witty montage includes vignettes of writers conjuring scripts on "Love, Sex, Murder, Who Done It"; executives snoring around a huge table labeled "Conference"; a sign painter retouching the studio motto "Tremendous Stupendous Colossal"; agents demanding their 10 percent cut from hapless actors; extras lining up to receive their daily pay; movie stars getting massages and manicures; tour guides

Fig. 11. Robert Witt Ames, *Hollywood* (detail), 1935. Mahogany bas-relief. Los Angeles County Museum of Art, Gift from the Estate of Barbara Carol Weston, sister of Robert Witt Ames, M.2002.85

hawking maps to "movie homes"; and chaotic sets where scenes of pirate ships, alligator-infested swamps, and musical dance numbers are in production. In a detail of a starlet posed on a sofa, surrounded by publicity flacks and the carved words "never drinks," "never smokes," and "hates publicity," Ames pokes fun at the industry's hypocritical standards, especially topical after the Hays Code was established in 1930, banning excessive depictions of sex and drinking in the movies.[34]

Like other artists, Benton's critique of the dream factory extended to free-for-all scenes of crowded movie premieres, where frenzied fans gathered to catch a glimpse of a star or get a prized autograph. His drawing *Carthay Circle* (1937; see fig. 2) depicts police trying to control such a mob at the ornate Carthay Circle Theatre, a Spanish colonial style movie palace (built in 1926) where 20th Century Fox often opened its films. In this sketch and in *Hollywood*, Benton seemingly anticipates the violence that erupts in the final pages of *The Day of the Locust* (1939), Nathanael West's damning account of mass culture, and the movies in particular. Interestingly, West's protagonist is a former Yale art student named Tod Hackett, who is lured to Hollywood to design sets for one of the big studios and fantasizes about painting a prophetic mural titled *The Burning of Los Angeles*.[35]

During Hollywood's Golden Age, however, these critiques of the dream factory fell flat: West's novel sold fewer than fifteen hundred copies when it was first published, and Benton's commission to paint a "movie mural" for *Life* magazine was canceled. When *Hollywood* was finally published in the magazine, late in 1938, it appeared in a story about prizewinning canvases at the annual Carnegie International art exhibition in Pittsburgh, not as a perceptive interrogation of "what goes on" in the movie industry.

THE HOLLYWOOD "NOTES"

Janet C. Blyberg

In 1937, Thomas Hart Benton received a commission from *Life* magazine to produce "a painting and [a] forty-drawing commentary on Hollywood and the movie industry."[1] Benton arrived in California in August armed with credentials that gave him full access to 20th Century Fox Studios, and he spent a month on the lot observing the mechanics, industry, and culture of Hollywood. Fresh off another *Life* project chronicling labor union disputes in Michigan,[2] Benton must have found the glitz and glamour of Tinseltown worlds apart.

For the piece on Hollywood, Benton clearly considered himself a visual journalist, calling his drawings "notes," a term that he used throughout his career to refer to the sketches he made on his cross-country journeys.[3] The Hollywood notes show an artist intensely interested in the process of making movies, from the film equipment and the people behind the scenes—set builders, dress designers, film editors, scriptwriters—to the business of filmmaking. His sketches of the tobacco smoke–filled offices at 20th Century Fox provide rare glimpses of the "Napoleons" and "yes-guys" (as Benton refers to the movie executives and their underlings) and demonstrate the absurdity of Hollywood culture.

There is a wry humor in his drawings of Hollywood denizens—the pictures are at once literal and bitingly satirical. His drawing *Member of the Chorus* (pl. 66) is especially poignant when juxtaposed with an image of society photographer Jerome Zerbe surprising a Hollywood star at her dressing table (pl. 68). "Zerbie," who worked for *Life* and *Look*, among other popular magazines, was well-known for his photographs of celebrities.[4] Benton probably worked frequently with Zerbe in Hollywood, and the photographer also appears—hard at work—in the background of *Thursday Night at the Cock and Bull* (pl. 69). The star in the foreground is Bette Davis, with cocktail and cigarette in hand; the presence of her anonymous dinner partner is tantalizingly indicated outside the frame of the drawing. Another Hollywood figure captured by Benton is the author William Faulkner, pictured with his signature pipe in *Conference* (pl. 63).[5]

Even when the scenes in the drawings appear banal, Benton assigned them tongue-in-cheek captions—such as *Aspirants' Party: Cocktails and Astrology*—infusing them with wit. Benton sometimes offered up several potential titles, as in the case of the drawing of the actress at her dressing table (pl. 68), which he inscribed "Hollywood Note / Candid Camera / or / More Private Life / or / Life's Cameraman Zerbie Goes after Hollywood Interviews." The handwritten title variations underscore Benton's journalistic approach, demonstrating his ability to picture a scene from different perspectives and imagine several possible story lines for his editors at *Life*.

During his time in Hollywood, Benton produced more than four hundred graphite sketches,[6] which resulted in forty finished ink-and-wash drawings; an oil on canvas, *Hollywood* (pl. 72); and a lithograph titled *The Poet* (see p. 114), after his drawing (pl. 62) of the same subject, a lone Hollywood screenwriter laboring over his script.[7] Only a handful of the sketches are extant, while roughly one-third of the more polished ink-and-wash drawings survive, most of which are in private collections.[8] Some of the drawings are known only through reproductions.[9]

Life ultimately decided not to run the Hollywood feature illustrated with Benton's visual commentaries of the movie industry. Instead—no doubt as consolation, *Life* reproduced the oil painting, *Hollywood*, as a color spread in a story about the 1938 Carnegie International art exhibition, where the picture happened to be exhibited.[10] Hoping to salvage something from what he clearly considered an important body of work, Benton began writing his own "Hollywood Journey" (see pp. 22–27, this volume), the intended text for a book of his Hollywood material, but this project also came to naught. In February 1940, however, *Coronet* magazine published a portfolio of six of his 1937 drawings to accompany critic and art dealer Harry Salpeter's short review of "that mission to Hollywood" (figs. 1–3). Salpeter dismisses Benton's efforts as the "notations of a tourist who could draw."[11] What Salpeter identified as "by-products" of Benton's Hollywood commission subsequently remained in Benton's possession, and the drawings were not published again until after his death.[12]

A TOUR OF HOLLYWOOD

Drawings by Thomas Benton

Some while back, Thomas Benton, the highly rated American artist, was despatched to the West Coast to paint a composite picture of life in Hollywood. Eventually he filled up a large piece of canvas with a montage effect and some of the more intelligent spectators who saw the opus on public exhibition wondered, Was it art? The half-dozen drawings reproduced in this portfolio are among the by-products of that mission to Hollywood. They range from sketches on the spot to labored elaborations of sketches made on the spot. The artist's base of operations was the couch in the luxuriously appointed office of Raymond Griffith, one of the producers for 20th Century-Fox. When the pre-conference buzzing started, Benton awoke and listened in, taking notes all the while. From this couch he made forays into the vast departmentalized domain that is a major moving picture studio, and also a little beyond. Although the drawings are interesting notations, they were primarily intended, and should primarily be regarded, as the notations of a tourist who could draw.—HARRY SALPETER

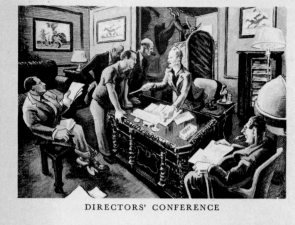

DIRECTORS' CONFERENCE

ASSOCIATED AMERICAN ARTISTS, NEW YORK

CASTING OFFICE

PROP DEPARTMENT

CARTHAY CIRCLE

DUBBING IN MUSIC

ASPIRANTS' PARTY: COCKTAILS AND ASTROLOGY

GOOD EYES FOR LIFE

IF YOUR EYES COULD PICKET YOU, THE SIGN MIGHT READ: "POOR WORKING CONDITIONS"

This eye-doctor's old wheeze is still the best slogan for the lay public: "Wait and see and you'll wait and not see." Still, wanting to do right by your seeing-machinery and knowing how to go about it are two different things. People used to tell you you'd go blind if you kept on reading in a dark corner. But you can no longer pass that dubious chestnut along to Junior and let it go at that. People also once believed that growing a mustache cured weak eyes, that gymnastics made children cross-eyed, that the eye-tooth is especially responsible for eye-disease. If it were that simple it would be easier to be a good oculist.

Junior's eye-troubles may have begun before he was born. "Some day soon we'll be able to tell parents what eye defects—if any—their future children will have," says one expert, meditating on the fact that more and more of the things that can go wrong with the eye are now suspected of being hereditary. Meanwhile danger signals can be spotted in a fairly der infant and appropriate measures taken. New babies never focus their eyes properly but, if they haven't begun to in about six months, they should be bundled off to the oculist.

Even the child whose eyes team up normally should see the oculist good and early. Man is the only animal with eyes tuned for close scrutiny. He has been using them that way for a mere few thousand years. So the great majority of human eyes are as yet better fitted to spot a deer on the distant horizon than to peer at columns of figures and fine type or into delicate instruments — more likely means for eating regularly nowadays. That is why all babies are born farsighted, arriving only gradually at the perversion of modern "normal vision." And why the child needs a doctor's check-up on how this adjustment is working before he is asked to

MACHINERY OF THE INDUSTRY

Leo G. Mazow

Just below eye level in the lower-right corner of Thomas Hart Benton's *Hollywood* (1937–38; pl. 72), a tie-clad man in headphones listens to recorded sounds emanating from the piece of electronic equipment in front of him. His stasis stands out in a picture otherwise marked by swirls of motion. Leaning slightly forward, placing his left hand on his knee, and casting his gaze slightly to his left, the sound engineer is absorbed in his task. The seriousness of his work, however, is perhaps most evident in the labyrinth of rubber-coated wires extending from the playback device. The cables repeat the painting's formal characteristics and facilitate the work of the poles that, in turn, support the lights, boom microphones, cameras, and other wires strewn throughout the composition. These cables connect the technician physically and sonically to the action-packed vignettes around him, what Benton called (albeit in a somewhat different context) "the machinery of the industry."[1] Facing the engineer, this biomorphic equipment complements the work and echoes the physical stances of the human players in this composite of Hollywood activity.

Other parts of the painting have their bold color combinations, dramatic foreshortening, and strong lighting, but this somewhat shaded, relatively small passage reminds us of a critical strain in Benton's paintings and drawings, and one that dominates his Hollywood pictures: the integration of linear details into a dynamic but orderly whole. These dual, interdependent objectives are found in various measures throughout the artist's oeuvre, but they are especially evident in the Hollywood drawings of cameras, microphones, lights, and film- and sound-editing equipment. Another case in point is *Projection Room* (1937; fig. 1), in which Benton drew the wires, pipes, and cast metal of the projector in the foreground with the meticulous finesse of a still life. Yet the pipes and wall opening at left join the otherwise detached zones of the picture. Like a film director seeking to elicit a broad gaze, Benton uses electronic imagery to cast us simultaneously in fore- and background, with a view to the film project*or* and the project*ed* movie.

Throughout his career, Benton was interested in not only formal but also literal interconnectedness—the latter as suggested in his use of radio and mass-distributed

prints to reach individuals in rural areas and increase his audience overall. For Benton, regionalism was a matter of not just depicting the so-called regions but also bringing cultural fare to nonmetropolitan locales, and it comes as little surprise to find Benton deeply invested in *Hollywood* and related film-based projects.[2] Works like *Young Executive*, *Conference Table*, and *Candid Camera* (all 1937; pls. 64, 65, 68, respectively) concern advertising and publicity to various degrees, elaborating on the artist's ongoing, multifaceted interest in the promise of visual and auditory communication to span vast spaces. Benton reminds us in these and other drawings that much of the business of Hollywood is in the publicizing and distribution of its products, its films and its stars. But part of the visceral appeal of the Hollywood drawings—even the sketchier, more summarily drawn works, such as *Untitled (Movie Camera)*, *Untitled (Movie Set)*, and *Member of the Chorus* (all 1937; pls. 54, 55, 66, respectively)—resides in the almost obsessive attention to details.

One finds these dynamics in selected passages of Benton's four mural cycles of the 1930s—*America Today* (1930–31), *Arts of Life in America* (1932), *The Social History of Indiana* (1933), and *A Social History of the State of Missouri* (1936). But, in part because these were large

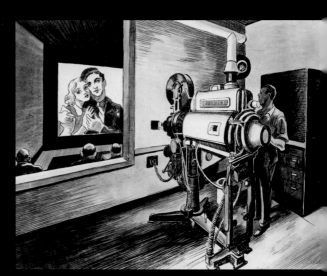

Fig. 1. Thomas Hart Benton, *Projection Room*, 1937. Ink, ink wash, and graphite on paper. Location unknown.

Fig. 2. Benton studying a branch along the Santa Fe
Trail, c. 1960. Harry S. Truman Presidential Library and
Museum, Independence, Missouri, 71-138

matters of historical recollection, they did not foreground
modern electrical apparatuses.[3] In contrast, it is apparent
that the film and sound equipment found in Hollywood
offered the artist an opportunity to draw with diagram-
matic specificity. Perhaps because of the murals' rushed
schedules, Benton may not have had time to produce
many finished preparatory drawings, such as *Dance
Director* (1937; pl. 59), in which one can make out the min-
ute concentric circles on the foreshortened microphone.
The other works from this period that show Benton con-
sistently delineating particulars are largely limited to his
vertically formatted river subjects—including the paintings
Susanna and the Elders (1938) and *Persephone* (1938–39;
pl. 73).[4] Benton's friend and traveling companion John
Callison reminisces about the deep pride Benton took
in his comprehensive knowledge of flowers, trees, and
grasses—many of which he drew and painted in all
their minutiae and variety (fig. 2). "He could name all the
flowers," Callison remembers; similarly, the artist dis-
played his close observation of details in *Hollywood* and
the related drawings.[5]

 The most impressive aspect of *Hollywood* and the
river subjects, however, is the integration of myriad details
within the overall composition. The reconciliation of parts
within the larger whole was deeply rooted in Benton's ar-
tistic practice, and it is outlined in Benton's five-part article

in *The Arts* titled "Mechanics of Form Organization in
Painting" (1926–27). The essay calls for the balancing,
ordering, and merging of pictorial parts.[6] Even prior to this,
Benton had addressed grappling with "form distribution"
in correspondence with the photographer Alfred Stieglitz,
for whom Benton desperately wanted to provide a paint-
erly and theoretical rationale.[7] Related manifestations of
the "equilibrium" advanced in *The Arts* articles are found in
Hollywood drawings such as *Cutting Room* (1937; pl. 58)
and *Carthay Circle* (1937; see p. 107). In the latter, the
rays of spotlights forming a triangle in the top half of the
drawing balance—almost forcefully so—the foreground
pyramid of human figures. Benton occasionally compared
composing art to "mak[ing] sentences" and finding
suitable "linguistic forms," and the loose markings in a
drawing like *Untitled (Movie Set)* suggest an analogous
exercise, in which the foreground equipment and workers
bring to life the as-yet-unseen action at right.[8] This
dynamic is present as well in the Hollywood drawing
Director and Camera (1937), in which a box camera and
a powerful spotlight focus on regions outside the picture
plane. The grammar analogy has its limits, but, like the
author of a sentence in a paragraph in process, Benton
understood with uncommon foresight the role of these
drawings as elements within the larger enterprise of the
painting *Hollywood*.

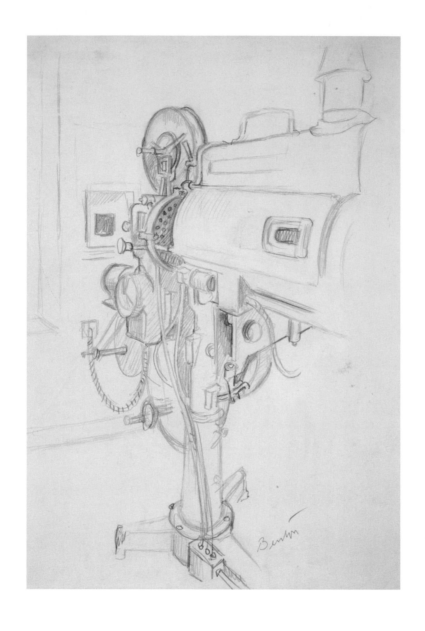

Plate 54
Untitled (Movie Camera), 1937
Graphite on paper
10 ¾ × 7 ⅜ in. (27.3 × 18.7 cm)
Private collection

Plate 55
Untitled (Movie Set), 1937
Graphite on paper
13 ¾ × 10 ¾ in. (34.9 × 27.3 cm)
Private collection

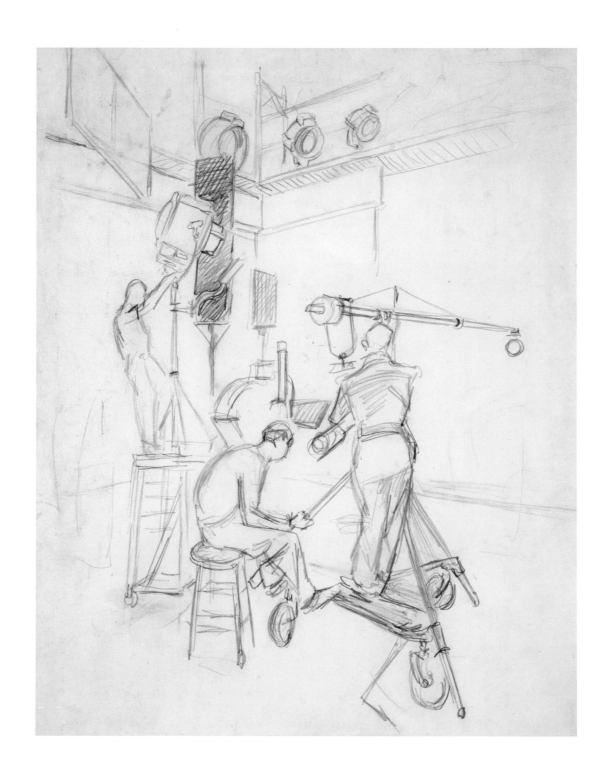

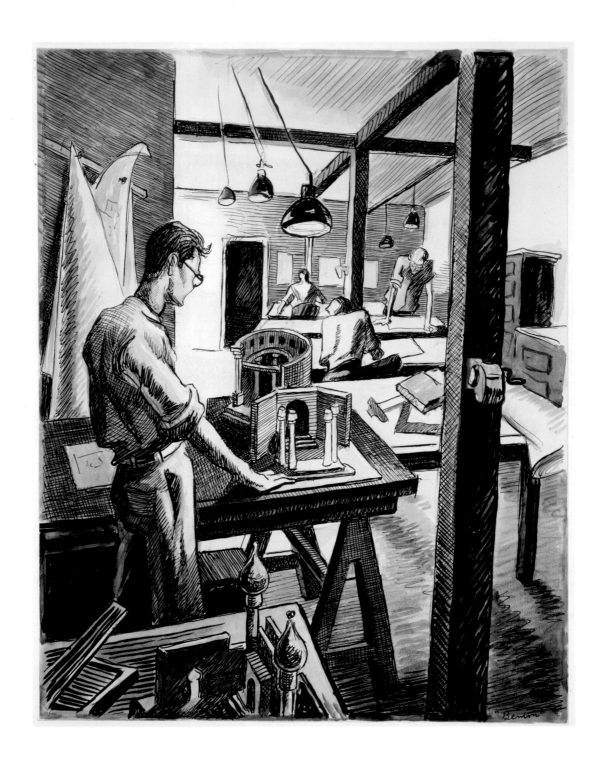

Plate 56
Set Designing, 1937
Ink, ink wash, and graphite on paper
13½ × 11 in. (34.3 × 27.9 cm)
Private collection

Plate 57
Set Building, 1937
Ink, ink wash, and graphite on paper
13¾ × 10⅞ in. (34.9 × 27.6 cm)
Private collection

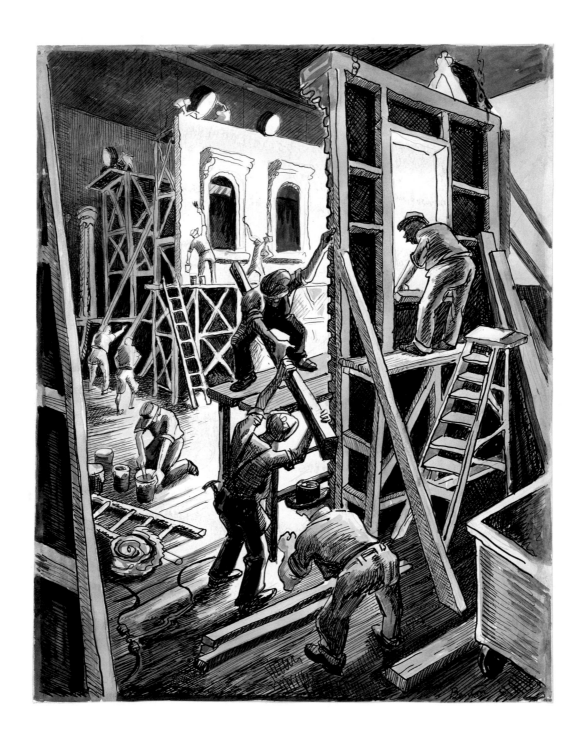

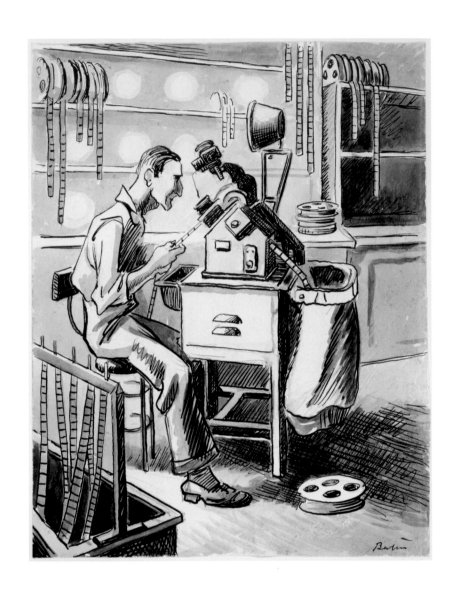

Plate 58
Cutting Room, 1937
Ink, ink wash, and graphite on paper
7 ¾ × 6 in. (19.7 × 15.2 cm)
Private collection

Plate 59
Dance Director, 1937
Ink and ink wash on paper
10 ¾ × 13 ½ in. (27.3 × 34.3 cm)
Kiechel Fine Art, Lincoln, Nebraska

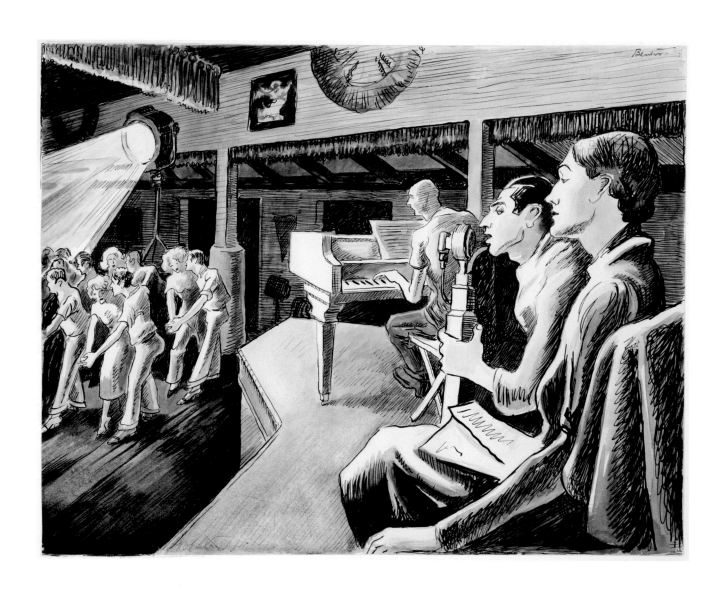

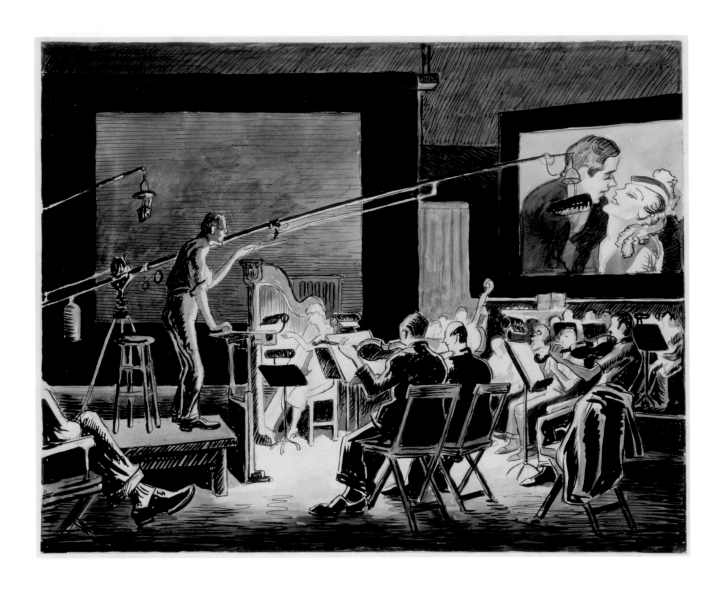

Plate 60
Dubbing in Music, 1937
Ink, ink wash, and graphite on paper
10⅞ × 13¾ in. (27.6 × 34.9 cm)
Private collection, Courtesy Guggenheim
Asher Associates, New York

Plate 61
Dress Designer, 1937
Ink, ink wash, gouache, and graphite on paper
13¾ × 10⅞ in. (34.9 × 27.6 cm)
Collection of Milton and Sheila Hyman

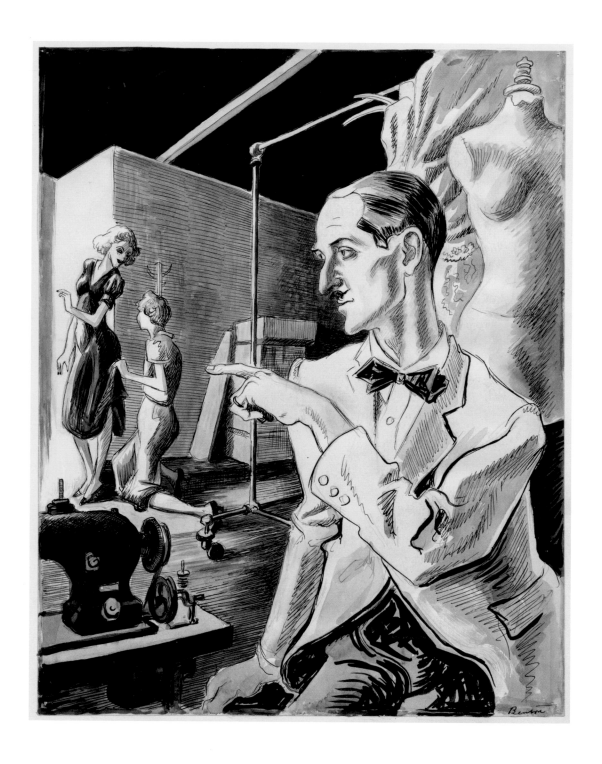

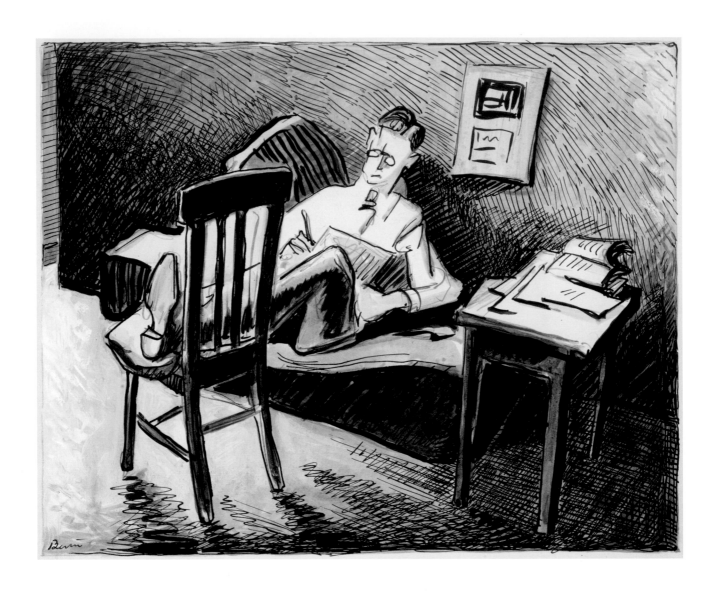

Plate 62
Hollywood Writer, 1937
Ink, ink wash, gouache, and graphite on paper
8 ½ × 10 ½ in. (21.6 × 26.7 cm)
Private collection

Plate 63
Conference, 1937
Ink, ink wash, and graphite on paper
10 ¾ × 13 ¾ in. (27.3 × 34.9 cm)
Private collection

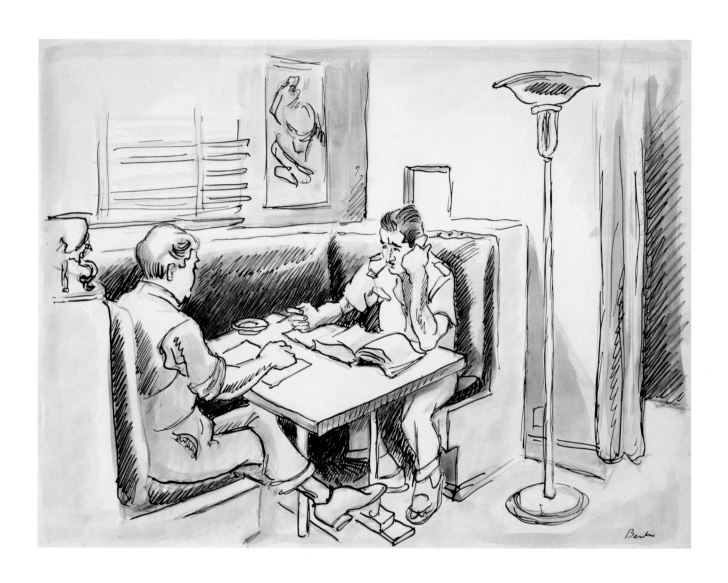

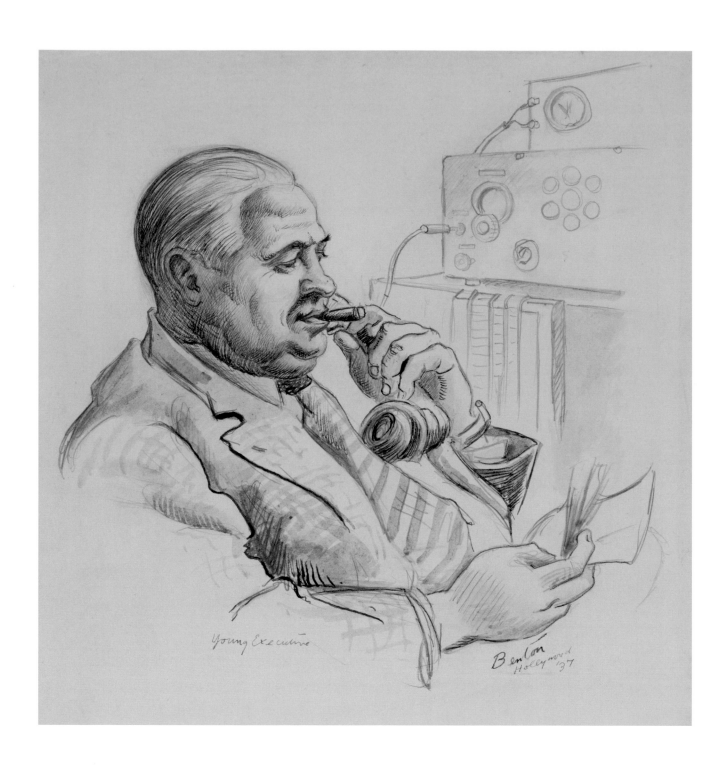

Plate 64
Young Executive, 1937
Graphite, ink, and ink wash on paper
10¾ × 10⅞ in. (27.3 × 27.6 cm)
Rob and Claire LaZebnik

Plate 65
Conference Table, or *Directors' Meeting,*
20th Century-Fox Studio, 1937
Ink and ink wash on paper
10¾ × 13¾ in. (27.3 × 34.9 cm)
Private collection

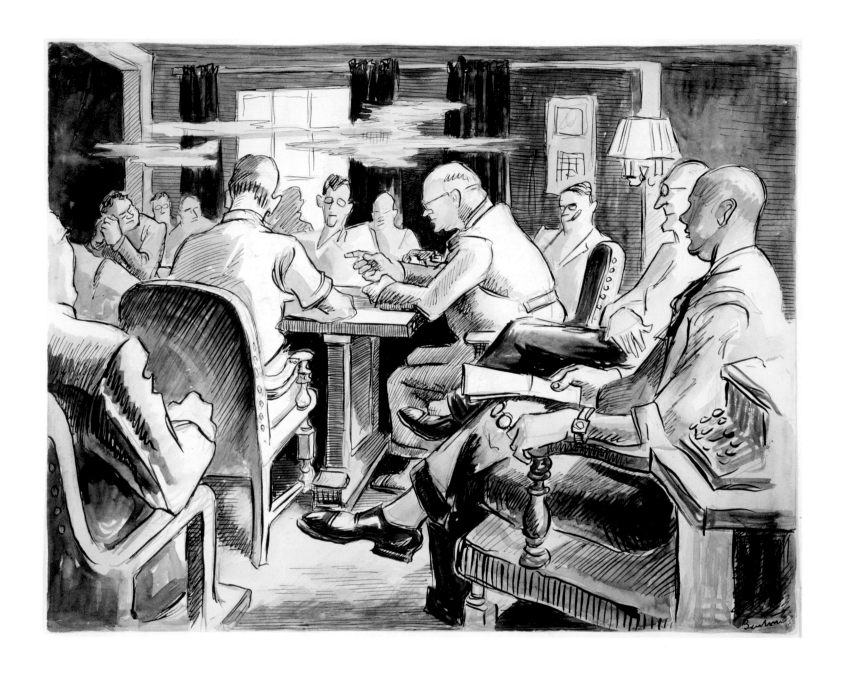

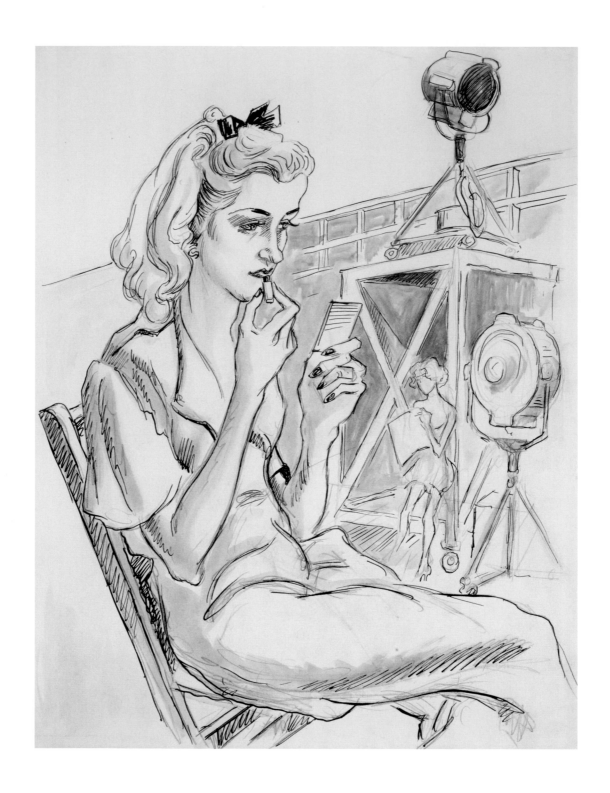

Plate 66
Member of the Chorus, 1937
Ink, ink wash, and graphite on paper
14 × 10¾ in. (35.6 × 27.3 cm)
Private collection

Plate 67
Untitled (Two Women Admiring Will Rogers), 1937
Ink, ink wash, and graphite on paper
10¼ × 14¾ in. (26 × 37.5 cm)
Private collection

Plate 68
Candid Camera, or *More Private Life*,
or *"Life's" Cameraman Zerbie Goes after*
Hollywood Interviews, 1937
Ink, ink wash, and graphite on paper
13 × 10 ⅝ in. (33 × 27 cm)
Private collection

Plate 69
Thursday Night at the Cock-and-Bull.
It's the Maid's Night Out, 1937
Ink, watercolor, gouache, and graphite
on paper
12 ⅝ × 16 ¾ in. (32.1 × 42.5 cm)
Private collection

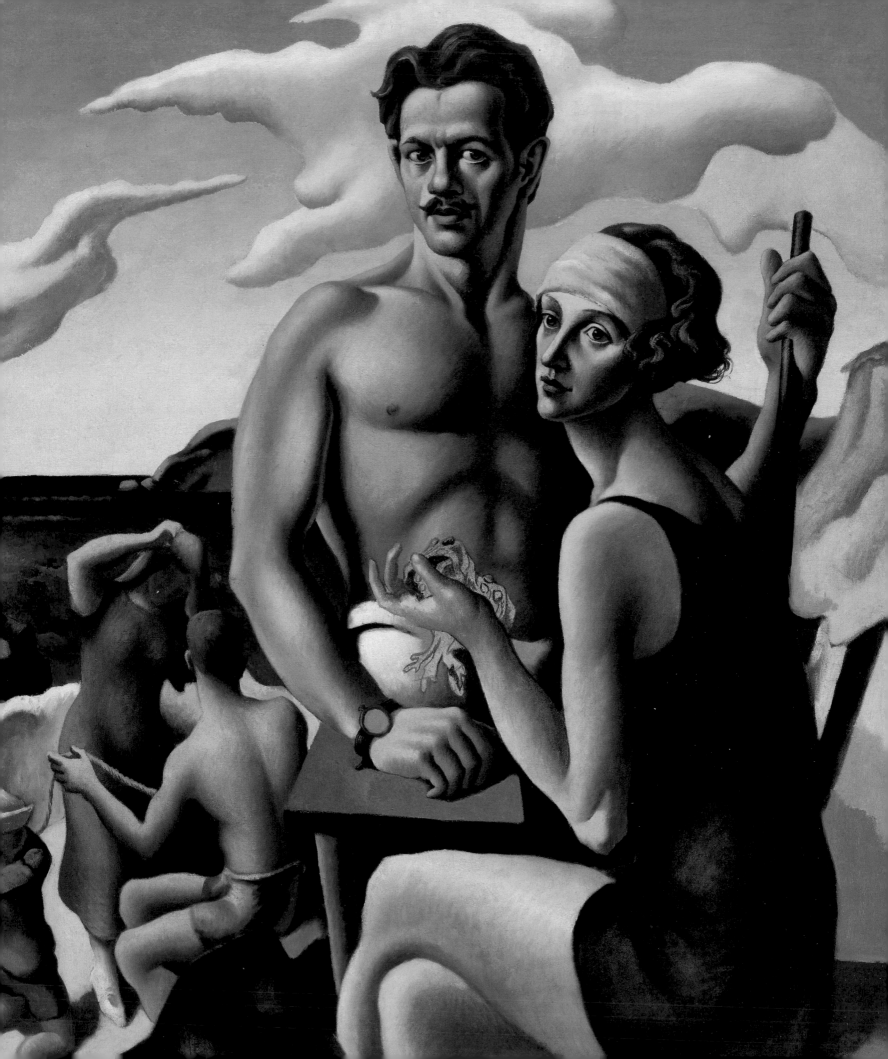

THOMAS HART BENTON AND THE ART OF PAINTING CINEMATICALLY

Jake Milgram Wien

Thomas Hart Benton's intimate knowledge of motion-picture production links the style and narrative content of his paintings and murals directly to the cinema. His artistic techniques capture qualities intrinsic to the experience of watching movies, particularly the illusion of three-dimensional space and the glow of light projected evenly across a movie screen. Moreover, his celebrated full-room mural installations, such as *America Today* (1930–31) and *A Social History of the State of Missouri* (1936; fig. 1), bring to mind the large-scale immersive environment of the movie theater – a space that director Martin Scorsese has described as "a kind of sanctuary where the living world . . . [is] re-created and played out."[1] With a skilled directorial eye, Benton conceived elaborately constructed compositions cast with characters situated in dynamic settings, wearing carefully researched costumes and accoutrements, and animated with expressive movement and gestures to further a story.[2] He saw himself in a rivalry with the movies, and his ambition to compete with the cinema was driven by the realization that it had become the most powerful medium informing modern American imaginations.

THE CHALLENGE AND ALLURE OF MOVIES

By 1915, moviemaking was transporting 10 million viewers daily to another time and place, making it America's fourth-largest industry.[3] Opportunities in the silent film studios attracted many academically trained artists. The influx to Fort Lee, New Jersey, a center of motion-picture production in the 1910s, included Irish émigré Rex Ingram (fig. 2), who had studied painting and sculpture at Yale University School of Art. Ingram became an acclaimed silent film

Self-Portrait with Rita (detail of pl. 71), c. 1924

Fig. 1. View of Thomas Hart
Benton's *A Social History of
the State of Missouri*, 1943.
Missouri State Capitol,
Jefferson City

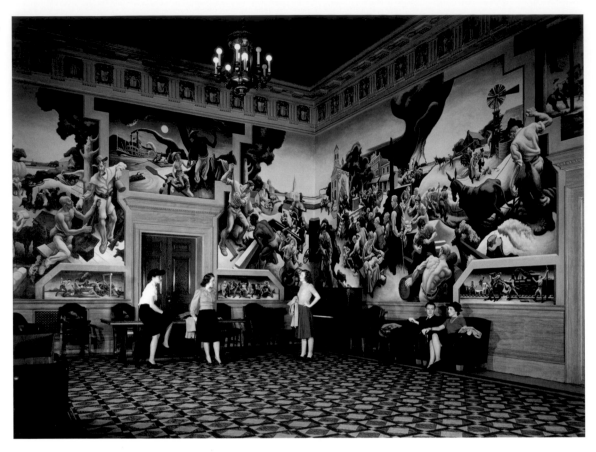

director, renowned for the historical epic that introduced Rudolph Valentino to America, *The Four Horsemen of the Apocalypse* (1921).[4] Ingram met Benton through mutual friends in New York in the summer of 1913 and provided him with contacts and commissions, enabling Benton to eke out a living in silent film production work from 1914 to 1918. Under Ingram's tutelage, Benton gained exposure to acting, stagecraft, cinematic techniques, and the art and power of contemporary storytelling.[5] He served as general handyman for Pathé and Fox studios, researched and made illusionary backdrops, and designed sets, occasionally strategizing with the set designer, head scene-painter, and other workmen.[6]

Benton witnessed the growing respect accorded the new art form as a visual medium, a development that the poet Vachel Lindsay examined in his groundbreaking study, *The Art of the Moving Picture* (1915). Lindsay proclaimed moviemaking to be the supreme art form and contended that "the destiny of America . . . may be bound up in what the prophet-wizards among her photoplaywrights and producers mark out for her." He encouraged painters and sculptors to "take the higher photoplays in hand"—a call to arms that Ingram heeded.[7] Notably, Lindsay suggested that the old master techniques of the sixteenth-century Venetian painter Jacopo Tintoretto might sharpen a movie director's visual acumen. Tintoretto created tiny wax models of the figures he painted, suspended them in a box of wood or paperboard, and cast candlelight on them. He sat for hours "moving the light about amidst his assemblage of figures" to inform his compositions.[8]

Fig. 2. Director Rex Ingram (holding palette and brush) with Rudolph Valentino, 1921. Liam O'Leary Collection, National Library of Ireland

In early 1922, Ingram published his own insights about moviemaking, likening the new art form's conceptual strategies of planning and visualization to the methods of painting or sculpture:

> The same laws apply to the production of a film play which has artistic merit, and to the making of a fine piece of sculpture or a masterly painting. . . . As the sculptor has to compose his grouping, to fit a certain space, on a pediment or a monument, so the director must place his people within given lines, according to the distance they are from the camera, in order that the massing of figures, the distance, and the arrangement of light and shade will go to make up something that has pictorial value. . . . The sculptor and director are . . . striving for the same result—the one in the round, the other on a flat surface, simulating the form which is not there by an arrangement of light and shade calculated to create an optical illusion.[9]

In 1919, Benton began to sculpt small figures in clay and situate them in dioramas, allowing him to more capably heighten the three-dimensional, sculptural realism of his paintings.[10] He later acknowledged that the moving picture was a "true Art form" whose merit resided "not so much in the images . . . as in the dramatic meanings their sequential use unfolds."[11] Benton never credited Lindsay or Ingram with the new methods and ideas he pursued, but the synchronicity of their published texts with his technical and stylistic turn is compelling evidence of their influence.[12] The cinematic experience was central to the new spirit of Benton's art after 1919, and his shift in approach hinted at a rivalry between Ingram and Benton—between the visual languages of film and painting. As America's self-appointed history painter, Benton never wavered in his conviction that painting reigned over the upstart moviemaking as the essential American art form. He described his relationship with Ingram as "friendly-enemy," because he sensed, although he could never confirm, that Ingram always regretted abandoning painting and sculpture "for the more exciting" life of a film director.[13]

Fascinated with popular culture, Benton recognized the utility of the excitement and star power surrounding the industry in advancing his own career. After meeting such silent film stars as Valentino, and Theda Bara and Clara Kimball Young (whose portraits he painted), Benton was inspired to reconstruct his self-image. While a student in Paris, he had picked up the style of modernist "artiste." In New York, he kept his little black moustache but later abandoned the affectations of a floor-length black cape, wide-brimmed hat, and silver-topped cane, all of which were humorously noted by Ingram when he first met Benton in 1913.[14] Benton captured his new look in *Self-Portrait with Rita* (c. 1924; pl. 71), a dual portrait not only grounded in reality but also steeped in fantasy, which recalls the idealized star narratives of screen idols concocted by the media for public consumption.[15] The Bentons summered on Martha's Vineyard beginning in 1920, and Benton swam avidly, but their metamorphoses into leading man and lady of movie posters belie anatomical reality.

Posing his five-foot-three-inch frame as though facing a publicity camera, Benton evokes the male glamour and sex appeal of such 1920s male film stars as Douglas Fairbanks (fig. 3). Fairbanks was the King of Hollywood and the era's exemplar of the kinetic, youthful body. Similarly mustachioed, roguishly buff, and sporting a faceless watch on his right wrist, Benton's picture of

Fig. 3. Douglas Fairbanks in *The Thief of Bagdad*, c. 1923. Postcard from "Famous Cinema Star" series, published by J. Beagles & Co., London. Private collection

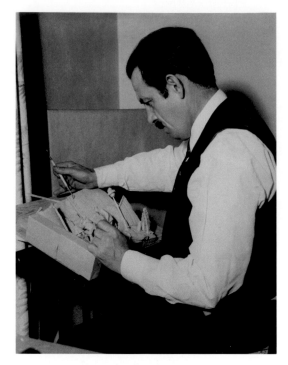

Fig. 4. Thomas Hart Benton models a maquette after a scene from *The Long Voyage Home*. Photograph by Culver Pictures, Inc. Private collection

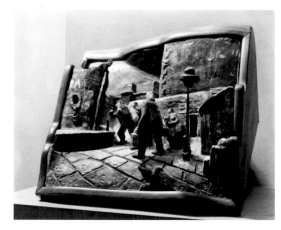

Fig. 5. Thomas Hart Benton, clay maquette for *No More Sea for Us (from "The Long Voyage Home")*. Photograph by Peter A. Juley & Son, Smithsonian American Art Archives, Washington, DC

himself falls within traditions of the ideal figure as well as the timeless pantheon of painters. He grasps in his left hand a wooden pole that could be the staff of Poseidon's trident, and he stands beside his statuesque wife, who could be the goddess Aphrodite, born of sea foam. But the pole is in fact an upturned beach umbrella with a red-white-and-blue canopy, just visible at the right edge of the painting. By tipping this American tricolor in the ground, Benton staked a claim for his artistic career and American art.

Benton relished the fame he later attained as a painter and compared it to that of "movie stars, baseball players and loquacious senators." He recalled receiving hundreds of fan letters as well as living in the "continuous glare of spotlights."[16] Benton's glamorous makeover aligned with his new cinematic approach to painting. His intent was neither to mimic film nor to achieve a hyperrealistic style but, in the same way that movie directors engage audiences, to create painterly visual effects that viewers would never forget.

MASTERING THE ART OF ILLUSION

Benton's paramount artistic concern, particularly as a painter of murals, was to conquer what he called "deep space," comparable to the lifelike quality of cinematic projection.[17] He rendered the figures in the foreground and the background of his paintings with equally sharp clarity, anticipating cinematic techniques that deep-focus photography made possible. Benton achieved this effect through the use of his handmade models. For more than fifty years, in the way a director might visualize a scene for a movie in production, Benton molded small clay figures, situated and lit them within a diorama, and then manipulated them to achieve a sense of volume, accuracy of form, and beauty of design. His working process evolved to include modeling in bas-relief (figs. 4, 5, 6, 8). When lighting his clay models for study during painting, he muted or eliminated shadows that might distort details of the human form, particularly facial expressions. He described using "a tissue paper screen to diffuse the light and eliminate cast shadows," adding that "the models are so designed in the studio that no shadow is ever cast across a form. . . . This control of light on superimposed forms is what makes for the three-dimensional effect of my paintings."[18] This was also a means of avoiding any sense of divine light often found in Renaissance painting. In so doing, Benton aligned his paintings with a cinematographer's use of artificial light to achieve visual and narrative effects on set and with Hollywood's secular sensibility.

Modeling clay was also a conceptual and sensual experience for Benton, who remarked, "I feel my paintings in my hands."[19] Sculptural form fascinated him. He began to sculpt as a student in Paris but he incorporated it into his working process as a painter only in New York in the 1910s after observing Ingram and fellow modernist Morgan Russell, who modeled clay counterparts to the images he was painting, including abstractions.[20] With *People of Chilmark (Figure Composition)* (1920; pl. 70), considered his first masterpiece conceived with the use of a clay model, Benton demonstrated his aptitude for dynamic organization of multiple figures and sculptural illusion. Over time, he learned "to paint in clay" and model quarter-round projections. An important example of the fully three-dimensional clay models that he used to work out his color schemes is the rare surviving maquette for *Weighing Cotton* (figs. 6, 7).[21] The preproduction phase of one of his most cinematic

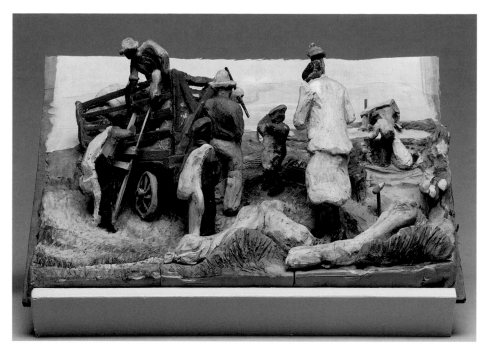

Fig. 6. Thomas Hart Benton, clay maquette for *Weighing Cotton*, 1939. Painted modeling clay, cardboard, and wood. Milwaukee Art Museum. Gift of Malcolm K. Whyte, M1976.63

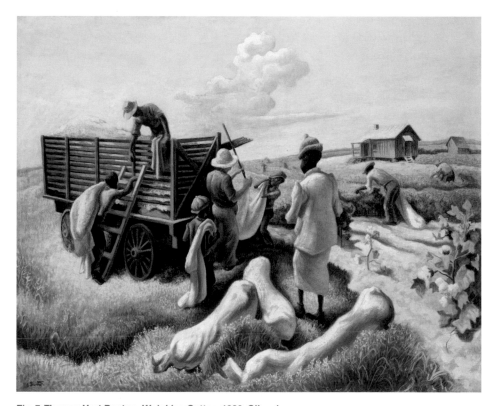

Fig. 7. Thomas Hart Benton, *Weighing Cotton*, 1939. Oil and tempera on canvas, mounted on wood panel. Yale University Art Gallery, New Haven, Purchased with the Stephen Carlton Clark, B.A. 1903, and John Hill Morgan, B.A. 1893 Funds; Collection of Mary C. and James W. Fosburgh, B.A. 1933, M.A. 1935, by exchange; and gifts from George Hopper Fitch, B.A. 1932, by exchange, William S. Kilroy, B.S. 1949, and Stanley Stone, B.S. 1916, 1989.68.1

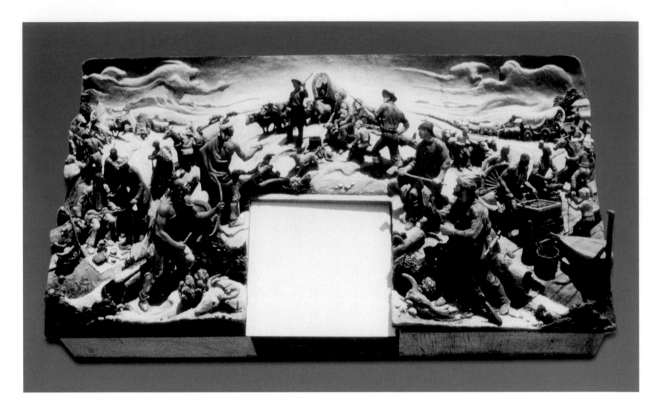

murals, *A Social History of the State of Missouri*, lasted two months; his clay model, the largest he ever sculpted, stood twelve feet long and nearly four feet high.[22]

LUMINOSITY

Many of Benton's large-scale works after 1927 have luminous qualities evocative of the *silver screen*, a romantic term that acknowledges the actual silver or aluminum used during the silent era to create a projection screen's highly reflective surface. To achieve his effect, Benton first primed his canvases with white gesso, illuminating the ground layer, and then built up the paint surface with multiple thin layers of oil and egg tempera suspended in translucent glazes. Benton along with many other modern American artists, including Paul Cadmus, Reginald Marsh, and Andrew Wyeth, revived the old master technique of tempera painting, the materials of which require painstaking discipline and planning but produce a brilliant surface and glowing colors.[23] To create *Hollywood* (1937–38; pl. 72), for instance, Benton used thousands of small, meticulously applied brushstrokes in a vast spectrum of colors, which vibrate as if in motion.[24] The energetic quality of the paint application compares with the flickering liveliness of the very medium *Hollywood* depicts.

Tempera remained an essential ingredient of Benton's historical murals between 1930 (*America Today*) and 1956 (*Trading at Westport Landing*; see p. 214). His first large-scale work conceived in tempera and oil was *Bootleggers* (1927; pl. 43), and he had fully mastered the technique by the time he completed *Persephone* (1938–39; pl. 73). While tempera is painted over layers of oil in some passages, in others, oil glazes are suspended over

tempera ground.[25] Benton essentially "drew" his brushstrokes, and the precision further aligned his work with cinematic realism. With the sensitivity of a Hollywood lighting designer, Benton applied white highlights as the final touches to his paintings. As a complementary mode to the complex process of color mixing and layering, they contributed to the overall glow of his work. Benton contended that the extraordinary light emanating from his paintings also resulted from the "play of color all around."[26]

CASTING

In 1922 Ingram published his advice for the potential movie director: "Mix with all classes of people in all walks of life" and become "a close student of human nature."[27] In 1924, as though heeding Ingram's directive, Benton began wandering the back roads of America, where he compiled notebooks full of sketches of the characters he encountered. He actively scouted for nonactors to "star" or appear as extras in his paintings even though he found it "difficult to go into an unfamiliar area, find the right types to draw, and then talk the subjects into posing."[28] With a lively sense of the observed quirk and a practiced gift for caricature and cartoon, Benton deployed elements of the individual physiognomies he captured in ways that reinforced the national, local, or ethnic generalizations in his work. In the same spirit that movie directors utilize the talents of character actors, Benton often simplified his portrayals to articulate an American type (see, for example, *Yankee Driver*, 1923; pl. 41). He meticulously attended to the accuracy of historical detail by researching the trappings of his subjects so that his paintings, particularly the murals, would stand up to intense visual scrutiny. By the late 1930s, Hollywood studios responded to Benton's fluid, actor-centered renderings of the American character by hiring him to work with staff responsible for promoting and advertising feature films set in rural America. Benton assisted 20th Century Fox in its efforts to publicize the film adaptation of John Steinbeck's *The Grapes of Wrath*. His series of lithographs – *Departure of the Joads* and five character studies (1939; pls. 32–37) – was so successful in furthering John Ford's directorial vision that the studio commissioned him to conceive another six lithographs in 1941 to assist with the promotion of Jean Renoir's *Swamp Water* (see pp. 204–5).

But Benton also cast ordinary Americans as stars in his allegorical paintings, many of which collapse time by uniting mythic and modern worlds. He had already brought Poseidon and Aphrodite to life in his *Self-Portrait with Rita*; later, he transformed a burlesque queen into the goddess Persephone, an African American lay preacher into the biblical Aaron (pl. 49), and a midwestern farmer into Hercules in the mural *Achelous and Hercules* (1947; see p. 210).[29] By portraying a young naked schoolteacher as Susanna (*Susanna and the Elders*, 1938), he activated a dialogue between the Apocrypha and the modern era.

VISUALIZATION

Benton considered his historical murals to be his foremost achievement, and for creative guidance on how to organize them, he turned to the old masters he revered. Their finest works, he believed, reconceived the conventions of

Fig. 9. Michelangelo, *Battle of the Centaurs*, 1491–92. Carved marble relief. Casa Buonarroti, Florence, Italy

public storytelling by carefully orchestrating figures and forms in historical or biblical settings in ways most likely to leave an indelible impression. Benton wrote in 1922 that "true painting is the ideal organization not of phenomena, but of their effects on memory and imagination."[30] He emulated the old masters' means of visual communication to tell American stories as effectively and popularly as stories had been told in paintings in churches across Europe and as they were being told in movie theaters across America. Benton's tightly composed figural groups in paintings like *People of Chilmark* are evocative of Michelangelo's marble sculpture *Battle of the Centaurs* (1491–92; fig. 9). And the dramatic gestures, figures in motion, and bold perspective that characterize Benton's murals not only recall the orchestrated works of such old master painters as Tintoretto but also convey the movement and energy of the cinema. Probably intended for a wall in a Venetian chapel, Tintoretto's large-scale *Miracle of the Loaves and Fishes* (1545–50; fig. 10) exemplifies the fluid design and sculptural, dramatic forms and compositions that Benton admired and sought after for his murals.

Benton followed the method of Tintoretto and other "Venetian space composers" by preparing sketches that he then transferred to canvases as underdrawings.[31] After determining how the vignettes would be arranged in an overall design scheme, he prepared a cartoon of the mural. He first experimented with these methods in his *American Historical Epic* (1920–28; pls. 1–14), in which he intended the individual panels to hang tightly together in a series to form the interrelated and unified composition. For his later, more expansive mural installations, like *The Social History of Indiana* (1933), he rendered a cartoon of the contours of the forms rhythmically interconnecting throughout the entire length of the mural and prompting the eye to follow his painted narratives up and around the composition from one passage to another as though visualizing them sequentially like storyboards (fig.11). Benton's many preparatory studies for his final paintings are analogous to the multiple outtakes a movie director often shoots to arrive at his final cut.

As a director blocks his scenes, placing actors and props, Benton visualized his final paintings by adding or removing figures and component parts in his working compositions. His intensive working method involved a succession of sketches and studies in various media conceived from life, as exemplified by his preparatory works for *The Kentuckian* (pls. 20–28). Problems of composition, color, and design had to be resolved before he scaled up to the final (generally, largest) painting, because making alterations in oil and tempera was onerous. He summed up this preemptive practice: "I never touch the final painting until I know what I'm going to do."[32]

Like the cinema, the action in Benton's murals flows laterally in successive scenes and engages the viewer with multiple narratives. The dramatic interplay unfolds in time and transforms conventional history painting from a frozen tableau into a picture show for modern times. The approach foreshadowed the directorial strategies of Robert Altman, who hailed from Benton's Kansas City. Altman's movies are known for their conversational heartland style, which is animated, like Benton's murals, by crosscutting storylines — a staple of au courant film technique in which multiple actions take place in various locations simultaneously. With their colliding vignettes of conversations, backstories, innuendos, gossip, melodrama, and human incident, passages from Benton's murals activate their surroundings with American histories and fictions that play upon memory and stir imaginations.

Fig. 10. Jacopo Tintoretto, *The Miracle of the Loaves and Fishes*, 1545–50. Oil on canvas. The Metropolitan Museum of Art, New York, Francis L. Leland Fund, 1913, 13.75

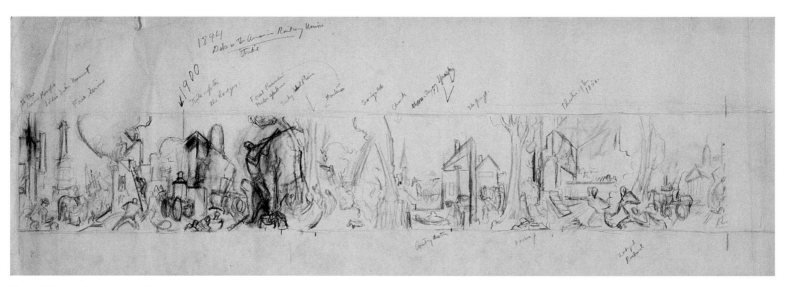

Fig. 11. Thomas Hart Benton, *Chronological Study for Cultural Panels 5–9, "The Social History of Indiana,"* c. 1933. Graphite on tracing paper. Indiana University Art Museum, 87.19.75

Plate 70
People of Chilmark (Figure Composition), 1920
Oil on canvas
65 5/8 × 77 5/8 in. (166.5 × 197.3 cm)
Hirshhorn Museum and Sculpture Garden, Smithsonian
Institution, Washington, Gift of the Joseph H. Hirshhorn
Foundation, 1966, 66.468

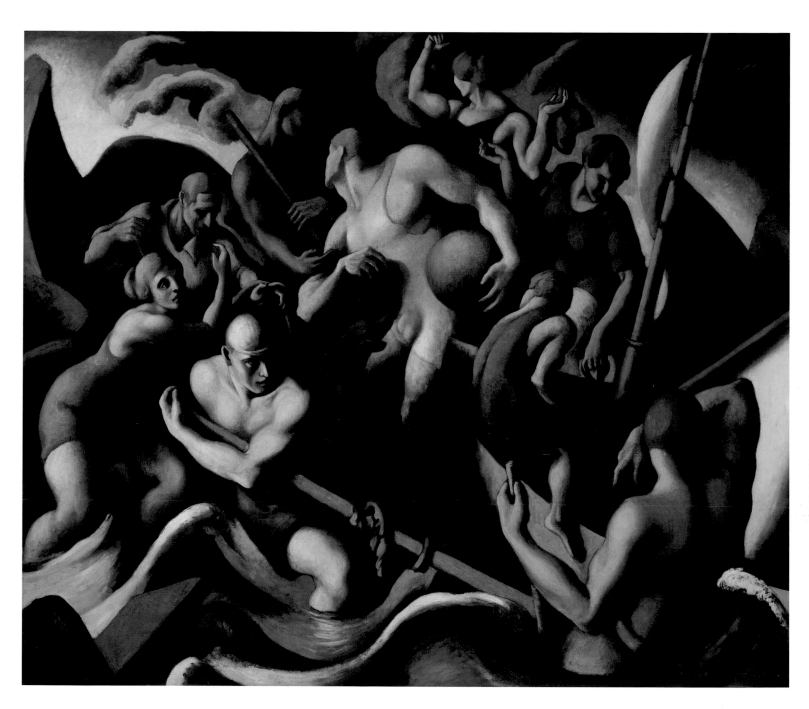

Plate 71
Self-Portrait with Rita, c. 1924
Oil on canvas
49 × 39 3/8 in. (124.5 × 99.9 cm)
National Portrait Gallery, Smithsonian Institution,
Washington, Gift of Mr. and Mrs. Jack H. Mooney,
NPG.75.30

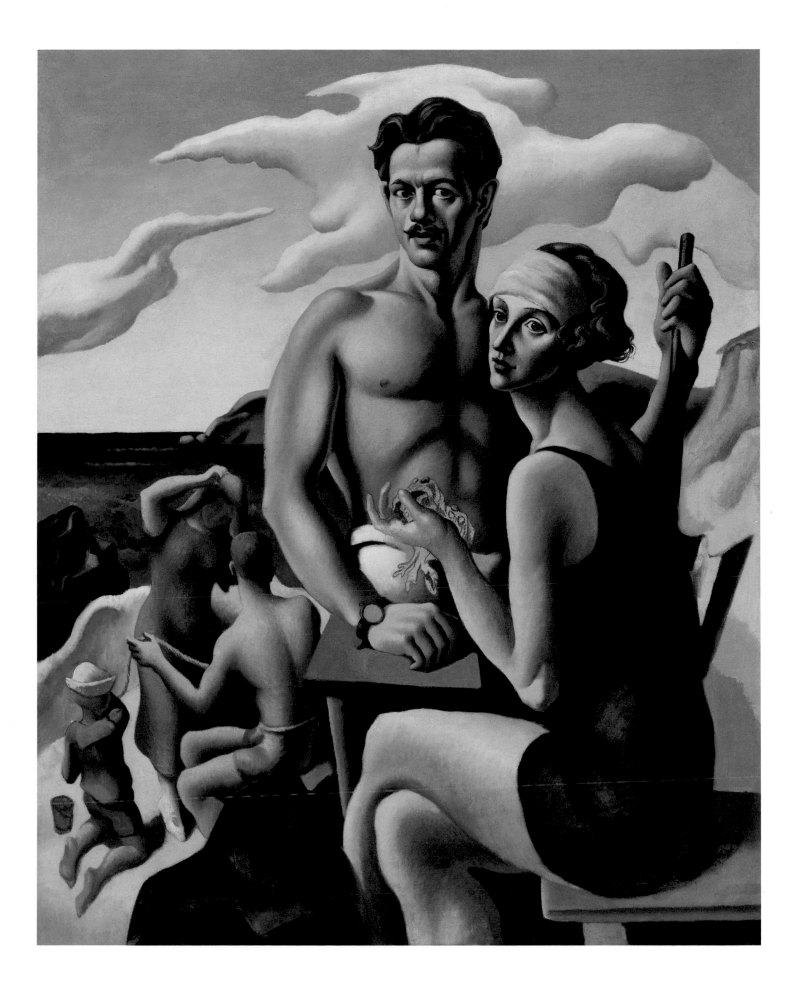

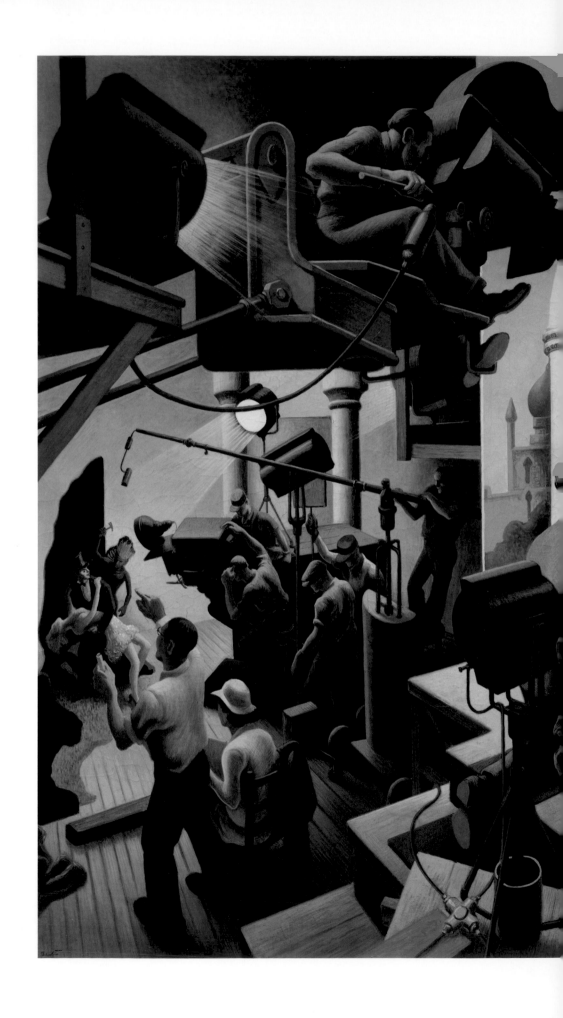

Plate 72
Hollywood, 1937–38
Tempera with oil on canvas, mounted on panel
56 × 84 in. (142.2 × 213.4 cm)
The Nelson-Atkins Museum of Art, Kansas City,
Missouri, Bequest of the artist, F75-21/12

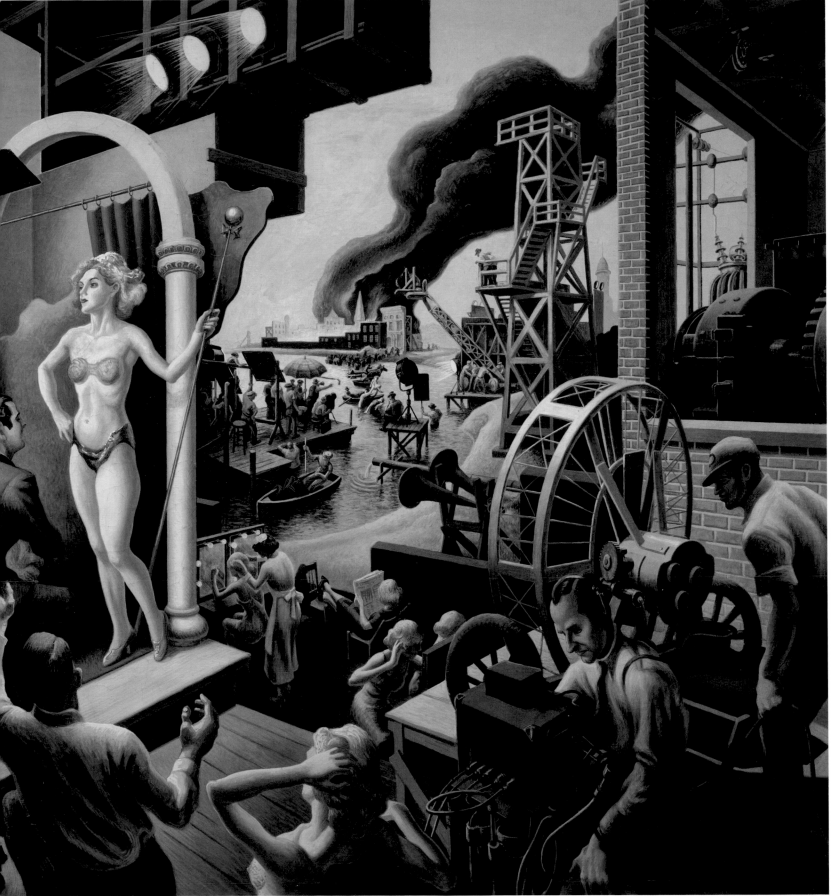

Plate 73
Persephone, 1938–39
Tempera with oil glazes on canvas, mounted on panel
72 ⅛ × 56 1/16 in. (183.2 × 142.4 cm)
The Nelson-Atkins Museum of Art, Kansas City, Missouri, Purchase:
acquired through the generosity of the Yellow Freight System
Foundation, Mrs. Herbert O. Peet, Richard J. Stern, the Doris Jones
Stein Foundation, the Jacob L. and Ella C. Loose Foundation,
Mr. and Mrs. Richard M. Levin, and Mr. and Mrs. Marvin Rich, F86-57

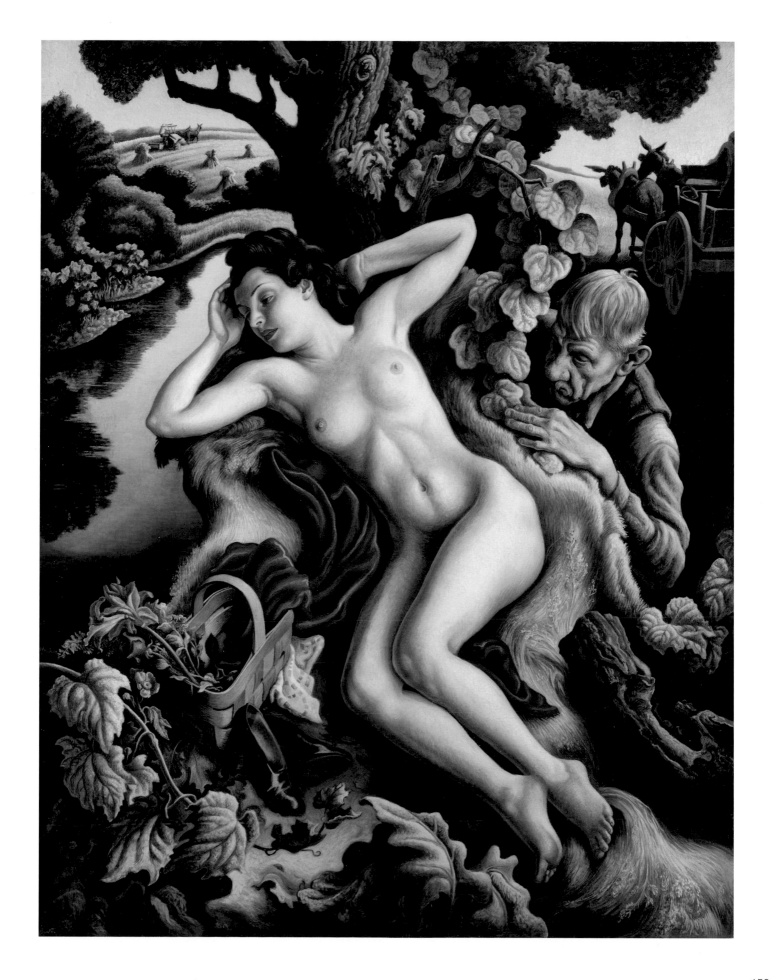

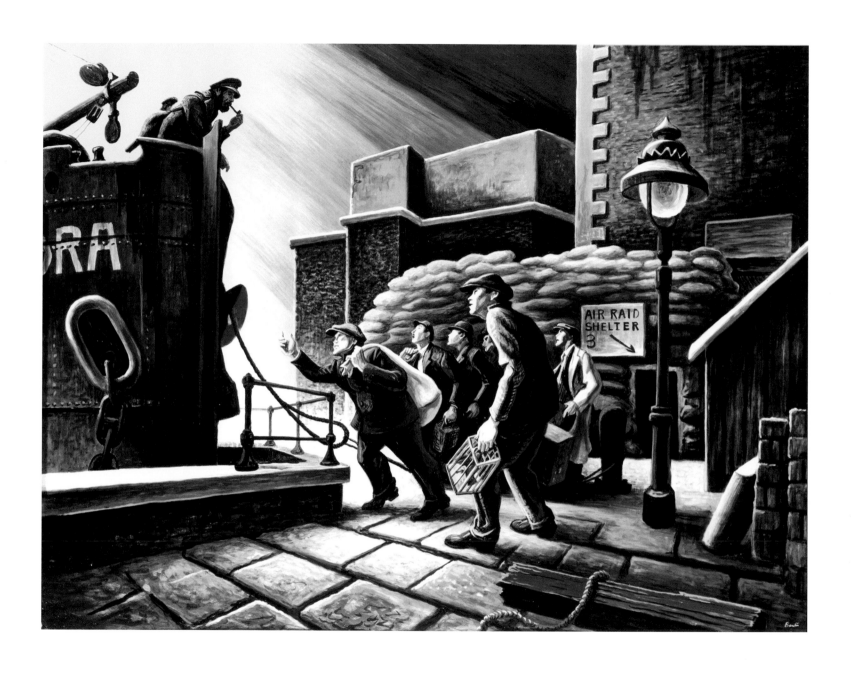

Plate 75
Poker Night (from "A Streetcar Named Desire"), 1948
Tempera and oil on panel
36 × 48 in. (91.4 × 121.9 cm)
Whitney Museum of American Art, New York,
Mrs. Percy Uris Bequest, 85.49.2

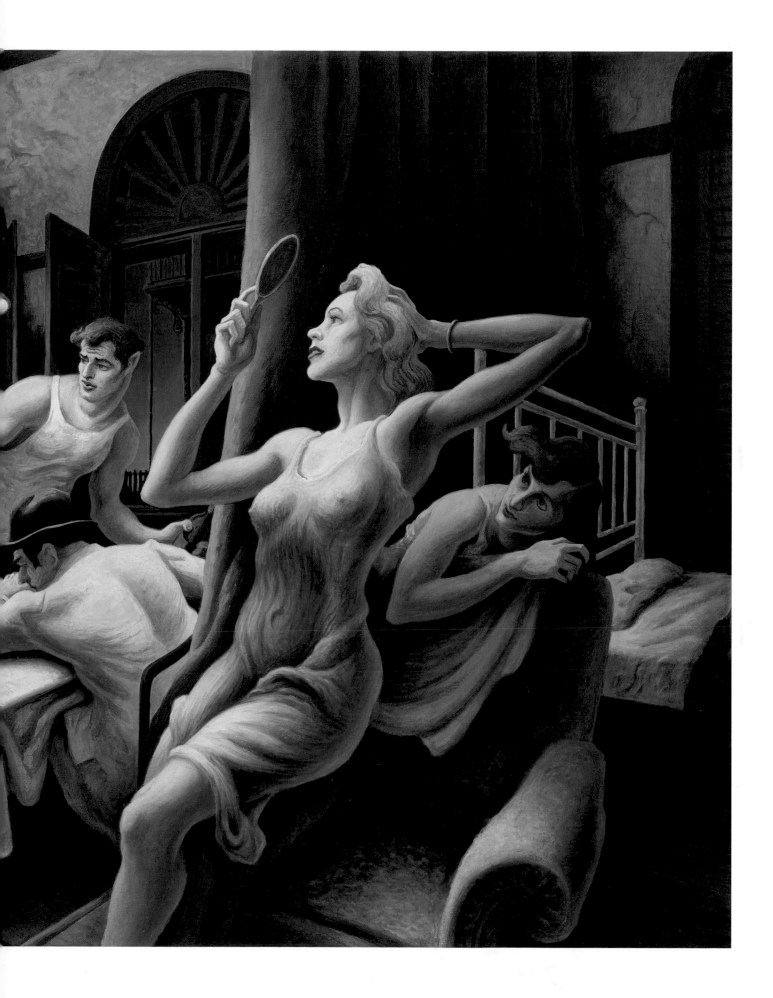

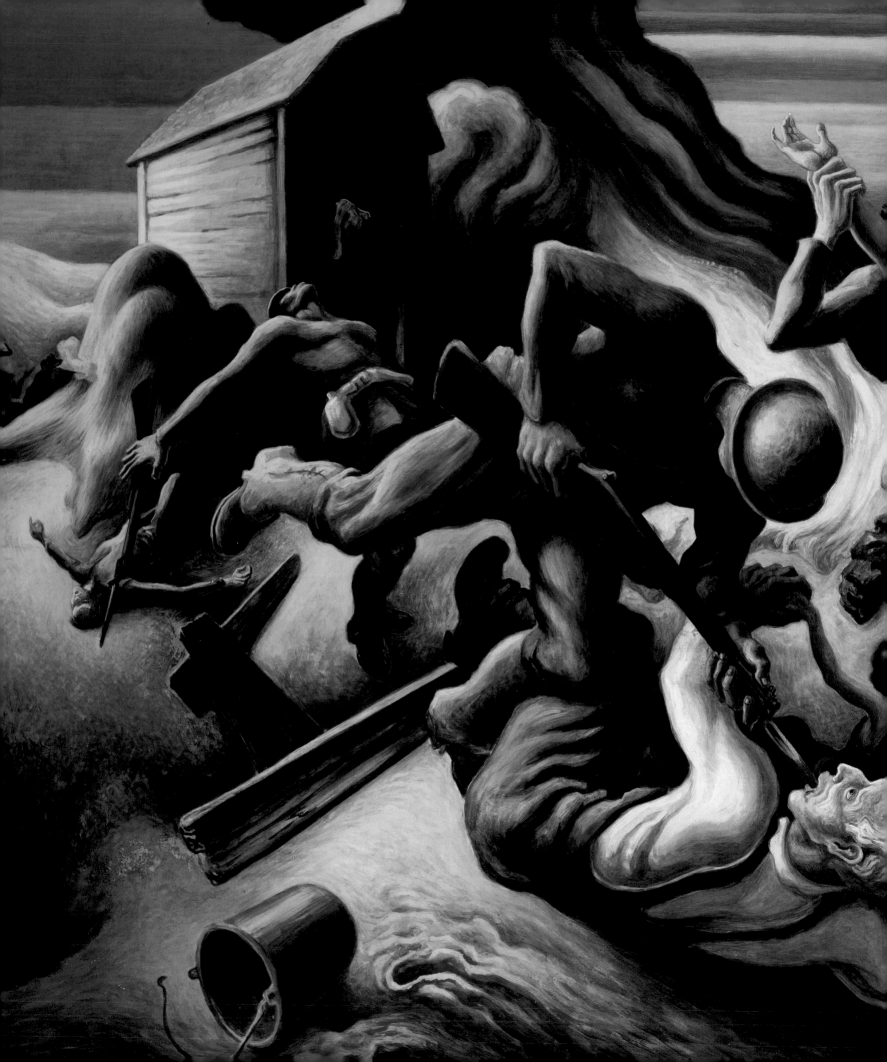

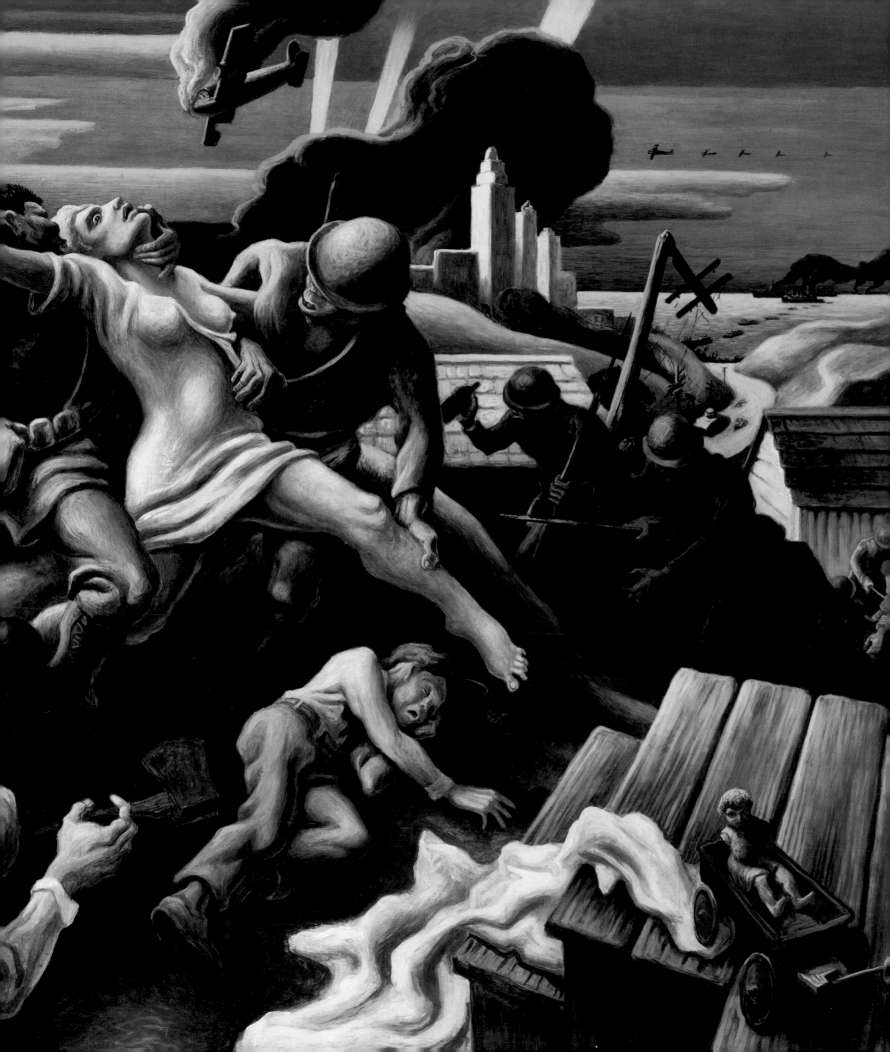

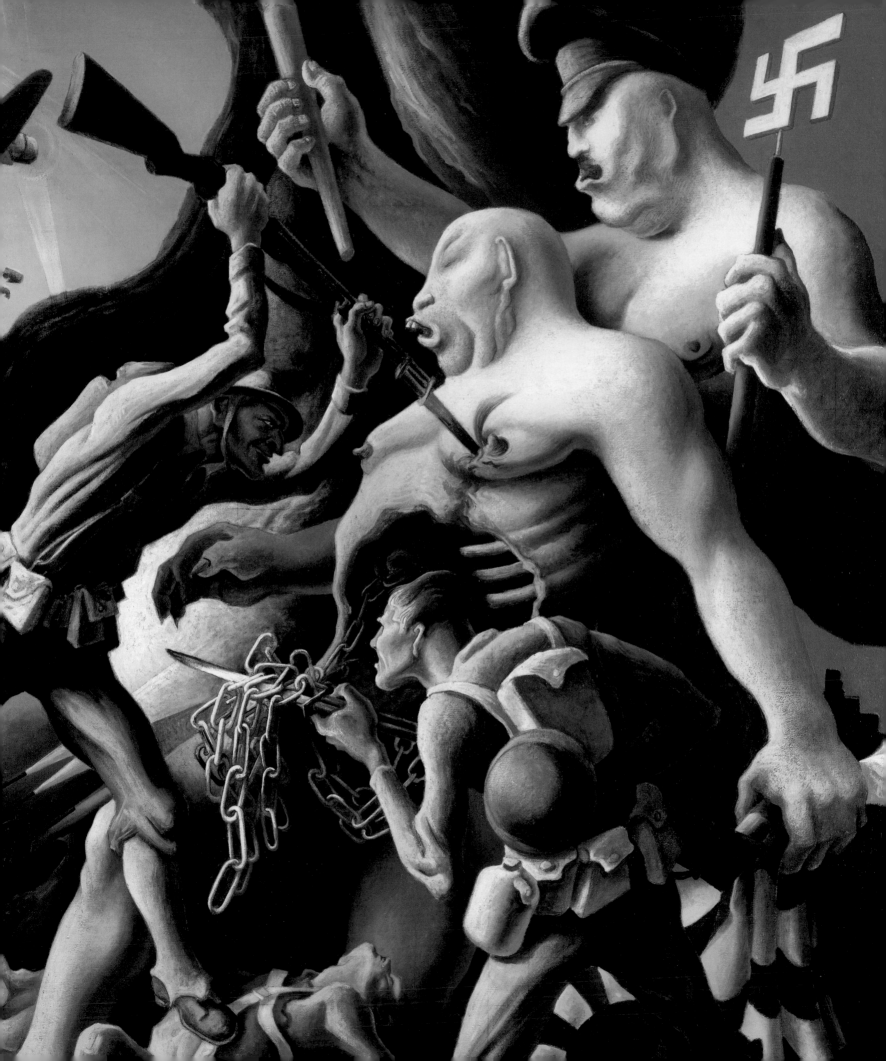

THE YEAR OF PAINTING FURIOUSLY

THOMAS HART BENTON, 1942

Jake Milgram Wien

YEAR OF PERIL

The tragic attack on Pearl Harbor, December 7, 1941, propelled the United States into a world war that had previously provoked widespread public apathy. Americans resisted the internationalist vision President Franklin D. Roosevelt had conveyed in his State of the Union address in January, during which he defined the "four essential freedoms." The prevailing isolationism also concerned *Life* publisher Henry Luce, who had written "The American Century" in February to rouse Americans from "their slothful indifference and inspire them to undertake a great mission on behalf of what he considered the nation's core values."[1] The Japanese bombing of Pearl Harbor provided an instantaneous casus belli, mobilizing public and private support for American engagement in total war. Benton's own pent-up anxieties about the security of the nation were unleashed by the attack, and he began to work immediately, and furiously, on an ambitious project called *Year of Peril* (*YOP*), a series of eight propagandistic paintings he finished in about four months. Benton dedicated the project to "those new Americans who, born again through appreciation of their country's great need, find themselves with new shares of patriotism and intelligence, and new wills to see what is what and to come to grips with it, in this Year of Peril." Upon completion of the project, Benton published the titles of the paintings in the following order: *Starry Night*, *Exterminate!*, *Indifference*, *Casualty*, *The Sowers*, *The Harvest*, and *Again* (figs. 1–7).[2] The eighth painting, *Invasion* (fig. 8), appeared soon after.

Benton funded the project himself and envisioned the eight works hanging on the walls of Union Station near downtown Kansas City to grab the attention of throngs of midwestern travelers and passersby. He forged a new

YEAR OF PERIL

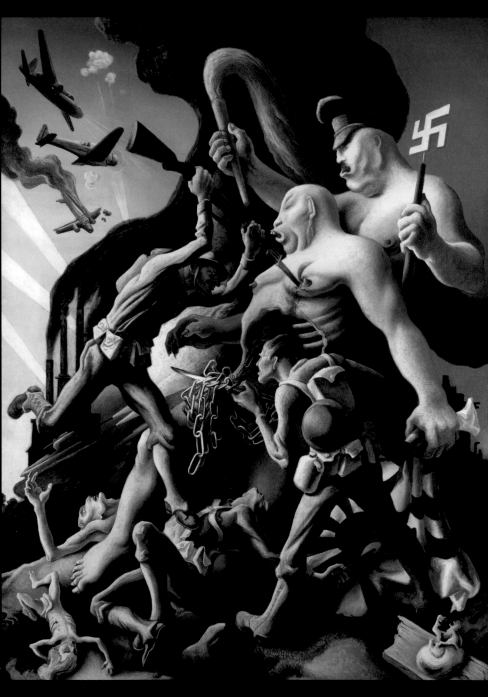

Fig. 1.
Starry Night, 1942. Oil on canvas, 24 × 30 in.
(61 × 76.2 cm). State Historical Society of
Missouri, Columbia, 1944.8

Fig. 2 (pl. 76).
Exterminate!, 1942
Oil and egg tempera on canvas,
mounted on panel
96 × 72 in. (243.8 × 182.9 cm)

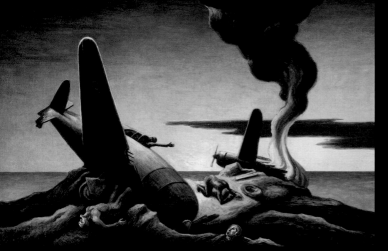

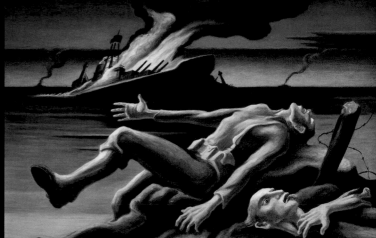

Fig. 3. *Indifference*, 1942. Oil on canvas,
21 × 31 in. (53.3 × 78.7 cm). State Historical
Society of Missouri, Columbia, 1944.7

Fig. 4. *Casualty*, 1942. Oil on canvas, 21 ½ ×
30 ½ in. (54.6 × 77.5 cm). State Historical
Society of Missouri, Columbia, 1944.6

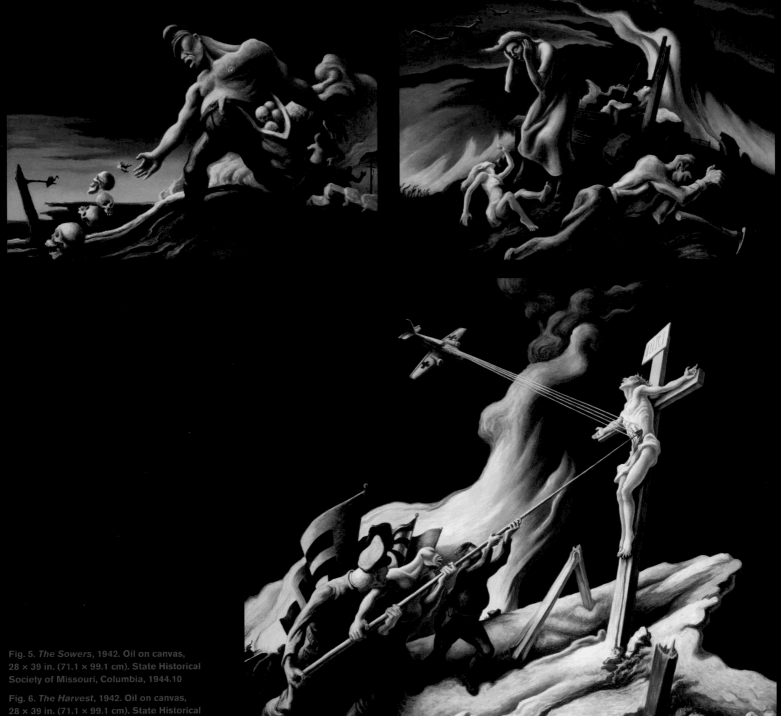

Fig. 5. *The Sowers*, 1942. Oil on canvas,
28 × 39 in. (71.1 × 99.1 cm). State Historical
Society of Missouri, Columbia, 1944.10

Fig. 6. *The Harvest*, 1942. Oil on canvas,
28 × 39 in. (71.1 × 99.1 cm). State Historical
Society of Missouri, Columbia, 1944.9

Fig. 7. (pl. 77)
Again, 1942
Oil on canvas
47 × 56 in. (119.4 × 142.2 cm)
State Historical Society of Missouri, 1944.21

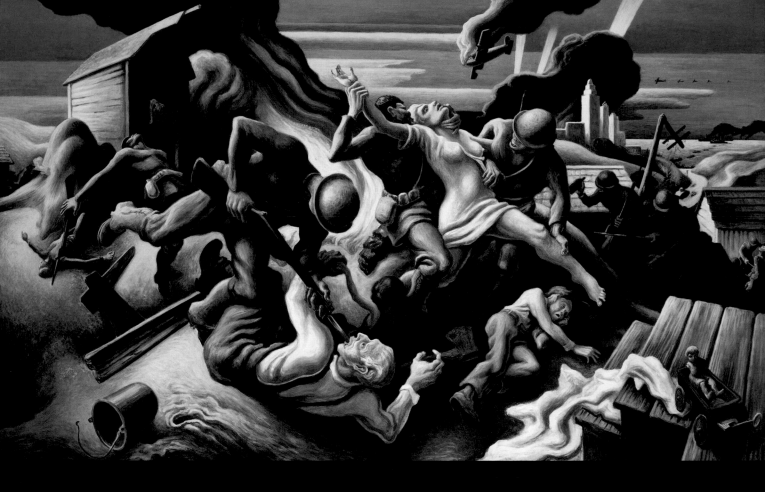

Fig. 8 (pl. 78).
Invasion, 1942
Oil on canvas
48 × 84 in. (121.9 × 213.4 cm)

and distinctive style for *YOP* and called the paintings "cartoons," a term that not only acknowledged their blatant caricature, stereotyping, and shorthand narrative devices but also distinguished their obvious didactic intent from the rest of his work.[3] One of the early critics of *YOP* described the style as an amalgamation of a "vague Baroque mannerism" and a "boys'-book imagination."[4] Although perplexing, the murals' dynamic tension, created by pairing high and low art forms, achieved the arresting effect of the eye-catching wartime propaganda posters Benton wished to emulate. The stylistically low elements evoked not only the comic book but also the pulp magazine, a kindred and similarly flourishing popular genre. Pulp's visual language, described as "men's art fueled on testosterone" or "hard whiskey," together with its lowbrow storytelling, typically targeted adolescent and adult males, whose wartime complacency Benton evidently sought to shake by satisfying their appetite for violence and prurience.[5] His brand of propaganda differed markedly from that of the US Department of War, which harnessed the power of the movies to build national solidarity: Americans flocked to theaters more than ever during World War II and some 80 million movie tickets were sold each week.[6] The government expeditiously mobilized staff and channeled resources to produce films for military and civilian audiences that typically re-created "authentic scenes" or made "free use . . . of motion pictures with historical backgrounds. . . . official War Department films, newsreels, United Nations sources and captured enemy material."[7]

Because Benton originally set his sights locally, he never anticipated that his paintings would appear nationally on movie screens, receive mentions in leading newspapers and magazines, command the attention of the 77th US Congress, or play a role on the world stage in the battleground of ideas.[8] Reeves Lewenthal, Benton's agent and director of Associated American Artists art gallery in New York City, was responsible for raising public awareness of the murals. Lewenthal orchestrated a campaign to promote the paintings nationally as wartime propaganda and convinced Abbott Laboratories, a Chicago-based manufacturer of pharmaceutical and biological products, and a major supplier to the US military, to acquire them and sponsor their exhibition and promotion nationwide. Abbott produced a ten-page magazine devoted entirely to *YOP*, with a foreword by Archibald MacLeish, director of the War Department's Office of Facts and Figures, and a commentary by Benton on each of the paintings.[9] In its *YOP* publication, Abbott billed the paintings as "a contribution to our National War Effort" and presented them "to the American People through widespread granting of reproduction rights to appropriate agencies." Benton calculated that some 58 million images of *YOP* were circulated.[10]

Between April 6 and April 25, 1942, about seventy-five thousand visitors viewed the exhibition *Thomas Hart Benton's "Year of Peril"* at the New York galleries of Associated American Artists. Paramount Pictures filmed the opening and included close-ups of the paintings in a newsreel segment released on April 14. "War Art Creates Sensation" (fig. 9) captured Benton at work on *Invasion* while a voiceover introduced "a great American artist, Thomas Hart Benton." Looking confidently at the camera, Benton articulated his reasons for painting *YOP*: "I made these paintings because of a conviction obtained by traveling around the country. . . . I saw that too many people were overconfident, overoptimistic and under the impression that their lives could go on much as usual while George won the war."[11] The historic contribution of *YOP* was further trumpeted on April 16 when longtime Missouri Democratic

Fig. 9. From the newsreel "War Art Creates Sensation," April 14, 1942. Paramount Pictures

congressman Joseph B. Shannon (who had known the painter's father, Missouri congressman M. E. Benton) delivered a speech that entered the Congressional Record. Shannon recalled Benton's famous forebearers and read passages from Benton's descriptions of each painting and his general overview of *YOP*: "The pictures are not technically realistic. They do not represent accurately anything that I have seen with my eyes or that another may see with his. They are realistic just the same. I believe that they are true representations of the moment even though the symbols used are imaginative."[12]

The imaginative symbolism of Benton's *YOP* was precisely the socially and politically volatile imagery routinely excised from movies by the Motion Picture Production Code of 1930.[13] The paintings' gruesome melodrama – with explicit portrayals of rape, disembowelment, and strewn body parts – far exceeded the limits of Hollywood censorship. As *YOP* burst onto the national scene, Benton explained why his imagery had to be so emphatic:

> There are no bathing beauties dressed up in soldier outfits in these pictures. There are no silk-stockinged legs. There are no pretty boys out of collar advertisements to suggest that this war is a gigolo party. There is no glossing over of the kind of hard ferocity that men must have to beat down the evil that is now upon us. In these designs there is no hiding of the fact that War is killing and the grim will to kill. There is none of the Pollyanna fat that the American people are in the habit of being fed.[14]

Benton's passionate patriotism is made manifest by this flamboyant rhetoric and the overwrought scenes of carnage running through *YOP*. This manly take on war operates on yet another level: in the aftermath of a recent public rebuke, it demonstrates his need to convince audiences of his virility. Just seven months earlier, Benton had been fired by the board of the Kansas City Art Institute for making homophobic statements about the directors of leading American museums. The press had disseminated his caustic comments, which described the typical American museum as "a graveyard run by a pretty boy with delicate wrists and a swing in his gait. . . . The pretty boys run the museums because it's a field most living men wouldn't take on. It's a field where you take care of the dead, and nobody wants that. . . . Do you want to know what's the matter with the art business in America? It's the third sex and the museums."[15]

Fig. 10. *Amazing Stories* magazine, August 1939. Private collection

The passages of machismo, violence, and sexism in the mural series found visual counterparts in the comics, pulp fiction, and horror and action-adventure feature films. Racially stereotyped bare-breasted brutes, sporting the limbs of ogres and chains for viscera, overrun the terrifying world of *Exterminate!* – the largest *YOP* painting, at eight feet high and six feet wide. The brethren of these villains and ghouls were born in the popular culture of the anxious 1930s in the pages of *Captain America*, *Superman*, and *Flash Gordon*; in such films as *Dracula* (1931), *Frankenstein* (1933), and *King Kong* (1933); and on the covers of such pulp magazines as *Thrilling Adventures* and *Amazing Stories* (fig. 10). The first issue of *Captain America* (on sale in late 1940, although it bears the date "March 1941") featured a cover illustration of the comic book's hero punching Adolf Hitler. Superman, too, had battled Nazis before Pearl Harbor. In *Starry Night* (see fig. 1), selected for the cover of Abbott's *YOP* magazine, Benton conjured the horrors of Pearl Harbor and other naval defeats that America suffered in the Pacific; in such harrowing films as

Fig. 11. H. R. Hopps, "Destroy This Mad Brute,"
1917. US Army recruitment poster, offset
lithograph. Courtesy of Swann Auction
Galleries

John Farrow's *Wake Island* (1942), nominated for four Academy Awards, moviegoers were confronted with similar horrors. Like Benton, Farrow began work on his production immediately after Pearl Harbor, even before the American forces on Wake Island had surrendered.[16]

Through its title and its imagery, *Invasion* recalled the fictional Martian invasion of the United States, still fresh in the memory of millions who had heard the simulated newscast of H. G. Wells's *War of the Worlds* in 1938. Both Benton and his radio counterpart Orson Welles conveyed the primal fear of conquering hordes on American soil. The viewers of *Invasion* were disturbed by the added prospect of sexual violence, a recurring, perhaps pathological, theme in Benton's art. In the 1930s, he had painted the actual and potential violation of women in *Moonlight Ride* (1934), *Susanna and the Elders* (1938), and *Persephone (Rape of Persephone)* (1938–39; pl. 73). Beyond the heinous acts of violence depicted in *Invasion*, Benton added the incongruous twist of miscegenation: the Axis powers' rapist is a black man. This image of sexual peril harkens back to a World War I recruitment poster that dehumanized the German enemy as a gorilla invading America and abducting an eroticized Liberty (fig. 11). It also evokes the black-and-white terror of the interwar movie *King Kong*. The painting appeared in a widely published Associated Press photo and in the Paramount newsreel, but both the Congressional Record and Abbott's magazine left out this extreme painting, which one reporter could only describe as "vastly more complex" than the others in the series.[17] *Invasion* may not have been completed before the Congressional Record and Abbott's magazine brought *YOP* to public attention, but it is also possible that the painting's sexually and racially charged imagery may have provoked its early suppression.

FRANK CAPRA, HOLLYWOOD, AND BENTON'S PROPAGANDA

Soon after completing *YOP*, Benton painted three more propaganda paintings in 1942: *Embarkation: Prelude to Death* (fig. 12), *Shipping Out* (pl. 80), and *Negro Soldier* (pl. 79). The first two works comment on the steep mortal costs of combat and the third addresses the contribution of African Americans to the war effort. These paintings found a Hollywood counterpart in the work of Frank Capra, the celebrated director of popular, socially conscious movies. Capra joined the Army Signal Corps soon after Pearl Harbor, and at the request of General George Marshall and the War Department began assembling an expert production crew to produce *Why We Fight* (1942–45), a series of seven orientation films. The military also called upon Capra to produce an additional documentary film, *The Negro Soldier* (1944), on which scriptwriting began in May 1942.

Prelude to War (1942), the first in the *Why We Fight* series, won an Academy Award for best documentary. Capra, chilled by the acclaimed German filmmaker Leni Riefenstahl's masterful cinematic techniques, lifted footage from her 1935 Nazi propaganda film, *Triumph of the Will*, and inserted it into his movies in ways that ingeniously subverted Riefenstahl's original intent.[18] Winston Churchill considered *Why We Fight* the most "powerful statement . . . of our rightful case against the Nazi tyranny" that he had ever seen or read.[19]

In Benton's *Embarkation: Prelude to Death* and *Shipping Out*, enlistees board ships taking them to meet their fate, and their affecting story is told

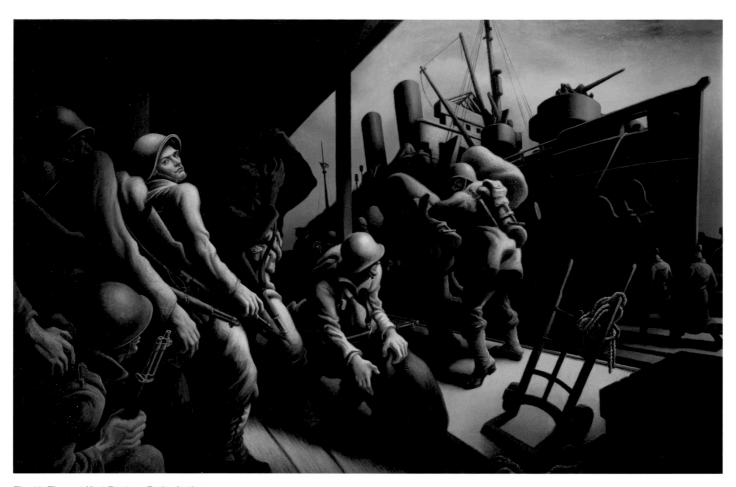

Fig. 12. Thomas Hart Benton, *Embarkation: Prelude to Death*, 1942. Oil on canvas. State Historical Society of Missouri, Columbia, 1975.96

Fig. 13. Film still from *All Quiet on the Western Front*, 1930, directed by Lewis Milestone. Universal Pictures

through the backward glance of one of the troops. With the national death toll mounting and the prospect of his son Thomas Piacenza "T. P." Benton serving in the military overseas, Benton reflected on the human costs of war. His compositions were inspired by a scene he witnessed on the waterfront docks in Brooklyn.[20] He recalled that "all the boys looked back as they were marched up the gangplanks and into the holds of the grey ships which were to take them away into the unknown."[21] By singling out a sole recruit and adding *Prelude to Death* to his title, Benton paid homage to a famous scene from director Lewis Milestone's acclaimed antiwar movie of 1930, *All Quiet on the Western Front*, which won Academy Awards for best picture and best director. In the movie's final, heart-wrenching moments, ghostly images of young soldiers silently marching toward their bleak fate and into eternity are superimposed over a sea of graveyard crosses; each soldier will have been killed by the movie's end and each one turns to lock eyes with the viewer in a final farewell (fig. 13).[22]

The two dockside paintings spotlight the personal sacrifice of American troops called to arms, but as wartime propaganda, they strike dissonant emotional chords. The title *Embarkation: Prelude to Death* mocked the battle call of Capra's *Prelude to War*, and the Hollywood sentimentality that it and *Shipping Out* employed – namely, a young recruit looking back at the viewer – questioned the notion of national sacrifice. Benton's *Negro Soldier*,

Fig. 14. Poster for *The Negro Soldier*, 1944, directed by Stuart Heisler. Margaret Herrick Library, Academy of Motion Picture Arts and Sciences, Beverly Hills, California, Poster Collection, 2009-506-13

and the Hollywood conventions it relied upon, were also problematic, but in a different way. As it happened, Capra was investigating the same subject when the War Department tapped him to produce *The Negro Soldier*, a recruitment film aimed at African Americans. During World War II, black soldiers were required to serve in a segregated army, and a high priority for the government was boosting their morale. An innocent in the realm of race relations, Colonel Capra turned to emerging African American filmmaker Carlton Moss to write the film, directed by Stuart Heisler.[23] Moss's screenplay highlighted the patriotic roles blacks played throughout American history, from Valley Forge to World War I, but it omitted any reference to slavery or segregation. Moss starred in the film as a minister preaching to a black congregation on the subject of racial pride. The minister's sermon contrasts Nazi theories of racial domination and subjugation with the democratic freedoms that produced such citizen-athletes as Joe Louis, the champion boxer known as the "Brown Bomber." Louis became a national hero and enlisted in the US Army during World War II.

Before writing on *The Negro Soldier* began in May 1942, Capra expressed concern about how African Americans should be depicted in the movie, which was originally intended for all-black audiences. In response, Donald Young, a sociologist in the Army Research Branch, prepared a memorandum that cautioned Capra to "avoid stereotypes such as the Negroes' alleged affinity for watermelon or pork; also avoid strong images of racial identity ('play down colored soldiers most Negroid in appearance' and omit 'Lincoln, emancipation, or any race leaders or friends of the Negro')."[24] With Moss at the helm, Capra and his production team closely adhered to these guidelines, and the movie was praised by African American recruits, journalists, and the National Association for the Advancement of Colored People.[25] The forty-three minute film debuted at the Pentagon in January 1944, and it soon became mandatory viewing for all soldiers, regardless of race.[26] The War Activities Committee of the Motion Pictures Industry distributed the movie, which was seen by millions of soldiers in subsequent years. The film challenged Hollywood racial stereotypes and became an influential force for tolerance. It ultimately helped move the United States along the path toward desegregating its military. In 1948, President Harry S. Truman issued Executive Order Number 9981, officially declaring "equality of treatment and opportunity for all persons in the armed services without regard to race, color, religion, or national origin." The US armed forces finally achieved complete desegregation on September 30, 1954, when Secretary of Defense Charles Wilson abolished the last all-black unit.

Capra's *The Negro Soldier* is now historic whereas Benton's painting *Negro Soldier* has fallen into obscurity. To make a propaganda film designed to encourage African Americans to join the military, Moss and Capra abandoned Hollywood stereotypes of African Americans. Conversely, working alone in Kansas City, a racially divided and conservative town, without the expert advice that Capra received, Benton painted a soldier who had much in common with the stereotypes of African Americans typically purveyed by mainstream Hollywood during the war.[27] He created an image of a young recruit with grossly exaggerated features and body language. His sunken chest, jutting neck, and hunched posture fail to induce confidence in his masculinity and preparedness and are the antithesis of the erect body language manifested by the soldiers in Capra's film and, indeed, in the image of Joe Louis on its widely distributed promotional poster (fig. 14). Benton's depiction was precisely

the one Capra was warned to avoid. And because *Negro Soldier* accurately presented the black soldier as an isolated individual in a segregated unit, it was fundamentally flawed as propaganda designed to promote national solidarity.

Benton painted *Negro Soldier* as what he called a "follow-up" to *YOP* but he never clarified why. Perhaps he learned of the government's racial policy objectives and thought his painting might help promote them and Capra's film. If so, *Negro Soldier* provides further evidence of his continuing ambition to collaborate with Hollywood. The recent sale of *Negro and Alligator* (1927; pl. 42) to King Vidor, director of *Hallelujah!* (1929), the first Hollywood major studio musical with an all-black cast, possibly spurred him on and validated his stereotyped image of a black man.[28] What is certain is that soon after the debut of Capra's movie and its promotional poster featuring the impressive figure cut by Joe Louis, Benton gave away his painting to the State Historical Society of Missouri.[29]

Benton's propaganda crusade of 1942, although well-intentioned, was ill conceived. His paintings relied on the ever-disparaging Hollywood stereotypes of black men (*Negro Soldier*); drew upon Hollywood sentimentality, which, in Benton's hands, mitigated their power (*Embarkation: Prelude to Death* and *Shipping Out*); and employed the visual language of escapist entertainment to convey a message of dire immediacy (*YOP*). Ironically, it would prove to be an artistic campaign emasculated by its own psychological contradictions.

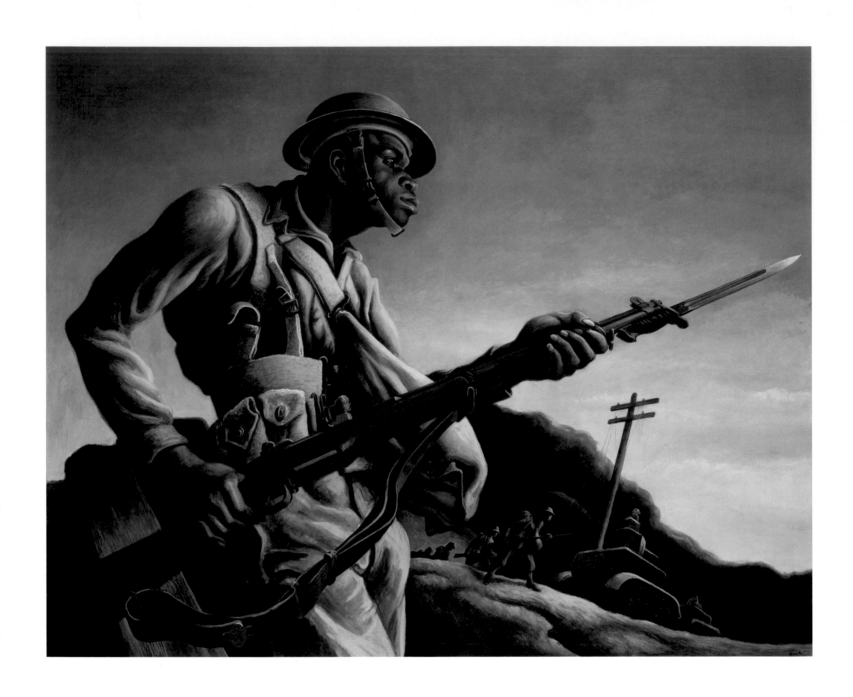

Plate 79
Negro Soldier, 1942
Oil and egg tempera on canvas, mounted on panel
58 ¼ × 70 ¼ in. (148 × 178.4 cm)
State Historical Society of Missouri, Columbia, 1944.1

AMERICAN MANHOOD PERSONIFIED

Pellom McDaniels III

At first glance, Thomas Hart Benton's *Negro Soldier* (1942; pl. 79) belies the history of African American men's full-fledged participation in the US armed services and their entitlement to all the rights and privileges associated with full citizenship in the American democratic system. A soldier's body, like a prizefighter's, is strength personified: a well-honed tool of war, both ready and willing to destroy a worthy opponent. Since the origins of America as a colony of freedom-seeking people of European descent pushing back against the monarchy of Great Britain, black men have fought alongside white men in the hope of securing their own freedom as well as America's. As "torchbearers of democracy," African American soldiers were consistently denied their birthright by the white majority, even as they sacrificed themselves for the good of the country.[1] And, indeed, that country became rich largely as a result of the coerced labor extracted from generations of enslaved people of African descent. Benton's *Negro Soldier* perpetuates the myth of African American inferiority through the representation of the black body as innately repugnant. The scale, posture, and stance of the figure emphasize the grotesque, simian-like features characteristic of the "Negro," supporting the mythology of blackness as animalistic and uncivilized. By depicting an African American in the guise of a soldier—traditionally seen as brave and heroic—Benton complicates that mythology.

Above all else, a man's body, and how he carries it, reveals his true essence. At least, this is what Benton believed and attempted to convey in his hundreds of drawings and paintings of American men at work. An erect, broad-shouldered, muscular man exuded the potential to wield his resolve and physical strength over the land, the machinery found on the farm and in the factory, and other men. Conversely, a man unwilling or unable to work for his fair share wasn't worth a damn in the enterprise of building America. He could not be a real man, and therefore he could not be a real American.

Benton's own enterprise involved elevating the value of hard work and promoting the necessity of being a productive individual, which were essential elements of the American creed. His paintings of African American men, however, bring to the surface the many contradictions and racial myths at the foundation of American society,

especially the notion of manliness, an inherent feature of white men's bodies that, by contrast, was perceived as inherently absent in black men's bodies. African American men—no matter how strong, hardworking, or brave, and even those whose service to the nation as soldiers helped solidify America as a global power—could never be equal to white men. They could never really be American.

CONTRADICTIONS AND MYTHMAKING

A native Missourian, Benton had midwestern roots and southern sensibilities that informed his view of rural whites as the salt of the earth; their work ethic and sense of Manifest Destiny were foundational in building America's wealth and maintaining its place in the world. He was also conscientious about acknowledging the role played by African Americans in the development of the land, being especially mindful of those who labored alongside whites to cultivate useful agricultural commodities, such as cotton, hemp, and tobacco, for local consumption. At the turn of the twentieth century, in Benton's hometown of Neosho, the social contract between blacks and whites was still based on the racial paternalism developed during slavery and reinforced by Jim Crow segregation. Benton's views on race were undoubtedly shaped by his upbringing as the son of Confederate colonel M. E. Benton, who had fought in the Civil War alongside Nathan Bedford Forrest, the first Grand Wizard of the Ku Klux Klan.

In Benton's portrayals of black people in the fields, the "Negro" hamlets, and the churches, as well as at play, race acts as a "floating signifier,"[2] grounded historically in slavery, the traditions of the South, and the artist's own family history. Some of Benton's early paintings of African Americans are eerily reminiscent of the popular stereographs and postcards of the late nineteenth and early twentieth centuries, in which African Americans were readily objectified as feckless coons and pickaninies. This early form of mass-produced and distributed photography brought canned images of African Americans to a growing audience throughout the United States.[3] Staged scenes of black men shooting craps, stealing chickens, and eating watermelon fostered the fantasies of whites, many of

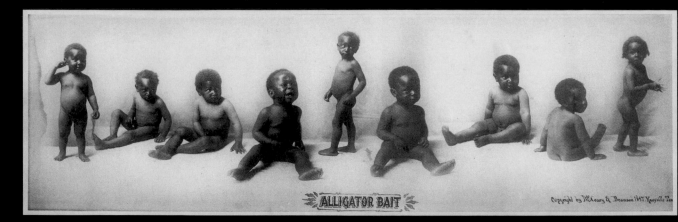

Fig. 1. "Alligator Bait," postcard, c. 1897

whom were psychologically, culturally, and politically invested in narratives of black degradation and inferiority. Benton's replications of these crude portrayals of African Americans represented the "best" kind of Negro: happy, obedient, and impotent.

THE BLACK BODY AS A SITE OF MEMORY

In his 1927 painting *Negro and Alligator* (pl. 42), Benton portrays a sinewy black man standing near a baby alligator on a riverbank. What is most important about the image is its connection to the history of domestic terrorism experienced by African Americans, especially in the South. The image of the alligator recalls the many instances of the bodies of murdered African Americans being thrown into the marshes, bayous, rivers, and backwaters to be devoured by alligators. The sick irony of the painting is that the figure is holding a pail that looks to have been used for carrying bait. He appears startled to see a grinning baby alligator approach him, as if conscious of the joke being played. Having traveled throughout the South, Benton was undoubtedly aware of references to black babies as "alligator bait" (fig. 1). And yet, in this painting, he chooses to invert the dangerous actions of deranged perpetrators into a playful scene that effectively emasculates his black subject.

This subtle, but extremely powerful, form of black emasculation is also found in *Negro Soldier*. Here, Benton personified African American manhood through the figure of a soldier whose body is bent and sinewy and whose profile resembles that of a primate. It is not known if Benton read the 1933 English translation of Adolf Hitler's *Mein Kampf* (1925), in which Hitler claims that black people were half-monkey and half-human. Nor do we know if it was Benton's intention to reduce the potency of black soldiers as men by recalling Darwinian racial theories. What is clear, however, is Benton's perpetuation of racialized definitions of African American masculinity as

grotesque, which manifests in the painting in the apish body language of the black figure.

According to the theologian Wilson Yates, the grotesque can be defined as "art whose form and subject matter appear to be a part of, while contradictory to, the natural, social, or personal worlds of which we are a part. . . . Its images most often embody distortions, exaggeration, a fusion of incompatible parts in such a fashion that it confronts us as strange and disordered, as a world turned upside down."[4] In Benton's *Negro Soldier*, the dark implications associated with the African American soldier holding his rifle with bayonet at the ready seems paradoxical in a country fearful of fully realized black manhood. Benton created *Negro Soldier* after his 1942 series of war paintings, *Year of Peril*. It was no doubt a response to the idea that an invasion of America had the potential outcome of a foreign power elevating the marginalized Negro into the role of ally. This would have confirmed the fears of many Americans that blacks were capable of becoming traitorous foes.

In the end, Benton's portrayal of the grotesque physiognomy of the figure as apelike, animalistic, and nonhuman — and therefore emasculated — perverts the truth of African American men who served in the military with honor, courage, and bravery for their country, and in pursuit of their own freedom. The painting demonstrates that African American men, even those fighting in service to the cause of defending democracy abroad, were perceived as a threat to white American definitions of manhood. In his poem, "Negro Soldiers" (1917), Roscoe C. Jamison writes:

These truly are the Brave,
These men who cast aside
Old Memories, to walk the blood-stained pave
Of Sacrifice, joining the solemn tide
That moves away to suffer and to die
For Freedom — when their own is yet denied.
O Pride! O Prejudice! When they pass by,
Hail them, the Brave, for you now crucified![5]

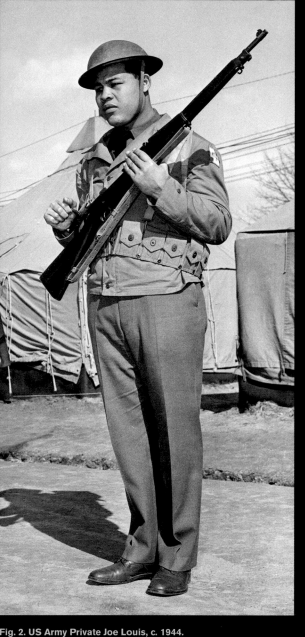

Fig. 2. US Army Private Joe Louis, c. 1944.
Chicago Tribune

When seen through the lens of Jamison's poem, Benton's
image of the Negro soldier signifies the long history of
African American men, bent from carrying the weight of
history upon their shoulders, yet still hopeful of claiming
their birthright of full citizenship. According to Jamison,
these men are truly free and able to "grandly rise above
base dreams of vengeance for their wrongs, who march to
war with visions in their eyes of Peace through Brotherhood."[6]
This image of Negro soldiers should prevail over any,
including Benton's, that could discredit and nullify their
value, both as men and as loyal American citizens.

Plate 80
Shipping Out, 1942
Oil on canvas
40 × 28 ½ in. (101.6 × 72.4 cm)
Private collection

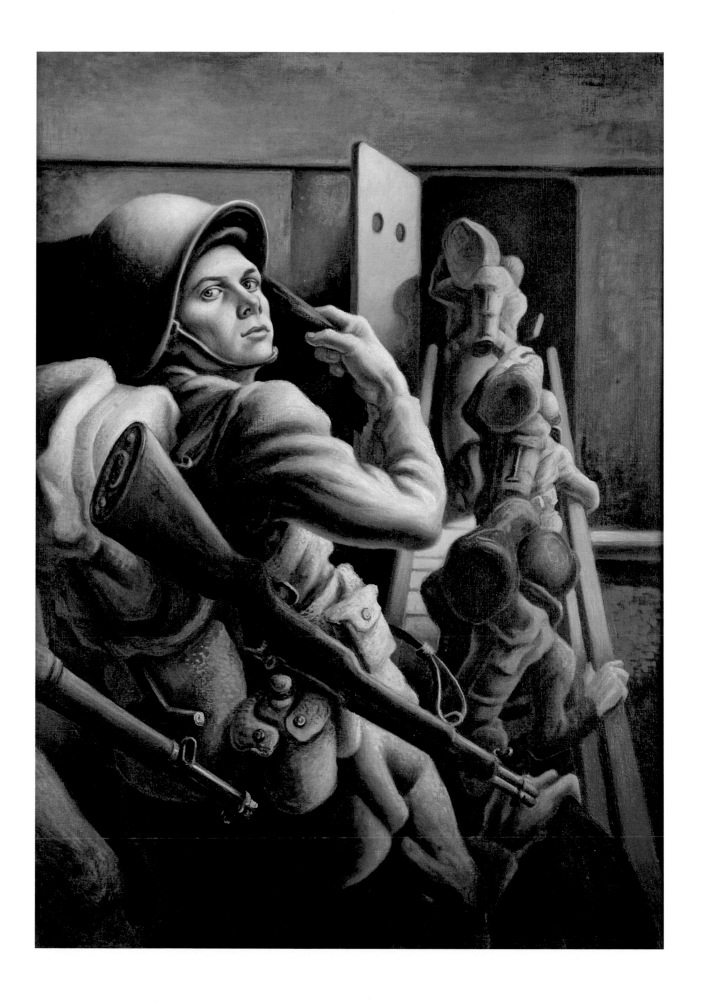

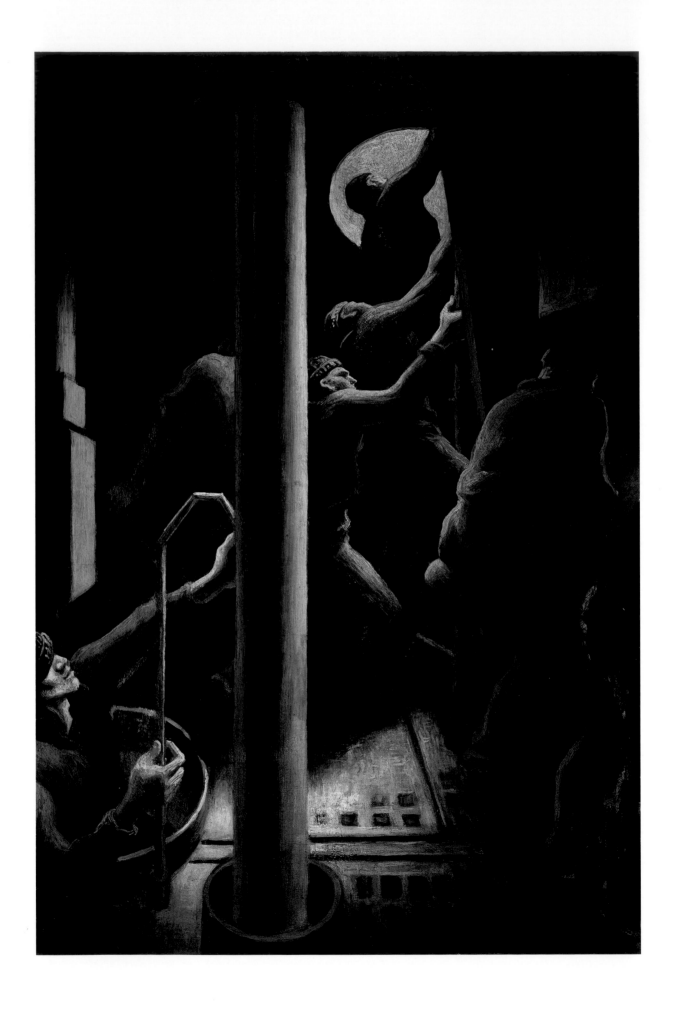

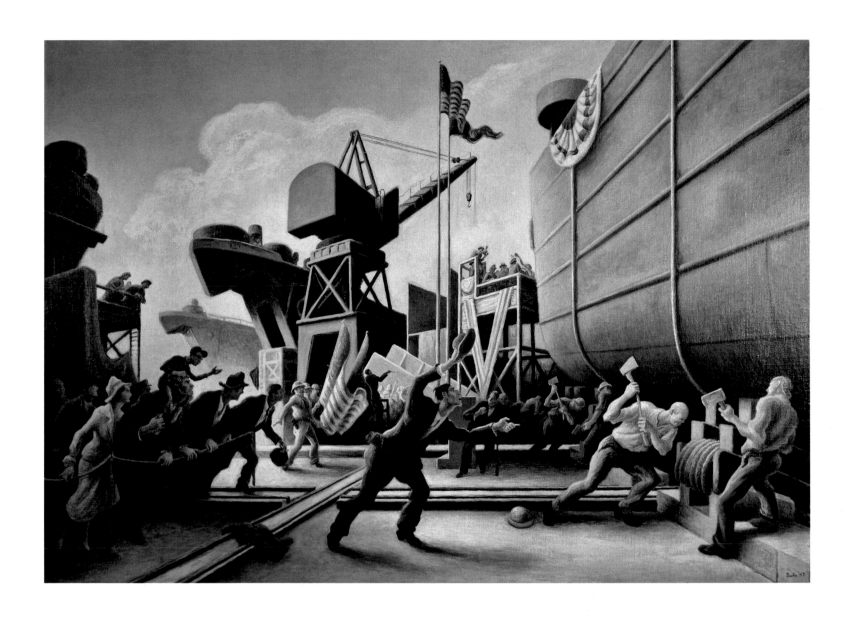

Plate 81
Up the Hatch, 1943/44
Oil on pressboard
30 ½ × 20 ½ in. (77.5 × 52.1 cm)
The Naval Historical Center, Washington,
Gift of Abbott Laboratories, 88-159-BQ

Plate 82
Cut the Line, Launching of an LST, 1944
Oil and tempera on canvas
34 × 48 ¼ in. (86.4 × 166.6 cm)
The Naval Historical Center, Washington,
Gift of Abbott Laboratories, 88-159-BO

ART NEWS FROM NOWHERE

**Thomas Hart Benton,
Kansas City, Missouri**

He began to
paint as a symbolist,
an abstractionist,
an experimenter
who wedded the
Renaissance to Cubism
and even invented
an ism of his own—
a formal use of color
called synchromism.
But in the Age of
Picasso, who
will remember his
disciples? And so,
casting Paris
behind him, Benton
founded his reputation
in local color and the
American subject:
neurotic pioneer folk
writhing like modern
dancers in the tough
or homey landscape.
Big murals, big social
and literary mythology,
no palefaces need apply.
But Picasso had his
revenge. Benton's
baby-sitter and pupil,
Jackson Pollock (who
"never learned to
draw") took the
limelight after World
War II and the art
critics never looked
back. Now seventy-
seven, Benton
still makes big art
and big money.
But only the folk like
him. As Yeats wrote:
"Why should not
old men be mad?"

WHY I LIVE WHERE I LIVE

Greil Marcus

Esquire magazine used to run a regular column called "Why I Live Where I Live"—where, in essence, various writers were invited to explain why they didn't live in New York. This forced people into a position of defensiveness: that anyone with a claim to a working intelligence or even a tinge of sophistication would choose to live anywhere else suggested big-fish-in-a-small-pond syndrome (*Oh, that's old Frank, you know, our writer feller*) if not laziness, cowardice, misanthropy, or regionalism. If you can't make it here, who cares where else you can make it? In perhaps the best-known entry in the series, Walker Percy weighed in, in 1980, from Covington, Louisiana. He adopted the tone of the grandee:

> Another attraction is Covington's rather admirable tradition of orneriness and dissent. . . . It is a backwater of a backwater. Yet the region was a refuge for Tories in full flight from the crazy American revolutionaries. Shortly thereafter, when several local parishes revolted against Spain to set up their own republic—capital at St. Francisville, flag with one star, which lasted three months—Covington was against it. It liked the Spanish. When the United States and Louisiana proposed to annex the Republic of West Florida, we voted against it. We didn't like Louisiana. When Louisiana voted to secede from the Union in 1861, we voted against that too. We liked the Union. Yet when the war was over, slave owners kept their slaves as if the Emancipation Proclamation never occurred. During the years of prohibition, the Little Napoleon bar served drinks.[1]

Thomas Hart Benton (fig. 1) first came to New York, after three years in Paris and "a few depressed months at home in Missouri,"[2] in 1912, when he was

Fig. 1. Duane Michals, photograph of Thomas Hart Benton for *Esquire* feature "Art News from Nowhere," January 1965. Courtesy of Carnegie Museum of Art, 2013.33.TN.34.1–2

twenty-two; after home-front Navy service during World War I, he returned, in 1921, and stayed twenty-four years. "I love the place," he wrote in a long, un-published why-I'm-not-going-to-live-where-I-lived-memoir-cum-sociological-treatise-cum-antihomosexual-rant-cum-sentimental farewell in 1935. "There are many people I shall remember," he wrote, "people I learned to like, artists and writers and lawyers, actors and pugs, homos and skirt chasers, radicals and conservatives, men and women, Jews, gentiles, yellow men and black. I shall remember best my students, especially those who used to sit with me on Monday night and blow on the harmonica to the accompaniment of Rudy, the furrier who lived around the corner."[3]

That clichéd and banal statement, redeemed by its honesty – "people I learned to like," with the sense that New York was a project for Benton, that he had to change, to become a new person, to learn to like anyone he might encounter, to suspend any hesitations or trepidations or bigotries or flinches without ever altogether erasing them – opens up into so-called regionalism, a label Benton knew was dismissive pigeon-holing ("The term was, so to speak, wished upon us," he wrote in 1951 of himself and the other so-called region-alists, John Steuart Curry and Grant Wood), and that he accepted, because for him regionalism, as an idea, not a school, was a window onto the whole of the country itself. Percy celebrated his Covington, or pretended to, as a "non-place," but for Benton every American place was a real place. Every place had its own history, its own provincialisms, its own purchase on the greater world, its own manners, its own gestures, and, finally, its own language, which you could learn to speak. You could watch, listen, engage, argue, sit back, have a drink, and keep talking, until the person you were talking to trusted you and you were actually interested in what that person might be saying – until you learned to trust the place itself. Benton did this through rambles – journeys out from Missouri or New York to Appalachian Pennsylvania, the Carolinas, Wyoming, Arkansas, Colorado, Texas, West Virginia, Georgia, Louisiana, and Virginia,[4] ideally on foot, the better to meet people, but with rides accepted (never, Benton said, with his thumb out), by bus or train, or by car with a stu-dent at the wheel – but he also did it in place. The idea – the faith – was that America was a ruling notion, an expanding experiment, geographically but also politically, that imprinted itself *as* an idea on every town, city, farm, forest, swamp, or hamlet under the sway of the country's history, so that, if you knew how to look, you could see that any place could at once enact and speak for the country itself. And you can see this happening everywhere in Benton's work, because that idea was his ruling passion.

"I set about painting American histories,"[5] Benton writes of his early postwar years in New York in *An Artist in America*, which rivals Larry Rivers's *What Did I Do?* as the most engaging American artist's autobiography of the twentieth century. The plural "histories" is the crucial signifier in Benton's sen-tence: every American place, for that matter every American, carried a version of American history. We can see that in two completely dissimilar paintings, one now existing solely in Benton's words,[6] the other on the walls of the state capitol in Jefferson City, Missouri.

"That was the first of a long series of American portraits,"[7] Benton writes of his first New York commission: he's been brought to a Tammany clubhouse to render a likeness of the new boss. One look and Benton is see-ing a part of the country he hasn't seen before. He'll be told to work from re-touched photos, not to paint the smeared face of the man himself, to make him look good, and he'll have to all but steal his work out of the building in

order to scrape off the fake portrait he's made over the real one, but it's a visitation and he can't let it go: "I didn't give a damn about the commission, but I wanted my young alderman."[8] Because this is what he'd seen, what he had to catch:

> The circle of men parted and out came the very prince of young aldermen, the very archetype of young Tammany schemers. Benny, the neighborhood political genius, took me off my feet. He was *it* so thoroughly, so completely, that without my eyes to show me I shouldn't have believed him real. He was immaculately dressed. His swank derby was cocked at the exactly correct aldermanic angle. His broken, flattened nose was squashed over his fat lips and his uptilted cigar was a silent cock's crow to the world.[9]

But you can catch that same sense of pluralism, where each detail implies the greater, ultimately unpaintable whole, churning through perhaps the most ordinary, or merely characteristic, panel in Benton's 1936 series *A Social History of the State of Missouri*, the mural that, following on his 1930–31 *America Today* for the New School in New York (where the alderman would have fit right in), the 1932 *Arts of Life in America* at the Whitney Museum of American Art in New York, and the 1933 *Social History of Indiana* for the Chicago World's Fair: not the uproarious Frankie and Johnnie panel, or the ugly slavery panel, but the prosaic *Politics, Farming, and Law in Missouri* (fig. 2). Here the plural "American histories" shows its real engine. It's the plural of an absolutely modernist simultaneity—which until the late-1940s work of Benton's onetime student Jackson Pollock was far more present in film, poetry, and jazz than in painting—where everything is happening at once. In such a confusion, it's up to the viewer, the artistic and political citizen, to make sense of it all, to affirm that part of the whole he or she is drawn to, to join the composition or turn away.

Here, with the elongated figures that lie somewhere on the twentieth-century arc that bends from Picasso's *Les Demoiselles d'Avignon* to DC Comics's Plastic Man and makes Benton's murals less a form of music than a form of dance, the eye is drawn first to a gathering on the left—and maybe because in this spot there is less movement on the wall than there is anywhere else. A crowd of people—nine seated, six standing, two in a wagon, the mere seventeen nevertheless seeming like a substantial gathering, in fact like the whole citizenry of the town with its storefronts behind them—is listening to a politician giving a campaign speech. There are two men seated behind the politician on the stage: a fat, impressive-looking man in a broad Stetson off to the right, and a young woman, the only woman in this crowd, changing a baby. The speaker on the stage raises his left hand in vehemence, even if he is really only introducing the more distinguished-looking man behind him, whose portrait, draped with pretentious folds of red, white, and blue, watches over the whole scene as if it's seen it all before. It's hard to tell whether this part of the picture has anything to do with the rest of it—if politics is central to labor, farming, social life, railroads, train-robbing, even, perhaps, a lynching, or if real life is elsewhere, which is to say, right here, where in the center foreground two men are sawing a timber in half, where directly above them three women unpack baskets of food on a table, where to the right a man wrestles a plow behind a horse, where beneath him others reap a wheat field, where off to the right and above a woman feeds chickens and

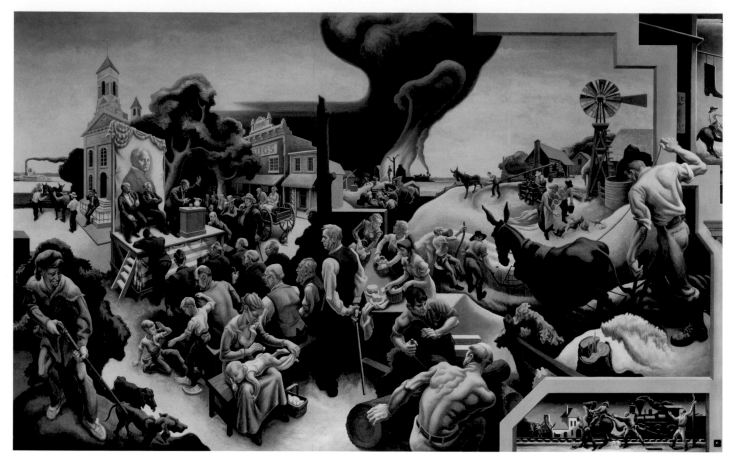

Fig. 2. Thomas Hart Benton, *Politics, Farming,
and Law in Missouri*, east wall of the mural series
A Social History of the State of Missouri, 1936.
Missouri State Capitol, Jefferson City

a boy tends to a mule, and where to the far right a mounted cowboy fires a
gun. After a few moments, it's the faint glimpse of a river in the far back of the
panel, the orange smoke from a fire and the black smoke from a train engine
rising behind it, and the billows of both dwarfed by the specter of an enor-
mous tornado that seem to suck up everything else that's taking place; then
that part of the tableau breathes, and the eye goes back to postures, faces,
and the play of detail, where as the speaker hits his peroration a man leans on
the stage, his head resting on his arms over the red, white, and blue bunting,
as if he has, in the midst of all this noise, fallen asleep.

"A mural for me is an emotional spree," Benton wrote, summing up this
panel and all the dozens of others, down to those of the 1975 *Sources of
Country Music*, which he was working on in the studio behind his house in
Kansas City when he died. "A certain kind of thoughtless freedom comes over
me. I don't give a damn about anything."[10] In words that could have been
Pollock's, as Pollock described his own ecstasy, his "When I'm painting, I'm not
aware of what I'm doing," his "the painting has a life of its own," his insis-
tence—where even if all anyone could see was random, meaningless (what to
Benton himself was a kind of nihilism)—that "when you're painting out of your
unconscious, figures are bound to emerge," Benton went on: "Once on the wall,
I paint with downright sensual pleasure. The colors I used make my mouth
water. The sweep of my brushes, after I get really started, becomes precise and
somehow or other beyond error. I get cocksure of mind and temperamentally
youthful. I run easily into childish egomania or adolescent emotionalism."[11]

There is a way in which Benton was driven out of New York. He was a New Dealer, and downtown left-wing art circles, with the painter Stuart Davis their most prominent and forceful spokesperson, saw FDR as the capitalist wolf in the people's sheep's clothing. Regionalism—as found in Benton's yeomen and city slickers, Woods's stolid farmers, and Curry's pastoral scenes—was fascist and racist, insisting on who was American and who wasn't, never mind the sardonic critique thoughout Benton's murals or the suggestion of terror, even horror, in the words *American Gothic*. "Benton has been criticized as fascist, but such a judgment is premature," the critic Meyer Schapiro wrote in *Partisan Review* in 1938 in a review of Benton's autobiography, before proceeding to establish that such a judgment was, if anything, an old story, Benton a relic, and New York well rid of him.[12] "In all places I was heckled when I got up to talk," Benton wrote of the controversy his murals kicked up:

> But when I rose in New York I could count on a raging torrent of opposition. I gave as good as was given to me, sometimes a little better, and an incredible number of people got to disliking me. Down in the streets of Greenwich Village where I lived I used to overhear the young radical artists say, "There goes that son-of-a bitch Benton."

— You know, old Tom, our painter feller —

> In the course of time I began to see that I was doing a lot more talking than painting and that I was making more enemies than friends.[13]

Benton wrote off New York in 1935 as "a highly provincial place": "It has such a tremendously concentrated life of its own that it absorbs all the attention of its inhabitants and makes them forget that the city is, after all, only an appendage to the great aggregation of states to the north, south, and east,"[14] and the chip that any westerner carries on his shoulder when considering the East grew large and burdensome, then light and pleasurable. With a teaching post at the Kansas City Art Institute and a commission to paint the Missouri capitol, he was ready to go back where he came from, even if, soon enough, he would find the Midwest just as parochial as New York: "the same damn bores."[15] He was kicked out of the Art Institute as a Communist, or a New Dealer, as if anyone cared about a difference. In 1934, he was on the cover of *Time*; soon, he would be out of fashion. He stayed angry and irritated and unsatisfied to the end of his life, painting his way out of the conviction, as he wrote at the end of his goodbye to New York, in as frank and plain as any American artist, in any medium, has ever put it, summing up, to me, the essential unknowability of the American subject, its reality as at once a fact and a myth, a truth and a lie, a place and a nonplace, a subject that no American artist could turn away from and none could stand up to, that "when I take stock of myself, apart from alcoholic drinks and the equally intoxicating effect of words, I find that I don't believe anything very much."[16] That faith allowed him to live in any place that caught his eye, to talk to anyone, to listen, and to keep both himself and the country, the country he traveled, the country he painted, unsettled.

BENTON, HOLLYWOOD, AND HISTORY

A TIMELINE

Sarah N. Chasse

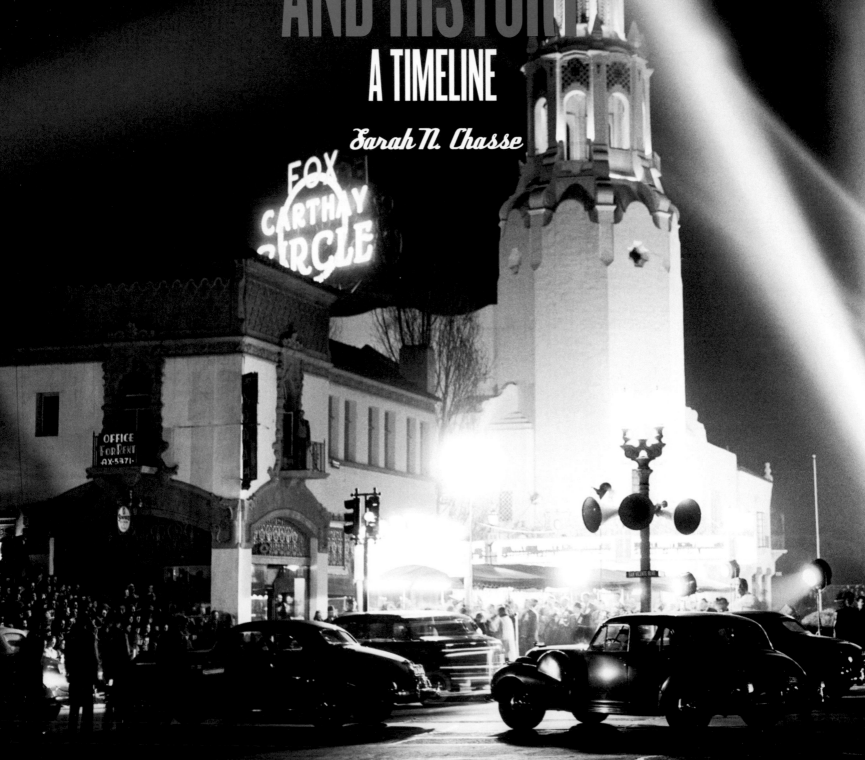

1889
Birth of Thomas Hart Benton, on April 15, in Neosho, Missouri.

1894
Thomas Edison films reenacted scenes of Buffalo Bill's Wild West show at his laboratories and film studio in West Orange, New Jersey. These scenes, or "actualities," including *Annie Oakley, Buffalo Dance*, and *Bucking Broncho*, are among the earliest known motion pictures produced in the United States.

1903
Edwin S. Porter's *The Great Train Robbery* captivates audiences and heralds the popularity of the western as a film genre.

1904
Benton visits the St. Louis World's Fair (the Louisiana Purchase Exposition), where he meets Buffalo Bill and shakes hands with Geronimo.

1907
Benton enrolls at the Art Institute of Chicago school.

1908–11
Benton studies independently in Paris, briefly enrolling at the Académie Julian.

1911
Benton moves to New York City.

1912
Moving Picture World magazine uses the term *western* to describe widely popular films about the American West; director William N. Selig claims to produce a western "every Tuesday."

1913
Benton meets and shares a studio at the Arcade Building, Lincoln Square, in Manhattan with Rex Ingram, a Yale University–trained sculptor who becomes a leading film director.

Benton does commercial art jobs, including set designing, historical reference work, and portrait painting, for motion-picture productions in Fort Lee, New Jersey—site of the emerging film industry—and soon sets up a studio there.

Director and producer Cecil B. DeMille abandons New Jersey for Arizona and then finally settles on Hollywood in search of more realistic locations for *The Squaw Man*, the first feature-length film made in Hollywood.

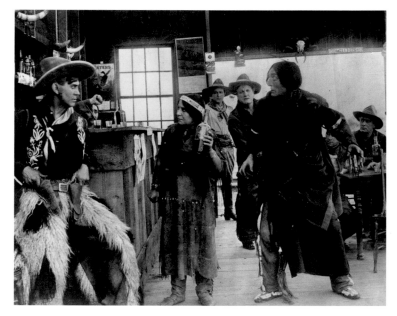

1913
Scene from *The Squaw Man*

Opposite: The Carthay Circle Theatre lit up for the premiere of Walt Disney's *Fantasia*, January 1941

1914

New York Times uses the new terms *to film* and *movie* in an editorial.

Assassination of Archduke Franz Ferdinand of Austria on June 24 leads to beginning of WWI in Europe.

1915

In his book *Art of the Moving Picture*, poet Vachel Lindsay proclaims that moviemaking may be "the destiny of America."

The Bell & Howell 2709 movie camera allows directors to take close-ups without physically moving the camera.

Director D. W. Griffith's silent epic *The Birth of a Nation* premieres in Los Angeles. President Woodrow Wilson screens the film at the White House and describes it as "writing history with lightning." The movie glorifies the South and the Ku Klux Klan, prompting the NAACP to organize a national protest.

1916

677 feature films released; 10 million average weekly attendance

Benton becomes director of the Chelsea Neighborhood Art Gallery, dedicated to forging alliances between artists and this New York neighborhood's business and Americanization efforts. Benton begins teaching free art classes, mostly to immigrants, including his future wife, Italian-born Rita Piacenza.

Rex Ingram begins directing movies for Fox, Universal, and World studios in Fort Lee and employs Benton to design sets and paint backdrops.

Technicolor Corporation receives US patent for its "auxiliary registering device for simultaneous projection of two or more [color] pictures."

President Woodrow Wilson's reelection campaign uses Thomas H. Ince's film *Civilization* to support Wilson's isolationist campaign to keep the US out of WWI.

National Park Service established.

1915
Scene from *The Birth of a Nation*

1917
Thousands of African Americans lead a protest march down New York City's Fifth Avenue

1917

US enters WWI in April.

US government establishes Division of Films to promote the American cause in WWI. The secretary of war subsequently assigns the US Army Signal Corps the task of documenting the war on film.

Riots in East St. Louis, Missouri, prompt a silent NAACP-organized demonstration in New York City, protesting racial discrimination and violence in America.

1918

Benton enlists in the US Navy.

Benton serves as a draftsman at Norfolk, Virginia, naval base, where he spends free evenings reading American history.

The word *cinema* enters common parlance and *Hollywood* is now used generically to describe the American film industry.

Government designates filmmaking an "essential industry"; employment in the movies becomes a basis for exemption from military service.

WWI ends on November 11, 1918.

1919

Benton conceives and "self-commissions" a mural series, later called *American Historical Epic* (pls. 1–14), depicting a people's history of the United States.

Oscar Micheaux, a pioneering African American film director and producer, releases his first film, *The Homesteader*, based on his novel and set in South Dakota.

Joint committee of the House and Senate directs the movie industry to make films that will "upbuild and strengthen the spirit of Americanism."

1918
Benton in his naval uniform

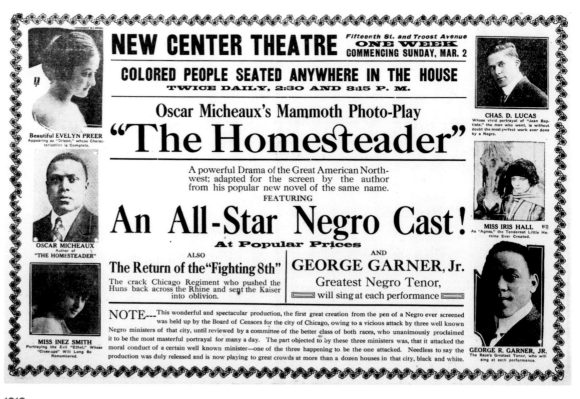

1919
Advertisement for *The Homesteader* in the *Kansas City Sun*, March 1

1920

797 feature films released; 35 million average weekly attendance

Ratification of the Eighteenth Amendment prohibits production, transport, and sale of liquor, ushering in Prohibition, an era notorious for bootleggers and gangsters.

The National Americanization Committee, a group of movie executives and politicians, including Secretary of the Interior Franklin K. Lane, producer Lewis J. Selznick, and founder of Paramount Pictures, Adolph Zukor, releases the documentary *Land of Opportunity*, the first in a series of films aimed at assimilating immigrants.

Film adaptation of James Fenimore Cooper's 1826 novel, *The Last of the Mohicans*, directed by Clarence Brown and Maurice Tourneur, is released. White actors painted in "brownface" play the Indians.

The Mitchell camera comes into use, allowing cinematographers to compose shots while looking through the lens. It eventually replaces the Bell & Howell 2709.

Benton spends his first summer on Martha's Vineyard, Massachusetts, at the invitation of Rita Piacenza, one of his former art students and future wife.

1921

Landmark musical revue *Shuffle Along*, written, produced, and performed by African Americans, debuts on Broadway. Hugely popular, the show subverts common racial stereotypes.

Rex Ingram directs *The Four Horsemen of the Apocalypse*, starring Rudolph Valentino. Considered Hollywood's first blockbuster, the film is also one of the longest features of the silent era (eleven-reels, running time 156 minutes).

1922

Benton and Rita Piacenza marry in New York.

Chester M. Franklin's *The Toll of the Sea*, the first feature film produced in two-color Technicolor process, blending red and green negatives, is released.

1923

Benton first exhibits *Discovery* (1920; pl. 1), the initial panel from the mural series now known as *American Historical Epic*, at the Architectural League of New York's annual exhibition under the title *Symbolical History of the United States*.

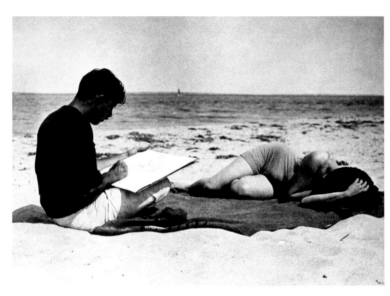

1920
Benton sketches Rita Piacenza on the beach, Martha's Vineyard

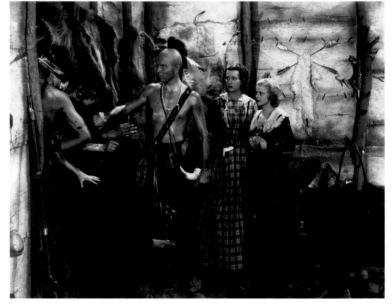

1920
Scene from *The Last of the Mohicans*

1920
Rita Piacenza

James Cruze's *The Covered Wagon*, the first film epic of American expansionism, is the top-grossing movie in North America. Shot on location in Utah, it uses more than 500 wagons. Native American actors are cast for authenticity.

1924

Director John Ford releases his first major feature-length film, *The Iron Horse*, which chronicles the building of the transcontinental railroad. The movie takes inspiration from *The Covered Wagon*, with its focus on westward expansion and its attention to realistic detail.

D. W. Griffith's *America* premieres in New York. Based on Robert W. Chamber's 1905 novel, *The Reckoning*, it covers American history from the beginning of the Revolution through 1782.

During President Calvin Coolidge's administration, Native Americans become full US citizens under the Indian Citizenship Act (aka the Snyder Act), enacted partially in recognition of Indians' service during WWI.

The enactment of the Immigration Act (aka the National Origins Act) further restricts the number of immigrants allowed to enter the country.

Benton publishes his first article on modern painting, "Form and the Subject," in *The Arts* magazine.

Benton travels to Missouri, inaugurating a lifelong series of annual journeys through America.

1925

The Bentons purchase a permanent summer home on Martha's Vineyard.

The *Grand Ole Opry* begins broadcasting live country and western music. It remains the nation's longest-running radio show.

1926

740 feature films released; 50 million average weekly attendance

Benton goes on a walking tour of the Ozarks and then travels through Texas and New Mexico. Sketches made in Borger, in the west Texas panhandle, inspire him to paint *Boomtown* (pl. 16) the following year.

Benton begins teaching at the Art Students League of New York, a position he holds for ten years. His most famous student there is Jackson Pollock.

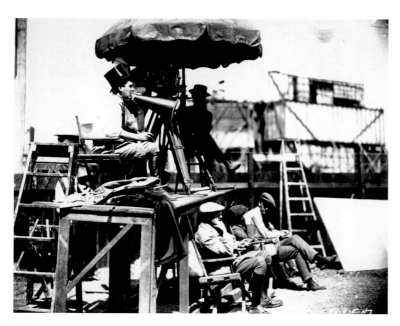

1921
Rex Ingram (holding megaphone), directing *The Four Horsemen of the Apocalypse*

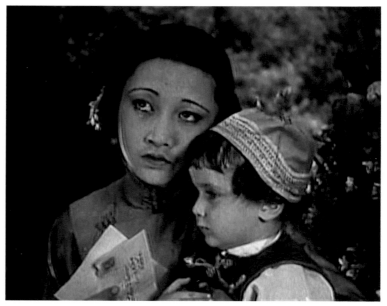

1922
Scene from *The Toll of the Sea*, featuring Anna May Wong

Benton publishes "Mechanics of Form Organization in Painting," the first article in a five-part series published 1926–27 in *The Arts*. The articles examine compositional ideals of balance, sequence, and rhythm, as well as the three-dimensional qualities of form in painting.

Birth of Thomas Piacenza "T. P." Benton, Benton and Rita's first child.

Warner Bros. and Western Electric perfect synchronized sound between a phonograph record and a film projector, calling the system, and the company formed around it, Vitaphone.

A review in the *New York Sun* of Robert J. Flaherty's *Moana*, the follow-up to his *Nanook of the North*, introduces the word *documentary*.

The Carthay Circle Theatre opens in Los Angeles.

1927

Benton completes *The History of New York* in an unsuccessful attempt to secure a commission from the New York Public Library. The self-commissioned mural series includes the panels *1400: Aboriginal Days*; *1653: Pilgrims and Indians*; *1865: Civil War*; and *1927: New York Today*.

Thomas H. Benton opens at the New Gallery in New York. Cultural critic Lewis Mumford writes the catalogue essay for this exhibition of recent work by Benton, including *The History of New York* and new mural panels from *American Historical Epic*.

Harry A. Pollard directs *Uncle Tom's Cabin*, the film adaption of abolitionist Harriet Beecher Stowe's 1851 antislavery novel.

Premiere of director Alan Crosland's *The Jazz Singer*, starring Al Jolson. The Warner Bros. film uses its Vitaphone sound-on-disc system, allowing for sequences of synchronized singing and talking.

Producer Louis B. Mayer cofounds the Academy of Motion Picture Arts and Sciences. Douglas Fairbanks becomes the academy's first president.

1927
Thomas Hart Benton, *1927: New York Today*, from the mural series *The History of New York*

1927
Benton poses for a publicity photo in front of *The History of New York*

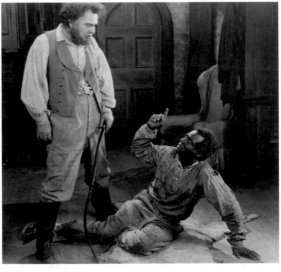

1927
Scene from *Uncle Tom's Cabin* relates to the composition of Benton's *The Slaves* (1925; pl. 8) from the mural series *American Historical Epic*

1927
The Jazz Singer opens at Warner Bros. Theatre, New York

1928

The Motion Picture Producers and Distributors of America issues "Don'ts and Be Carefuls," stipulations advising studios to avoid depicting nudity, drugs, cursing, white slavery, and miscegenation in their films.

Grauman's Chinese Theatre opens in Hollywood.

First sound newsreel is screened in New York.

Benton travels through the Deep South, visiting Alabama, Georgia, Louisiana, and Mississippi.

Benton publishes "My American Epic in Paint" in *Creative Art* magazine, a response to criticism of his *American Historical Epic* mural series.

Benton paints *Bootleggers* (pl. 43), a work about the activities of Prohibition, in an effort to create a more contemporary history painting.

Warner Bros. releases *Lights of New York*, a gangster movie directed by Bryan Foy; it is the first "all-talking picture."

1929

707 feature films released; 95 million average weekly attendance

Benton's solo exhibition *The South* opens at Delphic Galleries in New York. It presents more than 100 drawings made during Benton's southern travels in 1927 and 1928; 60 of these pictures are organized into a section titled "King Cotton."

King Vidor's film *Hallelujah!*, the first Hollywood feature with an all–African American cast, premieres in New York.

Founder of Eastman Kodak, George Eastman, shows the first color motion pictures in Rochester, New York.

On October 24, the US stock market crashes, plunging the world into economic crisis.

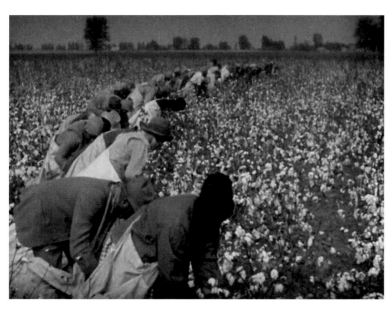

1929
Scene from *Hallelujah!* depicting cotton pickers on location at Wilson Plantation in Arkansas

Cotton Pickers

1929
Benton's illustration *Cotton Pickers*, from his autobiography *An Artist in America*

193

1930

The Big Trail, a western directed by Raoul Walsh, stars John Wayne in his first lead role.

Hollywood officially adopts the Motion Picture Production Code (aka the Hays Code), establishing formal guidelines on the depiction of sex, violence, crime, and religion in films.

Launch of *The Hollywood Reporter*, the first daily trade newspaper for the film industry; President Franklin D. Roosevelt is an early subscriber.

1931

Benton completes *America Today*, commissioned for the boardroom at the New School for Social Research in New York. The mural series consists of ten panels: *Instruments of Power*; *City Activities with Dance Hall*; *City Activities with Subway*; *Deep South*; *Midwest*; *Changing West*; *Coal*; *Steel*; *City Building*; and *Outreaching Hands* — a panel addressing the onset of the Great Depression.

1932

Benton completes *Arts of Life in America*, commissioned for the reference library of the Whitney Museum of American Art in New York. The mural series consists of eight panels: *Indian Arts*; *Arts of the West*; *Arts of the City*; *Arts of the South*; *Unemployment, Radical Protest, Speed*; *Political Business and Intellectual Ballyhoo*; *Folk and Popular Songs.*

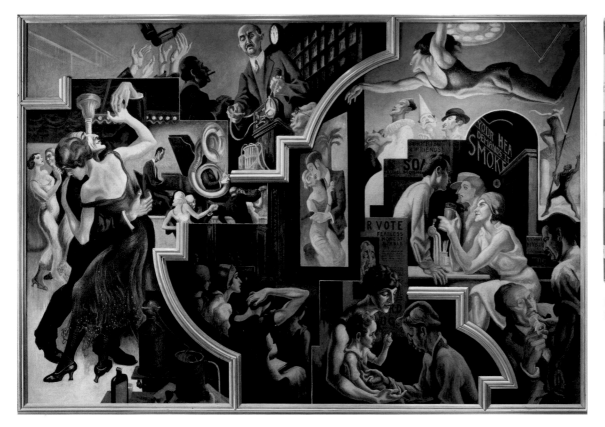

1931
Thomas Hart Benton, *City Activities with Dance Hall*, from the mural series *America Today*

1932
Leo Huberman, *We, the People*

Benton completes illustrations and dust jacket design for socialist writer Leo Huberman's *We, the People* (Harper & Brothers).

President Roosevelt first uses the phrase "New Deal" to describe the government's "relief, recovery, and reform" programs intended to help the American people during the Great Depression.

1933

The state of Indiana commissions Benton to paint *The Social History of Indiana* for its hall at the Century of Progress Exposition held in Chicago. Benton completes the 250-foot-wide mural in six months.

The Metropolitan Museum of Art acquires its first Benton painting, *Cotton Pickers, Georgia* (1928–29).

The ratification of the Twenty-First Amendment ends Prohibition.

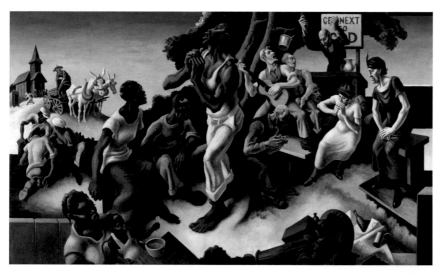

1932
Thomas Hart Benton, *Arts of the South*, from the mural series *Arts of Life in America*

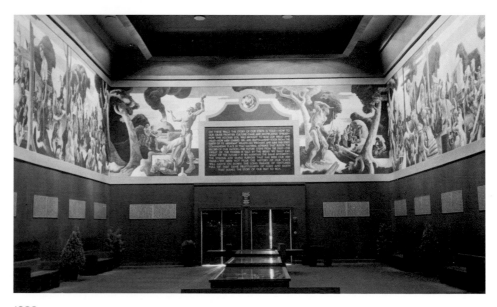

1933
Indiana Hall at the Chicago World's Fair

1934

622 feature films released; 70 million average weekly attendance

Benton, inspired by summer travels in West Virginia, paints *Minstrel Show* (pl. 44), depicting waning traditions of minstrelsy performed by African Americans for white audiences.

Associated American Artists (AAA), an organization founded by Reeves Lewenthal, helps support American artists by making their art widely available to middle-class buyers.

Benton creates first lithograph for AAA, *Plowing It Under*, which is sold in department stores nationwide for five dollars per print. The title refers to Roosevelt's New Deal policy to "plow under" more than 10 million acres of planted cotton and drive up prices. The edition of 12,000 sells out.

Benton designs dust jacket for Mary Childs Nerney's *Thomas A. Edison: A Modern Olympian* (H. Smith & R. Haas).

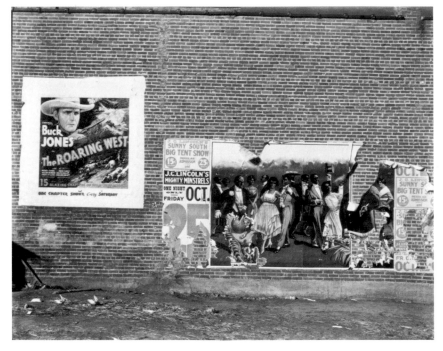

1934
Walker Evans, *Movie and Minstrel Show Posters on a Brick Wall, Demopolis, Alabama*

1934
Thomas Hart Benton, *Plowing It Under*

1934
Mary Childs Nerney, *Thomas A. Edison: A Modern Olympian*

1935

Benton's 1925 self-portrait appears on the cover of *Time*. He is the first artist to appear on the cover of the magazine.

Benton permanently moves to Kansas City to head the painting department of the Kansas City Art Institute.

The Missouri legislature officially recognizes Benton as "one of the greatest living painters" and commissions him to create murals for the House Lounge of the Missouri State Capitol in Jefferson City. Benton's $16,000 fee is more than the governor's annual salary.

Becky Sharp, directed by Rouben Mamoulian, is the first feature film shot entirely using the three-color Technicolor process, which added a blue film record to the red and green components of the two-color process. The new technology spurs Hollywood's shift from black-and-white motion pictures to color.

Weeks of devastating dust storms sweep across the central plains, culminating with the most severe damage on April 14, Black Sunday.

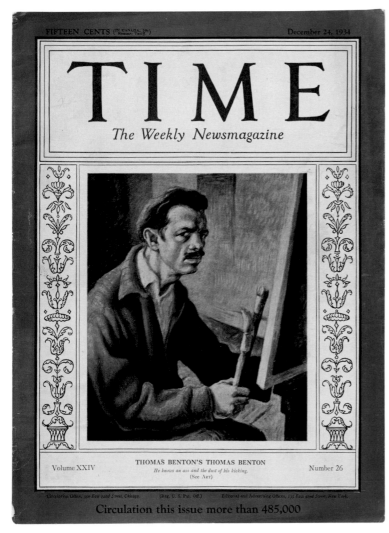

1934
Time magazine, December 24

1935
Lobby card for *Becky Sharp*, featuring Miriam Hopkins

1935
Dust storm, Kansas

1936

Benton completes his commission to decorate the House Lounge of the Missouri State Capitol Building with a mural cycled titled *A Social History of the State of Missouri*, which explores the people, histories, and mythologies of his native state.

1937

Benton creates lithographs of the *Huck Finn* and *Jesse James* (pls. 47, 48) scenes from his *Social History of the State of Missouri* mural series.

Benton publishes his nationally acclaimed autobiography *An Artist in America* (Robert M. McBride & Company). Illustrated with his drawings, Benton's narrative chronicles his journeys around the US and the chapters are titled accordingly: "The Corner of the Century," "Art and the Cities," "On Going Places," "The Mountains," "The Rivers," "The South," "The West," and "Back to Missouri."

Benton tours regions of southeastern Missouri ravaged by the flooding of the Ohio and Mississippi Rivers, a disaster that wreaked damage throughout the Midwest. Drawings produced on the journey inspire several paintings, including *Spring on the Missouri* (1945; pl. 51).

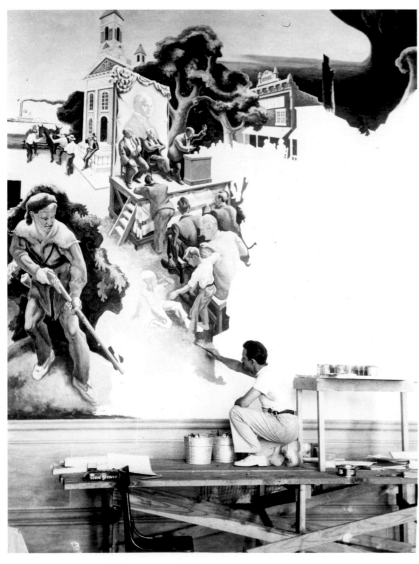

1936
Benton painting a section of the mural *A Social History of the State of Missouri*

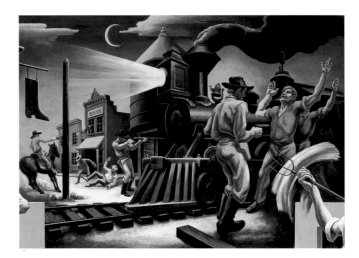

1936
Thomas Hart Benton, *Jesse James*, mural from
A Social History of the State of Missouri

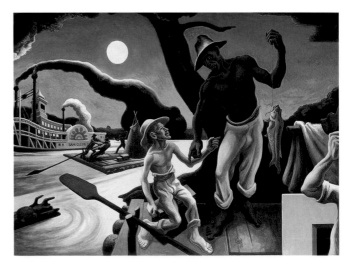

1936
Thomas Hart Benton, *Huck Finn*, mural from
A Social History of the State of Missouri

1938

Life magazine commissions Benton to portray the motion-picture industry for an article on Hollywood. Benton spends August in Los Angeles with behind-the-scenes access to 20th Century Fox Studios and creates hundreds of sketches, a series of 40 ink-and-wash drawings he calls Hollywood "notes" (pls. 54–69), and a major oil painting based on his experiences. The magazine never publishes the article.

Benton completes the painting *Hollywood* (pl. 72), a mural-size canvas based on his observations on the lot at 20th Century Fox, including the filming of *In Old Chicago*, directed by Henry King.

Life magazine publishes Benton's painting *Hollywood* in a story about the annual Carnegie International art exhibition in Pittsburgh, where it was exhibited.

1938
Scene from *In Old Chicago*

Mississippi Fisherman

1937
Benton's illustration *Mississippi Fisherman*, from his autobiography *An Artist in America*

1939

761 feature films released; 85 million average weekly attendance

Benton and Rita's second child, daughter Jessie, is born.

Life and *American Artist* magazines document Benton painting *Persephone* (1938–39; pl. 73).

Benton illustrates Mark Twain's *The Adventures of Tom Sawyer* for the Limited Editions Club.

Richard Thorpe's adaption of *The Adventures of Huckleberry Finn*, starring Mickey Rooney, is released.

John Ford's *Stagecoach* is one of the many "A" westerns produced in 1939, a trend that revived the genre. Another western, *Dodge City,* directed by Michael Curtiz and starring Errol Flynn, is among the highest-grossing films of the year.

The Wizard of Oz premieres at Grauman's Chinese Theatre in Hollywood.

David O. Selznick's Civil War saga, *Gone with the Wind*, premieres. Hattie McDaniel, who plays Mammy, becomes the first African American to win an Academy Award.

John Steinbeck publishes *The Grapes of Wrath*, an immediate best seller.

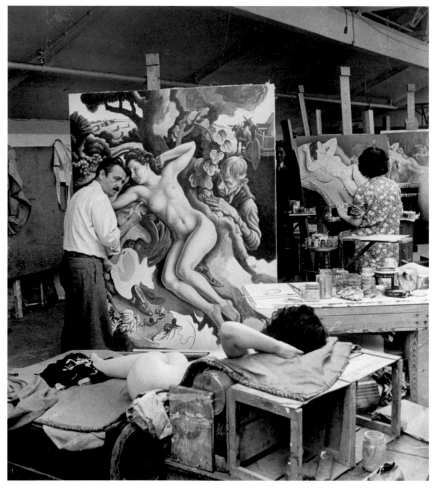

1939
Benton is photographed painting *Persephone* by Alfred Eisenstaedt for *Life* magazine

" . . . the retired artist sat on a barrel in the shade close by . . ."

1939
Benton's illustration *". . . the retired artist sat on a barrel in the shade close by…"* from Mark Twain's *The Adventures of Tom Sawyer*

20th Century Fox commissions Benton to make lithographs to promote the film *The Grapes of Wrath*, directed by John Ford. Benton creates five character studies and interprets a key scene from Steinbeck's novel and the film, *Departure of the Joads* (pls. 32–37). Independently, Benton creates a painting of the same scene, also titled *Departure of the Joads* (pl. 38).

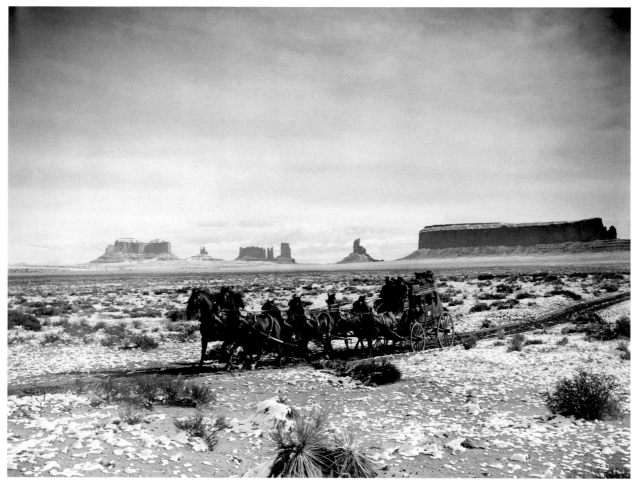

1939
Scene from *Stagecoach*

1940

Benton's *Grapes of Wrath* lithographs appear on 20th Century Fox's movie posters and brochures at the movie's New York premiere at the Rivoli Theatre. The movie wins two Academy Awards: Jane Darwell for Best Actress in a Supporting Role and John Ford for Best Director.

Benton creates 67 two-tone (yellow-and-black) lithographs to illustrate a deluxe rawhide-and-grass-cloth bound two-volume edition of John Steinbeck's *The Grapes of Wrath* (1939; pl. 39), published by the Limited Editions Club. Benton's lithograph *Departure of the Joads* appears on the popular Modern Library edition.

Producer Walter Wanger persuades United Artists to hire Benton and seven other American artists to promote John Ford's *The Long Voyage Home*, an adaptation of four sea plays by Eugene O'Neill. The painters observe the production of the movie and interpret various scenes in paintings displayed at the movie's New York premiere and then exhibited nationwide.

American Artist magazine interviews Benton and illustrates *No More Sea for Us (from "The Long Voyage")* (pl. 74) for an article about *The Long Voyage Home* commissions.

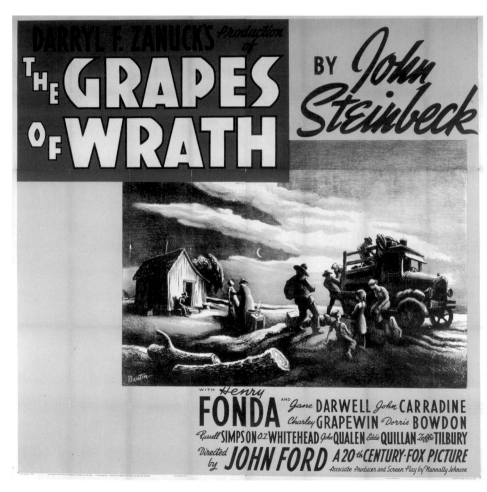

1940
John Steinbeck, *The Grapes of Wrath*

1940
Poster for *The Grapes of Wrath*

Benton's painting *No More Sea for Us* is featured in *Esquire* magazine's September 1940 article "Art Comes to Hollywood: Fifty Thousand Smackers for a Team of Artists to Paint the Take of *The Long Voyage Home*," by Harry Salpeter.

Coronet magazine publishes "A Tour of Hollywood: Drawings by Thomas Hart Benton," by Harry Salpeter, illustrated with six of Benton's 1937 Hollywood drawings made originally for his commission for *Life*.

The government produces US Armed Forces training films in Hollywood studio facilities and adds a two-cent tax to movie tickets to support defense programs.

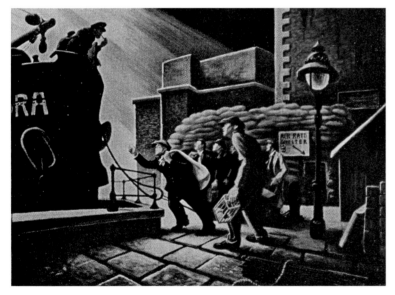

1940
Thomas Hart Benton, *No More Sea for Us (from "The Long Voyage Home")*, reproduced in *Esquire*

1940
Premiere of *The Long Voyage Home* at the Rivoli Theatre, New York, October 8; a reproduction of *No More Sea for Us* hangs to the right of the marquee

1940
Sailors admire *No More Sea for Us* at *The Long Voyage Home* exhibition, San Diego, California

1941

Benton receives a commission from 20th Century Fox to create promotional images for Jean Renoir's first US movie, *Swamp Water*, based on the novel by Vereen Bell and filmed on location at Okefenokee Swamp, Waycross, Georgia.

For a newsreel segment on National Art Week, Paramount Pictures films Benton teaching his Advanced Art class at the Kansas City Art Institute and painting *Aaron* (pl. 49).

Benton records *Saturday Night at Tom Benton's*, a three-record set of the artist playing harmonica with professional musicians; released by Decca the following year.

Kansas City Art Institute fires Benton for making homophobic remarks about directors of prominent US art museums.

The *New York Times* runs Bosley Crowther's review of Leo C. Rosten's new book *Hollywood — The Movie Colony, The Movie Makers* and illustrates it with a reproduction of Benton's painting *Hollywood* (1937–38, pl. 72).

Japanese bomb US naval base at Pearl Harbor on December 7; the following day the United States enters WWII.

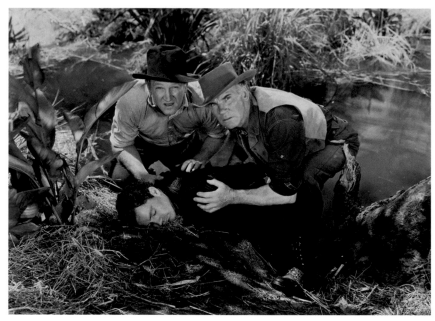

1941
Production photograph from *Swamp Water*, featuring Walter Huston (on the right) and Dana Andrews (on the ground)

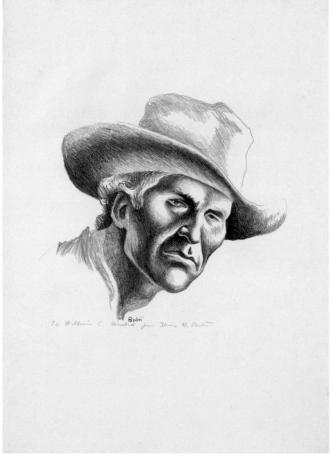

1941
Thomas Hart Benton, *Thursday Ragan*, lithograph from the *Swamp Water* series

The War Department commissions popular film director Frank Capra to produce and direct *Why We Fight* (1942–45), an Oscar-winning series of propaganda films intended to educate troops about the events that led to WWII and remind them of the principles they are fighting for.

1941
Thomas Hart Benton, *Swampland*, lithograph from the *Swamp Water* series

1941
Decca Records, *Saturday Night at Tom Benton's*, featuring Benton, T. P. Benton (Benton's son), Edward Robinson, and the Frank Luther Singers, under the direction of Harry Sosnik

1942

In response to the Japanese bombing of Pearl Harbor, Benton produces seven propaganda paintings collectively titled *Year of Peril* (see pp. 162–65).

Abbott Laboratories, a pharmaceutical company, purchases *Year of Peril* to support the war effort by exhibiting the murals and making reproductions of the paintings as widely available as possible.

More than 75,000 people view Benton's *Year of Peril* paintings in an exhibition held in April at the Associated American Artists galleries in New York.

Paramount News interviews Benton and films the exhibition of his *Year of Peril* paintings for its newsreel segment "War Art Creates Sensation."

Major Frank Capra writes to officers in the Army's Film Production Section, "This is total war, fought with every conceivable weapon. Your weapon is film! Your bombs are ideas! Hollywood is a war plant!"

1942
Paramount newsreel featuring Benton painting *Invasion* (pl. 78) from the mural series *Year of Peril*

1942
John Ford, photographed by Hollywood studio photographer Roman Freulich

1942
Film still from *The Battle of Midway*, 1943

Benton paints the large canvas *Negro Soldier* (pl. 79) in an effort to address contributions to the war effort by African Americans serving in the segregated US military.

Benton illustrates Mark Twain's *Adventures of Huckleberry Finn* for the Limited Editions Club.

The Battle of Midway, a color documentary directed by John Ford and shot by US Navy cameramen, is released.

Newspaperman Nelson Poynter, who served in the Office of War Information Motion Picture Bureau, says that Hollywood's guiding principle should be "Will this picture help to win the war?"

1943
Abbott Laboratories commissions Benton and other American artists to produce artworks about the US Navy's submarine force. Benton produces *Score Another for the Subs* and *Up the Hatch* (pl. 81), among other works, onboard the U.S.S. *Dorado*, which is lost in action in October 1943.

1942
Benton's illustration *"…a skiff, away across the water,"* from *The Adventures of Huckleberry Finn*

1943
Benton and fellow artist Georges Schreiber (right) on the U.S.S. *Dorado* submarine

1943
Thomas Hart Benton, *Score Another for the Subs*

Benton illustrates Jesse Stuart's novel *Taps for Private Tussie* (E. P. Dutton & Company). The book wins the Thomas Jefferson Award for Best Southern Book of the Year and sells more than 2 million copies.

1944

442 feature films released; 85 million average weekly attendance

Benton illustrates *Benjamin Franklin's Autobiography and Other Writings* for the Modern Library.

Benton illustrates Mark Twain's *Life on the Mississippi* for the Limited Editions Club.

1943
Jesse Stuart, *Taps for Private Tussie*

1944
Benjamin Franklin's Autobiography and Other Writings

1944
Mark Twain, *Life on the Mississippi*

Abbott Laboratories commissions Benton to produce another series of wartime drawings and paintings, recording naval mobilization efforts, landing ship tank construction, and on- and off-duty sailor life.

US War Department releases the documentary *The Negro Soldier*, directed by Stuart Heisler, written by Carlton Moss, and produced by Frank Capra for the *Why We Fight* series.

Allies land on the beach at Normandy June 6 for D-day invasion.

1944
Film still from *The Negro Soldier*

1943
Thomas Hart Benton, "Back Him Up! Buy War Bonds," poster funded by Abbott Laboratories

1945

Benton relies on sketches made while traveling in the West in the summer of 1944 as basis for illustrations for the Limited Editions Club's reissue of Francis Parkman's *The Oregon Trail*.

WWII ends for the US: V-E day, May 8; V-J day, September 2.

1946

Kansas City department store Harzfeld's commissions Benton's *Achelous and Hercules*. Encyclopedia Britannica shoots Benton working on the painting for its educational film *The Making of a Mural*.

Benton turns down the opportunity to collaborate with Walt Disney on a project about Davy Crockett.

1945
Francis Parkman, *The Oregon Trail*

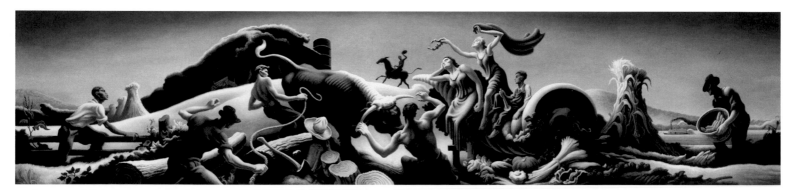

1946
Thomas Hart Benton, *Achelous and Hercules* mural, Smithsonian American Art Museum, Washington, DC

Benton solo exhibition opens at Associated American Artists galleries in Chicago; Harpo Marx purchases the painting *Spring on the Missouri* (pl. 51) at this exhibition.

Benton gives two drawings to Harpo — the sketch that inspired *Spring on the Missouri* and a sketch of "a Marx Brother."

On the former, he inscribes: "Dear Harpo — This note made in the great 1937 floods / in Missouri was the original idea for our picture / Tom Hart Benton."

On the latter, he writes: "Dear 'Harpo' — This is certainly not you. I think, however, it / may be your brother 'Groucho' but I'm not positive. / Anyway it's a drawing. You might add the proper / moustache and see if it looks like Groucho. Yours Tom / Thomas H Benton."

1946
Harpo Marx with Benton's *Spring on the Missouri*

1946
Thomas Hart Benton, drawing for *Spring on the Missouri*

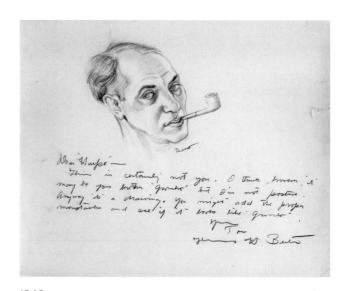

1946
Thomas Hart Benton, *A Marx Brother*

211

1947

Playwright Tennessee Williams publishes *A Streetcar Named Desire*, which wins a Pulitzer Prize. The play opens on Broadway, December 3 and runs through December 17, 1949.

1948

Hollywood producer David O. Selznick commissions Benton to create a painting as a gift for his wife, Irene, producer of the Broadway production of *A Streetcar Named Desire* and daughter of Louis B. Mayer. Benton paints *Poker Night (from "A Streetcar Named Desire")* (pl. 75).

President Harry S. Truman issues Executive Order No. 9981, officially desegregating the armed services.

1949

470 feature films released; 87.5 million average weekly attendance

1950

Televisions are now in 9 percent of US homes.

1951

The film version of *A Streetcar Named Desire*, directed by Elia Kazan and starring Marlon Brando, Vivien Leigh, Kim Hunter, and Karl Malden, premieres in Beverly Hills.

Benton updates his 1937 autobiography with a chapter titled "After."

1953

Benton illustrates Virginia S. Eifert's *Three Rivers South: A Story of Young Abe Lincoln* for Dodd, Mead and Company.

Shane, directed by George Stevens, is shot on location in Grand Teton National Park, Wyoming, where Benton travels in the 1950s.

CinemaScope, created by 20th Century Fox president Spyros Skouras and introduced in the biblical epic *The Robe* (1953), becomes the industry standard for wide-screen motion pictures.

1947
Broadway production of *A Streetcar Named Desire* photographed by Eliot Elisofon for *Life* magazine

1953
Virginia S. Eifert, *Three Rivers South: A Story of Young Abe Lincoln*

1953
Scene from the archetypal western, *Shane*

1954

427 feature films released; 49 million average weekly attendance

Benton illustrates Thad Snow's *From Missouri: An American Farmer Looks Back* for Houghton Mifflin.

Benton creates illustrations for the 1954 Limited Editions Club version of *Green Grow the Lilacs*, a 1931 play by Lynn Riggs that became the basis for Rodgers and Hammerstein's hit stage musical *Oklahoma!* (1943) and the film version released in 1955.

Burt Lancaster independently coproduces, directs, and stars in *The Kentuckian*, which he shoots in CinemaScope. The movie is based on *The Gabriel Horn* (1953), Felix Holt's novel for young people about an American frontiersman of the 1820s. Benton paints a life-size canvas, *The Kentuckian* (pl. 19), fulfilling his commission to create a painting to promote the movie.

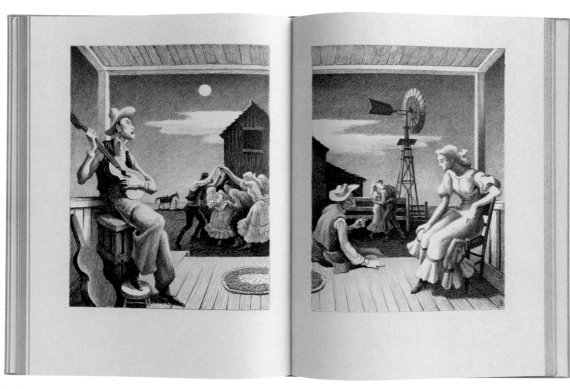

1954
Benton's illustrations for *Green Grow the Lilacs*

1954
Thad Snow, *From Missouri: An American Farmer Looks Back*

1955

The Kentuckian premieres in Chicago. The movie poster (pl. 29) features Benton's painting.

Lincoln University, a historically black university in Jefferson City, Missouri, installs Benton's mural *Abraham Lincoln* in its Inman E. Page Library.

1956

Benton completes *Trading at Westport Landing (Old Kansas City)*, a mural for a private collection in Kansas City, Missouri.

1957

Benton creates three murals for New York Power Authority buildings in Massena, New York, and the Niagara Power Project Visitors Center: *Jacques Cartier Discovers the Indians (1534)*, *The Seneca Discover the French (1535)*, and *Father Hennepin at Niagara Falls (1678)*.

1958

Benton signs a contract to paint *Independence and the Opening of the West*, a mural for the lobby of the Harry S. Truman Presidential Library in Independence, Missouri.

1959

439 feature films released; 42 million average weekly attendance

Hollywood releases dozens of westerns this year, including *Rio Bravo*, directed by Howard Hawks and starring John Wayne, Dean Martin, and Ricky Nelson.

Journalist Edward R. Murrow interviews Benton at home for an episode of CBS's *Person to Person*.

1960

Televisions are now in 90 percent of US homes.

Benton travels along the Santa Fe Trail, conducting preparatory research for the Truman Library mural. He sketches Pawnee and Cheyenne Indians in Oklahoma and Colorado and continues to western Nebraska along the Oregon Trail.

1955
Thomas Hart Benton, *Abraham Lincoln* mural, 1954–55, Lincoln University, Jefferson City, Missouri

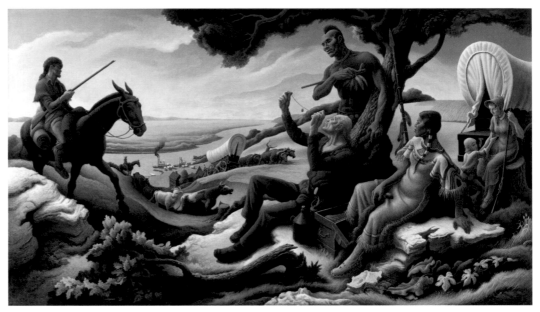

1956
Thomas Hart Benton, *Trading at Westport Landing (Old Kansas City)* mural, Kansas City, Missouri

1961

Benton's *Independence and the Opening of the West* mural (p. 40) for the Truman Library is dedicated. President Truman and Chief Justice Earl Warren attend the ceremony.

1963

Sidney Poitier wins an Academy Award for his role in *Lilies of the Field* and becomes the first African American to receive an Oscar for best actor.

More than 200,000 people march on Washington, DC, in the nation's largest civil rights demonstration; Martin Luther King, Jr., gives his "I Have a Dream" speech.

1964

502 feature films released; 43.5 million average weekly attendance

Benton tours the Canadian Rockies from Banff to Mt. Assiniboine on horseback. The painting *Trail Riders* (pl. 30) is inspired by this trip.

Congress passes the Wilderness Act, providing for the "protection of these areas (untrammeled by man), the preservation of their wilderness character, and for the gathering and dissemination of information regarding their use and enjoyment as wilderness."

President Lyndon B. Johnson signs the Civil Rights Act, giving the federal government far-reaching powers to prosecute discrimination in employment, voting, and education.

1965

Voting Rights Act passes.

President Johnson orders Operation Rolling Thunder, a bombing campaign against North Vietnam.

President Johnson signs the Highway Beautification Act; the Land and Water Conservation Fund Act also passes.

Benton canoes down the Buffalo River, which flows through the Ozark Mountains in northern Arkansas.

Benton takes a three-week trip to the headwaters of the Missouri River, an excursion organized by Army Corps of Engineers. He sketches scenes later incorporated into his painting *Lewis and Clark at Eagle Creek* (1967; pl. 31).

Artist Duane Michals photographs Benton for an *Esquire* magazine article called "Art News from Nowhere."

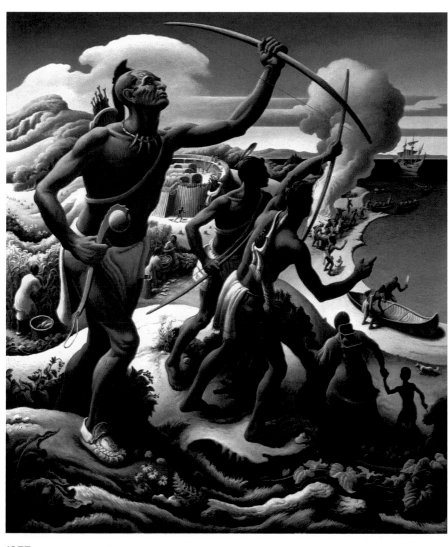

1957
Thomas Hart Benton, *The Seneca Discover the French (1535)* mural, New York Power Authority, Massena, New York

1960
Benton working on the mural series for the Harry S. Truman Presidential Library, photographed by Cecil Schrepfer

1965
Benton sketching by the Buffalo River, Arkansas

1966

Fiftieth anniversary of the National Park Service and the launch of MISSION 66, a ten-year $1 billion program to upgrade the national parks.

1967

Thurgood Marshall becomes the first African American justice on the Supreme Court.

1968

Benton updates his 1937 autobiography with another chapter, "And Still After."

Wild and Scenic Rivers Act passes.

1969

412 feature films released; 17.5 million average weekly attendance

Benton creates a lithograph based on his painting *Discussion*. The scene derives from a 1937 drawing made during labor union disputes in Michigan that Benton reported on for *Life* magazine; it shows a black worker seated across from a union recruiter.

Benton's *An American in Art: A Professional and Technical Autobiography* is published by University Press of Kansas.

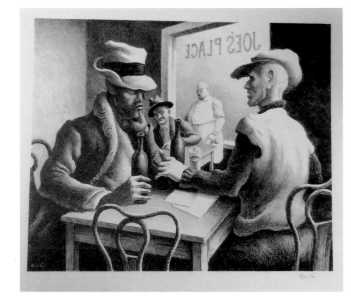

1969

Thomas Hart Benton, *Discussion*

1970

Benton on the Buffalo River, photographed for *Sports Illustrated*

1970

Benton's five-day canoe trip down the Buffalo River is featured in a *Sports Illustrated* story by Robert F. Jones, "The Old Man and the River."

1972

Benton completes *Joplin at the Turn of the Century*, a mural installed in the City of Joplin Building in Joplin, Missouri.

The National Park Service designates the Buffalo River as the country's first National River, which saves it and the surrounding land from damming and development.

1975

604 feature films released; 19.9 million average weekly attendance

Benton dies on January 19 in his backyard studio in Kansas City while putting the finishing touches on *The Sources of Country Music*, his commissioned mural for the Country Music Hall of Fame and Museum in Nashville, Tennessee. The mural was installed at its intended location and remains there today.

Benton's death is front-page news in the *New York Times* on January 20.

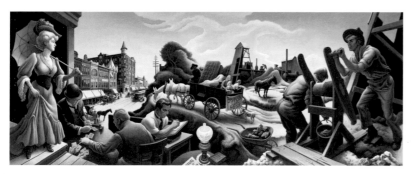

1972
Thomas Hart Benton, *Joplin at the Turn of the Century* mural, City of Joplin Municipal Building, Joplin, Missouri

1975
Thomas Hart Benton, *The Sources of Country Music* mural, Country Music Hall of Fame and Museum, Nashville, Tennessee

1975
Benton in his studio, c. 1975

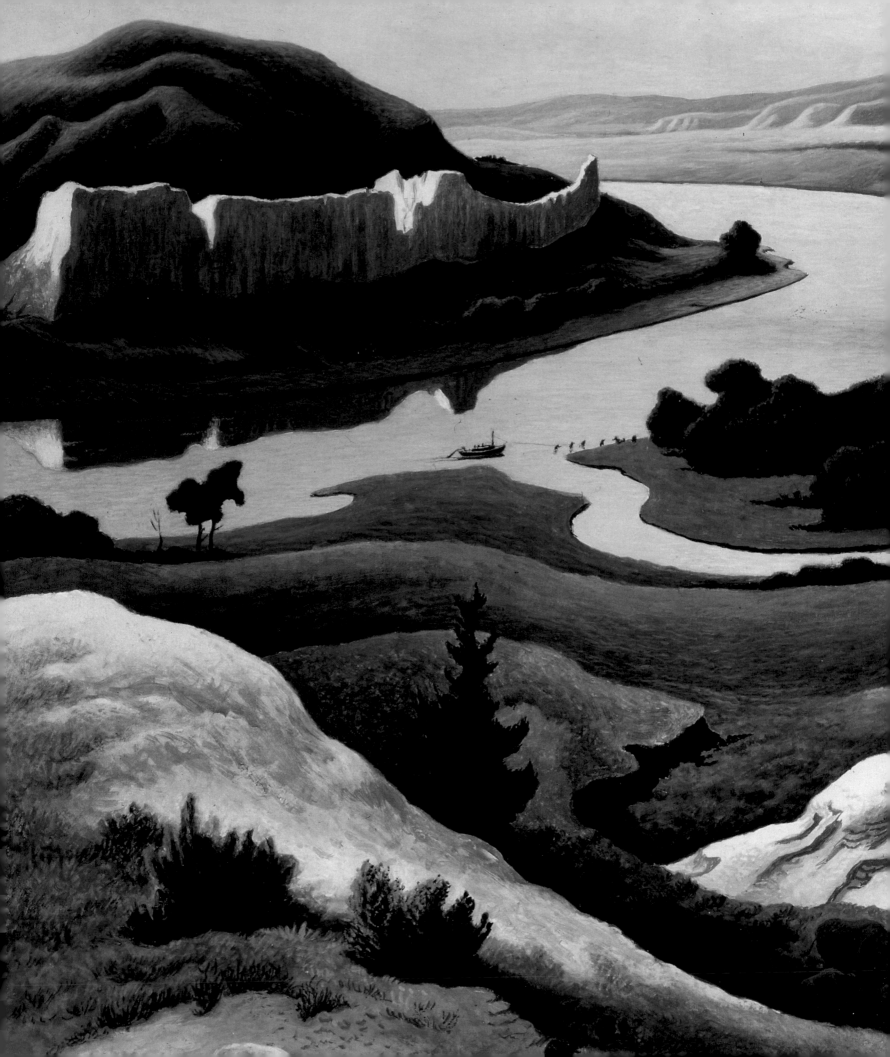

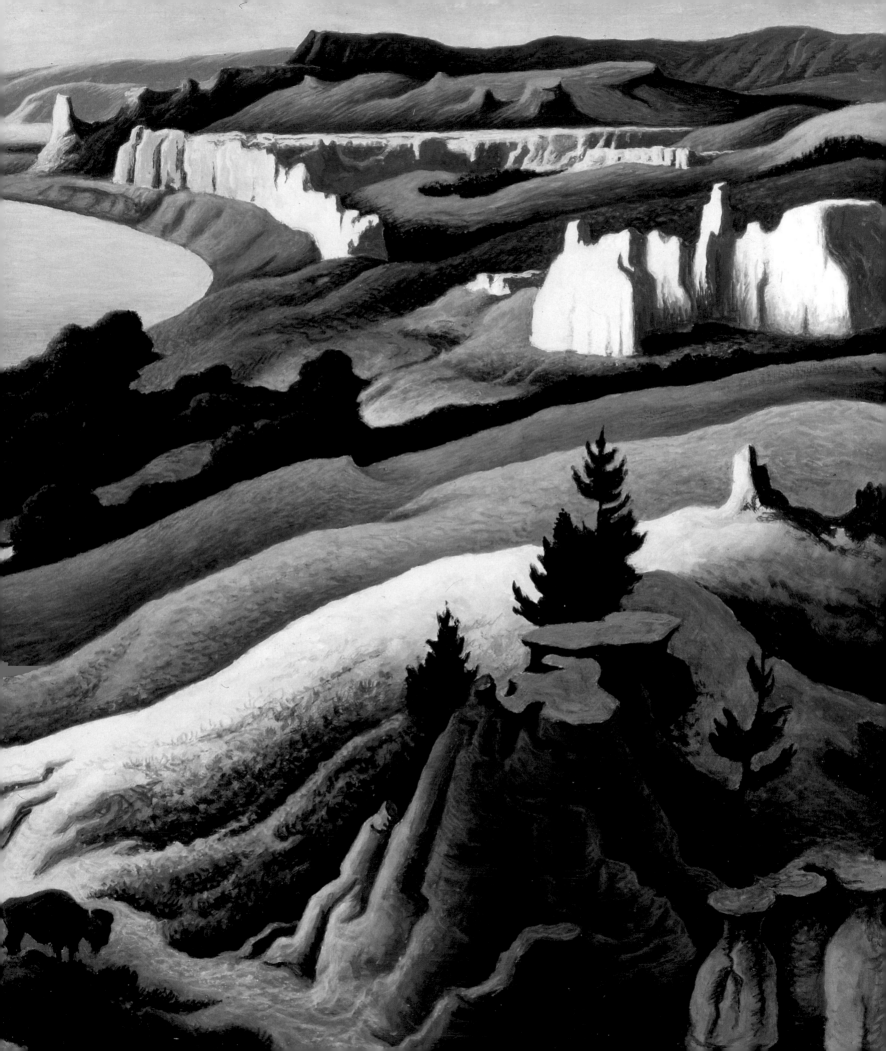

NOTES

Introduction

1. Benton's father, Maecenas Eason Benton, was a populist Missouri congressman who served from 1897 to 1905. The artist's namesake was Senator Thomas Hart Benton, Missouri's first senator, who served five terms, from 1821 to 1851.
2. Alexander Nemerov, "Projecting the Future: Film and Race in the Art of Charles Russell," *American Art* 9 (Winter 1994): 70–89.
3. Thomas Hart Benton, *An Artist in America* (1937; repr., Columbia: University of Missouri Press, 1983), 77.
4. Constance Rourke, *American Humor: A Study of the National Character* (1931; repr., New York: New York Review of Books, 2004), xii.
5. Ibid., 86.
6. Ibid., 117.

LaZebnik

1. Erika Doss, *Benton, Pollock, and the Politics of Modernism: From Regionalism to Abstract Expressionism* (Chicago: University of Chicago Press, 1991), 199.
2. Thomas Hart Benton, *An Artist in America* (1937; repr., Columbia: University of Missouri Press, 1983), 165.

Bailly

1. Rose Mary Fisk, "Murals by Americans Is Dull Show," *Chicago Evening Post*, May 10, 1932.
2. Holger Cahill, *American Painting and Sculpture, 1862–1932* (New York: Museum of Modern Art, 1933), 18.
3. Thomas H. Benton, "The Arts of Life in America," in *The Arts of Life in America: A Series of Murals by Thomas Benton* (New York: Whitney Museum of American Art, 1932), 4.
4. Ibid., 5.
5. Homer Brown, "'The Work of Art': An Interview with Thomas Hart Benton, Part 2," recorded May 6, 1962, ed. Lynn Wolf Gentzler, transcribed by Jeff D. Corrigan, in *Missouri Historical Review* 108, no. 2 (January 2014), 85.
6. The titles accompany illustrations of each mural panel in *The Arts of Life* series in *The Arts of Life in America: A Series of Murals by Thomas Benton*. On the sonic qualities of Benton's art, see Leo G. Mazow, *Thomas Hart Benton and the American Sound* (University Park: Pennsylvania State University Press, 2012).
7. Robert Warshow, "Movie Chronicle: The Westerner," in *The Immediate Experience: Movies, Comics, Theatre, and Other Aspects of Popular Culture* (Garden City: Doubleday, 1962), 135.
8. Benton, *The Arts of Life*, 4.
9. Toni Morrison, *Playing in the Dark: Whiteness and the Literary Imagination* (New York: Vintage, 1993), 47.
10. See Austen Barron Bailly, "Painting the American Historical Epic: Thomas Hart Benton and Race, 1919–1936" (PhD diss., University of California, Santa Barbara, 2009), 80–95. Benton envisioned the series comprising fifty to seventy-five panels, divided into ten or more chapters covering the entire history of the United States, from its discovery through the 1920s.
11. According to 1920s exhibition records, these are Benton's original titles for the panels, some of

which Benton misremembered late in life and renamed. See Bailly, "Painting the American Historical Epic," 302–4.
12. Julia Leyda, "Black-Audience Westerns and the Politics of Cultural Identification in the 1930s," *Cinema Journal* 42, no. 1 (Autumn 2002), 51.
13. Senator Benton is often erroneously referred to as Benton's great-uncle, but he was the artist's great-grandfather's brother; see mostateparks.com /page/55154/benton-genealogy.
14. See Tom Chaffin, *The Pathfinder: John Charles Frémont and the Course of American Empire* (New York: Hill & Wang, 2002), 7–8.
15. Mary Lea Bandy and Kevin Stoehr, *Ride, Boldly, Ride: The Evolution of the American Western* (Berkeley: University of California Press, 2012), 79.
16. See Jill Lepore, *The Name of War: King Philip's War and the Origins of American Identity* (New York: Vintage, 1988). Benton used his figure of King Philip again for the Indian seen at the right side of *The Palisades* in his *American Historical Epic*.
17. Bandy and Stoehr, *Ride, Boldly, Ride*, 9.
18. See Richard White and Patricia Nelson Limerick, eds., *The Frontier in American Culture*, exh. cat. (Berkeley: University of California Press, 1994).
19. Richard Slotkin, *Regeneration through Violence: The Mythology of the American Frontier, 1600–1860* (Wesleyan: Wesleyan University Press, 1973), 4.
20. Ibid., 5.
21. Ibid., 4.
22. Morrison, *Playing in the Dark*, 42–46.
23. Ibid., xiii.
24. Leyda, "Black-Audience Westerns," 61. For further discussion of these forms of racial representation, see the essay by Pellom McDaniels III, this volume.
25. Thomas H. Benton, "A Dream Fulfilled" (1933), in Kathleen A. Foster, Nanette Esseck Brewer, and Margaret Contompasis, *Thomas Hart Benton and the Indiana Murals* (Bloomington: Indiana University Art Museum; Bloomington: Indiana University Press, 2000), 31.
26. Ibid.
27. Patricia Nelson Limerick, "The Adventures of the Frontier in the Twentieth Century" in *The Frontier in American Culture*, ed. Richard White and Patricia Nelson Limerick, exh. cat. (Berkeley: University of California Press, 1994), 55.
28. Michael Kammen, *Mystic Chords of Memory: The Transformation of Tradition in American Culture* (New York: Vintage, 1993), 497.
29. Gerald Butters, Jr., "Portrayals of Black Masculinity in Oscar Micheaux's *The Homesteader*," *Literature Film Quarterly* 28, no. 1 (2000): 55.
30. James A. Nottage, "Authenticity and Western Film," in *Gilcrease Journal* 1, no. 1 (1993): 55.
31. "Broadcasted to the World: What the New York Newspapers Said About 'The Covered Wagon,'" *Variety*, March 19, 1923, 31. See also Bandy and Stoehr, *Ride, Boldly, Ride*, 14.
32. "*The Covered Wagon* . . . The Great American Picture At Last!," *Variety*, May 30, 1923, 23.
33. See Marcia Landy, "The Hollywood Western, the Movement-Image, and Making History," in *Hollywood and the American Historical Film*, ed. J. E. Smith (New York: Palgrave Macmillan, 2012), 29.

34. Tom Gunning, "Passion Play as Palimpsest: The Nature of the Text in the History of Early Cinema," in *Une invention du diable? Cinéma des premiers temps et réligion*, ed. André Gaudreault, Roland Cosandey, and Tom Gunning (Sainte-Foy, Switzerland: Les Presses de l'Université Laval; Lausanne: Payot, 1992), 109.
35. "The Biggest Opening Chicago Ever Had!," *Pictures*, April 26, 1923, 27; and *The Covered Wagon* . . . The Great American Picture At Last!
36. Thomas Schatz, "*Stagecoach* and Hollywood's A Western Renaissance," in *John Ford's Stagecoach*, ed. Barry Keith Grant (Cambridge: Cambridge University Press, 2003), 21.
37. "Art: Benton v. Adams," *Time*, March 4, 1946, 49. Thanks to Jake Wien for finding this article. Benton also included a barroom image of Custer's Last Stand in the Frankie and Johnnie panel from his 1936 mural series for the Missouri State Capitol.
38. Herman Melville, "Mr. Parkman's Tour," *New York Literary World* 4 (March 31, 1849): 291–93; for an online transcript, see also Scott Norsworthy, "'Mr. Parkman's Tour': The Text of Melville's 1849 Review," *Melvilliana* (blog), March 24, 2012, http:// melvilliana.blogspot.com/2012/03/mr-parkmans -tour-text-of-melvilles-1849.html.
39. Thomas Hart Benton, *An Artist in America* (1937; repr., Columbia: University of Missouri Press, 1983), 200.
40. Thomas Hart Benton, "My American Epic in Paint," *Creative Art* 3, no. 6 (December 1928): xxxi.
41. Peter C. Rollins, "*Tulsa* (1949) as an Oil-Field Film: A Study in Ecological Ambivalence," in *The Landscape of Hollywood Westerns: Ecocriticism in an American Film Genre*, ed. Deborah A. Carmichael (Salt Lake City: University of Utah Press, 2006), 81.
42. Benton, *An Artist in America*, 201–2.
43. Schatz, "*Stagecoach*," 21.
44. André Bazin, "The Evolution of the Western" (*1955*), in *Movies and Methods: An Anthology*, ed. Bill Nichols (Berkeley: University of California Press, 1976), 150–57.
45. Bazin, "The Evolution of the Western," 157.
46. Bernardo Rondeau suggested I consider why Benton chose a vertical composition for a painting to promote a widescreen movie.
47. Benton, "And Still After" (1968), in Thomas Hart Benton, *An Artist in America* (1937; repr., Columbia: University of Missouri Press, 1983), 358.
48. Brown, "The Work of Art," 14; and Thomas Hart Benton, *An American in Art* (Lawrence: University of Kansas Press, 1969), 74.
49. Benton, "And Still After," 365.
50. Benton, *An Artist in America*, 241.
51. Benton, "And Still After," 366.
52. Paul Varner, *The A to Z of Westerns in Cinema* (Lanham, MD: Scarecrow Press, 2009), 205–6.
53. Benton, "And Still After," 366.
54. Ibid.
55. Wilderness Act of 1964, Pub. L. No. 88-577, http://www.wilderness.net/NWPS/documents// publiclaws/PDF/16_USC_1131-1136.pdf.
56. Meriwether Lewis and William Clark, *Journals of the Lewis and Clark Expedition*, 13 vols., ed. Gary E. Moulton (Lincoln: University of Nebraska Press, 2001), 4:225–26.
57. For a discussion of the interrelationships

between myth and history in Hollywood westerns and their historiographies, see Janet Walker, "Introduction: Westerns through History," in *Westerns: Films through History*, ed. Walker (New York: Routledge, 2001), 10.

58. Benton, "A Dream Fulfilled."

Herron

1. See Ronald L. Davis, *John Ford: Hollywood's Old Master* (Norman: University of Oklahoma Press, 1997), 113–14; and Joseph McBride, *Searching for John Ford: A Life* (New York: St. Martin's Press, 2001), 317–18. For more information about Benton on Ford's film set, see "*The Long Voyage Home* as Seen and Painted by Nine American Artists," *The American Artist*, September 1940. Benton's close friend Grant Wood, as well as artists Luis Quintanilla, Ernest Fiene, and Georges Schreiber, were also invited to the studio.

2. Henry Adams, "Thomas Hart Benton's Illustrations for *The Grapes of Wrath*," *San Jose Studies* 16 (Winter l990): 6–18; Justin Wolff, *Thomas Hart Benton: A Life* (New York: Farrar, Straus and Giroux, 2012), 294–95; Scott Eyman, *Print the Legend: The Life and Times of John Ford* (New York: Simon & Schuster, 1999), 223–24, 231; and Erika Doss, *Benton, Pollock, and the Politics of Modernism: From Regionalism to Abstract Expressionism* (Chicago: University of Chicago Press, 1991), 242–52.

3. Doss, *Benton, Pollock*, 42–44; and Doss, "Artists in Hollywood: Thomas Hart Benton and Nathanael West Picture America's Dream Dump," *The Space Between* 7 (2011): 20–22. Doss also points out that Benton was critical of Hollywood's impact on society.

4. On Benton, see Thomas Hart Benton, *An Artist in America* (Columbia: University of Missouri Press, 1983), 37–38. See also Henry Adams, *Thomas Hart Benton: An American Original* (New York: Alfred A. Knopf, 1989). On the place of the western within classic cinema, see André Bazin, "The Western: Or the American Film Par Excellence," in *What Is Cinema?* (Berkeley: University of California Press, 1971), 2:140–57. Two excellent sources on Ford, politics, and philosophy are Robert B. Pippin, *Hollywood Westerns and the American Myth: The Importance of Howard Hawks and John Ford for Political Philosophy* (New Haven: Yale University Press, 2010), esp. 1–25; and Sidney A. Pearson, Jr., ed., *Print the Legend: Politics, Culture, and Civic Virtue in the Films of John Ford* (Lanham, MD: Lexington Books, 2009).

5. See Jonathan Lethem, *The Disappointment Artist and Other Essays* (New York: Doubleday 2005). The volume's lead essay, "Defending *The Searchers* (Scenes in the Life of an Obsession)," 1–14, is especially insightful. See also John Marini, "Defending the West: John Ford and the Creation of the Western Epic," in Sidney A. Pearson, Jr., ed., *Print the Legend: Politics, Culture, and Civic Virtue in the Films of John Ford* (Lanham, MD: Lexington Books, 2009), 1–20.

Conrads

1. Erika Doss, "No Way Like the American Way," in *A New Literary History of America*, ed. Greil Marcus and Werner Sollors (Cambridge, MA: Belknap Press, 2009), 737.

2. Doss, "No Way Like the American Way," 737; and Erika Doss, "Borrowing Regionalism: Advertising's Use of American Art in the 30s and 40s," *Journal of American Culture* 5 (Winter 1982): 13.

3. Doss, "Borrowing Regionalism," 13. The other two movies were *Long Voyage Home* (1940), also directed by John Ford, and *Swamp Water* (1941), directed by Jean Renoir. See Justin Wolff, *Thomas Hart Benton: A Life* (New York: Farrar, Straus and Giroux, 2012), 294.

4. Creekmore Fath, *Lithographs of Thomas Hart Benton* (Austin: University of Texas Press, 2001), 88. The fifth lithographic portrait was of Pa Joad.

5. The images appeared in publications large and small, for example, "Movie of the Week: *The Grapes of Wrath*," *Life*, January 22, 1940, 30–31, and *Oak Leaves* (Oak Park, IL), April 25, 1940, 59.

6. Richard B. Jewell, *The Golden Age of Cinema: Hollywood, 1929–1945* (Malden, MA: Blackwell, 2007), 151; and William Stott, *Documentary Expression and Thirties America* (Chicago: Univeristy of Chicago Press, 1973), 67–73.

7. According to Warren French, Zanuck had a particular gift for finding the edge of a tolerable amount of discomfort. Warren French, quoted in Nina Allen, "Thomas Hart Benton and John Steinbeck: Populist Realism in the Depression Era" (PhD diss., Boston University, 1995), 179. On Ford, see Tag Gallagher, *John Ford: The Man and His Films* (Berkeley: University of California Press, 1986), 176–78.

8. Dan Ford, *Pappy: The Life of John Ford* (New York: Da Capo Press, 1998), 143.

9. John Mosher, "Zanuck's Joads," *New Yorker*, February 3, 1940, 6.

10. Zanuck's comment may have been colored by the acknowledged jealousy among film studio artists; see Erika Doss, "Regionalists in Hollywood: Painting, Film, and Patronage, 1925–1945" (PhD diss., University of Minnesota, 1983), 156, 159.

11. Fath, *Lithographs*, 90.

12. No known archival material identifies a specific source for the subject. Existing stills from the movie do not match compositionally either, even though, as Erika Doss notes, Benton did have access to some of these photographs; Erika Doss, e-mail message to author, June 23, 2014.

13. Thomas Craven, "Thomas Benton and *The Grapes of Wrath*," in *The Grapes of Wrath* (New York: Limited Editions Club, 1940), xxi.

14. On Ford's specific use of motion in *The Grapes of Wrath*, see John C. Flinn, Sr., "Review: 'The Grapes of Wrath,'" *Variety*, January 30, 1940.

15. On this shift in Benton's art, see "The Metamorphosis of Thomas Hart Benton," *Art Digest* 13 (April 15, 1939): 10. On Benton and Steinbeck's shared view of the West, see Doss, "No Way Like the American Way," 740.

16. The print was issued in an edition of one hundred. It is unclear when Benton began the colorful painting, in which he reversed the print's composition, diffused the clouds, and removed the moon, which lifted the print's menacing tone overall. Benton was not consistent in privileging one medium over another for a subject's first iteration, and there is no archival evidence of the precise timing of the lithographs' or the painting's creation. Several factors suggest the lithograph preceded the painting, which is dated 1940 at the lower-left corner. Benton had barely a month to complete the advertising images, which would have limited his ability to create an exhibition-scaled canvas, especially given the fact that the request for the book illustrations came on January 11, 1940, barely two weeks before the opening of the movie. See

Allen, "Thomas Hart Benton and John Steinbeck," 185. There are no compelling reasons to suggest he painted the canvas in advance of the commissions. Neither the artist nor his greatest champion, Thomas Craven, mentioned that the painting inspired the print in their writings about the latter. With other prints, Benton had often said when it was based on a painting, as he did, for example, with the 1940 print *Instruction*. See, Fath, *Lithographs*, 2001, 88, 102; and Craven, "Thomas Benton and *The Grapes of Wrath*," xxi. Finally, there were no press mentions of the painting when the movie opened or when the Limited Editions Club book was published. The artist never sold the canvas, though it likely was painted with that hope in mind, and it remained in Benton's possession until he donated it to the College of the Ozarks.

17. For more on the newsreel feel of the film, see Philip T. Hartung, "Trampling Out the Vintage," *The Commonweal*, February 9, 1940, 348.

18. See, for example, Howard Devree, "Benton Returns," *Magazine of Art*, special issue, May 1939, 301–2; and Wolff, *Thomas Hart Benton*, 271.

19. Wolff, *Thomas Hart Benton*, 266.

Powell

1. Jean Toomer, *Cane* (1923; repr., New York: Perennial Classic, 1969), 31.

2. Roland Barthes, *Camera Lucida: Reflections on Photography* (New York: Hill and Wang, 1981).

3. Thomas Hart Benton, *An Artist in America* (1937; repr., Columbia: University of Missouri Press, 1983), 165.

4. Mark Twain, *The Adventures of Tom Sawyer*, ed. Bernard DeVoto, ill. Thomas Hart Benton (Cambridge, MA: Limited Editions Club at the University Press, 1939); Mark Twain, *Adventures of Huckleberry Finn (Tom Sawyer's Companion)*, ed. Bernard DeVoto, ill. Thomas Hart Benton (New York: Limited Editions Club, 1942); and Mark Twain, *Life on the Mississippi*, ed. Willis Wagner, ill. Thomas Hart Benton (New York: Heritage Press, 1944).

5. Benton, *An Artist in America*, 186.

6. Geoffrey Batchen, *What of Shoes? Van Gogh and Art History* (Cologne: Wallraff-Richartz-Museum & Fondation Corboud, 2009).

7. Had Benton submitted *Romance*, with its allusion to racial violence via the dangling shoes, it would have perhaps received serious consideration for inclusion (along with his more explicit painting, *A Lynching*) in the 1935 NAACP-sponsored art exhibition *Art Commentary on Lynching*, at the Arthur U. Newton Galleries in New York City. For a description of Benton's *A Lynching*, see Margaret Rose Vendryes, "Hanging on Their Walls: An *Art Commentary on Lynching*, the Forgotten 1935 Art Exhibition," in *Race Consciousness: African American Studies for the New Century*, ed. Judith Jackson Fossett and Jeffrey A. Tucker (New York: New York University Press, 1997), 153–76.

8. According to the art historian Erika Doss, Benton took great pains to artistically represent the presence of blacks throughout American life, which reflected both his liberal New Deal politics and, in the case of the American South, his desire for an accurate portrayal of blacks' demographic preponderance and their oppressed, proletarian status. See Erika Doss, *Benton, Pollock, and the Politics of Modernism: From Regionalism to Abstract Expressionism* (Chicago: University of Chicago Press, 1991).

9. Leo G. Mazow, "Regionalist Radio: Thomas Hart Benton on *Art for Your Radio*," *Art Bulletin* 90 (March 2008): 101.

10. Julia Peterkin (text) and Doris Ulmann (photographs), *Roll, Jordan, Roll* (New York: R. O. Ballou, 1933). See also Philip Walker Jacobs, *The Life and Photography of Doris Ulmann* (Lexington: University Press of Kentucky, 2001). Thanks to the efforts of the art historian Henry Adams, Benton's travel itinerary during the 1920s and 1930s—much of it through the American South—has been corroborated and reconciled with his art and the historical record. See Henry Adams, "Travel Drawings," in *Thomas Hart Benton: Drawing from Life* (New York: Abbeville Press, 1990), 93–125.

11. Benton, *An Artist in America*, 169.

12. For remarks on the cultural impact of these two films, see: "Screen Negro Melodies," *New York Times*, February 24, 1929; and "Vidor's Negro Film," *New York Times*, August 25, 1929.

13. "My Romance," lyrics by Lorenz Hart, music by Richard Rodgers, © 1935 (renewed) Williamson Music and Lorenz Hart Publishing Co. in the U.S. All rights administered by Williamson Music. All rights reserved. A particularly stirring version of this song can be heard on *Roberta Flack/Roberta*, Atlantic, B003A9WSXK, CD, 1994.

14. Benton, *An Artist in America*, 197. "Benton," observes the art historian Karal Ann Marling "was the first outlander of any stature to suggest that the South and its traditions might warrant respectful attention." Karal Ann Marling, "Chain Gangs and Cotton Fields," in *Tom Benton and His Drawings: A Biographical Essay and a Collection of His Sketches, Studies, and Mural Cartoons* (Columbia: University of Missouri Press, 1985), 49–50.

15. Benton, *An Artist in America*, 197–98.

16. Ibid., 198.

Bernstein

1. For an excellent and pioneering overview of black theaters and segregation practices, see Douglas Gomery, "Movie Theatres for Black Americans," in *Shared Pleasures: A History of Movie Presentation in the United States* (Madison: University of Wisconsin Press, 1992), 155–70. Many case studies of individual black theaters exist. See, for example, Dan Streible, "The Harlem Theater: Black Film Exhibition in Austin, Texas: 1920–1973," in *Black American Cinema*, ed. Manthia Diawara (New York: Routledge, 1993), 221–36; and Arthur Knight, "Searching for the Apollo: Black Moviegoing and Its Contexts in the Small-Town US South," in *Explorations in New Cinema History: Approaches and Case Studies*, ed. Richard Maltby, Daniel Biltereyst, and Philippe Meers (Malden, MA: Wiley-Blackwell, 2011), 226–42.

2. Oddly, southern black theaters booked these films more quickly than in the North. Historian Douglas Gomery argues this was the case because black Americans could attend more white theaters in the North, relegating African American theaters to the very bottom of the exhibition system. In a southern city like Atlanta, however, "colored theaters" could book first-run major studio films only weeks after their white downtown premieres, partly because Atlanta was a major distribution hub for film prints and segregation was so firmly in place. See Gomery, "Movie Theatres."

3. Gomery, "Movie Theatres," 157, 158, 160, 162.

4. See Anna Everett, *Returning the Gaze: A Genealogy of Black Film Criticism, 1909–1949* (Durham: Duke University Press, 2001). Thomas Cripps first discussed this dilemma for black film critics in *Slow Fade to Black: The Negro in American Film, 1900–1942* (New York: Oxford University Press, 1977), see especially 178. Many other case studies on the black reception of Hollywood and race films have followed.

5. See, for example, Matthew H. Bernstein and Dana F. White, "*Imitation of Life* in a Segregated Atlanta: Its Promotion, Distribution, and Reception," *Film History* 19, no. 2 (2007): 153–78.

6. For a general overview of race filmmaking, see Cripps, *Slow Fade to Black*, especially the chapters "Two Early Strides toward a Black Cinema," "The Black Underground," and "Meanwhile, Far Away from the Movie Colony," 70–89, 115–49, and 309–48, respectively; Thomas Cripps, "Hollywood Wins: The End of 'Race Movies,'" in *Making Movies Black: The Hollywood Message Movie from World War II to the Civil Rights Era* (New York: Oxford University Press, 1993), 126–50; and Henry T. Sampson, *Blacks in Black and White: A Source Book on Black Films* (Metuchen, NJ: Scarecrow Press, 1995). On Oscar Micheaux, see Pearl Bowser and Louise Spence, *Writing Himself into History: Oscar Micheaux, His Silent Films, and His Audiences* (New Brunswick: Rutgers University Press, 2000); Pearl Bowser, Jane Gaines, and Charles Musser, *Oscar Micheaux and His Circle: African-American Filmmaking and Race Cinema of the Silent Era* (Bloomington: Indiana University Press, 2001); and Patrick McGilligan, *Oscar Micheaux: The Great and Only; The Life of America's First Black Filmmaker* (New York: Harper, 2008). For a detailed study of another (white) race filmmaker in the silent era, see Barbara Tepa Lupack, *Richard E. Norman and Race Filmmaking* (Bloomington: Indiana University Press, 2014).

7. See Mary Carbine, "'The Finest outside the Loop': Motion Picture Exhibition in Chicago's Black Metropolis, 1905–1928," *Camera Obscura* 23 (1994): 9–42. For an excellent study of black moviegoing in Chicago in the first two decades of the twentieth century, see Jacqueline Stewart, *Migrating to the Movies: Cinema and Black Urban Modernity* (Berkeley: University of California Press, 2005). For an excellent account of southern black moviegoing in the silent era, see Gregory Waller, "Another Audience: Black Moviegoing from 1907 to 1916," in *Main Street Amusements: Movies and Commercial Entertainment in a Southern City, 1896–1930* (Washington, DC: Smithsonian Institution Press, 1995), 161–79.

Doss

1. Thomas Hart Benton to Daniel Longwell, November 15, 1937, Daniel Longwell Papers, box 32, Rare Book and Manuscript Library, Columbia University, New York (hereafter, DL Papers), as noted in Erika Doss, "Hollywood, 1937–1938," in *The Collections of the Nelson-Atkins Museum of Art: American Paintings to 1945*, vol. 1, ed. Margaret C. Conrads (Kansas City, MO: Nelson-Atkins Museum of Art, 2007), 86.

2. Thomas Hart Benton to Daniel Longwell, February 8, 1938, DL Papers, as noted in Erika Doss, *Benton, Pollock, and the Politics of Modernism: From Regionalism to Abstract Expressionism* (Chicago: University of Chicago Press, 1991), 199.

3. "Thomas Hart Benton, Muralist, Visits City," *St. Louis Post-Dispatch*, November 11, 1937, Benton Files, Nelson-Atkins Museum of Art Archives.

4. Benton's typed, twelve-page, unpublished essay ends with the words, scrawled in Benton's handwriting: "And so on." See "Hollywood Journey," this volume. A few of his Hollywood notes were published; see Harry Salpeter, "A Tour of Hollywood: Drawings by Thomas Benton," *Coronet*, February 1, 1940, 34–38. For more on his Hollywood notes, see Karal Ann Marling, *Tom Benton and His Drawings: A Biographical Essay and a Collection of His Sketches, Studies, and Mural Cartoons* (Columbia: University of Missouri Press, 1985), 94–96, 102–3; and the text by Janet C. Blyberg, this volume.

5. Ruth Suckow, "Hollywood Gods and Goddesses," *Harper's*, July 1936, 189.

6. See, for example, Hortense Powdermaker, *Hollywood, The Dream Factory: An Anthropologist Looks at the Movie-Makers* (Boston: Little, Brown, 1950).

7. See Jan Lin, "Dream Factory Redux: Mass Culture, Symbolic Sites, and Redevelopment in Hollywood," in *Understanding the City: Contemporary and Future Perspectives*, ed. J. Eade and C. Mele (Oxford: Blackwell, 2002), 397–418; Brian Gallagher, "Greta Garbo Is Sad: Some Historical Reflections on the Paradoxes of Stardom in the American Film Industry, 1910–1960," *Images: A Journal of Film and Popular Culture*, no. 3 (1997), http://www.imagesjournal.com/issue03/infocus/stars2.htm.

8. Erika Doss, "Artists in Hollywood: Thomas Hart Benton and Nathanael West Picture America's Dream Dump," *The Space Between: Literature and Culture, 1914–1945* 7, no. 1 (2011): 9–32.

9. Ben Singer, *Melodrama and Modernity: Early Sensational Cinema and Its Contexts* (New York: Columbia University Press, 2001), 4; Lary May, *Screening Out the Past: The Birth of Mass Culture and the Motion Picture Industry* (New York: Oxford University Press, 1980), 35, 163–64; and Richard Butsch, *The Making of American Audiences: From Stage to Television, 1750–1900* (New York: Cambridge University Press, 2000), 141.

10. "Ingraham [*sic*] Tells Life Romance," *The Boston Post*, March 19, 1922, Rex Ingram Clipping File, Academy of Motion Picture Arts and Sciences, Margaret Herrick Library, Beverly Hills, California.

11. Thomas Hart Benton, *An Artist in America* (1937; repr., Columbia: University of Missouri Press, 1983), 37.

12. For more biographical information on Ingram, see Liam O'Leary, *Rex Ingram: Master of the Silver Screen* (New York: Harper & Row, 1980); and Leonhard H. Gmür, *Rex Ingram: Hollywood's Rebel of the Silver Screen* (Berlin: epubli, 2013).

13. See the description of Ingram preceding his article "Art Advantages of the European Scene: One of the Great Directors of the Screen Deplores the Artificiality of Hollywood," *Theatre Magazine*, January 1928, 24; and Benton, "Hollywood Journey."

14. Benton, *An Artist in America*, 38. On *Broken Fetters*, which was released by Bluebird/Universal on July 3, 1916, see Gmür, *Rex Ingram*, 68, and the film's synopsis in *The Moving Picture World*, July 8, 1916, 307–8. For statistics on silent films today, see David Pierce, *The Survival of American Silent Feature Films: 1912–1929* (Washington, DC: Council on Library and Information Resources, Library of Congress, 2013), vii, 29.

15. See Robert S. Gallagher, "An Artist in America," *American Heritage* 24 (June 1973): 43. Lüchow's was a popular German restaurant on East 14th Street, near Union Square, in New York.

16. Benton, *An Artist in America*, 38.

17. "Pathé, A New Idea in the Reproduction of Color Paintings," *The Moving Picture World* 22, no. 10 (December 5, 1914): 1340. Walter Dean Goldbeck (1882–1925), Arthur Watkins Crisp (1881–1974), and Z. P. Nikolaki (1879–?, born Nicholas Panoyatti Zarokilli in Turkey) were highly successful commercial artists who did covers for the *Saturday Evening Post* and other popular magazines.

18. Ingram invited Barton to work as a technical director on his 1921 film *The Conquering Power*, and in 1926, Barton made a short film titled *Camille*, which featured Ingram and other movie industry notables; see Bruce Kellner, *The Last Dandy: Ralph Barton, American Artist, 1891–1931* (Columbia: University of Missouri Press, 1991), 32, 70–71.

19. Gail Levin, *Edward Hopper: An Intimate Biography* (1995; repr., New York: Rizzoli, 2007), 94–95. On Éclair studios, see Richard Koszarski, *Fort Lee: The Film Town* (Bloomington: Indiana University Press, 2004), 100–117. Unfortunately, Hopper's movie posters have either been destroyed or remain undiscovered.

20. "Wonders of Camouflage That Are Accomplished in Movieland: What Hugo Ballin, Everett Shinn, William Cotton, and Other Artists Are Doing to Give the Camera More Power of Expression," *Current Opinion* 64, no. 1 (January 1918): 31. Shinn also worked as an art director on several pictures filmed by Henry King in the early 1920s; see Richard Koszarski, *Hollywood on the Hudson: Film and Television in New York from Griffith to Sarnoff* (New Brunswick: Rutgers University Press, 2008), 86.

21. Gregory Gilbert, *George Overbury "Pop" Hart* (New Brunswick: Rutgers University Press, 1986), 34–35; and Thomas Hart Benton, *An American in Art: A Professional and Technical Autobiography* (Lawrence: University Press of Kansas, 1969), 40.

22. Benton, *An Artist in America*, 38.

23. Bob Priddy, "Appendix 2: Benton the Model Maker," in *Only the Rivers Are Peaceful: Thomas Hart Benton's Missouri Mural* (Independence, MO: Independence Press, 1989), 272–75; and O'Leary, *Rex Ingram*, 187.

24. Benton, *An American in Art*, 34–35.

25. Kevin Starr, *Inventing the Dream: California through the Progressive Era* (New York: Oxford University Press, 1985), 315; and *Hollywood's America: United States History through Its Films*, ed. Steven Mintz and Randy Roberts (New York: Blackwell, 2010), 14.

26. Margaret Farrand Thorpe, *America at the Movies* (New Haven: Yale University Press, 1939), 188–89; and Joel W. Finler, *The Hollywood Story* (London: Wallflower Press, 2003), 365, 376.

27. Will South, "Stanton Macdonald-Wright (1890–1973): From Synchromism to the Federal Art Projects" (PhD diss., City University of New York, 1994), 141, 145–46.

28. Quotes in this paragraph are taken from Stanton Macdonald-Wright, *Santa Monica Library Murals* (Los Angeles: Angelus Press, 1935), n.p.; and Stanton Macdonald-Wright, "Photography and the New Literature," *Manuscripts* 4 (February 1922): 7–8. See also Will South, "Invention and Imagination: Stanton Macdonald-Wright's Santa Monica Library

Mural," *Archives of American Art Journal* 39, nos. 3 and 4 (1999): 11–20.

29. Tom Maloney, "Will Connell," in *In Pictures: A Hollywood Satire*, by Will Connell (New York: T. J. Maloney, Inc., 1937), 8. Thanks to Jake Wien for alerting me to this book.

30. "Hollywood Story Conference," *Saturday Evening Post*, October 10, 1936, 14–15, 92, 94, 96. The essay, which included one drawing by Tony Sarg, was written by screenwriters Gene Fowler, Nunnally Johnson, Grover Jones, and Patterson McNutt, who collectively challenged readers to "make any sense at all out of the factual record of the story conference here presented." The play was made into a movie of the same name in 1938.

31. Benton, *An Artist in America*, 23; Gallagher, "An Artist in America," 43; and Thomas Hart Benton, "The Arts of Life in America," a statement written about the murals he painted for the Whitney Museum of American Art in 1932, reprinted in *A Thomas Hart Benton Miscellany: Selections from His Published Opinions, 1916–1960*, ed. Matthew Baigell (Lawrence: University Press of Kansas, 1971), 22.

32. Benton, "Hollywood Journey."

33. Ibid.

34. See also Devi Noor, "Robert Witt Ames: Hollywood," *Unframed: The LACMA Blog*, May 14, 2014, http://lacma.wordpress.com/2014/05/14/robert-witt-ames-hollywood/.

35. Nathanael West, *The Day of the Locust* (1939), in *Nathanael West: Novels and Other Writings*, ed. Sacvan Bercovitch (New York: Library of America, 1997), 387–88.

Blyberg

1. Thomas Hart Benton, *An Artist in America* (1937; repr., Columbia: University of Missouri Press, 1983), 384.

2. See "Artist Thomas Hart Benton Hunts Communists and Fascists in Michigan," and "'Menaces to Michigan Democracy as Sketched and Captioned by Tom Benton," *Life*, July 26, 1937.

3. See, for example, the inscription on the sketch for *Spring on the Missouri* (see p. 211).

4. Zerbe is generally considered the original Hollywood paparazzo. See Jerome Zerbe, *Happy Times* (New York: Harcourt Brace Jovanovich, 1973).

5. From 1936 through the summer of 1937, when Benton was also in Hollywood, Faulkner worked at 20th Century Fox on the script for *Slave Ship* (1937).

6. "Carnegie Prize Winner and Other Canvases," *Life*, December 12, 1938.

7. Creekmore Fath, *The Lithographs of Thomas Hart Benton* (1969; repr., Austin: University of Texas Press, 1969), cat. no. 24, 68–69.

8. One of the graphite sketches, a portrait of W. C. Fields (NPG.98.34), is at the National Portrait Gallery, Washington, DC.

9. These include *Director's Conference*, *Casting Office*, *Prop Department*, and *Aspirants' Party: Cocktails and Astrology*, all of which were published in Harry Salpeter, "A Tour of Hollywood: Drawings by Thomas Benton," *Coronet*, February 1940, 34–38.

10. "Carnegie Prize Winner and Other Canvases," *Life*, December 12, 1938, 73–75.

11. Salpeter, "A Tour of Hollywood," 34. Seven months later, Salpeter authored another sardonic article on American art and Hollywood that mentions

Benton; see "Art Comes to Hollywood: Fifty Thousand Smackers for a Team of Artists to Paint the Take of *The Long Voyage Home*," *Esquire*, September 1940.

12. See Karal Ann Marling, "Your Roving Reporter," in *Tom Benton and His Drawings: A Biographical Essay and a Collection of His Sketches, Studies, and Mural Cartoons* (Columbia: University of Missouri Press, 1985), 94–96; Henry Adams, *Thomas Hart Benton: Drawing from Life*, exh. cat. (Seattle: University of Washington, 1990); Douglas Dreishspoon, *Benton's America: Works on Paper and Selected Paintings*, exh. cat. (New York: Hirschl & Adler Galleries, 1991), cat. nos. 40–45; and Erika Doss, "Thomas Hart Benton in Hollywood," in Doss, *Benton, Pollock, and the Politics of Modernism: From Regionalism to Abstract Expressionism* (Chicago: University of Chicago Press, 1991).

Mazow

1. Thomas Hart Benton to Daniel Longwell, February 8, 1938, Daniel Longwell Papers, Benton file, Rare Book and Manuscript Library, Columbia University, quoted in Erika Doss, *Benton, Pollock, and the Politics of Modernism: From Regionalism to Abstract Expressionism* (Chicago: The University of Chicago Press, 1991), 199. Longwell was an editor at Doubleday and at *Life* magazine.

2. See Leo G. Mazow, *Thomas Hart Benton and the American Sound* (University Park: Penn State University Press, 2012).

3. Exceptions include the panel *Arts of the City* in *Arts of Life in America* and the panel *Electric Power, Motor-Cars, Steel* in *The Social History of Indiana*.

4. Mazow, *Shallow Creek: Thomas Hart Benton and American Waterways* (University Park: Palmer Museum of Art, Pennsylvania State University; University Park: Penn State University Press, 2007).

5. John Callison, interview with author, July 26, 2006, Kansas City, Missouri.

6. In certain passages, this technical manifesto can be difficult to follow, but the articles nonetheless constitute a systematic explanation of Benton's nascent formalist modernism. See Thomas Hart Benton, "Mechanics of Form Organization in Painting: Part I," *Arts* 10, no. 5 (November 1926): 285–89; "Mechanics of Form Organization in Painting: Part II," *Arts* 10, no. 6 (December 1926): 340–42; "Mechanics of Form Organization in Painting: Part III," *Arts* 11, no. 1 (January 1927): 43–44; "Mechanics of Form Organization in Painting: Part IV," *Arts* 11, no. 2 (February 1927): 95–96; and "Mechanics of Form Organization in Painting: Part V," *Arts* 11, no. 3 (March 1927): 145–48. See also Henry Adams, *Thomas Hart Benton: An American Original* (New York: Knopf, 1989), 114–17; Susan Platt Carmalt, "Thomas Hart Benton as an Aesthetic Theoretician" (master's thesis, Brown University, 1973), 8–10, 12, 14; and Doss, *Benton, Pollock, and the Politics of Modernism*, 12, 14, 363.

7. Thomas Hart Benton to Alfred Stieglitz, December 9, 1921, Alfred Stieglitz/Georgia O'Keeffe Archive, Beinecke Library, Yale University, box 4, folder 7, quoted in Sarah G. Powers, "Images of Tension: City and Country in the Work of Charles Sheeler, Thomas Hart Benton, and Edward Hopper" (PhD diss., University of Delaware, 2010), 156.

8. Thomas Hart Benton, *Art and Democracy*, brochure (lecture, Young Democratic Club, Kansas City, MO, May 5, 1941).

Wien: The Art of Painting Cinematically

1. Martin Scorsese, "The Persisting Vision: Reading the Language of Cinema," *New York Review of Books* 60, no. 13 (August 15, 2013): 25.

2. Art historians have noted that elements of Benton's style are evocative of the cinema. See Henry Adams, *Thomas Hart Benton: An American Original* (New York: Alfred A. Knopf, 1989), 152–53, 175; Henry Adams, *Tom and Jack: The Intertwined Lives of Thomas Hart Benton and Jackson Pollock* (New York: Bloomsbury Press, 2009), 152–53; Erika Doss, *Benton, Pollock, and the Politics of Modernism: From Regionalism to Abstract Expressionism* (Chicago: University of Chicago Press, 1991), 42–44; Erika Doss, "From the Great Depression to the Cold War: Politics, Paintings, and Jackson Pollock," in Rudy Chiappini, ed., *Thomas Hart Benton*, exh. cat. (Lugano: Museo d'Arte Moderna; Milan: Electa, 1992), 92; and Douglas Dreishspoon, introduction to *Benton's America* (New York: Hirschl & Adler Galleries, 1991), 9.

3. Vachel Lindsay, *The Art of the Moving Picture* (New York: Macmillan, 1915), 249–50.

4. See Liam O'Leary, *Rex Ingram: Master of the Silent Cinema* (Dublin: Academy Press, 1980). Ingram aspired to raise cinema to a high art form, and his visionary style influenced filmmakers Yasujirō Ozu and David Lean and also captured the imagination of James Joyce: "his scaffold is there set up, as to edify, by Rex Ingram, pageant-master." See Joyce, *Finnegans Wake* (New York: Viking, 1939).

5. See Paul Cummings, *Artists in Their Own Words* (New York: St. Martin's Press, 1979), 31; and Paul Cummings, oral history interview with Thomas Hart Benton, July 23–24, 1973, Archives of American Art, Smithsonian Institution.

6. Robert S. Gallagher, "An Artist in America," *American Heritage* 24, no. 4 (June 1973): 43.

7. Lindsay, *The Art of the Moving Picture*, 7, 133. An academically trained painter who studied with Robert Henri alongside Edward Hopper and Rockwell Kent, Lindsay conceived a new vocabulary for discussing film. His provocative ideas were disseminated further in an ecstatic review by Francis Hackett; see "A Poet at the Movies," *New Republic* 5, no. 60 (December 25, 1915): 201–2. Film historians consider *The Art of the Moving Picture* the progenitor of movie criticism. See Stanley Kauffmann's introduction to the 1970 edition of the book (New York: Liveright).

8. Lindsay, *The Art of the Moving Picture*, 140.

9. Rex Ingram, "The Motion Picture as an Art," *Art Review* 1, no. 5 (February 1922): 12, 27.

10. The word *clay* is used throughout this essay instead of Plastilene or Plasticine, trade names for the non-hardening reusable modeling clay that Benton used.

11. Thomas Hart Benton papers, Archives of American Art, reel 2326, frames 519–20.

12. Benton consistently attributed his knowledge of clay modeling directly to Tintoretto. Before 1919, he "never thought of making models for paintings." See Cummings, *Artists in Their Own Words*, 39.

13. Thomas Hart Benton to Liam O'Laoghaire [O'Leary], November 14, 1959, Liam O'Leary Collection, National Library of Ireland. I am grateful to Ruth Barton for having shared a copy of this letter. See Ruth Barton, *Rex Ingram: Visionary Director of the Silent Screen* (Lexington: University Press of Kentucky, 2014).

14. Benton gave his Parisian cape and cane to Valentino, who used them as part of his costume in *Four Horsemen*; see Robert S. Gallagher, "An Artist in America," *American Heritage* 24, no. 4 (June 1973): 43.

15. On the "star system" that actors used to enhance their personal histories, see Paula Marantz Cohen, *Silent Film and the Triumph of the American Myth* (New York: Oxford University Press, 2001). I thank National Portrait Gallery (NPG) curators Brandon Fortune and Dorothy Moss for their support of this new interpretation of *Self Portrait with Rita*, now dated c. 1924. Five months before his death, Benton wrote to NPG curator Robert Stewart that the painting might be "about 1922." The redating of the portrait is based on Benton's inaccurate memory, stylistic analysis, and contextual evidence, including the Benton family's 1924 purchase of a permanent summer home on Martha's Vineyard, the summer 1923 appearance of Rita's swimwear and headband ensemble style in *Vanity Fair*, and the correlation between the influential image of a bare-chested Douglas Fairbanks in *The Thief of Baghdad* (see fig. 3) and Benton's shirtless self-presentation in the painting.

16. See Thomas Hart Benton, "After," in *An Artist in America*, 4th revised ed. (Columbia: University of Missouri Press, 1983), 278.

17. Benton explained that "[deep] space had become the very core of my dream of an art that might be inclusive of all the conditions of reality"; see Thomas Hart Benton, "My American Epic in Paint," *Creative Art* 3, no. 6 (December 1928), quoted in *A Thomas Hart Benton Miscellany*, ed. Matthew Baigell (Lawrence: University of Kansas Press, 1971), 18.

18. Thomas Hart Benton to Betty Chamberlain, response to telegram of August 15, 1940, Thomas Hart Benton files, Nelson-Atkins Museum of Art, Kansas City.

19. Ibid. For further discussion of Benton's clay model technique, see Thomas Hart Benton, *An American in Art* (Lawrence: University Press of Kansas, 1969), 72–74.

20. On Russell's dedication to sculpture as an adjunct to painting, see Marilyn S. Kushner, *Morgan Russell* (New York: Hudson Hills Press; Montclair, NJ: Montclair Art Museum, 1990), 29–30.

21. Benton considered his clay models makeshift tools rather than enduring works of art. He destroyed virtually all of them. See Homer Brown, "'The Work of Art': An Interview with Thomas Hart Benton, Part 1," recorded May 6, 1962, cd. Lynn Wolf Gentzler, transcribed by Jeff D. Corrigan, in *Missouri Historical Review* 108, no. 1 (October 2013), 13–14.

22. See Benton, *An American in Art*, 72. Atypically, Benton did attempt to replicate his large model for the Truman Library mural (fig. 8), but during the casting process the model was inadvertently destroyed. See Benton, *An American in Art*, 74.

23. See Richard J. Boyle et al., *Milk and Eggs: The American Revival of Tempera Painting, 1930–1950* (Chadds Ford, PA: Brandywine River Museum; Seattle: Washington University Press, 2002).

24. See technical notes documented in Margaret C. Conrads, ed., *American Paintings to 1945*, vol. 2 (Kansas City, Missouri: The Nelson-Atkins Museum of Art, 2007), 31.

25. Conrads, *American Paintings to 1945*, 2:33.

26. Cummings, *Artists in Their Own Words*, 46.

27. Rex Ingram, *Opportunities in the Motion Picture Industry* (Los Angeles: Photoplay Research Society, 1922), quoted in Richard Koszarski, *Hollywood Directors 1914–1940* (New York: Oxford University Press, 1976), 90.

28. Thomas Hart Benton, quoted in "For Tom Benton, A Mural Means Endless Detail," *Kansas City Times*, November 24, 1959.

29. Newspaper articles identified the model for *Aaron* as Ben Nichols, an eighty-two-year-old lay preacher from Independence, Missouri. See "Tom Benton and His Class Become Newsreel Fare," *Kansas City Star*, November 20, 1940, clipping in the Thomas Hart Benton files, Nelson-Atkins Museum of Art, Kansas City.

30. Thomas Hart Benton, "Painting and Photography," *Manuscripts Number Four* (December 1922): 8. Benton's assertion is part of his response to the question addressed to several artists, "Can a photograph have the significance of art?"

31. Benton referred to "Venetian space composers" in his unpublished papers; see Thomas Hart Benton papers, Archives of American Art, reel 2326, frame 1340.

32. Cummings, *Artists in Their Own Words*, 42.

Wien: The Year of Painting Furiously

1. Alan Brinkley, *The Publisher: Henry Luce and His American Century* (New York: Knopf, 2010), 271. Luce published "The American Century" in *Life* on February 17, 1941.

2. Thomas Hart Benton, "The Year of Peril," *University* [of Kansas City] *Review* 8 (Spring 1942): 178–88.

3. Benton first described *YOP* as "cartoons" in an autobiographical statement for the exhibition catalogue *Meet the Artist: An Exhibition of Self-Portraits by Living American Artists* (San Francisco: M. H. de Young Memorial Museum, 1943), 14–15. See also Thomas Hart Benton, "Painting and Propaganda Don't Mix," *Saturday Review* 43, no. 52 (December 24, 1960): 16–17.

4. Alfred M. Frankfurter, "Benton," *Art News* 41, no. 6 (May 1–14, 1942): 34. Because he was appalled by the works and the accompanying publicity campaign, Frankfurter did not attend the exhibition at Associated American Artists and based his review solely on the color reproductions in Abbott Laboratories' magazine (see note 9, below).

5. Roger T. Reed, "The Pulps: Their Weaknesses Were Their Strengths," in Robert Lesser, *Pulp Art: Original Cover Paintings for the Great American Pulp Magazines* (New York: Metro Books, 1997), 10. The high-art language of surrealism, particularly the paintings of Salvador Dalí, has been suggested as another stylistic influence on Benton's *YOP*. See Erika Doss, "*The Year of Peril*: Thomas Hart Benton and World War II," in *Thomas Hart Benton: Artist, Writer and Intellectual*, ed. R. Douglas Hurt and Mary K. Dains (Columbia: State Historical Society of Missouri, 1989), 35–63.

6. Clayton R. Koppes and Gregory D. Black, "Blacks, Loyalty, and Motion Picture Propaganda in World War II," in *Controlling Hollywood: Censorship and Regulation in the Studio Era*, ed. Matthew Bernstein (New Brunswick: Rutgers University Press, 1999), 137.

7. These source materials are identified in the opening sequence of *The Negro Soldier* (1944), the film produced by Frank Capra, sponsored by the US Department of War (discussed later in

this essay). "United Nations" here refers to those countries that signed an anti-Nazi declaration on January 1, 1942.

8. Benton recalled that Europeans viewed the images as though they were from a foreign film illuminating a darkened corner of the world. See Thomas Hart Benton, *An Artist in America* (1937; repr., Columbia: University of Missouri Press, 1983), 299–300.

9. Abbott Laboratories also published the paintings in its in-house publication, but without the foreword by MacLeish. See "The Year of Peril: A Series of Paintings by Thomas Benton," in *What's New*, no. 58 (April 1942): 7–15.

10. Thomas Hart Benton, autobiographical statement in *Meet the Artist: An Exhibition of Self-Portraits by Living American Artists* (San Francisco: M. H. de Young Memorial Museum, 1943), 15; and Benton, *An Artist in America*, 299.

11. David Lloyd George, the British secretary of war and prime minister during World War I, popularly remembered as "the man who won the war," is likely the George of Benton's allusion.

12. Congressional Record, vol. 88 (April 16, 1942): 3510–12. The paintings were not reproduced in the congressional report, although they were reproduced in the original article: Benton, "The Year of Peril," *University Review*.

13. "Appendix: The Production Code," in Thomas Doherty, *Hollywood's Censor: Joseph I. Breen and the Production Code Administration* (New York: Columbia University Press, 2007), 354; and J. Hoberman and Jeffrey Shandler, et al., *Entertaining America: Jews, Movies, and Broadcasting* (New York: Jewish Museum; Princeton: Princeton University Press, 2003), 61.

14. Benton, "The Year of Peril," 180.

15. Benton made the remarks in April 1941 while attending the opening of his solo exhibition at Associated American Artists in New York. See Floyd Taylor, "Thomas Hart Benton Says Art Belongs in Clubs and Saloons, Not Museums," *New York World-Telegram*, April 5, 1941. The story is more fully told in Justin Wolff, *Thomas Hart Benton: A Life* (New York: Farrar, Straus and Giroux, 2012), 271–72; and Henry Adams, *Thomas Hart Benton: An American Original* (New York: Knopf, 1989), 303–5.

16. The battle for Wake Island, an American possession and refueling base in the Pacific, occurred between December 8 and December 23, 1941. American forces fought heroically before finally surrendering.

17. Art Digest 16, no. 4 (April 15, 1942): 13. A small reproduction of *Invasion* accompanied this article.

18. See Thomas Doherty, *Projections of War: Hollywood, American Culture, and World War II* (New York: Columbia University Press, 1993), 70–76.

19. Joseph McBride, *Frank Capra: The Catastrophe of Success* (New York: Simon & Schuster, 1992), 453.

20. See Thomas Hart Benton to James W. Goodrich [director of the State Historical Society of Missouri], February 4, 1972, files of the State Historical Society of Missouri, Columbia, Missouri. Benton probably sketched the soldiers, part of the American expeditionary forces departing for Africa, during an autumn 1942 stopover in New York en route from Martha's Vineyard to Kansas City.

21. In a postscript to his 1937 autobiography,

Benton underscored the realism of his collective portrait. See Benton, *An Artist in America*, 300.

22. Benton knew well Raymond Griffith – the actor who played the unnamed French soldier whose mute yet memorable death in *All Quiet on the Western Front* takes place in a shell crater. Their friendship may extend as far back as 1915, when each was working in silent films. On assignment in Hollywood for *Life* magazine during the summer of 1937, Benton used Griffith's office on the 20th Century Fox lot as his base of operations. See Harry Salpeter, "A Tour of Hollywood: Drawings by Thomas Benton," *Coronet* 7, no. 4 (February 1940): 34.

23. Capra's much acclaimed film *Mr. Smith Goes to Washington* (1939) depicts blacks only in the minor roles of incompetent porters.

24. See Thomas Cripps and David Culbert, "*The Negro Soldier* (1944): Film Propaganda in Black and White," *American Quarterly* 31, no. 5 (Winter 1979): 622–23, 623n22.

25. Cripps and Culbert, "*The Negro Soldier*," 628–31.

26. Frank Capra, *The Name above the Title: An Autobiography* (New York: Macmillan, 1971), 358.

27. A survey conducted by Columbia University in 1945 demonstrated that 75 percent of black appearances in wartime films "perpetuated old stereotypes." Koppes and Black, "Blacks, Loyalty, and Motion Picture Propaganda," 149–50.

28. *Negro and Alligator* was one of four paintings by Benton included in *Contemporary American Paintings*, an exhibition presented by the Academy of Motion Picture Arts and Sciences, organized by Associated American Artists of New York City, and on view at the Beverly Hills Hotel from May 22 to June 1, 1940 (cat. no. 7). King Vidor purchased *Negro and Alligator* in New York in 1941. See King Vidor, *A Tree Is a Tree* (New York: Longmans, Green and Co., 1954), 170.

29. See the record of the State Historical Society of Missouri finance committee dinner conference, dated December 9, 1944, which documents Benton's personal gift of *Negro Soldier*. Files of the State Historical Society of Missouri, Columbia, Missouri.

McDaniels

1. Chad L. Williams, *Torchbearers of Democracy: African American Soldiers in the World War I Era* (Chapel Hill: University of North Carolina Press, 2010).

2. Gordon E. Slethaug, "floating signifier," in *Encyclopedia of Contemporary Literary Theory: Approaches, Scholars, Terms*, ed. Irena R. Makaryk (Toronto: University of Toronto Press, 1993), 546–47.

3. Rob Kroes, *Photographic Memories: Private Pictures, Public Images, and American History* (Hanover, NH: Dartmouth College Press, 2007), 61.

4. Wilson Yates, "An Introduction to the Grotesque: Theoretical and Theological Considerations," in *The Grotesque in Art and Literature: Theological Reflections*, ed. James Luther Adams and Wilson Yates (Grand Rapids, MI: William B. Eerdmans, 1997), 2.

5. Roscoe C. Jamison, "Negro Soldiers," in *Negro Soldiers and Other Poems* (St. Joseph, MO: William F. Neil, 1918), 1.

6. Ibid., 1.

Marcus

1. Walker Percy, "Why I Live Where I Live," *Esquire*, April 1980; collected in *Esquire's Big Book of Great Writing*, ed. Adrienne Miller (New York: Hearst Books, 2002), 103.

2. Thomas Hart Benton, *An Artist in America* (1937; repr., Columbia: University of Missouri Press, 1968), 37.

3. Benton, *An Artist in America*, 269.

4. Benton likely came across the recording of "Pretty Polly," by the banjoist Dock Boggs, in Virginia. In 1930, Benton pressed the ballad on the modernist Communist Party composer Charles Seeger, thus sparking a campaign in art that would lead to the identification of American folk music with a communist idealization of what were termed "the People," which was to say the poor, the deprived, the oppressed, and the pure. It also led to the identification of folk singers with communists.

5. Benton, *An Artist in America*, 45.

6. Ibid., 54–60.

7. Ibid., 60.

8. Ibid., 59.

9. Ibid., 56.

10. Ibid., 255.

11. Jackson Pollock ("when I'm painting" and "the painting has a life"), quoted in *Possibilities* 1, no. 1 (Winter 1947–48): 79, and ("when you're painting out of the unconscious"), quoted in Seldon Rodman, *Conversations with Artists* (New York: Capricorn, 1961), 84–85; and Benton, *An Artist in America*, 255–56.

12. Meyer Schapiro, "Populist Realism," *Partisan Review* 4, no. 2 (January 1938): 57, quoted in Erika Doss, *Benton, Pollock, and the Politics of Modernism: From Regionalism to Abstract Expressionism* (Chicago: University of Chicago Press, 1991), 144.

13. Benton, *An Artist in America*, 258.

14. Ibid., 262.

15. Ibid., 274.

16. Ibid., 268.

Adams, Henry. *Thomas Hart Benton: An American Original.* Biography/catalogue. New York: Alfred A. Knopf, 1989.

———. *Thomas Hart Benton: Drawing from Life.* Exhibition catalogue. Seattle: Henry Art Gallery, 1990.

———. "Thomas Hart Benton's Illustrations for *The Grapes of Wrath.*" *San Jose Studies* 16 (Winter 1990): 6–18.

———. *Tom and Jack: The Intertwined Lives of Thomas Hart Benton and Jackson Pollock.* New York: Bloomsbury Press, 2009.

Allen, Nina. "Thomas Hart Benton and John Steinbeck: Populist Realism in the Depression Era." PhD dissertation, Boston University, 1995.

American Artist. "The Long Voyage Home as Seen and Painted by Nine American Artists." September 1940, 4–14.

Art Digest. "Benton in Indiana." March 1, 1933, 20.

———. "The Metamorphosis of Thomas Hart Benton." April 15, 1939.

———. "The War and Thomas Benton." April 15, 1942, 13.

Baigell, Matthew. *Thomas Hart Benton.* New York: Harry N. Abrams, 1974.

———. *A Thomas Hart Benton Miscellany: Selections from his Published Opinions, 1916–1960.* Lawrence: University Press of Kansas, 1971.

Bailly, Austen Barron. "Painting the *American Historical Epic*: Thomas Hart Benton and Race, 1919–1936." PhD dissertation, University of California, Santa Barbara, 2009.

———. "Race in Benton's Murals." *Indiana Magazine of History* 105, no. 2 (June 2009): 150–66.

Bandy, Mary Lea, and Kevin Stoehr. *Ride, Boldly, Ride: The Evolution of the American Western.* Berkeley: University of California Press, 2012.

Bazin, André. "The Evolution of the Western." In *Movies and Methods: An Anthology,* vol. 1, edited by Bill Nichols, 150–57. Berkeley: University of California Press, 1976.

———. "The Western; Or, the American Film Par Excellence." In *What Is Cinema?,* vol. 2, essays selected and translated by Hugh Gray, 140–57. Berkeley: University of California Press, 1971.

Beard, Charles Austin, and Mary Ritter Beard. *The Rise of American Civilization: A Study of the Idea of Civilization in the United States.* New York: Macmillan, 1927.

Belhmer, Rudy. *Behind the Scenes: The Making of . . . "The Maltese Falcon," "Singin' in the Rain," "Snow White and the Seven Dwarfs," "Stagecoach," "A Streetcar Named Desire," "Tarzan and His Mate," "The Adventures of Robin Hood," "The African Queen," "All About Eve," "Casablanca," "Frankenstein," "The Grapes of Wrath," "Gunga Din," "High Noon," "Laura," "Lost Horizon."* Hollywood: Samuel French, 1990.

Benton, Thomas Hart. *An American in Art: A Professional and Technical Autobiography.* Lawrence: University Press of Kansas, 1969.

———. "American Regionalism: A Personal History of the Movement." *University of Kansas Review* 18, no. 1 (Autumn 1951): 41–75.

———. "Art and Nationalism." *Modern Monthly* 8, no. 4 (May 1934): 235–36.

———. *An Artist in America.* 1937. Reprint, 4th edition, Columbia: University of Missouri Press, 1983.

———. *The Arts of Life in America: A Series of Murals.* New York: Whitney Museum of American Art, 1932.

———. *Benton Drawings: A Collection of Drawings.* Columbia: University of Missouri Press, 1968.

———. "A Dream Fulfilled." In David Laurance Chambers, *Indiana: A Hoosier History; Based on the Mural Paintings of Thomas Hart Benton.* Indianapolis: Bobbs-Merrill, 1933.

———. "Form and the Subject." *The Arts* 5, no. 6 (June 1924): 303–9.

———. *Independence and the Opening of the West.* Independence, Missouri: Harry S. Truman Library, 1961.

———. "Mechanics of Form Organization in Painting." Parts I–V, respectively, *Arts* 10, no. 5 (November 1926): 285–89; *Arts* 10, no. 6 (December 1926): 340–42; *Arts* 11, no. 1 (January 1927): 43–44; *Arts* 11, no. 2 (February 1927): 95–96; *Arts* 11, no. 3 (March 1927): 145–58.

———. "My American Epic in Paint." *Creative Art* 3, no. 6 (December 1928): xxx–xxxvi.

———. "Painting and Propaganda Don't Mix." *Saturday Review* 43, no. 51 (December 24, 1960): 16–17.

———. "Thirty-Six Hours in a Boom Town." *Scribner's* 104, no. 4 (October 1938): 16–19, 52–53.

———. "Year of Peril." *University [of Kansas] Review* 8, no. 3 (Spring 1942): 178–88.

———. *The Year of Peril: A Series of Paintings by Thomas Benton.* Foreword by Archibald MacLeish. North Chicago: Abbott Laboratories, 1942.

Bernstein, Matthew. *Controlling Hollywood: Censorship and Regulation in the Studio Era.* New Brunswick: Rutgers University Press, 1999.

———. *Walter Wanger, Hollywood Independent.* Minneapolis: University of Minnesota Press, 1994.

Bernstein, Matthew, and Dana F. White. "*Imitation of Life* in a Segregated Atlanta: Its Promotion, Distribution, and Reception." *Film History* 19, no. 2 (2007): 152–78.

Blake, Casey Nelson. "Thomas Hart Benton and the Melodrama of Democracy." *Indiana Magazine of History* 105, no. 2 (June 2009): 167–78.

Booker, M. Keith. *Historical Dictionary of American Cinema.* Lanham, MD: Scarecrow Press, 2011.

Boston Post. "Ingraham [sic] Tells Life Romance." March 19, 1922.

Bowser, Pearl, Jane Gaines, and Charles Musser. *Oscar Micheaux and His Circle: African-American Filmmaking and Race Cinema of the Silent Era.* Bloomington: Indiana University Press, 2001.

Bowser, Pearl, and Louise Spence. *Writing Himself into History: Oscar Micheaux, His Silent Films, and His Audiences.* New Brunswick: Rutgers University Press, 2000.

Braun, Emily, and Thomas Branchick. *Thomas Hart Benton: The America Today Murals.* Exhibition catalogue. Williamstown: Williams College Museum of Art, 1985.

Brinkley, Alan. *The Publisher: Henry Luce and His American Century.* New York: Alfred A. Knopf, 2010.

Broun, Elizabeth, Thomas Hart Benton, Douglas Hyland, Marilyn Stokstad, and Helen Foresman. *Benton's Bentons: Selections from the Thomas Hart Benton and Rita P. Benton Trusts.* Exhibition catalogue. Lawrence: Spencer Museum of Art, University of Kansas, 1980.

Brown, Gene. *Movie Time: A Chronology of Hollywood and the Movie Industry from Its Beginnings to the Present.* New York: Macmillan, 1995.

Brown, Homer. "'The Work of Art': An Interview with Thomas Hart Benton, Part 1," *Missouri Historical Review* 108, no. 12 (October 2013), 1–26; and "'The Work of Art': An Interview with Thomas Hart Benton, Part 2," *Missouri Historical Review* 108, no. 2 (January 2014), 79–104. Interview originally recorded May 6, 1962, transcribed by Jeff Corrigan, edited by Lynn Wolf Gentzler, and annotated by Corrigan, Joan Stack, and Todd Barnett.

Burroughs, Polly. *Thomas Hart Benton: A Portrait.* Garden City, NY: Doubleday, 1981.

Butsch, Richard. *The Making of American Audiences: From Stage to Television, 1750–1900*. Cambridge: Cambridge University Press, 2000.

Cahill, Holger. *American Painting and Sculpture, 1862–1932*. Exhibition catalogue. New York: Museum of Modern Art, 1932.

Capra, Frank. *The Name above the Title: An Autobiography*. New York: Macmillan, 1971.

Carbine, Mary. "'The Finest outside the Loop': Motion Picture Exhibition in Chicago's Black Metropolis, 1905–1928." *Camera Obscura* 8 (May 1990): 9–42.

Carmichael, Deborah A., ed. *The Landscape of Hollywood Westerns: Ecocriticism in an American Film Genre*. Salt Lake City: University of Utah Press, 2006.

Chaffin, Tom. *The Pathfinder: John Charles Frémont and the Course of American Empire*. New York: Hill and Wang, 2002.

Chiappini, Rudy. *Thomas Hart Benton*. Exhibition catalogue. Lugano, Switzerland: Museo d'Arte Moderna, 1992.

Cohen, George Michael. "Thomas Hart Benton: A Discussion of His Lithographs." *American Artist* 26, no. 7 (September 1962): 22–25, 74–77.

Craven, Thomas. "The Great American Art." *The Dial* 81 (December 1926): 483–92.

———. *Thomas Hart Benton: A Descriptive Catalogue of the Works of Thomas Hart Benton, Spotlighting the Important Periods during the Artist's Thirty-Two Years of Painting*. New York: Associated American Artists, 1939.

Cripps, Thomas. "Following the Paper Trail to *The Birth of a Race* and Its Times." *Film and History: An Interdisciplinary Journal of Film and Television Studies* 18, no. 3 (September 1988): 50–62.

———. *Making Movies Black: The Hollywood Message Movie from World War II to the Civil Rights Era*. New York: Oxford University Press, 1993.

———. *Slow Fade to Black: The Negro in American Film, 1900–1942*. Oxford: Oxford University Press, 1978.

Cripps, Thomas, and David Culbert. "*The Negro Soldier* (1944): Film Propaganda in Black and White." *American Quarterly* 31, no. 5 (Winter 1979): 616–40.

Cummings, Paul. *Artists in Their Own Words: Interviews*. New York: St. Martin's Press, 1979.

Czestochowski, Joseph S. *A Question of Regionalism: Lithographs by Thomas Hart Benton, John Steuart Curry, Grant Wood*. Memphis: Brooks Memorial Art Gallery, 1975.

Danes, Gibson, "The Creation of Thomas Hart Benton's *Persephone*." *American Artist* 4, no. 3 (March 1940): 4–10.

Darby, William. *John Ford's Westerns: A Thematic Analysis, with a Filmography*. Jefferson, NC: McFarland & Company, 1996.

Davis, Ronald L. *John Ford: Hollywood's Old Master*. Norman: University of Oklahoma Press, 1995.

Dennis, James M. *Renegade Regionalists: The Modern Independence of Grant Wood, Thomas Hart Benton, and John Steuart Curry*. Madison: University of Wisconsin Press, 1998.

Devree, Howard. "Benton Returns." *Magazine of Art* 32, no. 5 (May 1939): 301–2.

Doherty, Thomas. *Hollywood's Censor: Joseph I. Breen and the Production Code Administration*. New York: Columbia University Press, 2007.

———. *Projections of War: Hollywood, American Culture, and World War II*. New York: Columbia University Press, 1993.

Doss, Erika. "Artists in Hollywood: Thomas Hart Benton and Nathanael West Picture America's Dream Dump." *The Space Between: Literature and Culture, 1914–1945* 7, no. 1 (2011): 9–32.

———. *Benton, Pollock, and the Politics of Modernism: From Regionalism to Abstract Expressionism*. Chicago: University of Chicago Press, 1991.

———. "Borrowing Regionalism: Advertising's Use of American Art in the 1930s and 40s." *Journal of American Culture* 5, no. 4 (Winter 1982): 10–19.

———. "Hollywood, 1937–1938." In *The Collections of the Nelson-Atkins Museum of Art, American Paintings to 1945*, vol. 1, edited by Margaret C. Conrads. Kansas City, Missouri: The Nelson-Atkins Museum of Art, 2000.

———. "No Way Like the American Way." In *A New Literary History of America*, edited by Greil Marcus and Werner Sollors. Cambridge, MA: Belknap Press, 2009.

———. "Regionalists in Hollywood: Painting, Film, and Patronage, 1925–1945." PhD dissertation, University of Minnesota, 1983.

———. "Thomas Hart Benton's Hoosier History." *Indiana Magazine of History* 105, no. 3 (June 2009): 127–39.

Dreishspoon, Douglas. *Benton's America: Works on Paper and Selected Paintings*. Exhibition catalogue. New York: Hirschl & Adler Galleries, 1991.

Eagan, Daniel. *America's Film Legacy: The Authoritative Guide to the Landmark Movies in the National Film Registry*. New York: Continuum International, 2010.

Edelman, Nancy. *The Thomas Hart Benton Murals in the Missouri State Capitol: A Social History of the State of Missouri*. Jefferson City: Missouri State Council on the Arts, 1975.

Everett, Anna. *Returning the Gaze: A Genealogy of Black Film Criticism, 1909–1949*. Durham, NC: Duke University Press, 2001.

Eyman, Scott. *Print the Legend: The Life and Times of John Ford*. New York: Simon & Schuster, 1999.

Farber, Manny. "Thomas Benton's War." *The New Republic* 106, no. 12 (April 20, 1942): 542–43.

Farrand Thorpe, Margaret. *America at the Movies*. New Haven: Yale University Press, 1939.

Fath, Creekmore. *The Lithographs of Thomas Hart Benton*. 1969. Reprint, Austin: University of Texas Press, 2001.

Finler, Joel W. *The Hollywood Story*. London: Wallflower Press, 2003.

Fischer, Lucy. *American Cinema of the 1920s: Themes and Variations*. New Brunswick: Rutgers University Press, 2009.

Fisk, Rose Mary. "Murals by Americans Is Dull Show." *Chicago Evening Post*, May 10, 1932.

Flinn, Sr., John C. "Review: 'The Grapes of Wrath.'" *Variety*, January 30, 1940.

Ford, Dan. *Pappy: The Life of John Ford*. New York: Da Capo, 1998.

Fort, Ilene Susan, and Michael Quick. "Thomas Hart Benton." In *American Art: A Catalogue of the Los Angeles County Museum of Art Collection*. Los Angeles: Los Angeles County Museum of Art, 1991.

Foster, Kathleen A., Nanette Esseck Brewer, and Margaret Contompasis. *Thomas Hart Benton and the Indiana Murals*. Bloomington: Indiana University Art Museum; Bloomington: Indiana University Press, 2000.

Fravel, Laura. "Harpo's Benton." In *Untitled*, a blog by the North Carolina Museum of Art, May 10, 2013. http://ncartmuseum.org/untitled/2013/05/harpo's-benton/.

Gallagher, Brian. "Greta Garbo Is Sad: Some Historical Reflections on the Paradoxes of Stardom in the American Film Industry, 1910–1960." *Images: A Journal of Film and Popular Culture*, no. 3 (1997).

Gallagher, Robert S. "An Artist in America." *American Heritage* 24, no. 4 (June 1973): 43.

Gallagher, Tag. *John Ford: The Man and His Films*. Berkeley: University of California Press, 1986.

Gmür, Leonhard H. *Rex Ingram: Hollywood's Rebel of the Silver Screen; The Life and Films of an Uncommon Director*. Berlin: epubli GmbH, 2013.

Gomery, Douglas. "Movie Theaters for Black Americans." In *Shared Pleasures: A History of Movie Presentation in the United States*, 155–70. Madison: University of Wisconsin Press, 1992.

Grant, Barry Keith, ed. *John Ford's Stagecoach.* Cambridge: Cambridge University Press, 2003.

Gruber, J. Richard. *Thomas Hart Benton and the American South.* Exhibition catalogue. Augusta, GA: Morris Museum of Art, 1998.

——. "Thomas Hart Benton: Teaching and Art History." PhD dissertation, University of Kansas, Lawrence, 1987.

Gunning, Tom. "Passion Play as Palimpsest: The Nature of the Text in the History of Early Cinema." In *Une Invention du Diable? Cinéma Des Premiers Temps et Réligion*, edited by André Gaudreault, Roland Cosandey, and Tom Gunning, 102–11. Sainte-Foy, Switzerland: Les presses de l'université Laval; Lausanne: Edition Payot, 1992.

Hall, Mordaunt. "Vidor's Negro Film." *New York Times*, August 25, 1929.

Hark, Ina Rae. *American Cinema of the 1930s: Themes and Variations.* New Brunswick: Rutgers University Press, 2007.

Heil, Walter. *Meet the Artist: An Exhibition of Self-Portraits by Living American Artists.* Exhibition catalogue. San Francisco: M. H. de Young Memorial Museum, 1943.

Hoberman, J., Jeffrey Shandler, et al. *Entertaining America: Jews, Movies, and Broadcasting.* New York: Jewish Museum; Princeton: Princeton University Press, 2003.

Huberman, Leo. *We, the People.* Illustrations by Thomas Hart Benton. New York: Harper, 1932.

Hurt, R. Douglas, Mary K. Dains, Sidney Larson, and Matthew Baigell. *Thomas Hart Benton: Artist, Writer, and Intellectual.* Columbia: State Historical Society of Missouri, 1989.

Ingram, Rex. "Art Advantages of the European Scene: One of the Great Directors of the Screen Deplores the Artificiality of Hollywood." *Theatre Magazine*, January 1928, 24.

——. "The Motion Picture as an Art." *Art Review* 1, no. 5 (February 1922): 12–13, 27.

Jacobs, Lewis. *The Rise of American Film: A Critical History.* New York: Harcourt Brace, 1939.

Jamison, Roscoe C. *Negro Soldiers ("These truly are the brave") and Other Poems.* St. Joseph, MO: William F. Neil, 1918.

Jewell, Richard B. *The Golden Age of Cinema: Hollywood, 1929–1945.* Malden, MA: Blackwell, 2007.

Johnson, Ken. "Art Review: A Panorama Starring a Cast of Stereotypes." *New York Times*, April 16, 2004.

Johnson, Nunnally. *In Pictures: A Hollywood Satire.* Illustrations by Will Connell. New York: T. J. Maloney, 1937.

Kammen, Michael. *Mystic Chords of Memory: The Transformation of Tradition in American Culture.* New York: Vintage, 1993.

Kansas City Star. "His Anger on Canvas." April 3, 1942.

Koszarski, Richard. *Fort Lee: The Film Town.* Bloomington: Indiana University Press, 2004.

——. *Hollywood on the Hudson: Film and Television in New York from Griffith to Sarnoff.* New Brunswick: Rutgers University Press, 2008.

Kroes, Rob. *Photographic Memories: Private Pictures, Public Images, and American History.* Hanover: Dartmouth College Press, 2007.

Landy, Marcia. "The Hollywood Western, the Movement-Image, and Making History." In *Hollywood and the American Historical Film*, edited by J. E. Smith, 26–48. New York: Palgrave Macmillan, 2012.

Larson, Sidney. *Thomas Hart Benton's Illustrations from Mark Twain: "The Adventures of Tom Sawyer," "The Adventures of Huckleberry Finn," "Life on the Mississippi"; From the State Historical Society of Missouri Collection.* Exhibition catalogue. St. Joseph, MO: Albrecht Art Museum; Kansas City, MO: Mid-America Arts Alliance, 1976.

Lepore, Jill. *The Name of War: King Philip's War and the Origins of American Identity.* New York: Vintage, 2013.

Lesser, Robert. *Pulp Art: Original Cover Paintings for the Great American Pulp Magazines.* New York: Metro Books, 2009.

Lewis, Meriwether, and William Clark. *Journals of the Lewis and Clark Expedition.* Edited by Gary E. Moulton. 13 vols. Lincoln: University of Nebraska Press, 2001.

Leyda, Julia. "Black-Audience Westerns and the Politics of Cultural Identification in the 1930s." *Cinema Journal* 42, no. 1 (Autumn 2002): 46–70.

Lieban, Helen. "Thomas Benton: American Mural Painter." *Design* 36, no. 6 (December 1934): 26–34.

Life. "Benton's Nudes People the Ozarks." February 20, 1939, 38–40.

Lin, Jan. "Dream Factory Redux: Mass Culture, Symbolic Sites, and Redevelopment in Hollywood." In *Understanding the City: Contemporary and Future Perspectives*, edited by John Eade and Christopher Mele, 397–418. Oxford: Blackwell, 2002.

Lindsay, Vachel. *The Art of the Moving Picture.* 1915. Reprint, New York: Liveright, 1970.

Marcus, Greil. *Mystery Train: Images of America in Rock 'n' Roll Music.* 5th edition. New York: Plume, 2008.

Marling, Karal Ann. "Thomas Hart Benton's *Boomtown*: Regionalism Redefined." *Prospects: An Annual of American Cultural Studies* 6 (1981): 73–137.

——. *Tom Benton and His Drawings: A Biographical Essay and a Collection of His Sketches, Studies, and Mural Cartoons.* Columbia: University of Missouri Press, 1985.

May, Lary. *The Big Tomorrow: Hollywood and the Politics of the American Way.* Chicago: University of Chicago Press, 2000.

——. "Making the American Way: Modern Theaters, Audiences, and the Film Industry, 1929–1945." *Prospects: An Annual of American Cultural Studies* 12 (1987): 89–124.

——. *Screening Out the Past: The Birth of Mass Culture and the Motion Picture Industry.* New York: Oxford University Press, 1980.

Mazow, Leo G. "Regionalist Radio: Thomas Hart Benton on *Art for Your Sake*." *Art Bulletin* 90, no. 1 (March 2008): 101–22.

——. *Shallow Creek: Thomas Hart Benton and American Waterways.* Exhibition catalogue. University Park: Palmer Museum of Art, Pennsylvania State University; University Park: Pennsylvania State University Press, 2007.

——. *Thomas Hart Benton and the American Sound.* University Park: Pennsylvania State University Press, 2012.

McBride, Joseph. *Searching for John Ford: A Life.* New York: St. Martin's, 2001.

McCausland, Elizabeth. "War Paintings by Thomas H. Benton." *The Springfield Sunday Union and Republican*, April 12, 1942.

McElroy, Guy C., Henry Louis Gates, Jr., and Christopher C. French. *Facing History: The Black Image in American Art, 1710–1940.* Exhibition catalogue. Washington: Corcoran Gallery of Art, 1990.

McGilligan, Patrick. *Oscar Micheaux, The Great and Only: The Life of America's First Black Filmmaker.* New York: Harper Perennial, 2008.

Mintz, Steven, and Randy Roberts, eds. *Hollywood's America: United States History through Its Films.* New York: Blackwell, 2010.

Morrison, Toni. *Playing in the Dark: Whiteness and the Literary Imagination.* New York: Vintage, 1993.

Mosher, John. "Zanuck's Joads." *New Yorker*, February 3, 1940.

Mumford, Lewis. "An American Epic in Paint." *New Republic* 50 (April 6, 1927): 197.

Nemerov, Alexander. "Projecting the Future: Film and Race in the Art of Charles Russell." *American Art* 9 (Winter 1994): 70–89.

New York Times. "Screen Negro Melodies." February 24, 1929.

Noor, Devi. "Robert Witt Ames: Hollywood." In *Unframed: The LACMA Blog*, May 14, 2014. http://lacma.wordpress.com/2014/05/14/robert-witt-ames-hollywood.

Nottage, James A. "Authenticity and Western Film." *Gilcrease Journal* 1, no. 1 (Spring 1993): 54–66.

O'Leary, Liam. *Rex Ingram: Master of the Silent Cinema*. New York: Harper & Row, 1980.

On the Road with Thomas Hart Benton: Images of a Changing America. Exhibition catalogue. Augusta, GA: Morris Museum of Art, 1998.

Onorato, Ronald J., ed. *Thomas Hart Benton, Frank Lloyd Wright: A Transcript of the Addresses and Exchanges between Frank Lloyd Wright and Thomas Hart Benton, Providence, Rhode Island, November 11, 1932*. Williamstown: Williams College Museum of Art, 1985.

"Pathé: A New Idea in the Reproduction of Color Paintings." *The Moving Picture World* 22, no. 10 (December 5, 1914).

Pearson, Ralph M. "The Artist's Point of View: Thomas Hart Benton Paints Missouri." *Forum and Century* 97, no. 6 (June 1937): 367.

Pearson, Sidney A., Jr., ed. *Print the Legend: Politics, Culture, and Civic Virtue in the Films of John Ford*. Lanham, MD: Lexington, 2009.

Philp, Kenneth R. "Stride toward Freedom: The Relocation of Indians to Cities, 1952–1960." *Western Historical Quarterly* 16, no. 2 (April 1985): 175–90.

Pierce, David. *The Survival of American Silent Feature Films, 1912–1929*. Washington: Council on Library and Information Resources and the Library of Congress, 2013.

Pippin, Robert B. *Hollywood Westerns and the American Myth: The Importance of Howard Hawks and John Ford for Political Philosophy*. New Haven: Yale University Press, 2010.

Powdermaker, Hortense. *Hollywood, The Dream Factory: An Anthropologist Looks at the Movie-Makers*. Boston: Little, Brown, 1950.

Priddy, Bob. *Only the Rivers Are Peaceful: Thomas Hart Benton's Missouri Mural*. Independence, MO: Independence Press, 1989.

Rodman, Seldon. *Conversations with Artists: 35 American Painters, Sculptors, and Architects Discuss Their Work and One Another*. New York: Capricorn, 1961.

Rohman, Jane. *Thomas Hart Benton: Original Illustrations for Francis Parkman's "The Oregon Trail."* Kearney: Nebraska Art Collection, 1988.

Salpeter, Harry. "Art Comes to Hollywood: Fifty Thousand Smackers for a Team of Artists to Paint the Take of *The Long Voyage Home*." *Esquire* September 1940, 64–65, 173–74.

———. "A Tour of Hollywood: Drawings by Thomas Benton." *Coronet* 7, no. 4 (February 1940): 34–38.

Sampson, Henry T. *Blacks in Black and White: A Source Book on Black Films*. Metuchen, NJ: Scarecrow, 1995.

Sarris, Andrew. *The John Ford Movie Mystery*. Bloomington: Indiana University Press, 1975.

Saturday Evening Post. "Hollywood Story Conference." October 10, 1936.

Schapiro, Meyer. "Populist Realism." *Partisan Review* 4, no. 2 (January 1938).

Schiller, Joyce K. *Passion, Politics, Prohibition: Benton's Bootleggers*. Exhibition catalogue. Winston-Salem, NC: Reynolda House Museum of American Art, 2002.

Singer, Ben. *Melodrama and Modernity: Early Sensational Cinema and Its Contexts*. New York: Columbia University Press, 2001.

Sobchack, Vivian C. "*The Grapes of Wrath* (1940): Thematic Emphasis through Visual Style." *American Quarterly* 31, no. 5, (Winter 1979), 596–615.

South, Will. "Invention and Imagination: Stanton Macdonald-Wright's Santa Monica Library Mural." *Archives of American Art Journal* 39, nos. 3–4 (1999): 11–20.

St. Louis Post-Dispatch. "Thomas Hart Benton, Muralist, Visits City." November 11, 1937.

Starr, Kevin. *Inventing the Dream: California through the Progressive Era*. New York: Oxford University Press, 1985.

Stewart, Jacqueline. *Migrating to the Movies: Cinema and Black Urban Modernity*. Berkeley: University of California Press, 2005.

Stott, William. *Documentary Expression and Thirties America*. Chicago: University of Chicago Press, 1973.

Stowell, H. Peter. "John Ford's Literary Sources: From Realism to Romance." *Literature/Film Quarterly* 5, no. 2 (Spring 1977): 164–73.

Suckow, Ruth. "Hollywood Gods and Goddesses." *Harper's*, July 1936, 189.

Time. "Art: Benton v. Adams." March 4, 1946.

Varner, Paul. *The A to Z of Westerns in Cinema*. Lanham, MD: Scarecrow, 2009.

Walker, Janet, ed. *Westerns: Films through History*. New York: Routledge, 2001.

Waller, Gregory. *Main Street Amusements: Movies and Commercial Entertainment in a Southern City, 1896–1930*. Washington, DC: Smithsonian Institution Press, 1995.

Warshow, Robert. *The Immediate Experience: Movies, Comics, Theatre, and Other Aspects of Popular Culture*. Garden City, NY: Doubleday, 1962.

Wernick, Robert. "Down the Wide Missouri with 'an Old S.O.B.'" *Saturday Evening Post*, October 23, 1965, 92–97.

West, Nathanael. *The Day of the Locust* (1939). In *Nathanael West: Novels and Other Writings*, edited by Sacvan Bercovich. New York: Library of America, 1997.

White, Richard, Patricia Nelson Limerick, and James R. Grossman, eds. *The Frontier in American Culture*. Exhibition catalogue. Chicago: Newberry Library, 1994.

Williams, Chad L. *Torchbearers of Democracy: African American Soldiers in the World War I Era*. Chapel Hill: University of North Carolina Press, 2010.

Williams-Sherrill, Jean, Linda Weintraub, and John Barnett. *World War II through the Eyes of Thomas Hart Benton*. Exhibition catalogue. San Antonio, TX: Marion Koogler McNay Art Museum, 1991.

Wills, Gary. *John Wayne's America*. New York: Simon & Schuster, 1998.

Wolff, Justin. *Thomas Hart Benton: A Life*. New York: Farrar, Straus and Giroux, 2012.

"Wonders of Camouflage That Are Accomplished in Movieland: What Hugo Ballin, Everett Shinn, William Cotton and other Artists Are Doing to Give the Camera More Power of Expression." *Current Opinion* 64, no. 1 (January 1918).

Archival and Online Resources

Archives of American Art, Smithsonian Institution, Washington, DC

Harry S. Truman Presidential Library and Museum, Independence, Missouri

Library of Congress, Washington, DC

Margaret Herrick Library, Academy of Motion Picture Arts and Sciences, Beverly Hills, California

Nelson-Atkins Museum of Art Archives, Kansas City, Missouri

State Historical Society of Missouri, Columbia, Missouri

T. H. Benton and R. P. Benton Testamentary Trusts, UMB Bank, Kansas City, Missouri

Thomas Hart Benton Home and Studio State Historic Site, Kansas City, Missouri

UCLA Film and Television Archive, University of California, Los Angeles

United States National Archives and Records Administration, Washington, DC

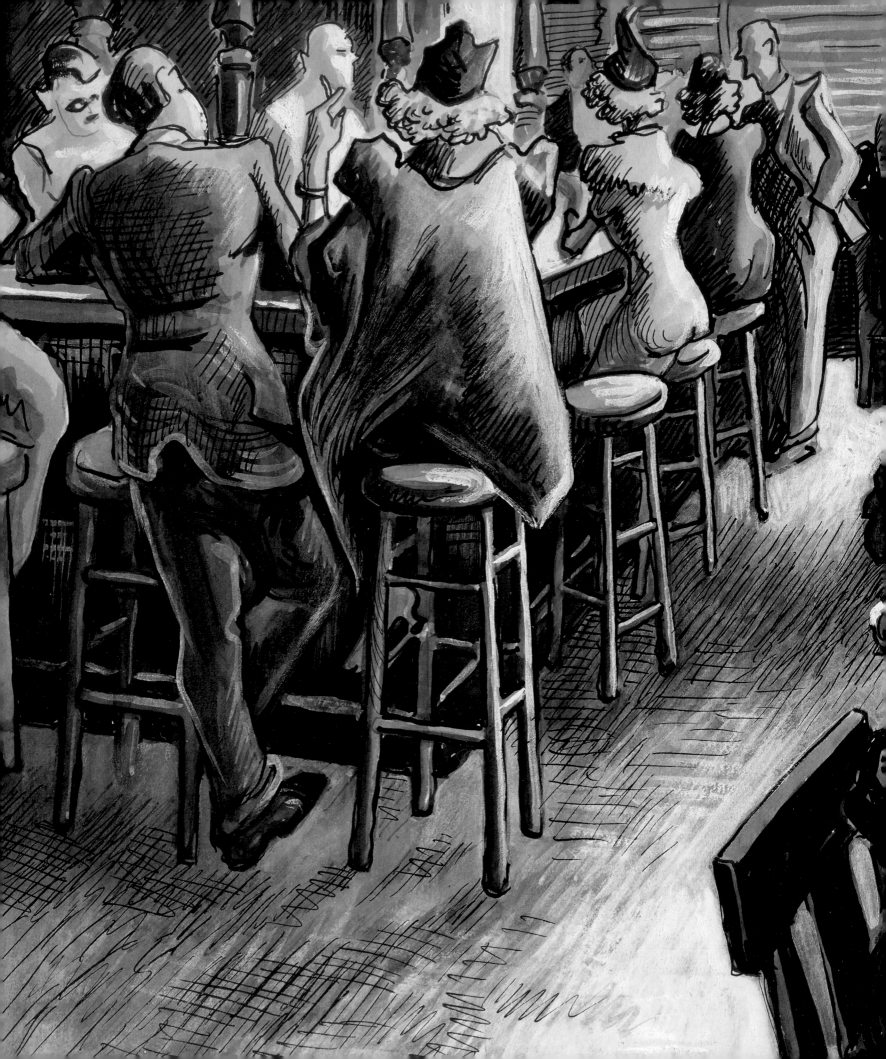

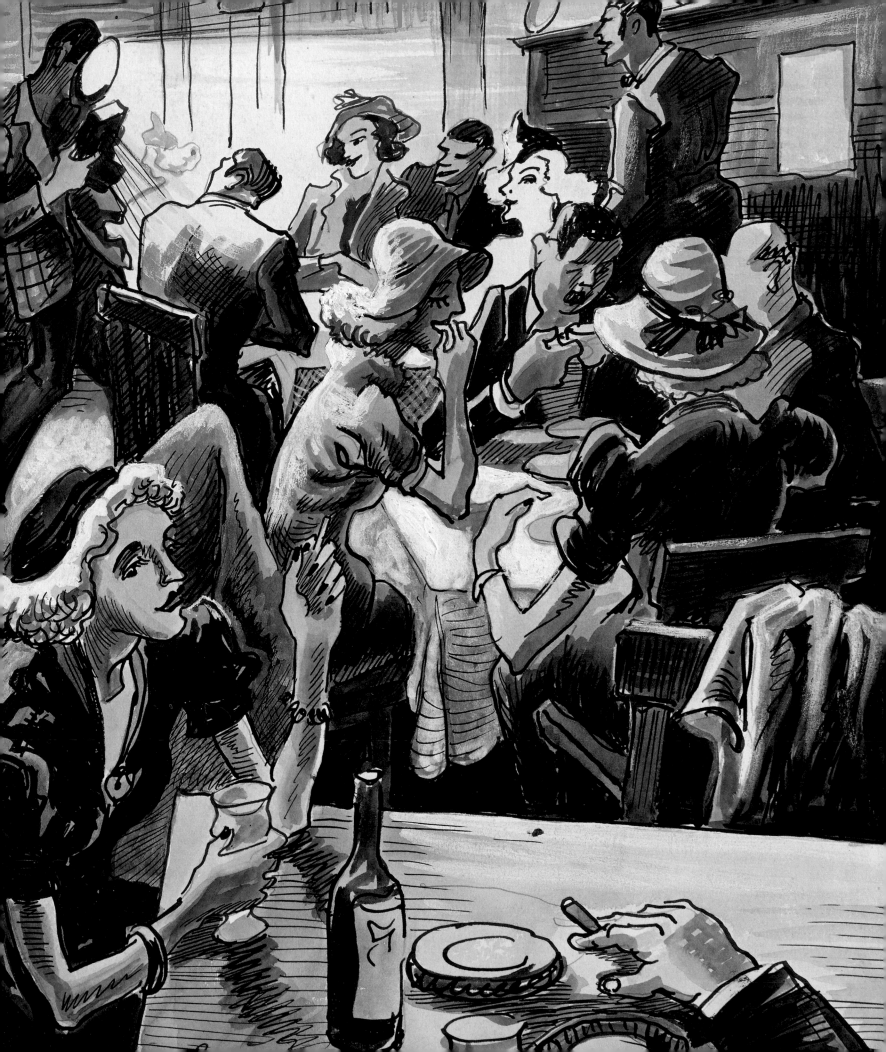

ILLUSTRATION CREDITS

All art by Thomas Hart Benton © T. H. Benton and R. P. Benton Testamentary Trusts / UMB Bank Trustee / Licensed by VAGA, New York, NY

Cover, pp. 28–29, 44 (all), 45 (all), 48 (all), 49 (all), 55, 80–81, 94, 106–7, 150–51, 153: Courtesy of The Nelson-Atkins Museum of Art. Photo by Jamison Miller; pp. 2–3, 54: Courtesy of Memorial Art Gallery, University of Rochester, NY; pp. 14, 147: Courtesy of Hirshhorn Museum and Sculpture Garden, Smithsonian Institution, Washington, DC; pp. 18–19, 120, 121, 122, 124, 125, 128, 129, 131, 132, 133, 135, 230–31: Photo by Larry Ferguson; pp. 21, 127, 130: Photo by Joshua White / JWPictures.com; pp. 31, 32, 195 (top): Courtesy of New Britain Museum of American Art; pp. 35 (all), 167 (top), 206 (left), 212 (bottom right): Paramount Pictures; pp. 36, 78, 79, 193 (right), 194 (right), 196 (bottom), 200 (right), 202 (right), 203 (left), 207 (left), 208 (all), 209 (all), 210 (top), 212 (top right), 213 (all): Phillips Library, Peabody Essex Museum, Salem, MA. Photo by Walter Silver / PEM; pp. 38, 194 (left): © The Metropolitan Museum of Art. Licensed by Art Resource, NY; pp. 40, 142: Courtesy of Harry S. Truman Presidential Museum & Library; p. 41: Courtesy of Louise Bruner papers, Archives of American Art, Smithsonian Institution, Washington, DC; p. 42 (left): Universal Pictures; p. 42 (right): Courtesy of American Museum of Western Art—The Anschutz Collection. Photo by William J. O'Connor; p. 46 (all), 47 (right): Photo by Scott Geffert / ImagingEtc; p. 47 (left): © Terra Foundation for American Art, Chicago; p. 50: Courtesy of Paul Quintanilla; pp. 51, 201: Ned Scott / The Kobal Collection at Art Resource, NY; p. 53: Courtesy of University of Saint Joseph. Photo by John Groo; p. 57: Courtesy of Albrecht-Kemper Museum; pp. 58, 59 (right), 60, 65: Courtesy of Museum Associates / LACMA; pp. 59 (left), 60 (right), 61, 64 (all): Photo by Jenifer Cady; pp. 62, 63, 126: Photo by Luke Abiol; p. 66: Courtesy of National Gallery of Art, Washington; p. 67: Courtesy of Eiteljorg Museum of American Indians and Western Art; p. 68: Photo by A. E. French / Hulton Archive / Getty Images, Inc.; pp. 69, 75, 204 (right): Photo by Kathy Tarantola / PEM; pp. 70, 71, 72, 73, 74, 158–59, 160, 162 (all), 163 (all), 164 (all), 165, 169, 172, 189 (right), 196 (right), 205 (left): Courtesy of The State Historical Society of Missouri, Columbia, Missouri; pp. 76–77: Courtesy of Ralph Foster Museum at College of the Ozarks; pp. 82, 95: Courtesy of Blanton Museum of Art. Photo by Rick Hall; p. 85: © Burstein Collection / CORBIS; p. 86: Courtesy of University of Oregon Libraries, Eugene; p. 87: Courtesy of David M. Rubenstein Rare Book & Manuscript Library, Duke University Libraries; p. 89: Courtesy of Historic Augusta, GA; p. 90: Courtesy of the Huntington Art Collections; p. 91: Photo by James Quine; p. 93: Courtesy of Reynolda House Museum of American Art, Winston-Salem, North Carolina; p. 97: Courtesy of Maier Museum of Art at Randolph College, Lynchburg VA; pp. 98, 99: Courtesy of The Nelson-Atkins Museum of Art. Photo by John Lamberton; p. 100: Courtesy of Pennsylvania Academy of the Fine Arts; p. 101: Courtesy of the Museum of Fine Arts, Boston;

pp. 102, 211 (top right): Courtesy of North Carolina Museum of Art, Raleigh; p. 103: Courtesy of Carnegie Museum of Art, Pittsburgh, PA; p. 105: Courtesy of Museum of Art and Archaeology, University of Missouri, Columbia, Missouri; pp. 109 (all), 117 (all), 199 (left): Phillips Library, Peabody Essex Museum, Salem, MA. Photo by Kathy Tarantola / PEM; pp. 110 (top), 112 (bottom): © The Museum of Modern Art / Licensed by Scala / Art Resource, NY; p. 110 (bottom): © 2009 Estate of Reginald Marsh / Art Students League, New York / Artists Rights Society (ARS), New York. Digital image © Whitney Museum of American Art; pp. 113 (bottom), 114 (top): Courtesy of California Museum of Photography, University of California, Riverside; pp. 114 (bottom), 210 (bottom): Courtesy of Smithsonian American Art Museum; p. 115: Courtesy of Museum Associates / LACMA. Licensed by Art Resource, NY; p. 118: Courtesy of Hirschl & Adler Galleries, New York; p. 119: Courtesy of Harry S. Truman Presidential Museum & Library. Photo by Charles Banks Wilson; pp. 123, 134, 167 (bottom): Photo by PEM; pp. 136, 149: Courtesy of National Portrait Gallery, Smithsonian Institution / Art Resource, NY; p. 138: NGS Image Collection / The Art Archive at Art Resource, NY; pp. 139 (top), 191 (left): Courtesy of National Library of Ireland; pp. 139 (bottom), 211 (left): Photo by Walter Silver / PEM; p. 140 (top): Culver Pictures, Inc. Photo by Kathy Tarantola / PEM; p. 140 (bottom): Courtesy of Peter A. Juley & Son Collection, Photograph Archives, Smithsonian American Art Museum. Photo by Peter A. Juley & Son; p. 141 (top): Milwaukee Art Museum. Photo by John R. Glembin; p. 141 (bottom): Yale University Art Gallery; p. 144: Scala / Art Resource, NY; p. 145 (top): Courtesy of Metropolitan Museum of Art, www.metmuseum.org; p. 145 (bottom): Courtesy of Indiana University Art Museum. Photo by Kevin Montague & Michael Cavanagh; p. 155: Courtesy of Peter A. Juley & Son Collection, Photograph Archives, Smithsonian American Art Museum; pp. 156–57: Image © Whitney Museum of American Art, NY; p. 168: Courtesy of Swann Auction Galleries. [Sale 2356, August 6, 2014, lot 39]; pp. 169 (bottom), 187, 190 (right), 192 (top right), 199 (right): The Kobal Collection at Art Resource, NY; pp. 170, 202 (left): Courtesy of Margaret Herrick Library, Academy of Motion Picture Arts and Sciences; p. 174: Courtesy of Pellom McDaniels III; pp. 175, 186, 192 (middle): © Bettmann / CORBIS; p. 177: Photo by Chip Cooper; pp. 178, 179, 207 (bottom right): Courtesy of Navy Art Collection; p. 180: © 1965 Esquire Magazine. Photo Courtesy of Carnegie Museum of Art, Pittsburgh, PA. Photo by Duane Michals; pp. 184, 198 (top right and bottom right): Courtesy of Missouri State Capitol Commission, Missouri State Archives; p. 188 (left): David W. Griffith Corp / mptvimages.com; p. 188 (right): Library of Congress, Prints and Photographs Division, Washington, DC, © Underwood & Underwood, New York; p. 189 (left): Courtesy of Mildred Small Collection / Missouri Division of State Parks; p. 190 (left and bottom): Courtesy of The Nelson-Atkins Museum of Art; p. 192 (bottom): Universal History Archive / Getty Images, Inc.; p. 193 (left): Warner

Bros. / MGM; p. 195 (bottom): Courtesy of Wallace Richards papers, Archives of American Art, Smithsonian Institution, Washington, DC; p. 196 (left): © Walker Evans Archive. Image © The Metropolitan Museum of Art. Licensed by Art Resource, NY; p. 197 (left): TIME Magazine, December 24, 1934, © 1934 TIME Inc. Used under license. TIME and Time Inc are not affiliated with, and do not endorse products or services of PEM; pp. 197 (right), 203 (bottom right), 209 (left): Library of Congress, Prints and Photographs Division, Washington, DC; p. 198 (left): Courtesy of Missouri State Archives; p. 200 (left): Photo by Alfred Eisenstaedt / Pix Inc. / The LIFE Picture Collection / Getty Images, Inc.; p. 203 (right): Courtesy of Wisconsin Center for Film and Theater Research; p. 205 (right): © 2014 The Nelson Gallery Foundation. Photo by John Lamberton; p. 206 (top right): Photo by Roman Freulich / mptvimages.com; p. 207 (top right): Courtesy of Georges Schrieber papers, Archives of American Art, Smithsonian Institution, Washington, DC; p. 209 (right): United States War Department; p. 211 (bottom right): Courtesy of Groucho Marx Collection, Archives Center, National Museum of American History, Smithsonian Institution, Washington, DC; p. 212 (left): Eliot Elisofon–Time & Life Pictures / Getty Images, Inc.; p. 214 (left): Courtesy of Lincoln University, Jefferson City, MO; p. 215 (left): Courtesy of New York Power Authority, Massena, NY; p. 215 (top right): Courtesy of Harry S. Truman Presidential Museum & Library. Photo by Cecil Schrepfer; p. 215 (bottom right): The State Historical Society of Missouri. Photo courtesy of Peter Anger, Missouri Division of Tourism; p. 216 (left): Paramour Fine Arts Collection of John W. Callison, Kansas City; p. 216 (right): Reprinted from Sports Illustrated, August 10, 1970. Copyright © 1970 by Time Inc. Photo by Stephen Green-Armytage; p. 217 (top left): Courtesy of City of Joplin, Missouri; p. 217 (bottom left): Courtesy of Country Music Hall of Fame® and Museum; p. 217 (right) Courtesy of Missouri Valley Special Collections, Kansas City Public Library

American Epics: Thomas Hart Benton and Hollywood accompanies the exhibition of the same name, organized by the Peabody Essex Museum, Salem, Massachusetts, in collaboration with The Nelson-Atkins Museum of Art, Kansas City, Missouri, and the Amon Carter Museum of American Art, Fort Worth, Texas.

Exhibition itinerary:

Peabody Essex Museum
June 6 – September 7, 2015

The Nelson-Atkins Museum of Art
October 10, 2015 – January 3, 2016

Amon Carter Museum of American Art
February 6 – May 1, 2016

Milwaukee Art Museum
June 9–September 5, 2016

The exhibition was made possible in part by major grants from the National Endowment for the Humanities: Celebrating 50 Years of Excellence, and the National Endowment for the Arts. Carolyn and Peter S. Lynch and The Lynch Foundation provided generous support. The East India Marine Associates of the Peabody Essex Museum and Furthermore: a program of the J. M. Kaplan Fund also provided support.

© 2015 Peabody Essex Museum, Salem, Massachusetts, and Prestel Verlag, Munich · London · New York

Published in 2015 by
Peabody Essex Museum and
DelMonico Books • Prestel

Peabody Essex Museum
East India Square
Salem, Massachusetts 01970
Tel. 978 745 9500
www.pem.org

DelMonico Books, an imprint of
Prestel, a member of Verlagsgruppe
Random House GmbH

Prestel Verlag
Neumarkter Strasse 28
81673 Munich
Tel. +49 89 4136 0
Fax +49 89 4136 2335

Prestel Publishing Ltd.
14–17 Wells Street
London W1T 3PD
Tel. +44 20 7323 5004
Fax +44 20 7323 0271

Prestel Publishing
900 Broadway, Suite 603
New York, NY 10003
Tel. +1 212 995 2720
Fax +1 212 995 2733
E-mail: sales@prestel-usa.com
www.prestel.com

Edited by Nola Butler
Designed by Roy Brooks,
www.foldfour.com
Production by Karen Farquhar

ISBN: 978–3–7913–5422–4 [hardcover]
978–3–7913–6581–7 [softcover]

Library of Congress Cataloging-in-Publication Data

American epics : Thomas Hart Benton and Hollywood / Edited by Austen Barron Bailly ; With contributions by Austen Barron Bailly, Matthew Bernstein, Janet Blyberg, Sarah N. Chasse, Margaret C. Conrads, Erika Doss, John Herron, Rob LaZebnik, Greil Marcus, Leo G. Mazow, Pellom McDaniels III, Richard J. Powell, Jake Milgram Wien.
 pages cm
 "American Epics: Thomas Hart Benton and Hollywood accompanies the exhibition of the same name organized by the Peabody Essex Museum, Salem, Massachusetts, in collaboration with The Nelson-Atkins Museum of Art, Kansas City, Missouri, and the Amon Carter Museum of American Art, Fort Worth, Texas."
 Includes bibliographical references and index.
 ISBN 978-3-7913-5422-4
 1. Benton, Thomas Hart, 1889-1975--Exhibitions. 2. Benton, Thomas Hart, 1889-1975--Sources--Exhibitions. 3. Motion pictures--United States--Influence--Exhibitions. 4. United States--In art--Exhibitions. 5. Arts and society--United States--History--20th century--Exhibitions. I. Bailly, Austen Barron. II. Benton, Thomas Hart, 1889-1975. Works. Selections. III. Peabody Essex Museum. IV. Nelson-Atkins Museum of Art. V. Amon Carter Museum of American Art.
 N6537.B457A4 2015
 759.13--dc23
 2014047829

Cover: *Hollywood* (detail of pl. 72), 1937–38

Pages 2–3: *Boomtown* (detail of pl. 16), 1927

Pages 218–19: *Lewis and Clark at Eagle Creek* (detail of pl. 31), 1967

Pages 230–31: *Thursday Night at the Cock-and-Bull. It's the Maid's Night Out* (detail of pl. 69), 1937

Printed and bound in China